RARE TREES

The FASCINATING STORIES *of the* WORLD'S MOST THREATENED SPECIES

SARA OLDFIELD & MALIN RIVERS

with contributions by ADRIAN NEWTON & PETER WILKIE

TIMBER PRESS · PORTLAND, OREGON

Photo credits appear on page 386.

Published in association with Botanic Gardens Conservation International, Global Trees Campaign, and Fauna & Flora International in 2023 by Timber Press, Inc., a subsidiary of Workman Publishing Co., a subsidiary of Hachette Book Group, Inc.
1290 Avenue of the Americas
New York, New York 10104
timberpress.com

Printed in China on responsibly sourced paper

Cover design by Adrianna Sutton
Text design by Hillary Caudle

ISBN 978-1-60469-952-4

Catalogue records for this book are available from the Library of Congress and the British Library.

Contents

Introduction

Taxonomy gives
species their names;
conservation
assessments give
them a voice.

—PETER WILKIE, Royal Botanic
Garden Edinburgh

Walking through the woods on a spring day, sheltering under a tree for shade or cover in a summer rainstorm, enjoying the shifting autumn colours, decorating a Yule tree at winter solstice—trees are part of our lives throughout the year. Through time, trees have been of immense importance, building civilisations and shaping our world. Even in the increasingly urbanised global society, trees are essential for our survival. They play a vital role in ecological functioning, helping in a major way to regulate atmospheric oxygen and store carbon, offsetting carbon emissions from fossil fuels, stabilising soils, and controlling water flow. As major components of the forest ecosystems that cover nearly one-third of the world's land surface, trees provide habitat for over 50 percent of terrestrial biodiversity, including 75 percent of birds and 68 percent of mammals. Trees provide us with vital resources for daily life. Timber, fruits, nuts, spices, perfumes, waxes, fuel, fibres, and medicine are just a few of the products we rely on that are provided by trees. And, as well, trees provide colour, shape, shade, mythology, and a sense of place in our landscapes and gardens. This book celebrates the global diversity of trees. It shows the threats now leading to extinction of trees around the world, as we collectively take these species for granted, and highlights the actions that are being taken to conserve the trees in most serious trouble.

Trees dominate forest landscapes worldwide. In total, there are over 58,000 tree species around the world. The huge diversity of trees results from evolutionary forces and adaptions to local climatic and soil conditions. Different forest types are found across the planet, from the vast expanse of boreal coniferous forests, through mixed temperate forests, to tropical rainforests. Trees first evolved over 300 million years ago with relatives of conifers and cycads being the earliest trees that we would recognise today. Although conifers and cycads are the oldest tree lineages, the characteristic of "woodiness" subsequently evolved in many plant families with the arrival of flowering plants in the Cretaceous period, 130 million years ago. Magnolias are among the oldest flowering plants. Trees continue to evolve, and new species are still being discovered and described. The extremely long history of trees and their evolution and survival over millennia provides a backdrop to the current dramatic loss of tree species globally.

EVOLUTIONARY HISTORY AND SHIFTING INFLUENCES

Over evolutionary history, some tree species became extinct through natural causes. Others proved remarkably resilient, with fossil records showing how species survived changing climates over millions of years. But the pace of extinction is now of a different order of magnitude. Extending back into prehistory, humans have exerted an influence on trees and the natural environment, initially causing very slow and gradual changes at the local level. But the pace of environmental change accelerated in the early 19th century, at the start of the industrial revolution and at the time when the human population passed one billion. With European colonisation and expanding international trade, environmental change spread rapidly around the world, with particularly significant loss of forests in the species-rich tropics. The impact of humanity on the biosphere is now considered so great that we have entered a new geological era in the history of the planet, known as the Anthropocene. With the destruction of forests, the rise of pollution, and the impact of carbon emissions, humankind itself has become a global geological force. The consequences for the earth's future are unprecedented.

We know that we are pushing more and more species to the brink of extinction without really understanding the consequences. There may

be a domino effect as ecosystems begin to unravel. In the process, an unimaginable amount of natural resources and genetic material that has scarcely been studied is being lost. Globally, the main threat to tree species is habitat destruction. The main reason for clearing forests has been to provide more land for agriculture to feed the growing human population and meet growing global expectations for cheap meat, soya products (used mainly for animal feed), and new crops (such as avocados). In the tropics, slash-and-burn farming has been a major cause of forest degradation and deforestation, but far more damaging now is plantation development. In addition to clearance for agriculture, the spread of towns and cities, transport systems, mining, and industry have all resulted in deforestation, threatening tree species on a global scale.

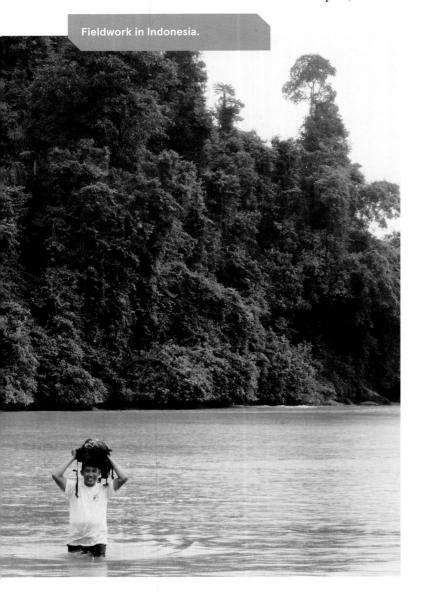

Logging too has been a major threat to tree species. Timber for local use and international trade is still extensively sourced from natural forests rather than plantations. Many selectively logged tree species with desirable wood qualities are threatened with extinction, and other trees are affected by clear-felling (clear-cutting). Trees are also harvested from the wild for various other products and may face the threat of overexploitation. Medicinal products are derived from a wide range of tree species and are of great importance in many rural parts of the world.

Forest clearance for agriculture and logging takes place at different rates and scales around the world. Added to these threats is the overarching global challenge of climate change. The impact of climate change due to the increase in CO_2 emissions during the 20th century is an increasing threat to tree species and one that we are only starting to understand. In addition to emissions from burning fossil fuels, global deforestation has been one of the main drivers of climate change with the release of the carbon stored in trees as CO_2 emissions. In turn, the impact of climate change on individual plant species is complex. As trees tend to be long-lived we are only now beginning to see the impacts

and assess the threats. On every continent we are experiencing more extreme tropical storms and hurricanes—weather events that can have severe impacts on tree species. We are witnessing more frequent and intense forest fires that threaten the survival of rare trees. Pollination and dispersal patterns of trees shift as flowering and fruiting times change, perhaps no longer coinciding with the presence of the appropriate insects and birds.

Rainfall and temperature are fundamental factors in the growth of trees, determining which species grow where, in which combinations, how they regenerate, and how they survive. As major determinants in the distribution of individual tree species, temperature and rainfall provide the so-called climate envelope for each species. Faced with climate change, species can either adapt, migrate, or become extinct. With climate change, plant ranges are shifting both altitudinally and latitudinally. Widespread species with greater genetic variation may fare better than naturally rare species with a restricted gene pool. Restricted-range plants—such as island species or cloud forest trees, which are often isolated at higher elevations—may simply have no suitable habitat to spread to.

Another rapidly emerging threat is the spread of invasive pests and diseases, assisted by changing weather patterns, and the global trade in living plants and plant products. The impact on ash species in Europe and the US is just one example of the devastation caused by introduced species. Threats to tree species often act together and vary at different locations and at different scales around the world. The solutions to tree loss are equally varied.

Around the world people are taking action to prevent the extinction of tree species. Sometimes working in dangerous conditions, international activists and local people are fighting bulldozers and mining companies to halt the pace of deforestation and protect individual species. Behind the scenes, herbarium botanists are working to document the diversity of trees, giving scientific names to individual species and understanding why each species is found where. Gardeners in the global network of botanic gardens, studying trees in their natural habitats and in cultivation, are working out how to grow and propagate some of the most threatened tree species. Park managers and forest rangers are looking out for rare trees and ensuring that they are safeguarded in their natural habitats. Firefighters are tackling the rising challenge of forest fires, which are increasing in intensity, frequency, and duration. Local forest communities are protecting the tree species on which they depend. Lawyers are arguing in courts for the protection of species and their habitats.

Did you know?

Over 17,500 trees are threatened with extinction— that's more than double the total number of globally threatened mammals, birds, reptiles, and amphibians.

Informed consumers are buying wood from sustainably managed forests. But much more needs to be done. Each tree species is a piece in the global biodiversity jigsaw. Each tree species extinction has profound and as yet not fully understood consequences. Everyone can play a part in saving trees from extinction.

GATHERING INFORMATION

Understanding which trees are under threat is an important first step in prioritising and planning for conservation action. Concern about the fate of the giant redwoods and other iconic trees dates back to the 19th century, but documentation of the conservation status of tree species around the world didn't began in earnest until the 1970s. Sir Peter Scott came up with the idea of Red Data books to highlight the species considered most in trouble. Following the first UN environmental summit, held in Stockholm in 1972, national Red Lists were produced in Australia, the US, and other countries, and experts began to compile information on a global scale for the International Union for Conservation of Nature (IUCN). In 1978, the IUCN Plant Red Data Book was published, providing 250 examples of the approximately 25,000 vascular plants species considered threatened at the time, including 92 tree species.

Equipment for collecting herbarium samples in Belize, with plants harvested and pressed in the field.

Twenty years later, the IUCN published a compilation of over 33,000 globally threatened plant species, and even that number represented only the tip of the iceberg; in it, plants were listed by their botanical families, and trees were not distinguished from other types of plants. The World List of Threatened Trees, also published in 1998, took a different approach, and, using the new Red List assessment system introduced by IUCN in 1994, identified at least 10 percent of the world's tree species as being under threat while simultaneously making a strong plea for measures to prevent extinctions. Responding to the call, the Global Trees Campaign (GTC) was established, with Fauna & Flora International (FFI) as the main driver. For more than two decades, the Global Trees Campaign has been an innovative and highly successful

conservation initiative, since 2005 working in partnership with Botanic Gardens Conservation International (BGCI). Many stories of action under the Global Trees Campaign are highlighted in this book.

But threats to trees continue to take their toll, and now we understand more fully the major impact that climate change is having on trees. The Global Tree Assessment (GTA) is an ambitious initiative to assess the conservation status of all tree species. An outline plan, built on earlier studies, was published in 2015, since when hundreds of tree experts and enthusiasts have contributed information. The GTA benefits from the huge improvements in data collection and sharing over the past 20 years but still depends on fundamental knowledge of what is happening to trees in the wild. The work is coordinated by BGCI and a group of tree experts brought together as the IUCN/SSC Global Tree Specialist Group (GTSG). SSC (Species Survival Commission) is another legacy of Sir Peter Scott, who was the first Chair of this voluntary network of species experts. BGCI and GTSG are working together to map and collect information on all tree species, updating conservation assessments and undertaking new assessments for many previously undescribed or poorly known species.

The first step in the Global Tree Assessment was to compile a baseline list of all tree species, something that, surprisingly, had never been undertaken. Emily Beech describes the laborious task, which took two years: "After trawling through a range of plant databases, over 500 scientific references, and contacting around 80 tree experts we had produced the list of nearly 60,000 tree species and their country distributions. The list is now online and searchable by taxonomy or country." Anyone can use this global list of tree species; it is updated regularly and provides a checklist for monitoring progress in assessing the conservation status of each tree species. The task of assigning IUCN threat categories falls to teams of national or taxonomic experts who are working hard to assess the conservation status of all trees. All relevant information is taken into account in the assessments—distribution, habitat type and ecology, species population size and trends, threats, uses, and conservation status.

The IUCN Red List status is given for the species discussed and described within this book. There are three categories of threat—Critically Endangered, Endangered, and Vulnerable. The category of Near Threatened suggests that a species is approaching the Vulnerable category. Data Deficient is used when there is simply not enough information to make a judgement about a species. Extinct, Extinct in the Wild, Least Concern, and Not Evaluated are self-explanatory.

DEVELOPING LEGISLATION AND INTERNATIONAL AGREEMENTS

Since the 1970s, countries have taken action to protect threatened trees through legislation. In the US, for example, the Endangered Species Act came into force in 1973 with lists of endangered and threatened species subject to legal protection. Assessment of the conservation of plant species for the Act was undertaken by the Smithsonian Institution in response to a request from Congress, and this legislation extends to some species found outside the country. In other countries, species assessed as threatened according to the IUCN Red List categories and criteria are automatically protected by law; this is the case, for example, in Chile, home to iconic conifers, and Brazil, the country with the greatest diversity of tree species. Many countries now have some form of legal protection for the threatened trees under their watch.

As awareness of environmental problems grew over the past 50 years, governments realised the need to work together to protect trees and other imperilled species. One of the first international agreements to tackle global threats was the Convention on International Trade in Endangered Species of Wild Fauna and Flora (CITES), which came into force in 1976. This Convention is designed to ensure that international trade in wild animals and plants and their products does not threaten their survival in the wild. Together, governments decide which species at risk from harvesting for international trade need to be monitored and protected. International trade in some very rare species sourced from the wild is totally banned, whereas for other species, trade is allowed when it can be shown that the trade is legal and will not be detrimental to the species. Implementation of CITES is primarily through national legislation and enforcement. When the lists of plants needing protection were first proposed, there was an emphasis on protecting ornamentals such as orchids, cacti, and cycads together with iconic plant species of national importance. Over time the emphasis has shifted to include commercially important timber species. Initially there was strong resistance from the timber trade, but environmental campaigners have helped to ensure that species such as mahogany and rosewood are now listed by CITES. This provides a framework for action, but implementation and enforcement remain challenging for timber products.

Implementation of CITES for trees is supported by the International Tropical Timber Organization (ITTO), created in 1983 through an

Did you know?

Over 2700 trees are listed as critically endangered on the IUCN Red List—likely to go extinct unless urgent action is taken to save them.

agreement between major timber-producing and -consuming countries. Initially ITTO questioned whether controls on tropical timber species of conservation concern was a good idea and was resistant to the idea of international legally binding action. Over time, their position shifted, partly as the scale of damaging illegal timber trade was realised. Since 2006, a joint CITES and ITTO programme of work strengthens sustainable management of timber resources and track the legality of CITES timber exports.

A second UN environmental summit was held in Rio de Janeiro in 1992. A major outcome of this so-called Rio meeting was the Convention on Biological Diversity (CBD). This is an international framework agreement that comprehensively addresses biological diversity with three objectives: conservation of biological diversity; sustainable use of its components; and fair and equitable sharing of benefits arising from the utilisation of genetic resources. The CBD is not a legally binding agreement and delivers its objectives through programmes of work rather than national legislation. The conservation of tree species is integral to these programmes, including the Forestry Programme, Protected Area Programme, and Sustainable Use Programme. It is also particularly relevant to the crosscutting Global Strategy for Plant Conservation (GSPC). The CBD has a Strategic Plan for Biodiversity, agreed in Japan in 2010, which provides the global framework for biodiversity action for the entire United Nations system.

Another equally important outcome of the second UN environmental summit in Rio was the United Nations Framework Convention on Climate Change (UNFCCC), adopted by 193 countries. The ultimate goal of this convention is to stabilize greenhouse gas concentrations "at a level that would prevent dangerous anthropogenic (human-induced) interference with the climate system. [S]uch a level should be achieved within a time-frame sufficient to allow ecosystems to adapt naturally to climate change, to ensure that food production is not threatened, and to enable economic development to proceed in a sustainable manner." Forest restoration, reforestation, and afforestation are recognised as valuable approaches for climate change mitigation, through the capture and storage of carbon by trees. According to the historic UNFCCC Paris Agreement in 2015, "Climate change represents an urgent and potentially irreversible threat to human societies and the planet and thus requires the widest possible cooperation by all countries." The central aim of the Paris Agreement is to strengthen the global response to the threat of climate change by keeping global temperature rise in the current century

well below two degrees Celsius above pre-industrial levels and to make efforts to limit the temperature increase even further. Additionally, the agreement aims to strengthen the ability of countries to deal with the impacts of climate change.

Forest restoration, benefitting threatened tree species, could potentially be supported by the developing market for carbon. Regulated or compliance carbon markets are governed by rules in the Kyoto Protocol of the UNFCCC; these markets include Clean Development Mechanism (CDM) projects, of which a number are forestry-related. Unregulated voluntary carbon markets, such as the Verified Carbon Standard (VCS), also offer project standards; these have been applied to a wide range of conservation and forestry schemes, many of which are operated by NGOs. In the context of climate change mitigation, a promising mechanism for funding forest restoration and tree conservation is REDD (Reducing Emissions from Deforestation and Forest Degradation), which provides incentives for developing countries to invest in low-carbon approaches to sustainable development. Developed within the UNFCCC, the focus of REDD was recently expanded (as REDD+) to include "enhancement of forest carbon stocks," which provides opportunities for supporting forest restoration efforts. REDD+ activities are supported by national and local governments, NGOs, and the private sector, with support from various development agencies, the World Bank, and research institutes.

Markets for carbon can generate revenues that support forest and biodiversity conservation. In practice, however, the mechanisms have not been as successful as initially hoped. The ecosystem service of carbon is part of a much wider range of ecosystem goods and services, all of which interact in complex ways. Potential negative social impacts include loss of livelihoods or access to lands undergoing reforestation, a risk that is particularly high in areas where land tenure is insecure.

The United Nations Convention to Combat Desertification (UNCCD) is the third major agreement developed in Rio and adopted in 1994. This aims to ensure long-term productivity of drylands and the biodiversity that they support. The convention promotes effective action through local programmes and supportive international partnerships. Tree planting is an important global activity promoted by UNCCD in its work to tackle deforestation. Launched in 2007, the Great Green Wall, a very ambitious undertaking, will become the largest living structure on the planet—an 8000-km wall of trees stretching across the entire width of Africa.

With international agreements in place, there is a now a framework for countries to work together cooperatively to save trees and the global

biodiversity they support through legislation, policies, and action. The agreements have resulted in many small conservation successes and more significant advances, but they have not yet prevented the loss of tree diversity. Economic concerns are universally given higher priority by governments than environmental concerns. Successes in biodiversity conservation that have been achieved around the world frequently reflect the efforts of voluntary and charitable organisations. Now with growing protests about the fate of the Amazon and calls for immediate action to save the planet, there is hope that the small conservation successes will be scaled up to achieve real impact.

CONSERVATION APPROACHES

In Situ Conservation: Reserves, Reintroductions, Sustainable Use

Legislation protects individual tree species in their natural habitats, aiming to prevent their removal from the wild and specifying the need for recovery. Protection of trees in their natural habitats is also greatly enhanced by the designation of nature reserves and national parks. Valued areas of forest have been revered and protected for centuries. In India, for example, forests were declared abhayaranyas (sanctuaries) over 2000 years ago. The world's first modern national parks were developed in the US in response to the loss of forests and iconic species, such as the bison. Yellowstone National Park, established in 1872, can rightly claim to be the first official national park. Earlier, the Yosemite Valley in California was declared a state park under the Yosemite Bill signed by Abraham Lincoln in 1864, and it became a national park in 1890. Canada and New Zealand soon adopted the idea of creating national parks to protect nature, and now very country in the world has a protected area system. Protected areas cover over 15 percent of the world's land area. As well as helping to reduce deforestation together with habitat and species loss, they collectively store 15 percent of the global terrestrial carbon stock, helping to buffer the impacts of climate change, and support the livelihoods of over a billion people.

Protected areas are an important component of in situ conservation for tree species. But even then, areas set aside for forest conservation are not enough. Management and vigilance—to prevent illegal logging and other threats to areas once they have been designated as protected—remains

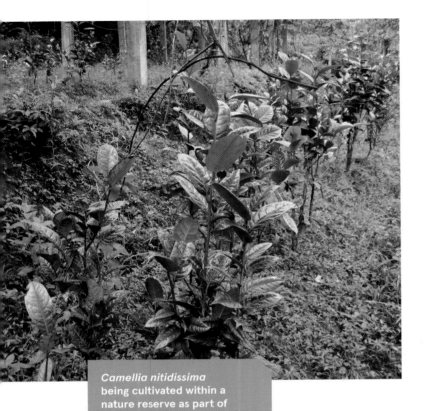

Camellia nitidissima being cultivated within a nature reserve as part of a conservation effort.

crucial. Much of the world's forest land, with some of the richest tree diversity, lacks formal protection. Forests and their timber stocks, whether under national control or private ownership, continue to be utilized as a primary source of wealth. In the years leading up to the environmental summit in Rio, there were calls for a global agreement on forest management and conservation. As with the debate on timber and CITES, resistance to any form of legally binding agreement was strong. In the forestry sector, calls for an international legal regime for control of forests and trade in timber were largely countered by the growth of voluntary schemes for certification of sustainable forest management supported by the private sector. The Forest Stewardship Council (FSC) was created by business interests, environmentalists, and community leaders in 1993 after the Rio summit failed to agree to a convention to stop deforestation. The mission of the FSC is to promote environmentally sound, socially beneficial, and economically prosperous management of the world's forests. Subsequently national governments set up national forest certification schemes, and these were brought together under the Programme for the Endorsement of Forest Certification (PEFC). True sustainable forestry as promoted by the FSC takes into account ecological, economic, and social criteria. Based on the application of these criteria, sustainability can be assessed and forest products from sustainably managed sites certified for the marketplace.

As of September 2019, according to the Global Forest Atlas of the Yale School of Forestry, over 440.3 million hectares of forest around the world were certified by the FSC and PEFC. This represents about 10 percent of the total global forest area. Unfortunately, 92 percent of certified forest is in temperate and boreal regions, which are far less biodiverse and have far fewer tree species than tropical regions. The certified timber available on the market represents only a small proportion of the species in trade, and logging for tropical timber is usually damaging to species diversity. Nevertheless some FSC-certified stocks of African blackwood (*Dalbergia melanoxylon*), big-leaf mahogany (*Swietenia macrophylla*), West Indian cedar (*Cedrela odorata*), and other valuable tropical

hardwoods are available, showing that forest certification can play a direct role in tree species conservation. Forest certification schemes can successfully link timber production to the consumer of timber products, and the trade in certified products has been particularly successful in areas with strong consumer interest in the environment.

Conservation through sustainable use and trade in timber has been widely presented as a dream ticket for forests and their trees, providing both ecological security and livelihood options for the millions of people who live in or around forest ecosystems. The same is true for non-timber forest products (NTFPs). In reality, however, sustainable use of forest resources is not an easy option. The "use it or lose it" argument for conserving forests is compromised by the fact that trade in forest products rarely (if ever) provides sufficient financial returns to protect the forest against other threats. This is the case even when high-value timber like mahogany is harvested for the international market and considerably more so where NTFPs (which include fruit, bark, exudates, and leaves) are harvested. Tropical hardwood remains undervalued, sustainable management adds many costs, and unfair competition with illegal and unregulated logging remains commonplace. Forestry expert Adrian Newton generally agrees: "Most efforts to manage tropical forests sustainably have focused on producing a sustained timber yield of a few species. On this basis a continuous supply of timber is assured but not necessarily the survival of populations of valuable timber species and undoubtedly not the survival of other tree species within the forest."

A similar form of certification for sustainable production has been developed for NTFPs harvested for food and medicine. FairWild Standard aims to enable transformation of resource management and business practices to be ecologically, socially, and economically sustainable throughout the supply chain of wild-collected products. Currently, products from tree species certified against the FairWild Standard include elderflower (*Sambucus nigra*), African baobab (*Adansonia digitata*), and two Indian medicinal trees, myrobalan (*Terminalia chebula*) and bastard myrobalan (*T. bellirica*). Many more tree products are in development. This is a small step in the right direction. Guaranteeing sustainability is a big challenge in the context of wild-harvesting. The international trade in NTFPs covers an extraordinary range of tree products from around the world, used for aromatic, medicinal, and food purposes. The trade is scarcely documented, overexploitation of trees remains a problem, and the livelihoods of people involved in harvesting are often precarious.

Did you know?

Baobab fruit was hailed as a superfood on the international market after it was approved for use in smoothies by the European Union in 2008.

The Sustainable Agriculture Network (SAN) is a coalition of leading conservation groups that links responsible farmers with conscientious consumers by means of the Rainforest Alliance Certified seal of approval. SAN promotes effcient and productive agriculture, biodiversity conservation, and sustainable community development by creating social and environmental standards. In August 2010, there were over 80,000 Rainforest Alliance Certified farms in 26 countries, covering a total of over 500,000 hectares. By June 2013, certification had expanded to 2.7 million hectares in 43 countries worldwide. The Rainforest Alliance has successfully introduced the concept of "landscape mosaics" to farm and forestry operations around the world. To meet the standards of FSC and Rainforest Alliance certification, farm and forest operations must allocate as protected reserves a portion of the land they are seeking to certify. To date, more than 11 million hectares have been set aside as reserves in Latin America alone.

Ex Situ Conservation: Botanic Gardens, Seed Collections

We need to do much more to protect trees in their natural habitats. We need to think about the impact of climate change on tree species and how this might affect future tree conservation needs. At the same time, with so many tree species declining in abundance as a result of human activities,

PlantSearch Database

BGCI maintains an extensive database that records the plant species grown by botanic gardens worldwide. This is an extremely useful tool for tracking the progress of ex situ conservation for species that are in decline in the wild. PlantSearch (bgci.org/resources/bgci-databases/plantsearch) is being used to measure progress toward Target 8 of the GSPC by tracking which threatened species are in botanical collections throughout the world. It also enables botanic garden staff to understand the global significance of their collections and to plan collaboratively for the conservation of particular species. Currently over 600 botanic gardens and related institutions provide data on the species they are growing.

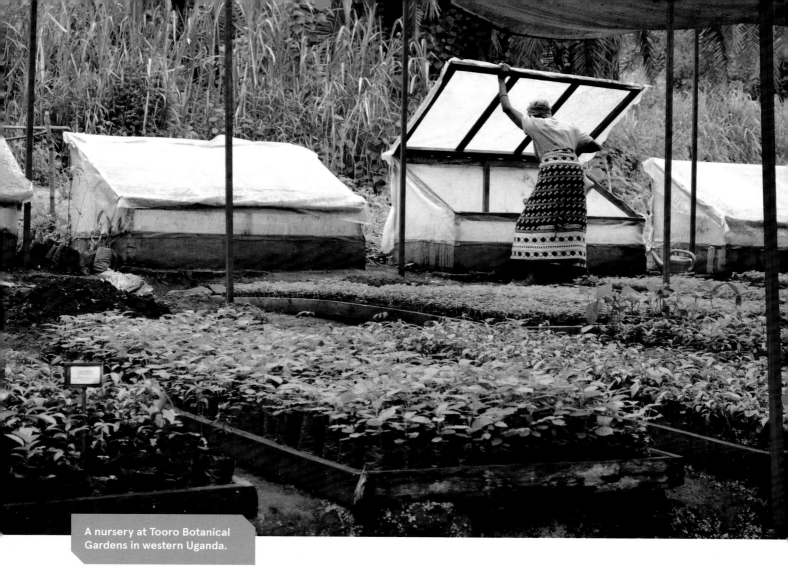

A nursery at Tooro Botanical Gardens in western Uganda.

there is an increasing need to consider ex situ conservation approaches. Ex situ conservation of plants is the conservation and maintenance of samples of living organisms outside their natural habitat, in the form of whole plants, seed, pollen, vegetative propagules, tissue, or cell cultures. Botanic gardens and arboreta play a major role in the ex situ conservation of plants, as do some zoos, academic institutions, non-profit organisations, forest services, and other government agencies. One huge value of ex situ collections is to connect people with the trees we are losing. Many favourites commonly cultivated in parks and gardens—monkey puzzles, magnolias, camellias—are endangered in the wild. This is not as well known as it should be.

For ex situ conservation action of a tree species to be truly effective, the material in a collection needs to be well documented, of known wild

origin, and genetically diverse. Paul Smith, Secretary General of BGCI, is convinced that with the backup provided by botanic gardens, no tree species should go extinct:

> We have the knowledge, experience, and networks to conserve tree species, either as living plants or seeds and where necessary using novel scientific techniques. For species with orthodox seeds which maintain their viability after drying and storing at low temperatures for many years, seed banks provide the greatest direct conservation value at the lowest cost. In contrast, for species with recalcitrant seeds that cannot be dried and stored, tissue culture or cryopreservation collections can also provide high direct conservation value but at a higher cost. We also cannot underestimate the conservation value of living collections of trees.

In general, well-documented, wild-collected ex situ collections that capture as much genetic variation of the species as possible will have the greatest conservation value. Botanic gardens often maintain collections of living plants represented by a few specimens of a range of species from cultivated or, where records have not been kept in the past, unknown

(→) New South Wales Seed Bank, Australia.

(↓) Germination trials to determine whether stored seeds are viable.

origin. Living collections represented by only a few individuals will often be of limited direct conservation value. They can, however, be of indirect conservation value—for example, through research, horticulture, and education, helping to tell the story of the plight of trees in the wild. It goes without saying that ex situ collection efforts must be conducted carefully to ensure wild populations are not placed at additional risk.

Once the material is brought into a collection, effective management is important to maintain the conservation value of the material. Collections with the most direct conservation application are genetically diverse and representative of the species; they must be managed to ensure the material is genetically sound and available for conservation activities over the long-term. Many living collections do not meet these standards, owing primarily to genetic issues such as having too little genetic diversity, being of unknown provenance, or losing genetic diversity via drift or adaptation to cultivation and hybridization. Management of ex situ collections should also minimize the risk of loss due to random events, natural disasters, or other catastrophic loss (staff changeover, theft, fire, disease) by ensuring that collections are maintained at more than one site. Additionally, curatorial oversight of living collections through time is crucial to maintaining associations between collection data (e.g., provenance) and specimens.

Ecological Restoration: Reinstating Tree Species, Diversity, and Functional Ecosystems

Conserving natural areas to allow tree species to flourish is an essential conservation goal. But can we also repair areas that have been badly damaged by mining, clear-felling, and intensive agriculture? The answer is a qualified yes. Sometimes forests will recover naturally if the damage has not been too intense. The deciduous forests of New England in the US were among the first to be cleared for farming with the arrival of European settlers. In the 20th century, forested areas increased in New England, with natural regeneration of marginal or abandoned agricultural land. Nevertheless the composition and structure of the forests has changed significantly, with a broad ecological shift away from genera such as *Fagus* (beech) and *Tsuga* (hemlock) to the now-dominant *Acer* (maple) and *Populus* (poplar). Generally in the northeastern states, 80 percent of the region was forested in 2010, but with less than 1 percent of original old-growth forest remaining intact. To recreate original forest we

have to decide on the baseline conditions to work toward and undertake active management.

Globally, the widespread environmental degradation that has resulted from human activities has led to a growing interest in restoring forests and other ecosystems. Ecological restoration has grown rapidly in importance over the past few decades, both in terms of scientific understanding and in terms of environmental management practice. Billions of dollars are now being invested in restoration actions throughout the world, supported by the CBD and other international policy commitments. Environmental organisations and community groups, governments and large companies are actively engaged in ecological restoration projects.

We have to be careful to distinguish between tree planting and ecological restoration. Often now tree planting is seen as a panacea for the world's environmental problems. Tree planting schemes are promoted as a way of reducing carbon dioxide in the atmosphere and mitigating the impacts of climate change. But it is very important to plant the right tree in the right place—and ideally with the right mix of species. Replicating the monocultures of eucalyptus and pine that have been a major threat to natural forests is a big mistake.

In planning tree conservation action, the focus is often on restoring populations of an individual tree species that has been depleted in the wild. This can be achieved by artificially establishing individuals of the tree species—for example, by enrichment planting, using planting stock derived from an ex situ population. If a species has been extirpated from its original habitat, it may be a candidate for reintroduction, which aims to re-establish new, self-sustaining populations of a species in locations where it occurred previously. Reintroduction is now a very important plant conservation tool, but tree species have seen relatively few success stories. To be successful, reintroductions are dependent on the availability of appropriate material, either from other nearby adapted populations or from suitable ex situ populations. Reintroduction can form part of a broader effort to restore an entire ecosystem.

A range of terms describes the restoration of whole areas of forest. Rehabilitation emphasizes the recovery of forest ecosystem function, without including the re-establishment of some pre-existing baseline state. Reclamation generally refers to the environmental improvement of mined lands, which have often lost all their natural vegetation and underlying soils, producing a barren wasteland. In the US, some exciting initiatives to restore Appalachian coal mine sites go beyond reclamation to introduce an interesting mix of species, including the American chestnut.

This is unusual at reclamation sites, which rarely aim to restore the original biodiversity. Afforestation and reforestation refer to the establishment of trees on a site—the former, where no trees existed before; the latter, following deforestation. Afforestation is tree planting, and great care needs to be taken to ensure that the site is suitable for growing trees and that the species chosen are appropriate.

The Bonn Challenge is a global effort to bring 350 million hectares of the world's deforested and degraded land into restoration by 2030. It was launched in 2011 by the government of Germany and IUCN, and later endorsed and extended by the New York Declaration on Forests at the 2014 UN Climate Summit. Underlying the Bonn Challenge is the forest landscape restoration (FLR) approach, which aims to restore ecological integrity at the same time as improving human well-being through multifunctional landscapes. There is huge scope to be bold in reintroducing threatened tree species as part of the FLR approach, effectively bringing together tree conservation and forest restoration action.

THE ONGOING CAMPAIGN

It seemed a simple idea at the outset. We had a list of around 7000 tree species evaluated as threatened with extinction—let's develop a campaign to save them. This would involve looking at tree conservation success stories and scaling up action globally. Of course this would involve financing, but surely everyone would understand the importance of trees and would want to contribute. That was 20 years ago. Initially FFI took the lead. Working with the UNEP World Conservation Monitoring Centre, who had produced the World List of Threatened Trees in 1998, FFI established the Global Trees Campaign in 1999. The aim was straightforward: to save globally threatened trees and their habitats. Over time, the work of UNEP WCMC evolved away from documenting the conservation status of tree species, and in 2005 BGCI replaced UNEP WCMC as the lead partner in the Global Trees Campaign alongside FFI.

The FFI and BGCI are ideal partners for the implementation of the Global Trees Campaign. For more than a century, the former has been developing innovative approaches to species conservation, working with local stakeholders and communities. The latter, with its focus on conserving plant diversity and working with a global network of botanic gardens, adds important skills to the mix. Various approaches—in situ

and ex situ conservation, restoration in natural habitats, sustainable for-
est management—are being implemented for a range of "flagship" tree
species, chosen because they are important to people and representative
of their habitats; these include magnolias in China, Colombia, and Cuba,
agarwood trees in Cambodia, oaks in the US, and rosewoods in Central
America. Over 20 years, the Campaign has acted to conserve over 400
tree species in more than 50 countries. It is an exciting time to join the
fight for threatened tree species. The involvement of an increasing range
of botanic gardens, arboreta, forestry departments, NGOs, and other
partners—partially in response to updated IUCN Red Lists for selected
tree groups—is an encouraging sign. But even as we learn more and
increase the level of action, the threats to tree diversity are increasing.
Much more support for saving trees, building on all available conserva-
tion options, is needed.

Trees and Their Ecosystems

Trees define landscapes worldwide. Outside the extreme polar regions and at the earth's highest altitudes, trees flourish in a wide variety of ecosystems. They are the main biological components of the world's forests and also grow in savannas, grasslands, deserts, and wetlands. Trees survive as remnants of natural

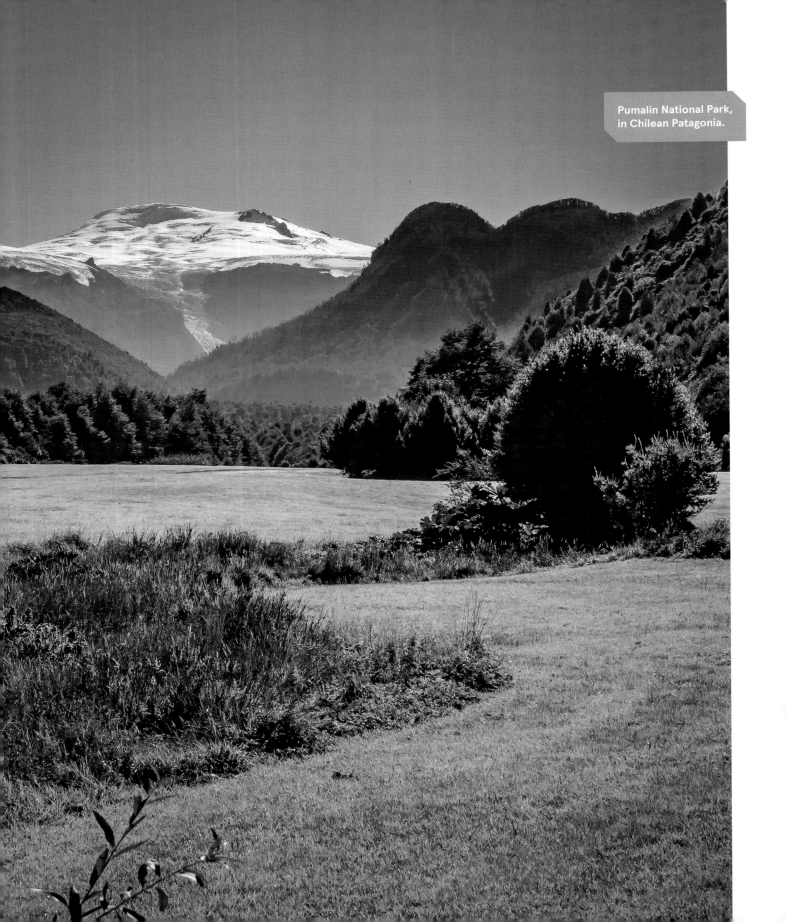

Pumalin National Park, in Chilean Patagonia.

vegetation in agricultural landscapes and are much loved in our towns and cities, whether in fragments of natural forest or planted in our parks and gardens or along our streets. The world's continental forests offer a rich diversity of trees, while islands include all the different types of forests found elsewhere and, because of their isolation, have a rich concentrations of endemic tree species.

TROPICAL RAINFORESTS

Magnificent tropical rainforests cover about 6 percent of the world's land surface. They are home to a huge amount of biodiversity (about half of all known plant and animal species) and maintain some 40 percent of the earth's carbon stocks. Trees are their essential components, defining the architecture and composition of tropical rainforests; they have evolved to reach their maximum diversity within these forests. The Amazon alone has an estimated 16,000 tree species. Rainforests in Southeast Asia also have a very large number of tree species, followed by rainforests in New Guinea, Madagascar, and elsewhere in Africa. Many tree species within rainforests are naturally rare, existing in low numbers over large areas. The reasons

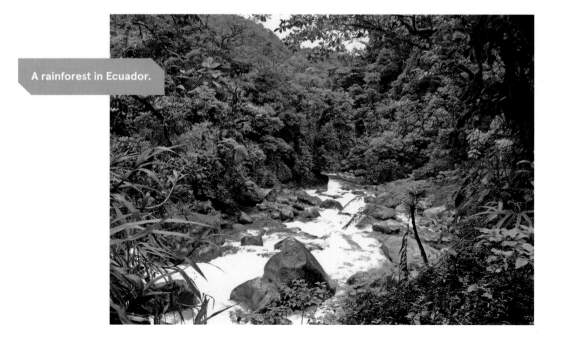

A rainforest in Ecuador.

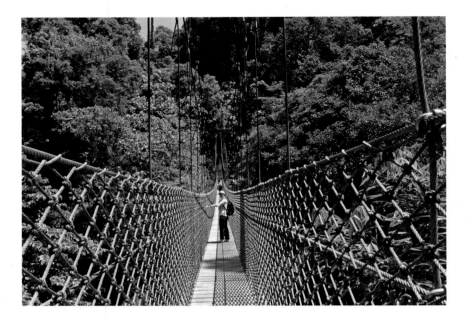

for the exuberant tree diversity are not fully understood but may be partially attributed to the stability of lowland rainforest areas over a very long period of time and climatic conditions that favour plant growth.

Walking high in the forest canopy on a jungle walkway is an exhilarating experience, giving some idea of the scale and diversity of the rainforest ecosystem. Jungle walkways are the perfect opportunity to see the abundance of trees of different heights, with different shapes and sizes of leaves in different hues of green, stretching for miles and miles. Flashes of colour are provided by flowering trees and epiphytic orchids and, at the right time of day, birds and butterflies animate the forest. Standing in the middle of the canopy walkway of Ulu Temburong National Park in Brunei, high above the forest floor, it is easy to imagine a world entirely covered in lush forest. No buildings or roads are in sight. But in reality most of the rainforests of Borneo and all the world's other tropical rainforests have been modified and are now fragmented and continuously under threat. National parks like Ulu Temburong are increasingly important refuges and among the few places where we can see tropical rainforest in a near pristine condition.

The hot and wet climatic conditions that support rainforests in the tropical lowlands are ideal for the luxuriant growth of trees. Generally the soils underlying tropical rainforests are formed from ancient rocks; they are leached by high rainfall and therefore infertile, with a lack of

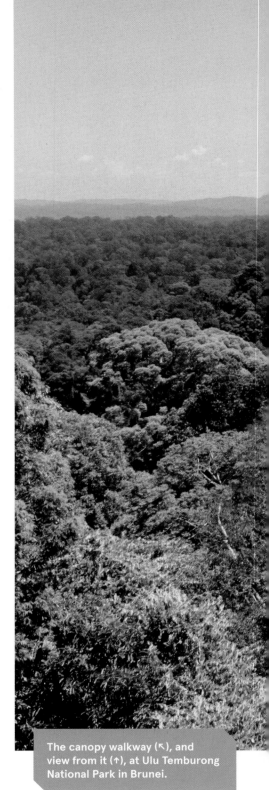

The canopy walkway (↖), and view from it (↑), at Ulu Temburong National Park in Brunei.

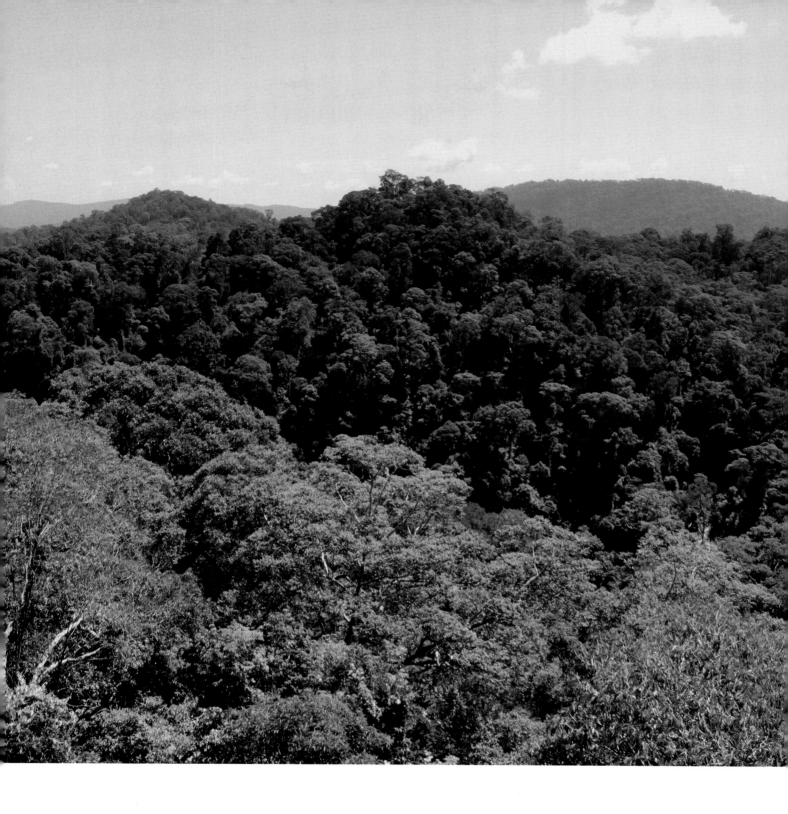

readily available nutrients. Tall, diverse forests can exist on these soils only because rainforests have evolved to recycle nutrients efficiently. Very often, symbiotic fungal associations (mycorrhizae) found in the tree roots enable trees to utilise nutrients and water resources more efficiently. These fungi may also provide protection against harmful plant pathogens, and the trees in turn provide carbon as an energy source to the fungi. Extensive buttresses often support the towering straight trunks of rainforest trees; these are necessary because root systems of rainforest trees are generally shallow, extending laterally to tap the nutrients in the surface litter layer.

Rainforest trees have also evolved to make maximum use of the sunlight essential for photosynthesis. Competition for light is intense. Many tree species have the ability to remain semidormant under the canopy until a light gap appears, for example, when another large tree dies or decays. Gaps in the forest may result from a tropical storm or natural fire, and then the semidormant tree seedlings "wake up" and undertake very rapid growth. Leaves in understory forest species are typically arranged in a single layer to minimise casting shade. Leaves in the forest canopy are usually leathery and drought resistant, to withstand severe sun intensity. Some leaves alter their orientation during the day to avoid sun stress.

Interactions between plants and animals are very highly developed in the rainforest. Seed dispersal, for instance, is largely accomplished by animals, and much pollination is by vertebrates and social bees, which travel long distances between scattered individuals of many plant species. An extraordinary example of large-scale bat pollination can be observed in the Calakmul Biosphere Reserve in the state of Campeche, Mexico, where every day just before dusk a whirlwind of 7–13 million bats (depending on the period of the year), leaving their subterranean cave for the night, can be observed. An unknown but important percentage of the 450 tree species recorded in this area of 20,000 km² depend on bats for pollination and dispersal.

Many rainforest tree species are in large plant families, some of which are entirely or largely restricted to tropical forest areas, including tropical cloud forests. These families include Anacardiaceae, Annonaceae, Bignoniaceae, Capparidaceae, Dipterocarpaceae, Lauraceae, Melastomaceae, Meliaceae, Moraceae, Myrsinaceae, Myrtaceae, Rubiaceae, Sapindaceae, Sapotaceae, and Sterculiaceae.

Rainforest trees provide a rich diversity of useful products. Tropical hardwoods are the most economically important on a global scale and provide major export earnings for tropical countries. Over a thousand

Did you know?

The Amazon rainforest is home to over 400 billion trees from 16,000 different species.

different tree species are sourced from tropical forests for use as commercial timber, and many more are used locally. Fuelwood sourced from the rainforest is also very important for people living in or near the forest. It has been estimated that approximately 1.3 billion people rely on forests for their livelihood. Wild fruits and nuts, leaves for thatching, latex, gums and flavourings for local use and trade, and medicinal products are just some of the products provided by rainforest trees. Exploitation of high-value products such as wild rubber and Brazil nuts attracted hundreds of thousands of migrants into the Amazon in the 19th century. Tropical forests are the source of around 2500 edible fruits. Papua New Guinea alone has more than 250 edible fruit tree species, 40 of which are in cultivation; the rest provide fruit sourced from the wild. The forests of Borneo are the origin of important tropical fruits such as mango, durian, breadfruit, and jackfruit, a new miracle fruit that is increasingly popular with vegans. Major commercial crops such as cocoa, avocados, and citrus fruits have all been developed from rainforest trees.

Local people living close to or in the rainforest typically collect wild fruit and other forms of food to supplement the crops they grow. Slash-and-burn farming (aka shifting cultivation, swidden) has been used to manage forests for food over the past 10,000 years. Land is first cleared by removing the trees and then burnt and used to grow crops. After one or many seasons, the land is abandoned, and a new area is cleared and burned. Slash-and-burn farming is now practised in over 40 countries in tropical regions of Africa, Asia, and Latin America. As human population increases, demand on land increases, and abandoned land is not left long enough to recover, nor is there enough natural forest left to provide the plants and seeds to allow for recovery to take place. Shifting cultivation has been considered a major threat to the rainforest and as general pressures on the land increase, it is contributing to forest loss in parts of the world. But where traditional knowledge relating to fallow management is well developed and applied, shifting cultivation can be a form of sustainable forest management, especially when human population density is low. In these cases, soil fertility is maintained while conserving biodiversity and maintaining the provision of other forest ecosystem goods and services. Within tropical countries, where most forest change has occurred, deforestation due to smallholder agricultural expansion has generally given way to large-scale agricultural forest conversion.

Meanwhile logging continues apace, and few tropical rainforest areas have not been exploited. Currently about 15 percent of the timber produced globally is sourced from tropical forests. Timber from the forests

of the Caribbean was shipped to Europe from the time of Columbus, with Cuban mahogany (*Swietenia mahagoni*) a prized resource. Exploitation of west African timber for the European market dates to at least 1672, when the Royal African Company received a charter from King Charles II of England to trade in African mahogany (*Khaya* and *Entandrophragma* spp.). By the early 18th century, west African timber replaced the diminishing and more distant supplies from the Caribbean region. Trade in African timber increased significantly with European colonialism at the end of the 19th century and evolved rapidly after 1945, still controlled by European interests, to supply utility-grade wood.

In Southeast Asia, tropical forests in Peninsular Malaysia have been managed for commercial timber since the early 1900s, initially to supply UK needs. International demand for Malaysian timber became significant in the 1950s; increasing postwar demand in 1953 and agricultural expansion after Malaysia's independence in 1957 made large quantities of logs available. In Indonesia, teak plantations developed in Java under Dutch colonial rule formed the basis for commercial forestry until after World War II. The vast forests of Indonesia and East Malaysia (Sabah and Sarawak) were opened up in 1965 for the international market. In the Philippines, intensive logging of the dipterocarp forests took place from the end of World War II until the 1970s. In 1968, timber accounted for 33 percent of the country's foreign exchange earnings, falling to 5 percent by 1986 because of lower global prices, forest depletion, and conservation policies.

The first global assessment of the extent of logging in the tropics, compiled in 2009, indicated that 20 percent of the tropical forest biome was either actively logged or allocated to logging concessions between 2000 and 2005. About half of this area had already been heavily affected by land-use change, losing over 50 percent of its forest cover. By 2010, commercial timber extraction reached into the centre of Amazonia and was expanding rapidly into new areas, including central Africa and Papua New Guinea; soon it would reach the very last remote tropical forests.

There are major efforts to conserve rainforests around the world, as highlighted in the introduction to this book. Managing tropical rainforests sustainably and setting aside sufficient natural areas is certainly an efficient way to conserve maximum tree species on a global scale. Approximately 25 percent of all tropical forest is now in some form of protected area. Serranía del Chiribiquete National Park, in the heart of the Colombian Amazon, is the world's largest national park protecting tropical rainforest. In 2018, the size of this protected area was doubled,

and it was declared a UNESCO World Heritage site, reflecting its enormous environmental, cultural, and social value. This biodiverse area, located at the westernmost edge of the Guiana Shield, protects many tepuis (steep-sided tabletop mountains), which have very high levels of endemism. The tepuis found in Chiribiquete have dramatic scenery that is relatively undisturbed, making the site one of the most important areas of wilderness rainforest in the world. But the tepuis also have a long history of human use. Some 75,000 pictographs have been recorded on the walls of rock shelters at the foot of tepuis. These scenes of hunting, battles, dances, and ceremonies are thought to reflect a thousand-year-old system of sacred beliefs, representing and explaining the relations between the cosmos, nature, and people. Even now they are believed to be accessed by uncontacted indigenous groups.

We still have a lot to learn about tropical forests and their trees. In some ways our understanding is no more advanced than that of ancient inhabitants, who relied on their forests for all their survival and spiritual needs. Now we have satellite imagery, which gives a broad picture of forest extent and condition. We can travel to rainforests from around the world with relative ease. But our knowledge of how tropical forest ecosystems function and sustain global ecosystems is still rudimentary.

At ground level, a global network of permanent forest plots is helping scientists to understand more about tree diversity and ecological functioning within the forest. The Forest Global Earth Observatory, for example, is a global network of forest research sites and scientists dedicated to the study of forest function and diversity in both temperate and tropical areas. With over 70 forest research sites across the world, Forest-GEO monitors the growth and survival of approximately 6 million trees and nearly 13,000 species that occur in the forest research sites. The initiative, begun in the 1980s, now conducts long-term, large-scale research to increase scientific understanding of forest ecosystems. This knowledge helps to guide sustainable forest management and natural-resource policy, monitor the impacts of climate change, and build capacity in forest science. Forest plots are mainly used for ecological research, to understand how trees and other species work individually and collectively in their natural environment. At the species level there is still much to learn, even concerning many relatively widespread tropical tree species, including our most important forest-dwelling flagship species.

The only way to fully document tree species diversity is to undertake fieldwork, both in the forest plots and in areas which are far less known. There are new species of trees to be discovered and distribution records

The Lacandon Forest

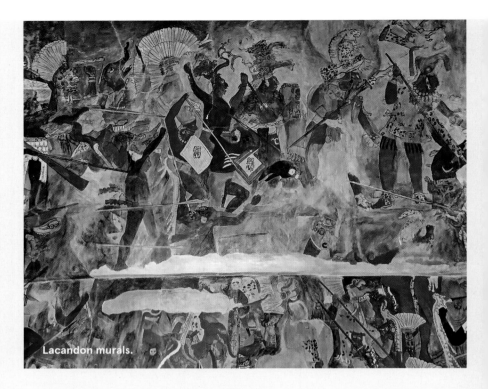

Lacandon murals.

The Lacandon Maya people, indigenous to the Yucatán Peninsula, initially moved to the forests of southern Chiapas and the Guatemalan Petén in the 1700s to avoid participating in the war that took place between the Mayas and the authorities of the Spanish colony (and later, the Mexican government). The frontiers in this completely unoccupied area were not well defined at the time, and neither were there authorities, so the Lacandon people developed a society that was totally self-sufficient, without any contact with neighbouring civilizations. An example: they never depended on commercial salt, instead obtaining their salt by burning the stems of the palm *Cryosophila stauracantha*.

At the beginning of the 20th century, when the frontiers between Mexico and Guatemala were defined, all the Lacandon migrated to Mexico, since in Guatemala they were persecuted, captured, and put on display in cities. In the 1950s, archeologists discovered the monumental murals of the Bonampak archeological site, through which the Lacandon presented their culture to the world. As a consequence, the Mexican government designated a large conservation area in the Lacandon forest.

The population of the village of Nahá maintains the most traditional lifestyle, and their conservation areas, although relatively small, are the best-conserved of the whole forest. Esteban Martínez Salas, botanist of the National Herbarium of Mexico, has worked with this community for more than 35 years, and his research team and other scientists have been able to generate extensive knowledge of the area's natural resources, as the Lacandon people are very open toward participation with researchers. This partnership in support of continuous conservation actions in the area is extremely important, given that 40 percent of Mexico's water resources originate in this extraordinary forest.

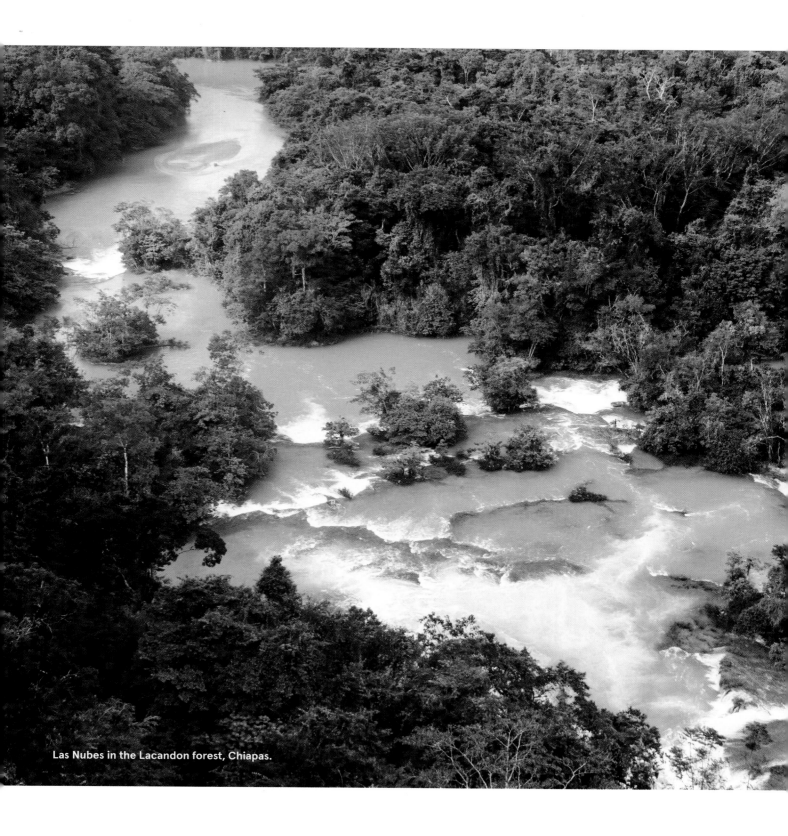

Las Nubes in the Lacandon forest, Chiapas.

to be compiled for species that are sometimes known only from a few herbarium records. With this baseline of knowledge, the conservation status of tree species can be assessed and ideally the ecology of at least an increased range of tropical trees can be studied.

Marie-Stéphanie Samain is a Belgian botanist now based in Pátzcuaro, Mexico. She has travelled extensively in the tropical Americas, undertaking work on hydrangeas, magnolias, and non-woody plants such as peperomias. She describes the reality of working in the tropical rainforest:

> The first time I set foot in a tropical rainforest, I felt deeply impressed and overwhelmed by the high trees, the forest noises and smells. At the same time, I was surprised that primary rainforest generally does not consist of impenetrable vegetation as I had imagined before or as you see in movies. You can easily walk among the trees and gaze up to their canopies to spot a little bit of the sky. . . . I am very fond of all the memories I have collected over the years, such as the time we camped in La Chinantla, Oaxaca, Mexico, and I slept outside in my sleeping bag, cradled asleep by myriad animal noises and waking up to a breakfast of raw inflorescences of the palm *Chamaedorea tepejilote*; or the visit to a 400-year-old brazil nut (*Bertholletia excelsa*)

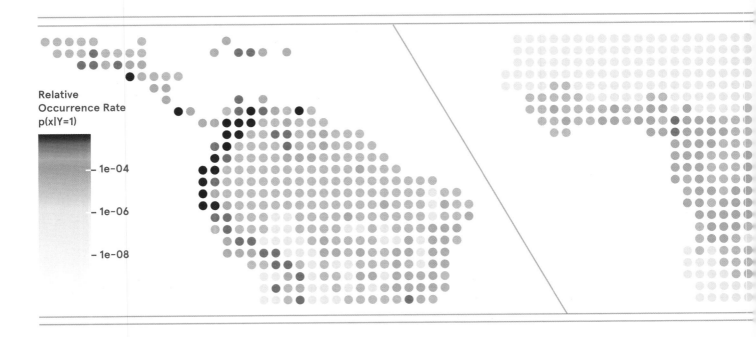

Relative
Occurrence Rate
$p(x|Y=1)$

— 1e-04

— 1e-06

— 1e-08

plantation in the middle of the forest near Kayserberg, Surinam, planted by indigenous people who used to travel by pirogue between Surinam and Brazil. Another unforgettable experience was when during a hydrangea collection trip in Peru, I climbed a tree north of San Ignacio in Cajamarca, near the border with Ecuador, and I was able to observe the forest stratification from above, looking down into the phyllotaxis of a giant tree fern!

TROPICAL CLOUD FORESTS

Step inside a cloud forest, and what do you see? Initially perhaps rather little, as everything is surrounded by a thick mist, swirling slowly around you. As you walk onward, the dark shapes of trees loom out of the fog, their trunks and branches completely covered with epiphytes. Ferns, bromeliads, and orchids grow densely together on every available surface. Perhaps your attention is caught by a flash of colour, as a hummingbird darts between flowers, or a tree frog hops onto a leaf. Underfoot, the ground might be springy with moss or poorly decayed leaves, which, owing to the low temperatures and high humidity, accumulate gradually over time. The air is very still, and sound is deadened by the mist, yet everywhere

(↓) Distribution of tropical montane cloud forests around the world.

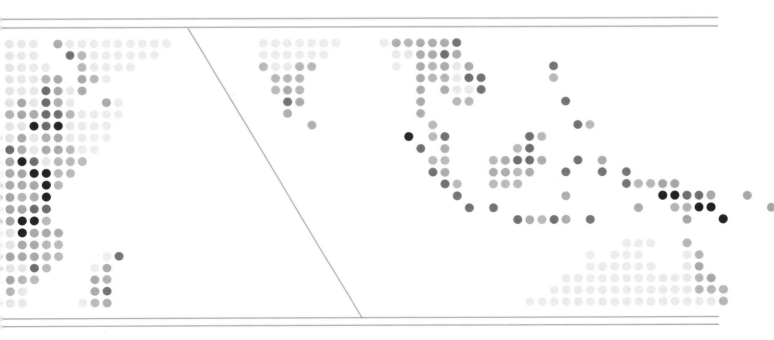

you hear the sound of dripping water. The silence is penetrated by the whistles and chatters of orioles and bellbirds, and maybe the booming calls of a troop of howler monkeys.

Cloud forests occur in some unusual places. For example, in the deserts of Peru and northern Chile are small islands of vegetation entirely supported by the fog that regularly rolls in from the Pacific Ocean. These are home to some mysterious trees, such as the critically endangered arrayan (*Myrcianthes ferreyrae*), which is found nowhere else in the world. However, most conservation attention has focused on the cloud forests found on the top of some tropical mountains. As you climb a tropical mountain, the forest changes in both structure and composition. The tall and often buttressed trees of multi-storied lowland rainforest gradually give way to trees that are shorter in height, with a simpler canopy structure. Epiphytes become more abundant, and trees are increasingly mossy. The shortest and mossiest forest of all, the upper montane cloud forest, is found at the highest elevations, on ridge crests and upper slopes. The transition from lower to upper montane cloud forest occurs where condensation from clouds is most persistent. This typically happens at 2000–3000 metres, although cloud forests occur at much lower elevations on some oceanic islands.

The most extensive tropical montane cloud forests occur in the neotropics, where they clothe the upper slopes of the Andes and extend through the mountain chains of Central America into southern Mexico. Other important cloud forest areas include parts of East Africa and Southeast Asia. Cloud forests are also found in the Pacific region, typically as small and isolated patches on the upland ridges and peaks of volcanic islands, such as Hawaii. The cloud forests of these different regions are characterised by very different floras. For example, neotropical cloud forests at lower elevations are dominated by members of Annonaceae and Melastomataceae. These same plant families often occur at higher elevations, but here they may be joined by temperate-climate genera, such as *Podocarpus*, *Drimys*, and *Weinmannia*. In Southeast Asia, the different vegetation zones associated with elevation are characterised by families of different continental origins. Plant families with Laurasian affinities, such as Fagacaeae, predominate in lower montane forests, whereas at higher elevations, members of Australasian families (Myrtaceae, Podocarpaceae, Araucariaceae) are more likely to be encountered. In other words, the world's cloud forests are united more by their structure and appearance than by their taxonomic affinities. Above all, these forests share an

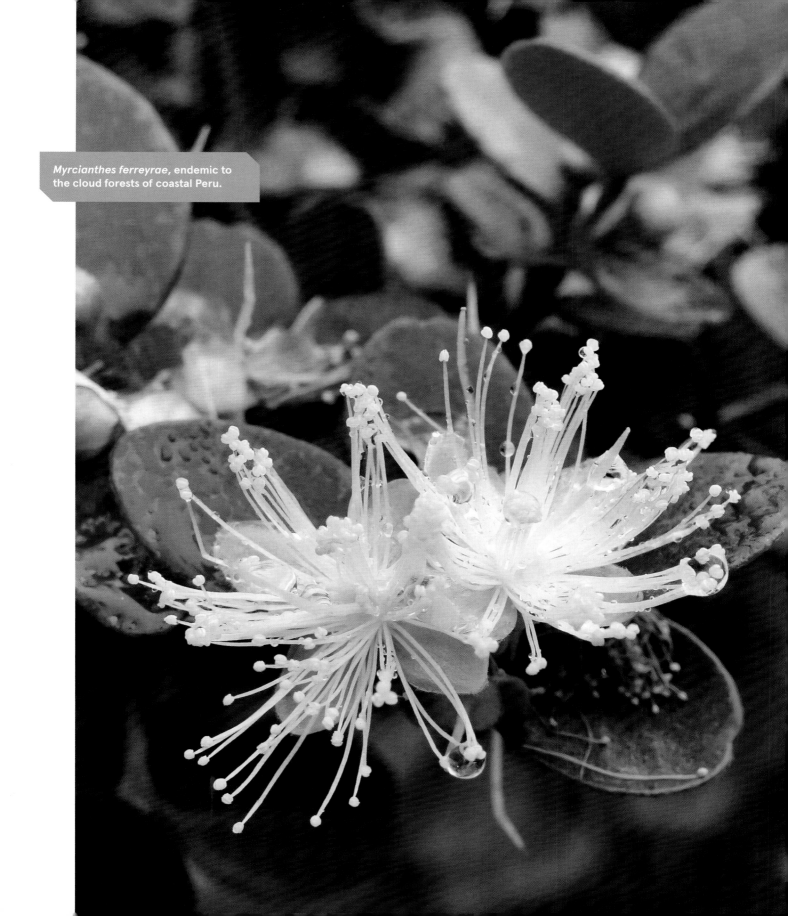

Myrcianthes ferreyrae, endemic to the cloud forests of coastal Peru.

adaptation to high cloud cover and frequent fogs and mists, which creates conditions of high humidity but low sunlight and air temperatures.

Although they occur in inaccessible locations, cloud forests are typically full of life. They are particularly rich in those groups that thrive in high humidity, such as mosses, fungi, lichens, ferns, orchids, and other epiphytes. Many reptiles and amphibians are also found here, including many species of brightly coloured tree frogs and poison arrow frogs. Recently, seven new species of miniature frog, each smaller than a thumbnail, were discovered in the cloud forests of Brazil. These live on sky islands—areas of cloud forest on mountains that are surrounded by lower-altitude rainforest. Such amphibians clearly benefit from the high humidity conditions found in cloud forests, but perhaps more surprisingly, the diversity of mammals can also be high. Examples of species that might be encountered include tapirs, sloths, jaguars, rodents, and monkeys. Again, new species continue to be discovered. As illustration, the Tabaconas Namballe National Sanctuary in Peru, a cloud forest reserve that extends over 70,000 acres, is home to the endangered mountain tapir and spectacled bear. In addition to the 82 mammal species known to occur there, eight new species were recently discovered, including the orange-eyed night monkey, a shrew opossum, an extremely long-quilled porcupine, and an olingo (a relative of the raccoon).

Cloud forests are also very important for birds. Ten percent of the world's 2609 restricted-range bird species (i.e., those with a range < 50,000 km²) are mainly found in cloud forests. Similarly, around 12 percent of the threatened bird species of the Americas are cloud forest species. Many songbirds and other bird species from North America migrate south and overwinter in neotropical cloud forests, where they play an important role in seed dispersal, with up to half of tree species producing fruit that are bird-dispersed. Cloud forests are particularly important for hummingbirds, with more species than any other habitat. Recent bird discoveries include the jocotoco antpitta (*Grallaria ridgelyi*), which lives in a small patch of cloud forest in Ecuador, and the scarlet-banded barbet (*Capito wallacei*), found on a single mountain in Peru. Perhaps the most iconic cloud forest bird is the resplendent quetzal (*Pharomachrus mocinno*), famed for its wonderful iridescent green plumage and long tail feathers. This neotropical species was venerated by pre-Columbian people of Mesoamerica; it was considered to be divine by the ancient Aztecs and Maya, who associated it with the snake god, Quetzalcoatl.

The high species richness of cloud forests makes them an important priority for conservation. Yet they are also important for another reason:

many cloud forest species occur nowhere else. In Mexico for example, cloud forests cover less than 1 percent of the country's land area, but provide a home to around 10 percent of the nation's plant species. Up to 30 percent of Mexico's endemic plant species—in other words, those not found in any other country—occur in cloud forests. Similarly, half of Ecuador's plant species occur in the montane forests of the Andes; of these, 39 percent are endemic. Patterns of endemicity can be quite extreme. As the great American botanist Alwyn Gentry put it, "Some plant families seem to have evolved locally endemic species in every patch of isolated Andean forest." As a result, up to a quarter of the species found in a single area of Andean cloud forest may be found nowhere else. This makes cloud forests a particularly rewarding place to hunt for new tree species. For example, during preparation of the Flora of Colombia, 21 endemic species of Magnoliaceae were discovered on Andean mountains. Similarly, new tree species continue to be discovered in cloud forests throughout Mesoamerica. Sometimes it is possible find new species without even leaving your desk. Two new *Magnolia* species, *M. rzedowskiana* and *M. pedrazae*, were recently discovered by Mexican botanists studying an online photographic archive, where photos taken in Mexico's Sierra Gorda cloud forest reserve had previously been deposited.

The reason so many endemic species are found in cloud forests is that many of them are geographically isolated. Each ridge or mountain top may be separated from the next by areas of lower elevation that are warmer, drier, and less cloudy, which do not provide suitable habitat for cloud forest species. This isolation limits the exchange of genes from one cloud forest to another, and as a result, evolution can take a different course on each separate mountain. Over time, this process of evolutionary divergence has created the patterns of endemicity we observe today. Researchers are studying these processes by examining patterns of variation in the DNA of species that occur across a cloud forest region. Such research is being undertaken by biologist Doug Soltis, a professor at the Florida Museum of Natural History and the University of Florida. "A species will occur in different areas, but each area has its own genetic fingerprint," he notes. "Populations of the same species may look very similar, but genetically, they're different." This research has shown how differences among cloud forests reflect the migration histories of different species and the periods of isolation that have occurred over the past few million years, together with the impact of glaciations and other environmental changes. This DNA detective work—"like CSI, but in natural populations," as Soltis says—has shown that geographic barriers to gene flow have occurred at

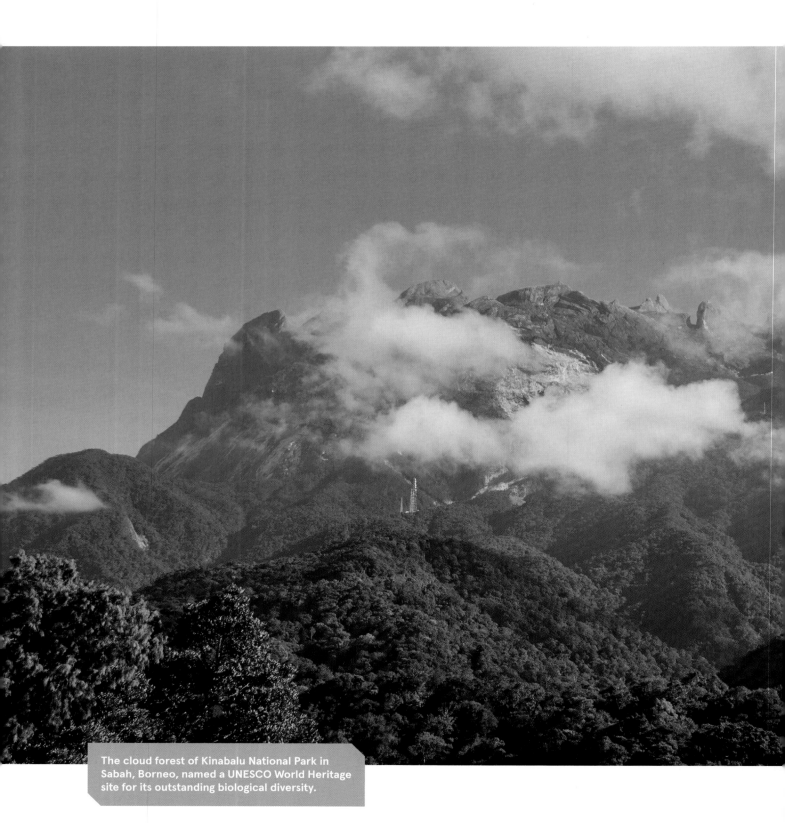

The cloud forest of Kinabalu National Park in Sabah, Borneo, named a UNESCO World Heritage site for its outstanding biological diversity.

different times in the past, for different taxa. A period of cool, wet climate, as experienced in Mesoamerica during the last ice age, might therefore provide opportunities for some species to spread from one mountain to another, which then become isolated as drier climates return.

As a result of this complex evolutionary history, if you climb a tropical mountain as a botanical explorer, you will never quite be sure of what you will find at the top. Sometimes you might find a tree species that is highly valuable to people—for example, *Persea americana* (avocado), a small tree or shrub from the cloud forests of Mesoamerica. Avocados have been eaten as a wild fruit for about 12,000 years and cultivated for perhaps 10,000 years. Today, the global trade in this nutritious fruit is valued at some US$9 billion. Other tree crops with wild relatives in montane forests include papaya (*Carica papaya*), passion fruit (*Passiflora* spp.), and tree tomato (*Cyphomandra betacea*). And the wild relatives of very important crop plants—peppers (*Capsicum* spp.), tomato (*Lycopersicon esculentum*), beans (*Phaseolus* spp.), potato (*Solanum* spp.)—provide another powerful reason to protect cloud forests: as a genetic resource. Wild populations can be a valuable source of genetic variation to help improve commercial food crops and to counter new pests and diseases that are encountered during cultivation, especially with the growing impacts of climate change.

Some cloud forest trees are also important sources of medicines. Examples include *Cinchona pubescens*, the bark of which is the source of quinine, which is used to treat malaria. The discovery of the antimalarial property of this species was once considered to be one of the greatest events in medical history. This led to the development of a major industry of bark collection and extraction in Ecuador, Peru, Colombia, and Bolivia in the 18th and early 19th centuries; as a result, the trees were completely extirpated over large areas.

Another important medicinal species is African cherry (*Prunus africana*), which is found in the cloud forests and other montane forests of Africa. Its bark is used to treat a variety of medical complaints but is particularly valued as a treatment for prostate conditions. The international trade in this medicine has been estimated at US$220 million, yet much of the bark harvesting appears to be unsustainable.

Another important way that cloud forests support human well-being is through the provision of water. Cloud forests are sometimes referred to as water towers, sky sponges, or forests that "drink from the clouds." This reflects the ability of cloud forest trees to strip moisture from clouds, as water condenses on their leaves and stems. The water which then flows

through the ground into streams and then rivers is pure and unpolluted. In this way, cloud forests provide water to people living at lower elevations, ensuring a regular flow that can persist even during periods of low rainfall. This regulation of water flow can also prevent erosion and mudslides. No wonder the importance of conserving cloud forests is often best appreciated by the people who depend on them. For example, the Maya of southern Mexico traditionally consider cloud forests as sacred and protected; the same is true for the people of Luzon in the Philippines. Large numbers of people depend on cloud forests for their drinking water, including inhabitants of Mexico City, Quito, and Dar es Salaam.

Despite their high value for wildlife and people, and their often remote locations, cloud forests everywhere are under intense pressure. The main threat is conversion to agricultural land, which has been reported from 90 percent of Latin American and Asian locations and more than half of African cloud forest areas. In the past, cloud forests were primarily cleared to support subsistence agriculture by resource-poor farmers, but increasingly forest is being cleared to support commercial production of coffee, temperate-zone fruits and vegetables, and other high-value crops. Cultivation of coca leaf is also a significant factor in Bolivia, Colombia, Peru, and Venezuela. Clearance of cloud forest for cattle ranching is also widespread, especially in Latin America. In Africa, this pressure is particularly important in seasonally dry areas, where the moisture in the cloud forest zone is attractive to herders. Such seasonally dry climates can also increase risk of fire. Although relatively few cloud forests are managed for commercial production of timber, its extraction for local use is a widespread threat. Similarly, collection of fuelwood is also common—for example, the oaks (*Quercus*) that dominate cloud forests in much of Mesoamerica are important sources of fuel.

Many cloud forests occur as relatively small "islands" that may be surrounded by other vegetation. Deforestation, urban expansion, and the building of roads and other infrastructure have increased the isolation of forest patches, reducing the ability of animals to move between them. Such habitat fragmentation can significantly affect wildlife, for example by increasing the nest predation of birds and reducing the ability of mammals to forage and reproduce. Smaller forest fragments become more accessible to people, who disturb the forest by collecting plants, introducing livestock, and hunting animals. The combination of habitat fragmentation and subsistence hunting can lead to the rapid loss of large animals, which can limit the future regeneration of the forest, as many animals play an important role in dispersing different tree species. For example,

research on *Xymalos monospora* (lemonwood) in Kenya has shown that in disturbed forest fragments, seed removal rates were on average 3.5 times lower than in more intact ones, hindering regeneration.

Climate change presents a particularly significant threat to cloud forests. Projections of temperature increases and rainfall changes suggest that in coming years, many montane forests will change radically. There is a risk that cloud forests will be replaced by ecosystems that currently occur at lower elevations, while the optimum climate for cloud forest species will increase in altitude. As cloud forests already occur at the top of mountains, this may leave them with no place to go. Another issue relating to climate change is the likely shift in the cloud base. Models predict a reduction in cloudiness at lower elevations as temperatures increase, and field observations suggest that this is already happening. Recent analyses suggest that the loss of cloud immersion as a result of climate change will affect as much as 80 percent of neotropical cloud forests by 2060, with all those in Mesoamerica likely to be affected. This could lead to a significant shrinkage of cloud forest area and will negatively affect the many cloud forest species that are dependent on high humidity. In the most detailed assessment to date, undertaken in the cloud forests of Mexico, some 60 percent of the 762 species evaluated were found to be threatened with extinction. A very similar value was found for tree species in the northern Andes, following a separate assessment.

TROPICAL DRY FORESTS

Tropical dry forests receive less conservation attention than rainforests, and yet they are one of the most threatened ecosystems on earth. These seasonal forests occur in tropical regions without yearlong rainfall and with several months of drought. They have a significant proportion of deciduous trees. Generally they grow on more fertile soils than rainforest; this may be because leaves are shed in tropical dry forests, enriching the soils, or because their soils have been less intensively leached of nutrients. It is difficult to define tropical dry forests because they merge with rainforest, savannas, and various types of woodland, and boundaries between different forest types can be very unclear. Furthermore, tropical dry forests are not uniform in structure. They vary from tall, closed canopy forest to short scrub vegetation; sometimes, especially in drier areas, a closed tree canopy is not formed. Unlike savannas, tropical dry

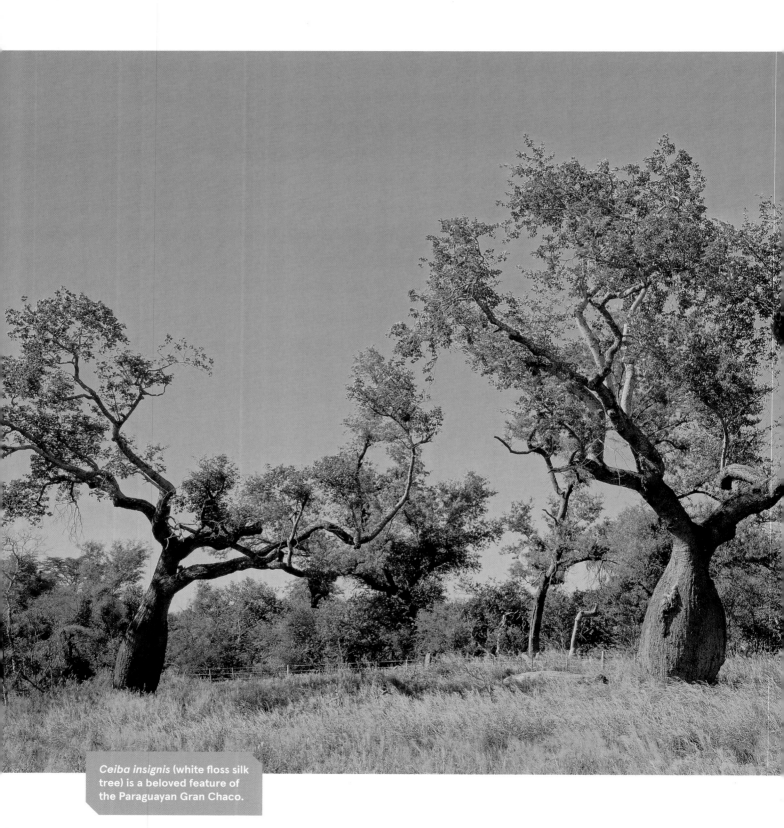

Ceiba insignis (white floss silk tree) is a beloved feature of the Paraguayan Gran Chaco.

forests do not have a significant grass component and do not experience regular natural fires.

More than half of the world's tropical dry forest is in South America. The Gran Chaco of southeastern Bolivia, Paraguay, and northern Argentina is one huge area of tropical dry forest, covering an area twice the size of California. The Gran Chaco contains the second-largest area of South American forest after the Amazon rainforest. A second major area of tropical dry forest is the Caatinga region of northeastern Brazil, which occurs inland from the Mata Atlântica (Atlantic Forest).

What does the future hold for tropical dry forests? A new law enacted by the indigenous autonomous government of the Charagua district in Bolivia conserved an additional 1.2 million hectares of critically threatened Gran Chaco forest habitat. The law formalises the protection of the Ñembi Guasu area, which together with Kaa-Iya National Park in Bolivia and protected land in Paraguay forms the biggest conservation area of the Chaco region, covering an area of land twice the size of Belgium. This continuous territory is linked with the Paraguayan Chaco Biosphere Reserve. World Land Trust and other international organisations helped Nativa Bolivia and the Autonomous Indigenous Aboriginal Farming Government (GAIOC) in establishing Ñembi Guasu; their plan is to support the indigenous autonomous government in protecting the land, which has many tree species and provides habitat for more than 100 species of mammals, 300 species of birds, and at least 80 species of reptiles and amphibians. The jaguar and puma depend on this habitat, which is one of the few places in Bolivia where long-term plans can be made for the jaguar population and for other large animals that inhabit it.

In Central America, tropical dry forest once extended along the Pacific coast from Baja California Sur in northern Mexico to the Azuero Peninsula in Panama. This forest type is now much reduced in the coastal plains and foothills, in valleys further inland, and in parts of the Yucatán Peninsula in Mexico. American ecologist Dan Janzen drew attention to the importance of the Mesoamerican tropical dry forests through his work in Costa Rica. Thirty years ago he estimated that less than 2 percent of the 550,000 km² of dry topical forest that existed on the Pacific coast of Mesoamerica when the Spanish arrived, was "sufficiently intact to attract the attention of the traditional conservationist." Janzen became a champion for tropical dry forest and has devoted much of his life to studying and restoring wild places.

Elsewhere in the world, tropical dry forests have a scattered and fragmented distribution. In Asia, the deciduous forests in the Western

Ghats of India, forests in Sri Lanka and Indonesia, and dry dipterocarp forests of Thailand, Vietnam, Laos, and Cambodia can all be considered tropical dry forests. These forests are also found on some South Pacific islands and in Australia. In Africa, tropical dry forest is distributed over a large geographical area but is very patchy in extent. The two main centres of distribution are western Ethiopia, South Sudan, and the Central African Republic; and Zambia, Zimbabwe, and Mozambique. Fragmented dry forests also remain in the western half of Madagascar and in parts of western Africa, especially in Mali.

Tropical dry forests are less diverse than rainforests in terms of tree species, and individual tree species growing within them tend to have wider geographical ranges. Nevertheless, tree diversity and endemism are still highly significant. Most dry forest trees are restricted to this type of forest. Economically important tree species found in tropical dry forests include valuable timbers such as teak (*Tectona grandis*) and the six deciduous dipterocarps that occur in the tropical dry forests of Vietnam, Laos, and Cambodia. Four of these—*Dipterocarpus obtusifolius*, *D. tuberculatus*, *Shorea siamensis*, and *S. obtusa*—usually dominate, often growing with smaller leguminous trees. Species that produce precious rosewood (*Dalbergia*) are also generally found in tropical dry forests—including those of continental Southeast Asia, Madagascar, and Central America.

Tropical dry forests also act as carbon sinks and provide many other ecosystem services in common with tropical rainforests and cloud forests. And yet, despite their importance, their decline is relentless, not only in Central America but around the world. Agriculture, habitat fragmentation, and climate change are among the familiar culprits. The Gran Chaco, one of South America's last frontiers according to the WWF, is currently under threat from agricultural development, largely to produce beef and soy.

In Central America, deforestation has been severe on the Pacific-facing slopes of El Salvador, Honduras, and Nicaragua. Tropical dry forest in these countries has largely been replaced by a mosaic of fields, fallow land, pastures, and small secondary woodlands. Lowland agriculture throughout the western coastal plains and interior valleys of Central American countries and Mexico is dominated by large commercial estates growing melon and sugarcane. Most of the original trees from the tropical dry forest have been mechanically removed. Original forest trees are mostly confined to fence lines, where regeneration is very limited.

Tropical dry forest in Central America and Mexico has also been extensively cleared for cattle pasture. Since 1950, nearly 60 percent of

Costa Rica's forests have been cleared for ranching. Cows now graze on over one-third of its land, including the hills in the dry northwest of the country. There is concern that many trees species of Central America's dry forests have suffered severe declines in their numbers and in the genetic diversity of their populations. Dan Janzen described mature trees scattered through the agricultural landscape as the living dead—they are no longer able to regenerate. He estimated that an 11,000-hectare area of dry forest in Costa Rica's Santa Rosa National Park contained 13,000 species of insects, 175 breeding species of birds, 115 species of non-marine mammals, and 75 species of reptiles and amphibians.

Elsewhere in Costa Rica, improvements are being made to farming practices. In 2014, the Tropical Agricultural Research and Higher Education Center (CATIE) achieved Rainforest Alliance certification for its dairy operations, the nation's first cattle farm to gain this recognition. To achieve certification, the farm met the comprehensive standards of the Sustainable Agriculture Network (SAN). Located in the lush valley of Turrialba, CATIE's commercial farm covers more than 600 hectares of land dedicated to cattle farming, coffee, sugarcane, and forestry products. Over 165 hectares are designated as pastureland, accommodating a herd of 324 cattle, including 123 dairy cows. The farm supplies its milk to Costa Rica's leading and largest dairy cooperative.

Across the world in Madagascar, tropical dry forest covers an area of 31,800 km², from the Mangoky River north of Toliara to Cap d'Ambre. The total forest area in this part of western Madagascar has been reduced around 40 percent over the past 50 years. To the south of the tropical dry forest belt is the succulent-rich spiny forest, and to the east, above around 900 metres, is low scrubby forest and grassland. This tropical dry forest of western Madagascar is diverse, with impenetrable thickets as well as bushland and low scrub. Nearly one-third of Madagascar's 5638 trees grow in the western half of the island, many within the tropical dry forests. Dominant forest canopy trees include species of *Adansonia* (baobabs), *Dalbergia*, and *Stereospermum*. Madagascar's magnificent baobab trees have a wide variety of uses and spiritual values for local people. As well as timber, tropical dry forests provide firewood, fodder, fruit, medicines, game, and water for the millions of people who live in them.

The loss of forests in western Madagascar is continuing at a faster pace than loss of the rainforests in the east of the island. All unprotected areas are under pressure from farming and mining, and even protected sites remain vulnerable. A growing potential threat to the tropical dry forests is the oil industry. Exploration for oil is already extensive in

Did you know?

Some baobab trees are believed to be the dwelling place of spirits. In Madagascar, offerings of honey and rum are traditionally left at their base.

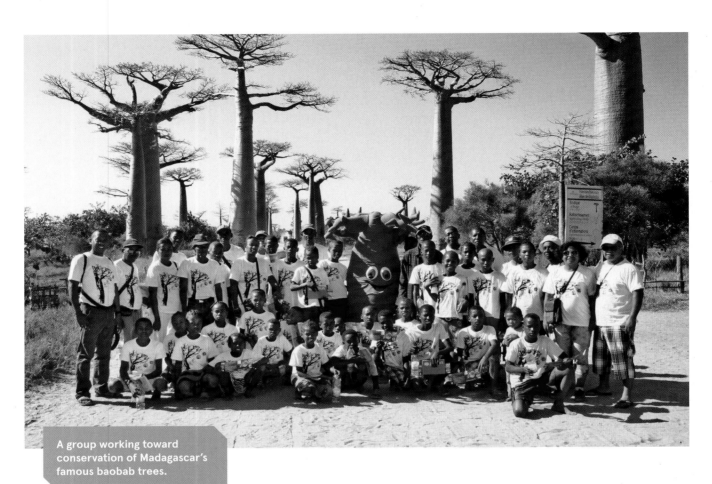

A group working toward conservation of Madagascar's famous baobab trees.

western Madagascar, and once the exploration phase turns into exploitation, extensive pipelines and road networks will be needed within the species-rich forest.

Maize is the main crop grown in western Madagascar, accounting for approximately 80 percent of agricultural land. Slash-and-burn methods are used to clear the tropical dry forest, usually in a manner that is unsustainable. Maize is grown for subsistence purposes and also for export to other countries of the Indian Ocean, sometimes to supply pig feed. After maize has been grown for several years, the fields are cultivated with less productive groundnuts, cassava, or sweet potatoes, and then they are usually abandoned. Agricultural land has also been targeted for biofuel production with, for example, European interests aiming to grow crops such as jatropha.

The forests of western Madagascar also serve as pasture for the ubiquitous zebu (*Bos indicus*) that are grazed throughout the country.

Zebu cattle were introduced to Madagascar, probably from mainland Africa, around the 11th century. The possession of a large zebu herd of male animals is considered a sign of wealth, and there are more zebu than people living in the country. With rising cattle theft and growing insecurity in Madagascar, people prefer to keep their cattle inside the forest. This contributes substantially to the degradation of the tropical dry forest, preventing regeneration. Forests are also burned to produce fresh pasture for zebu.

TEMPERATE AND BOREAL FORESTS

About one-fifth of the world's tree species are native to temperate climates. Some of the most abundant tree species on earth grow in the vast boreal forests that stretch for endless miles around the northern reaches of Europe, Asia, and the Americas. Boreal forests make up about one-third of the world's forest cover. They may not have rich tree species diversity but are immensely important as carbon sinks and wilderness areas for birds and mammals. Russia and Canada have particularly large tracts of relatively undisturbed forest. The boreal forests mainly consist of conifers and supply 45 percent of the world's softwood timber supplies.

South of the boreal forests, a broad belt of temperate deciduous forests covers large areas of Europe, Asia, and North America. These forests are mainly composed of broadleaved species, with conifers mixed in to varying degrees. Important genera found round the northern hemisphere include maple (*Acer*), oak (*Quercus*), elm (*Ulmus*), linden (*Tilia*), birch (*Betula*), beech (*Fagus*), and ash (*Fraxinus*). In North America, the eastern temperate forests are separated from a narrower belt in the west by the prairies, steppes, and mountains. In a similar way in Eurasia, temperate forest covers much of Europe in the west and is separated from temperate forest in northeastern China, Japan, DPR Korea, and Republic of Korea by the huge Central Asian steppe, desert, and mountains.

In the Russian Far East is a very important area of forest, transitional between the boreal forest and Asian warm temperate forests to the south. It is one of the largest regions where ancient conifer and broadleaved forests still exist. The Central Sikhote-Alin World Heritage site protects part of this extraordinary temperate forest and the animals that occur there, such as the Amur tiger (less than 500 individuals), Himalayan bear, brown bear, lynx, wolverine, and sable. The rich forests of the

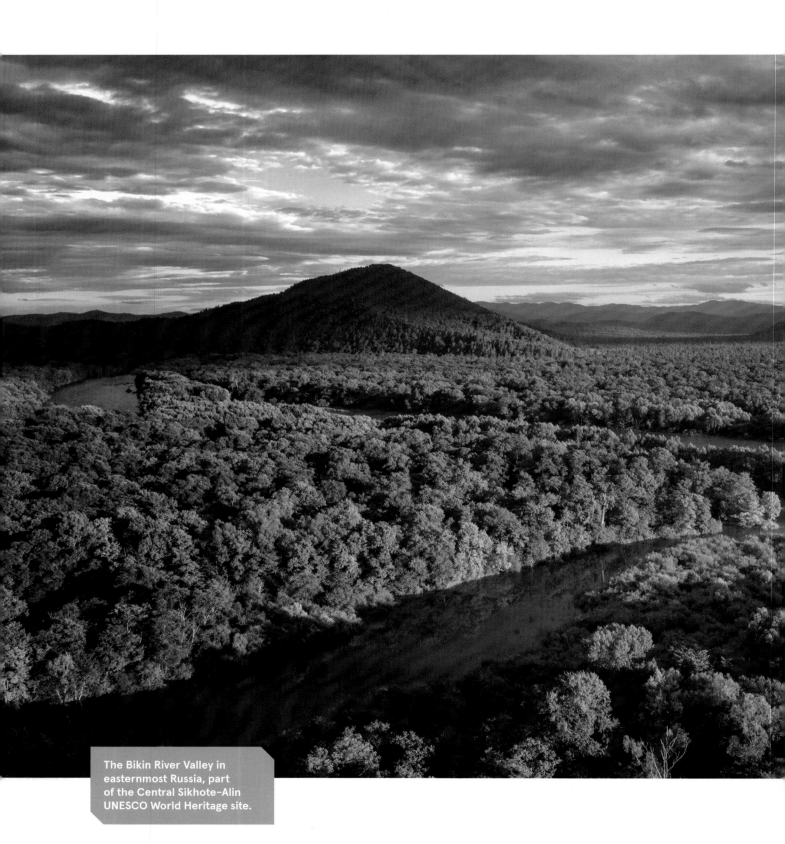

The Bikin River Valley in easternmost Russia, part of the Central Sikhote-Alin UNESCO World Heritage site.

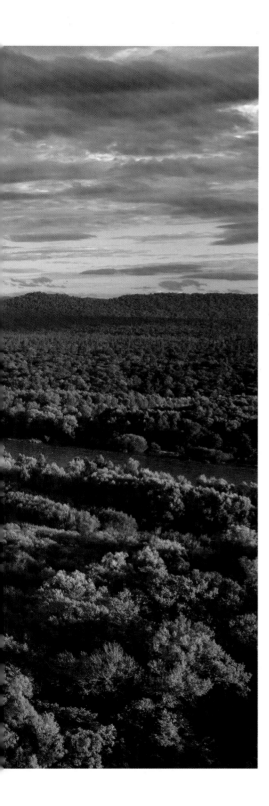

Russian Far East are dominated by Korean pine (*Pinus koraiensis*) and broadleaved trees such as Manchurian ash (*Fraxinus mandshurica*) and Mongolian oak (*Quercus mongolica*). Old-growth forests in the area have been drastically reduced as a result of logging and forest fires. The forest decline has been particularly marked in recent years, with growing demand from flooring and furniture manufacturers in China for Russian Far East hardwoods such as Mongolian oak and Manchurian ash—species which had already been heavily exploited within China. Illegal logging has been a major problem in the Russian Far East. Many of the finished products using Russian wood, manufactured in China, are exported to the US, European, and Japanese markets. Efforts to bring illegal logging under control include the Russian Federation's adding *F. mandshurica* to CITES Appendix III in 2013 and extending the legally protected area within the Central Sikhote-Alin World Heritage site.

In the southern hemisphere, temperate forest covers a much smaller land area. Temperate forest occurs in southeastern Australia, including Tasmania, New Zealand, Chile, Argentina, and southern Africa. The magnificent temperate rainforests of New Zealand, Tasmania, Chile, and Argentina have characteristics similar to the coastal rainforest of North America that extends along the Pacific coast from northern California to Alaska.

In total, temperate forests now cover about 1 billion hectares, or an estimated 40–50 percent of the original extent. They account for about 25 percent of the global forest area. Of course, there are many types of temperate forest, all providing vital ecological goods and services. Different forests are defined by their structure and composition, with characteristics determined by ecological conditions now and in the past. There is no globally accepted coherent classification of forest types, or indeed clear separation between forest and woodland, but we can see and feel the difference when we walk into forests in different parts of the world. Adrian Newton has worked in a range of temperate and tropical forests during his career, helping to conserve individual tree species, design sustainable forest management programmes, and restore degraded forests. He still appreciates his home patch, the New Forest in southern England, which has survived as a woodland since its patronage as a royal hunting ground (established by William the Conqueror circa 1079); it is now a national park.

All forests are ecologically important and worthy of conservation efforts. Most of the temperate forest loss in Europe occurred historically: many European countries had lost over 90 percent of their forest cover by

the Late Middle Ages, with prime oaks used in boat building and the roofs of cathedrals. The decline of the finest trees prompted timber exploitation in other parts of the world. Christopher Columbus reported the Caribbean islands were "filled with trees of a thousand kinds and tall, and they seem to touch the sky." Early European settlers cleared the temperate forests of eastern North America for both timber and more extensively for farming. China too lost much of its temperate forest cover centuries ago, and now less than 5 percent of all the country's forest is considered original. Historically, temperate forests around the world have been exploited for timber and charcoal or cleared for agriculture, grazing, and settlement.

We have now lost half the world's temperate forests. The overall temperate forest area is stable, but gains from new planting do not compensate from loss of biodiversity in the past. Most countries in Europe and the temperate parts of China have increasing forest cover as a result of population movement away from the countryside to urban areas, together with forest conservation and restoration. The temperate forests of the US, Japan, Republic of Korea, and New Zealand are stable. Tree composition within the forests has, however, changed over time, and new threats continue to change the forest landscape and the tree species that grow there.

Some of the richest areas of temperate forest in terms of tree diversity are areas that did not experience glaciation in the past. The rich deciduous forests of the eastern US and the temperate forests of eastern China and Japan show striking similarities. The forests of these two widely separated regions have a shared history dating from the Tertiary Period (66 to 2.6 million years ago), with related relict groups of plants. Over 60 genera including *Magnolia, Acer, Carya, Stewartia, Diospyros,* and *Cornus* (dogwood) have disjunct distributions in these distant regions. It is thought that similar forests spread round the northern hemisphere until the end of the Tertiary, beginning of the Quaternary—about 2.5 million years ago, when there was major geological and climatic upheaval. Subsequently, as scientists can see from the fossil record, cooling conditions and periods of glaciation led to the loss of magnolias in Europe, and species-rich forests remained only in small refugia. The Appalachian forests, extending from southern New York to Georgia, are among the most diverse temperate forests in the world, with only the corresponding temperate forests of eastern China considered slightly richer. Over 150 tree species grow in the Appalachian forest region, and the understory vegetation of shrubs, ferns, and herbaceous perennials is also highly diverse. Often over 30 canopy tree species grow together at a single site. Over the past several hundred years, more than 80 percent of the habitat of the Appalachian

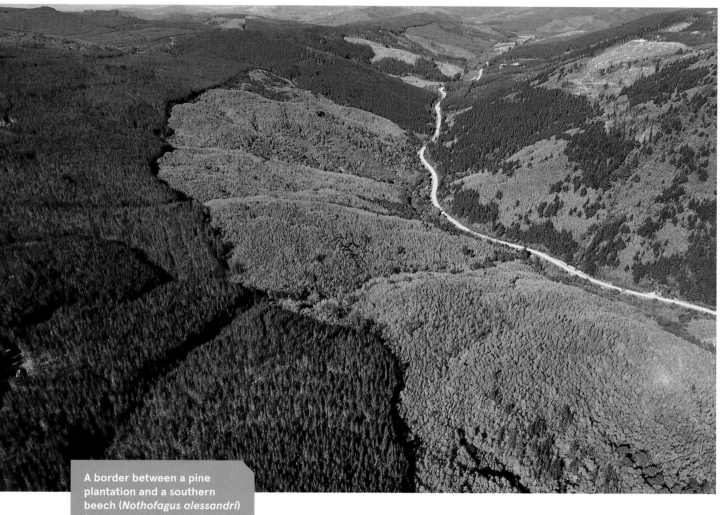

mixed forests has been altered, particularly in the ridge and valley provinces. Now most of the relatively intact forests of the region are found within public lands, where they can be appreciated and conserved.

The forests that cover about 20 percent of the Caucasus region are also among the richest in the world and form part of the Caucasus global biodiversity hotspot. Extending between the Black Sea and Caspian Sea, the Caucasus is a fascinating region with a rich cultural history and the longest history of wine production outside China. The Caucasus consists of Southern Russia, Georgia, Armenia, Azerbaijan, and parts of Turkey and Iran. Ecologically its forests are highly diverse—the result of evolutionary history, the varied relief of this mountainous region, and differing climatic

conditions, with particularly heavy rainfall in the west. Forests in the Caucasus include both conifer and broadleaved forest, together with arid open woodland in the eastern and southern Caucasus consisting of juniper and pistachio species. Broadleaved trees—the widespread oriental beech (*Fagus orientalis*) and various oaks, hornbeams, and chestnuts—make up most of the forested landscape. Two oak species, *Quercus macranthera* and *Q. pedunculiflora*, are endemic to the Caucasian broadleaved forests.

In common with the rich temperate forests of the eastern US and China, the abundance of relict and endemic plant species in the region is largely because the Caucasus was spared periods of glaciation. Around 25 percent of all plant species in the region are endemic. Tree species and plant associations that date back to the Tertiary Period survive in this mountainous region.

Two areas within the Caucasus are described as ecological refugia, reflecting the concentration of Tertiary relict plants found here. The Colchic Refugia in the Black Sea basin covers parts of Georgia, Russia, and Turkey. Relict forests of endemic box tree occur in the northern part of this region; other relict species include *Betula medwediewii* (a very rare birch) and shrubs such as *Epigaea gaultherioides* and *Ilex colchica*. The Hyrcanic Refugia is in the southeastern portion of the Caucasus on the Caspian Sea coast. Trees of this ancient forest include Caucasian wingnut (*Pterocarya fraxinifolia*), Persian ironwood (*Parrotia persica*), and Caspian poplar (*Populus caspica*). The endangered Persian leopard still prowls this forested area.

One Tertiary relict found in both the Colchic and Hyrcanian forests and scattered patches in between is the Caucasian elm (*Zelkova carpinifolia*); this large tree, commonly grown as an ornamental, has been extensively logged for its timber and is now recorded as vulnerable by IUCN.

The rich forests of the Caucasus have been heavily logged for their timber; they have also been affected by extraction of fuelwood and grazing. In northeastern Turkey, broadleaved forests are cleared for tea and hazelnut plantations, and the construction of major dams is a recent threat. In northwestern Iran, the Hyrcanian broadleaved forests have been severely reduced but are now protected as a World Heritage site. Around 16 percent of the Colchic forests of the Caucasus are protected.

Forest of the Caucasus have been described as temperate rainforests. Elsewhere, the world's temperate rainforests are towering cathedral-like forests that grow in areas where westerly winds bring high precipitation, usually throughout the year. Worldwide these rainforests make up a tiny proportion of the world's temperate forest. Nevertheless they are of major

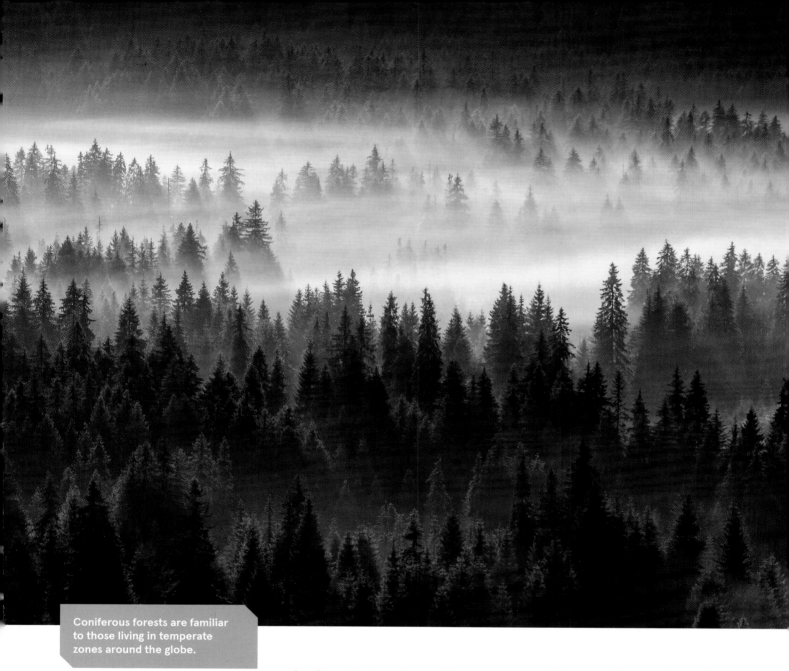

Coniferous forests are familiar to those living in temperate zones around the globe.

biodiversity importance. The temperate rainforests of the Pacific Northwest coast are dominated by conifers: spruce, hemlock, fir, Douglas-fir (*Pseudotsuga menziesii*), and western red cedar (*Thuja plicata*). In South America, the so-called Valdivian forests of Chile and Tierra del Fuego, Argentina, are rich in southern beech (*Nothofagus alessandri*) and the iconic conifers *Araucaria araucana* and *Fitzroya cupressoides*.

Temperate rainforest covers about 10 percent of Tasmania. One of the dominant species of these magnificent forests is the myrtle beech

(*Nothofagus cunninghamii*). This species is endemic to Australia, growing in the cool temperate rainforests of southern Victoria as well as Tasmania. It is now globally assessed as vulnerable as a result of threats from fire, habitat loss, poor regeneration, timber harvest, and the impact of a fungal infection, myrtle wilt. Pressure from logging has now eased, but the other threats continue, particularly in Victoria, and climate change is a growing threat. In Tasmania, myrtle beech grows with southern sassafras (*Atherosperma moschatum*) and King Billy pine (*Athrotaxis selaginoides*), among others. The endemic King Billy pine is named after William Lanne, the last Tasmanian aborigine, who died in 1869; this magnificent conifer has been heavily logged for its highly prized timber and is now listed by IUCN as vulnerable.

Efforts to conserve threatened tree species and their habitats and to restore temperate forests are ongoing worldwide. Extensive areas outside formal protection are being managed sustainably with certified timber production. Restoration of forests is gaining momentum. The US, for example, is committed through the Bonn Challenge to making forest ecosystems more resilient to climate change; as of September 2021, over 20 million hectares were planted under restoration (surpassing the 2012 pledge of 15 million hectares by 2020). In the US approximately 40 percent of land is in public ownership, and all the federal agencies responsible for this land are charged with restoration as part of their management roles. The USDA Forest Service has a long history of replanting native conifers in areas that have been logged or burned and increasingly is using a wider range of native species in ecological restoration.

Using appropriate tree species is essential for effective forest restoration. Often lack of native trees for restoration is a major barrier. In Chile, for example, a significant increase in the supply, diversity, and quality of native plant species in local nurseries is urgently needed. Among the native species being grown for restoration are Dombey's southern beech (*Nothofagus dombeyi*) and monkey puzzle (*Araucaria araucana*), but production needs to be scaled up and extended to many more tree species. Forest Stewardship certification requires forestry companies in Chile to convert a proportion of exotic plantations to native forests.

Threatened temperate trees range from the very rare relict *Zelkova sicula*, clinging to survival in Sicily, to the many *Fraxinus* species now critically endangered in the US by the emerald ash borer, a jewel beetle that lays its eggs in the bark of ash trees. We still do not fully understand the implications of the loss of tree species, but each is unique and irreplaceable.

ISLANDS

Islands are special places. They contain all the forest ecosystems we have discussed as well as uniquely threatened habitats for tree species. Islands have always captured our imagination, from tales of Robinson Crusoe to dreams of vacationing on a tropical beach. The things that make islands so attractive to people—remoteness, uniqueness, a sense of paradise—are the reasons islands are so special in terms of tree diversity and other forms of biodiversity.

Islands are hotspots of biodiversity, and for trees it is no different. At least 20 percent of tree species are endemic to single-island states worldwide; that means that about 12,000 tree species are found only on an island. But why are islands so special when it comes to trees? The reasons are various.

The Juan Fernández Archipelago, a bastion of endemic plants, lies off the coast of Chile.

Firstly, remoteness from the mainland means that island populations may have unique adaptations that have evolved in isolation from influences that may exist on the mainland. This could mean that a species found both on the mainland and on an island may show different traits, depending on its location, as one trait may be better adapted to the island and the other more suitable for the mainland. This could be single traits, but given time and continued isolation, these population can evolve into new species, as island species may not be subjected to the same type of pressures as on the mainland. For example, they may not face predators or herbivores that are present on the mainland, or their island habitat may have very few competitors.

Saint Helena Boxwood

Saint Helena, in the South Atlantic Ocean, is as isolated as islands get, and Saint Helena boxwood (*Withania begoniifolia*) is found only on this small island. This woody species can grow up to 2.5 metres tall and carries its small white flowers between a pair of leaves. It has a pungent smell, described as "smelly feet." In the early 1800s, Saint Helena boxwood was abundant on the island (Boxwood Hill was even named after it); however, by 1875 the species had greatly declined because of insect pests, grazing animals, and the poor dry soils.

Shortly after, it was considered extinct—a label that stuck for over a century. In 1998, a small patch of wild plants was rediscovered, but by 2010 only a single mature individual remained.

Any threat can have a detrimental impact and drive such an extremely rare species to extinction in the wild. Threats include drought and pest infestation (including aphids, whitefly, and root mealybugs). Invasive animal species, such as rabbits and goats, have also been known to graze on Saint Helena boxwood. Other natural threats include soil erosion and plants being crushed by shifting rocks. Also, as this species has undergone such an extreme decline in population size, its genetic diversity will be low, which means it may have a

Withania begoniifolia.

limited genetic ability to adapt to changes in its environment.

Conservationists on the island are now working hard to bring Saint Helena boxwood back from the brink. The hope is that seedlings of the island's last surviving boxwood plant will eventually be returned to their natural habitat there.

Islands are also home to a very large number of island endemic trees: species that are restricted to a single island and not found anywhere else. One of the best example of this very high endemism is in Madagascar. Madagascar is one of the world's largest islands. It is also one of the most diverse countries on earth in terms of tree species. Over 3300 different species of trees grow on Madagascar, and 93 percent of them are found only there. The unique flora of Madagascar also contains endemic genera and even plant families. The reason is that over time in highly isolated conditions (i.e., islands), evolution leads to the development of many new species from so-called founder species. Sometimes remote islands offer a refuge for lineages that were once more widespread but that have now gone extinct everywhere else.

The Didiereoideae consists of four genera of succulent trees that evolved and exist only in Madagascar—*Alluaudia* (six species), *Alluaudiopsis* (two species), *Didierea* (two species), and *Decarya* (one species). All members of this subfamily are endemic to southwestern Madagascar, where they are characteristic species of the dry spiny forest. The succulent trees of this group evolved to survive dry and arid habitats. They look

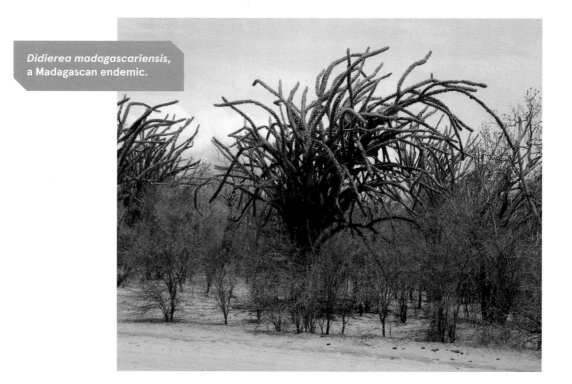

Didierea madagascariensis, a Madagascan endemic.

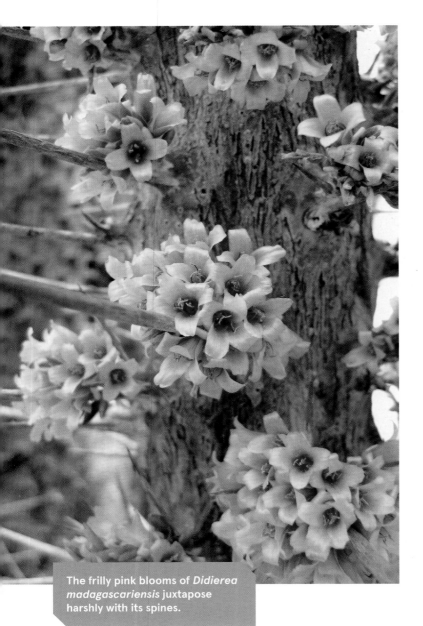

superficially very similar to cactus, and indeed this taxonomically distinct group has evolved similar strategies to cope with hot conditions and very little rainfall. The trees are exploited for handicraft, and the wood is used for firewood and construction. Avid collectors of unusual succulents around the world have contributed to the decline of these spiny plants. The trade of species in Didiereaceae is controlled by CITES, with all species listed in Appendix II.

The baobabs of Madagascar are iconic trees. In total there are eight species of baobab in the genus *Adansonia*. One is characteristic of the dry forests of tropical Africa, one occurs in Australia, and the other six species are endemic to Madagascar. All Madagascar's baobabs are threatened with extinction.

The magnificent Grandidier's baobab (*Adansonia grandidieri*) is classified as endangered. It is restricted to the dry spiny forests of southwestern Madagascar, occurring in Menabe and Atsimo-Andrefana. This giant, long-lived tree is highly valued locally. Its fruits and seeds provide food; its bark is used for rope to tether the zebu cattle, for roofing, and for medicinal products. The fruits are collected in late November, and a juice is made for local consumption. The seeds are often eaten with rice. Two large cosmetic companies in the capital city of Antananarivo sell products containing or made from baobabs, and the fruits are promoted as a superfood. Grandidier's baobab also plays an important role in local culture and traditional ceremonies. Local communities are fully involved in ensuring the sustainable management of the renala, as they know it, with careful emphasis on sustainable harvesting.

Grandidier's baobab, like so many other Madagascan trees, is threatenened by fire, slash-and-burn farming, overgrazing, and overexploitation of its highly valued products. The Global Trees Campaign has been supporting its partner Madagasikara Voakajy in a project to save the species as well as two other endemic baobabs. A conservation strategy

is in place, and work is continuing to protect, restore, and sustainably manage these charismatic trees.

Mauritius, off the eastern coast of Madagascar, is home to the bottle palm (*Hyophorbe lagenicaulis*). This species was once widespread in the palm savanna of Mauritius, which is thought to have covered northern parts of the main island; however, this habitat is now found only on the small islets north of Mauritius, and the bottle palm only on Round Island—a nature preserve smaller in area than New York City's Central Park. Here it was down to a handful of individuals, and recruitment was nonexistent due to the non-native rabbits and goats that had been introduced to the island as a source of food. These animals grazed on the seedlings, and no new trees could be established. In 1986 the goats and rabbits were removed, and the few surviving flowering and fruiting palm trees continued to produce fruits. Now the seedlings can survive. The species has no doubt undergone a severe genetic bottleneck, but it now has a much brighter future.

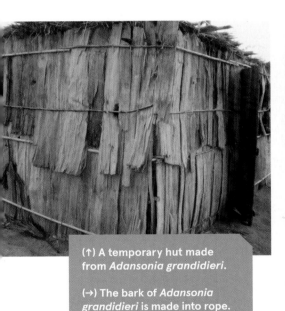

(↑) A temporary hut made from *Adansonia grandidieri*.

(→) The bark of *Adansonia grandidieri* is made into rope.

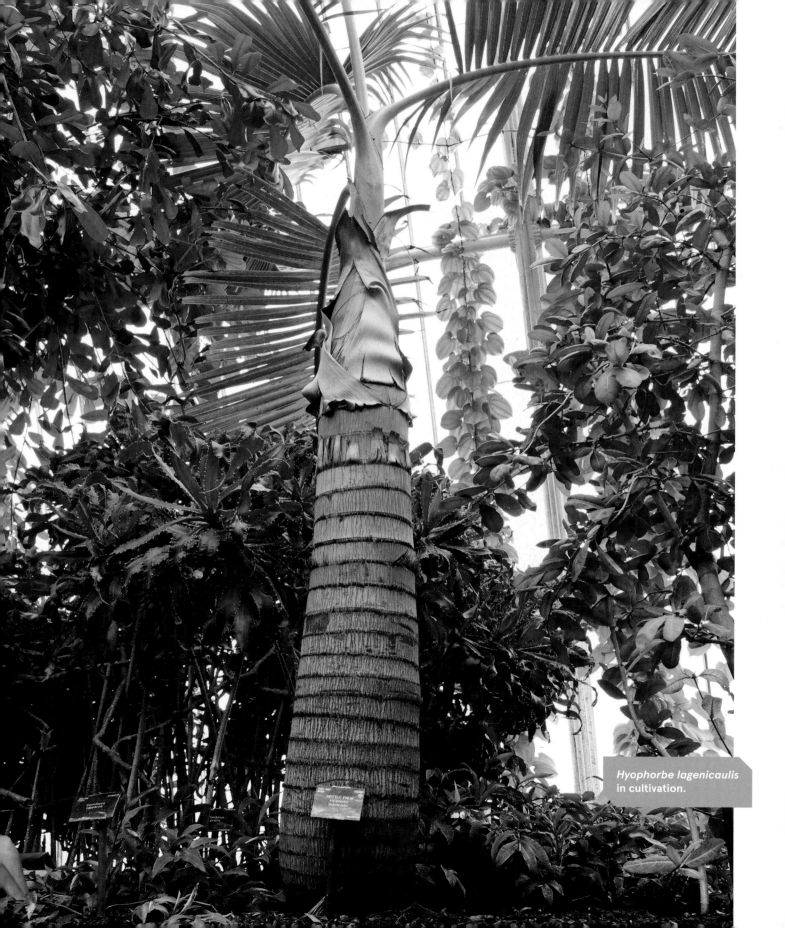

Hyophorbe lagenicaulis in cultivation.

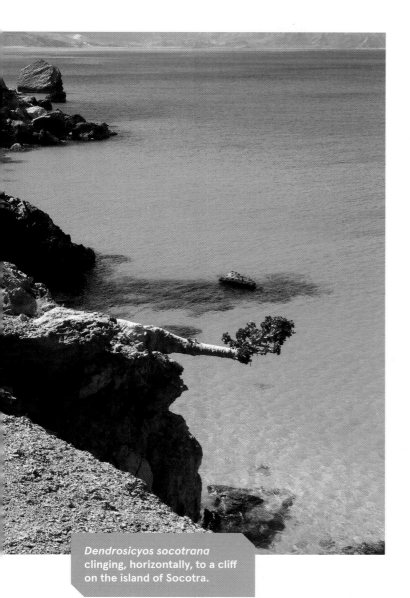

However, for its closest relative, *Hyophorbe amaricaulis*, the future is looking less bright. This species persists as a single individual at Curepipe Botanic Gardens in Mauritius. It is enclosed by fencing, for protection and support. It is the last remaining specimen of this palm; when this tree dies, we lose the entire species.

Several hundred miles north in the Indian Ocean, off the coast of Yemen, grows the cucumber tree (*Dendrosicyos socotrana*), an iconic bottle-tree found only on the island of Socotra. There it is widespread in dry areas and locally common in several vegetation types but has a rather frag-mented distribution. It is often found only as isolated trees or small relict populations; in other areas, it is more abundant. It relies on a dense cover of vegetation for its seeds to germinate and seedlings to grow.

Dendrosicyos socotrana is the only species in the monotypic genus *Dendrosicyos*. With its swollen, water-storing trunk, it is well adapted to withstand drought conditions and should therefore be better able than many species to tolerate any drying out of the archipelago due to climate change. However, it is cut and pulped for livestock fodder, especially in times of drought, which locally has resulted in almost total eradi-cation; and despite its being drought-tolerant, associated species needed for its germination are not. And as the level of exploitation rises, so does the cucumber tree's vulnerability to extinction.

The Juan Fernández Archipelago, located more than 600 km off the coast of Chile, also has high levels of endemism. The archipelago con-sists of three main islands, all of volcanic origin: Robinson Crusoe (so called since 1966 to attract tourists), Santa Clara, and Alejandro Selkirk, where the eponymous was marooned for more than four years from 1704. This (or similar tales) may have inspired Daniel Defoe to write *Robinson Crusoe*. Today the archipelago is home to 131 endemic plants, and nearly two-thirds of native plant species found on the islands are found only there. This is impressive, as the surface area covers less than 100 km^2.

However, in addition to a large number of endemic species, the islands are now ruled by non-native species; whether introduced deliberately or accidentally by humans, these invasive plants, such as elmleaf blackberry (*Rubus ulmifolius*) and Chilean guava (*Ugni molinae*), form dense thickets where no native species can grow. The grazing and seed predation of invasive animals also play a huge role in the survival and especially recruitment of native plants. For example, both *Sophora fernandeziana* and *S. masafuerana* are at risk of extinction due to their small populations, possibly as a consequence of rabbits limiting their regeneration. All 29 tree species endemic to the three Juan Fernández islands have at some stage had their conservation status evaluated as threatened.

Rosette trees (*Robinsonia*, *Centaurodendron*, and *Dendroseris*) are another very interesting group. These genera are all from the daisy family (Asteraceae), but on the Juan Fernández islands, their species have evolved to grow as rosette trees. There are at least 14 of these endemic rosette tree species. Some of the most threatened tree species are found in this group—for example, *D. gigantea* and *D. macrophylla*, both with only two trees found on Alejandro Selkirk Island. Or *C. palmiforme* with only two trees and *D. neriifolia* with three trees growing on Robinson Crusoe Island. However, there is some hope, as *D. neriifolia* is widely distributed across national nurseries and is grown at Chile's Jardín Botánico Nacional.

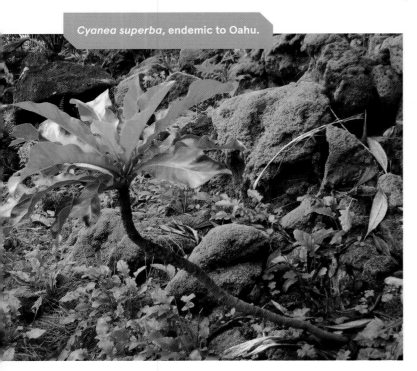

Cyanea superba, endemic to Oahu.

The main threat to the native flora of the Juan Fernández Archipelago is introduced species (plants and animals). Deforestation of previous centuries has been stopped, and the islands are now a protected national park as well as a biodiversity zone; but unfortunately, invasive species remain and are a continuing problem. When a species is down to a critically low number, existing only in extremely small, isolated populations, the ability to withstand any threat is compromised; many of the species on Juan Fernández Islands are therefore in a very precarious position.

Further north in the Pacific, the haha tree (*Cyanea superba*) was endemic to the island of Oahu, Hawaii. It grew in the understory of lowland forest and was known from the northern Waianae and southern Koolau Mountains. The species consists of two subspecies. Subspecies *regina* was

historically present in the southern Koolau Mountains but has not been seen since 1932. Subspecies *superba* was not seen for 100 years after its collection in 1870 but was then rediscovered in the Waianae Mountains in 1971. More than 60 trees were known in the 1970s, but those have since been lost.

The main threats to the haha were invasive alien plants and predation by feral pigs, rats, and slugs. Another major threat was wildfires generated by activities in the nearby military firing range. Protective measures and planting were carried out at Pahole as part of a recovery plan, but the taxon remains listed under the US Endangered Species Act. Plants are still extant in botanic gardens.

The advantages that some islands had—of isolation and protection from certain pressures found on mainland species—are changing. With the increased movement of humans, islands are no longer protected by their remoteness, and the pressures are building. Increased mobility may have started with exploration of the seas over 500 years ago, but the mobility of people—and other species—continues, at a much greater speed, in modern times.

Increased movement of people and goods has led to increased spread of non-native invasive species, even on some of the most remote islands, which can have devastating effects on native flora. These species may have been introduced deliberately (as pets or food, for example) or accidentally. Invasive species are often identified as one of the main threats to island species. Invasive plant species often outcompete native island species, as island species have not evolved with this competition and therefore do not have the mechanism to compete. However, it is not only other plants that can cause problems; introduction of animals or pests and diseases can be just as devastating. When human disturbances and introductions take place, the consequences are often severe, with native trees being shaded out by fast-growing exotic weeds.

Climate change is another major threat to islands. The baobabs of Madagascar have recently been shown to be highly vulnerable to climate change. One of the most widely recognized climate-related threats to islands and atolls is sea level rise. Significant sea level rise could decimate tree habitat on low-lying coastal areas. Increased severity of cyclones and hurricanes also leads to increased risk of extinction for trees.

Natural disasters are another threat to islands. Many tropical islands (e.g., Hawaii, Montserrat, Reunion) are of volcanic origin; where active volcanoes are still present, the vegetation is highly dynamic. Other islands regularly experience cyclones, hurricanes, or fires. The presence

of volcanic eruptions or cyclones is clearly part of an island's natural cycle. These natural events would have happened for centuries, and the natural cycles of recruitment, succession, and establishment have evolved in species that are found on these islands. However, recovery after natural disasters is no longer under the same premises: humans have introduced invasive species; significantly reduced available wild habitat due to deforestation for agriculture, and changed coastal areas of mangroves, to make way for tourist developments. Natural flora also has to compete with invasive pioneer species, up against beach developments, forest plantations, etc. Therefore, natural stochastic events now threaten the survival of island trees.

Although the majority of island tree species, and especially those that are threatened, are found on tropical islands, similar patterns of relatively high endemism and extinctions can be seen in temperate regions. A recent study of all European tree species shows that 13 percent (61 species) are endemic to European islands, including Malta, Cyprus, and islands associated with Portugal (Azores, Madeira), Spain (Canary Islands, Balearics), France (Corsica), Italy (Sicily, Sardinia), and Greece (Crete, Greek Islands). In addition, even more species are found only on other smaller islands or islets, such as *Sorbus arranensis*, endemic to the small Scottish island of Arran.

One reason for the high species richness on European islands is the diversity of habitats. The Macaronesian islands are home to laurisilva, ancient laurel forests with a plethora of different tree species and associated vegetation. The Canary Islands are volcanic, with active volcanos contributing rich nutrients in their lava flows while also potentially threatening tree populations. This is the same on the Sicily, where *Genista aetnensis* is found only around Mount Etna.

Crete is home to *Zelkova abelicea*, which shows a low and slow regeneration rate in the wild, mainly due to overbrowsing and trampling by goats and habitat deterioration by both ovine and caprine flocks, as well as dry, unfavourable summer conditions. The most important pressure in all investigated populations is livestock overgrazing and browsing. Seedlings rarely establish and survive in the wild, and individuals derived from clonal regeneration grow very slowly and can have difficulty attaining a height sufficient to escape browsing and produce fruit. Individuals grow in highly fragmented and isolated stands, and some subpopulations contain no sexually mature individuals. Soil erosion, a secondary disturbance, is clearly correlated with intensive trampling and grazing. Sheep and goats destroy seedlings and saplings, thus diminishing sexual

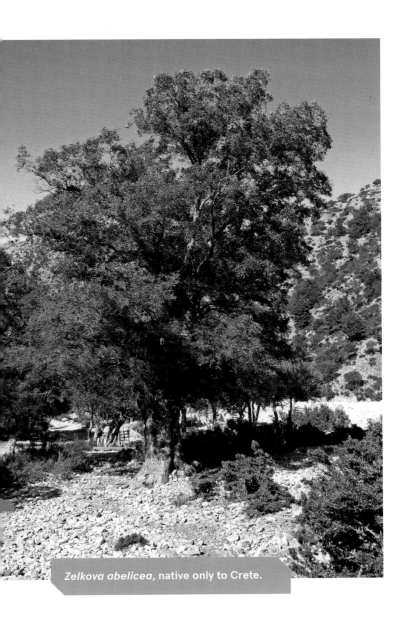

Zelkova abelicea, **native only to Crete.**

regeneration. Although the plant regenerates well by suckering, these clonal populations may never produce mature trees or seeds.

Despite the diversity of habitats, the threats to island tree species are more similar across islands. Fire is one of the most serious threat to many of the European island trees. For example, forest fires have increased with intensity and frequency on the island of Madeira. Significant fires pose a threat to native tree species, as regeneration often struggles in the face of new fire regimes.

The beauty of the European islands has contributed to the decline in many island tree species, as these islands become the centres of booming tourist industries. The creation of resorts along the coasts as well as the necessary infrastructure further inland are contributing to land-use change and the destruction of tree habitats.

Islands are unique places for trees, with more endemic species than elsewhere on the planet. The species that grow on them are more taxonomically distinct—and more at risk of being lost. It is very rare that islands contain no trees; those that lack trees (such as Easter Island and Iceland) nearly always carry a tale of human deforestation and destruction. The human impact on these fragile habitats has pushed some species to extinction, past the level of no return; others hang on in very small numbers. We have the power to conserve some of these species.

Trees and Their Uses

Products from tree species are woven into our lives in myriad ways. Many of these products, however, cannot yet be made from cultivated trees or with artificially synthesised replacements. Examples of trees being brought to the brink of extinction for their valuable products are many. As with timber

harvesting, sustainable solutions are needed to ensure that people can benefit from the use of natural products from trees and that the tree species can continue to thrive.

MEDICINES, POISONS, AND PERFUMES

From ancient remedies to fine perfumes, trees provide a huge range of compounds that are used in healthcare, the beauty industry, and religious rituals. An estimated 6000 tree species have some medicinal or aromatic use, whether in mainstream medicine, traditional medicine in China or India, or local healthcare in the Amazon rainforest. Aspirin was originally derived from willow trees, taxol—a major drug used in cancer treatment—from species of yew; eucalyptus is used to treat coughs and colds, ginkgo is used to treat dementia, and the list goes on. Wild ingredients of cosmetic products used for skincare, aromatherapy, and makeup include shea butter and oils from frankincense, argan, and baobab trees, to name a few. We still have much to learn about the traditional uses of medicinal trees and the potential future cures they might provide.

Essential oil for the best perfumes

Aniba rosaeodora
PAU ROSA, BRAZILIAN ROSEWOOD

Aniba rosaeodora is a highly valuable Amazonian rainforest tree that occurs in the forests of Brazil, Colombia, Ecuador, French Guiana, Guyana, Peru, Suriname, and Venezuela. All parts of the aptly named Brazilian rosewood are fragrant, and the wood is harvested to obtain rosewood oil, which has a mossy rose-like scent. It has been estimated that a tonne of trunks is necessary to produce 10 kg of rosewood essential oil, which is a major ingredient in fine perfume, including the iconic Chanel № 5. Populations throughout the range have seriously declined because of indiscriminate harvesting of the trees and even removal of their roots for the extraction of the valuable oil.

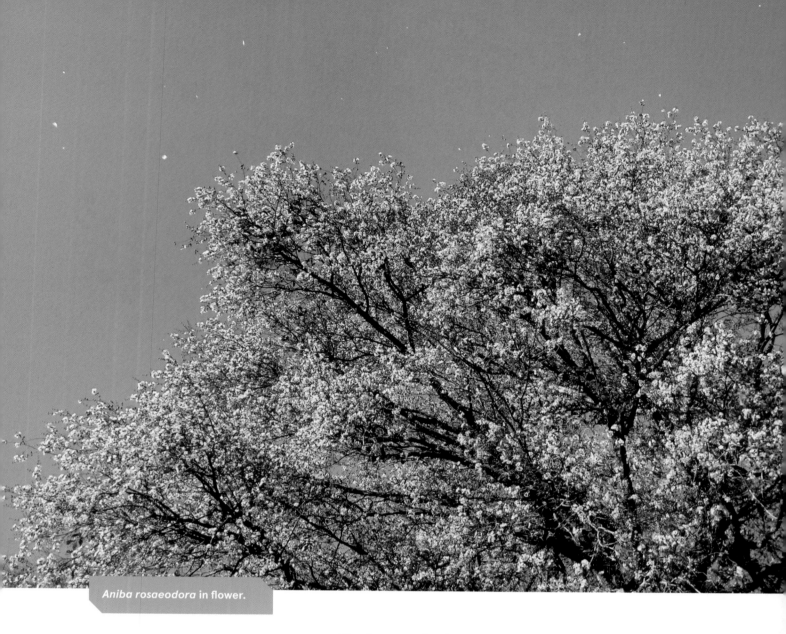

Aniba rosaeodora in flower.

The first records of the commercial exploitation of *Aniba rosaeodora* date back to 1883, when the species was harvested in French Guiana and its oil exported to Paris for distillation. This trade continued until World War I, when shipping to Europe became very difficult. Distillation facilities were set up in French Guiana, and demand was so intense that supplies of pau rosa were rapidly depleted in the rainforests of that country. The trade moved to Brazil following the discovery of the species in the state of Para in 1925. At this time the Amazonian rubber industry had collapsed, and new natural products for trade were eagerly pursued. Large

supplies of pau rosa were assumed to be available to supply the market, so no initial attempts were made to grow the species in plantations.

Demand for pau rosa remained so strong that it soon became clear that controls on the trade were necessary. In 1932, the state of Amazonas introduced legislation that set an annual quota for production of the essential oil. Legislation also required regeneration of the species after logging, with seedlings planted to replace the harvested trees. Producer cooperatives were created in Amazonas and, a few years later, in Pará. The cooperatives worked jointly with the government to determine how much pau rosa could be harvested and exported each year with set amounts for cooperative members. In this way a system for management of the species was introduced, with both sustainable harvesting and plantation for the future. Also in 1932, Perfumaria Phebo was established in the city of Belém, a trading centre for sugar, timber, and brazil nuts. This company used essential oil of rosewood as the basic component in its soap and a range of perfumes. The soap was a national success, and Phebo remains a well-known Brazilian brand.

Unfortunately, the early system for sustainable production of pau rosa did not last for long. During World War II, there was renewed demand for Amazonian natural rubber, and attention turned to harvesting the rubber trees rather than looking after the pau rosa plantations. Trade in pau rosa picked up again after the war, and by the 1950s there were over 50 distillation plants. Pau rosa remained relatively widespread in the wild and easily accessible along the banks of Amazonian rivers. Over time these trees have been logged, and with the expansion of small-scale farming into more remote areas of the rainforest, new stocks of pau rosa were discovered and exploited. By the 1960s, production of pau rosa essential oil in Peru, Colombia, and the Guianas came to an end, and only Brazil continued to export. At this time synthetic alternatives were introduced into the perfumery trade. By the 1980s, a century after commercial exploitation of pau rosa began, a further drop in demand for the commodity was caused by the introduction of ho wood and ho leaf oil as replacements for use in mid-range perfumery; these derive from *Cinnamomum camphora*, a widespread species native to China and Southeast Asia.

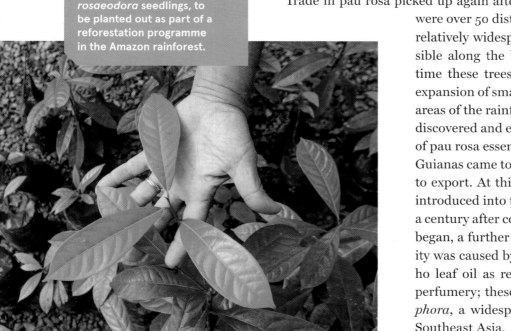

Nursery-grown *Aniba rosaeodora* seedlings, to be planted out as part of a reforestation programme in the Amazon rainforest.

An estimated 85 percent of pau rosa essential oil is exported. Despite its high value, and management requirements at state, national, and international level, the distribution and abundance of pau rosa has never been determined in detail. Natural regeneration of this slow-growing, insect-pollinated species is generally poor, and seeds are intensely predated upon by birds and insects. It is highly likely that harvest of the best phenotypes may have led to negative selection pressure on the species. General deforestation in the Amazon is another ongoing threat to the species. Pau rosa is now listed as endangered in Brazil and as endangered globally by IUCN.

Consideration has been given to developing a trade in essential oil obtained from the leathery leaves and young shoots of *Aniba rosaeodora*, which does not require felling the trees. This trade has good prospects, but pau rosa leaf oil is not considered a direct substitute for oil extracted from the wood, as it has different characteristics of smell. One solution is to involve consumers in the conservation of this enigmatic species.

Generally, the approximately 50 *Aniba* species that grow in the rainforests and cloud forests of Central and South America and the Caribbean do not form large stands but occur as small groups of trees. Some of the other species, such as *A. ferrea* and *A. santalodora*, are also used in perfume production, and around 14 are used by the timber industry. Currently 11 species are listed as threatened on the IUCN Red List, and others are recorded as threatened at a national level.

Wood of the gods

Aquilaria

AGARWOOD, GAHARU, EAGLEWOOD

Of all the valued resources produced by trees, agarwood most richly deserves the title of "wood of the gods." Renowned as a fragrant resinous wood used in the production of incense, perfume, and traditional medicine, agarwood has been treasured and traded for centuries. The earliest accounts of fragrant agarwood are in 3000-year-old Sanskrit texts. Agarwood was used by the ancient Egyptians to embalm the bodies of nobility and is referred to in the texts of several major religions; agarwood chips or incense are still used to purify places used in Islamic and Buddhist religious ceremonies.

Agarwood is primarily valued as an essential oil and incense, though it has had many more uses over the centuries.

Tropical trees of the genus *Aquilaria*, scattered within the forests of South and Southeast Asia eastward to Papua New Guinea, are the main source of this precious natural material. They are generally understory evergreens, growing in various types of mixed forest up to 1000 metres above sea level. Agarwood is found only in a proportion of the trees of a given species, with the resin being produced in response to injury and attack by fungal infection. Thirteen of the 20 *Aquilaria* species are threatened; the remaining are data deficient. The rarity and Asian-jungle origins of the trees have resulted in a highly lucrative and sometimes highly illegal trade in precious and expensive oils and perfumes.

Early records of international trade in agarwood are of export from India and China with products transported through Arabia to Persia, Mesopotamia, Egypt, the Roman Empire, and Greece. China has one endemic species, *Aquilaria sinensis*, which is native to Fuijan, Yunnan, Guangdong, Guangxi, and Hong Kong. To supplement local supplies of agarwood in China for use mainly by the ruling elite, imports were taking place from the Malay Peninsula and elsewhere by the 3rd century CE. Agarwood has been revered by the Chinese as a sign of wealth, for its fragrance and medicinal values, and to cleanse the soul. Marco Polo wrote about taxation of agarwood and other products bringing riches to the port cities of China. In 15th century, strong links were developed between China and northeastern Kalimantan, and significant amounts of gaharu were traded from Indonesia along with ironwood, rhino horn, and other valuable products. Over the centuries, harvesting for agarwood trade has moved progressively eastward from India and continental Southeast Asia, reaching as far as New Guinea in the last 50 years.

Worldwide demand for agarwood increased dramatically in the 1970s, with the trade developing into an industrial business. The pressure on trees in the wild intensified to meet global demand for new products containing agarwood, such as perfume, soap, and shampoo. New Guinea is the world's last frontier for substantial wild stocks of *Aquilaria* species and those of the related agarwood-producing genus *Gyrinops*, with Singapore a major trade hub re-exporting agarwood products from Indonesia

and Malaysia, the main countries of export. In Malaysia the primary collectors of agarwood are generally indigenous people, who depend on the natural forest for their livelihoods. Traditionally, the communities living near or within the forest harvested agarwood carefully and on a limited scale. The target trees were selected by calling on the support of traditional spirits. Agarwood is sold to middlemen who transport it to the larger towns to be sold. As the forests have diminished through industrial logging and conversion for agriculture while the international demand for agarwood has increased, it has become increasingly difficult for collectors to find agarwood in the forest. Both the trees and traditional livelihoods are under threat. Foreign nationals in Malaysia are reportedly involved in the harvesting of agarwood to supply legal and illegal markets.

The most commonly utilised species is *Aquilaria malaccensis*, a large evergreen tree with a widespread natural distribution in Bangladesh, Bhutan, northeast India, Indonesia, Iran, Malaysia, Myanmar, Philippines, Singapore, and southern Thailand. In some importing countries, it is considered to produce the only authentic agarwood, and this species is the preferred source of agarwood for perfumery and religious traditions in the Middle East and India. As a result of rapid population decline caused especially by exploitation, this species is assessed as critically endangered on the IUCN Red List. It is thought to be extinct in India and almost extinct in the East Kalimantan province of Indonesia. In Indonesia, gaharu products are retailed in the form of fragments of wood, chips, powder, or, more rarely, as a liquid suspension. The wood or chips vary in colour from light brown to nearly black. Classification is made according to resin content and quality, which is generally assessed by the trader using intuitive knowledge, with no quantitative standard for each class. The price of agarwood varies according to quality, place of origin, and time of collection.

Communities in northern Vietnam cut a hole in the trunk or main branches of *Aquilaria* trees to promote fungal infection. If the wound is kept open by regular chipping, agarwood may be induced after several years and can be extracted each time the tree is chipped. This method, like the "tapping" of rubber trees, is a sustainable alternative

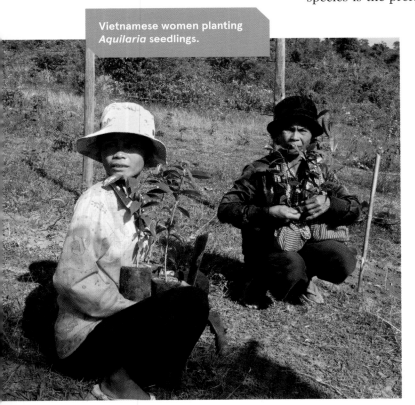

Vietnamese women planting *Aquilaria* seedlings.

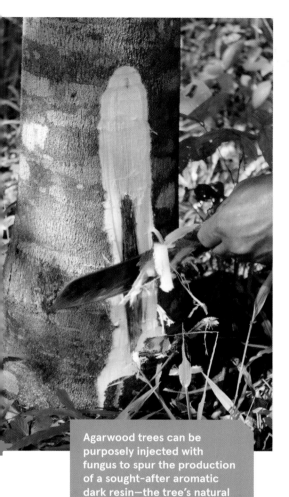

Agarwood trees can be purposely injected with fungus to spur the production of a sought-after aromatic dark resin—the tree's natural defense against pathogens.

to felling the entire tree. Sometimes the wound is plugged with a piece of wood or pottery shard to prevent the wound from closing and to provide a more reliable source of agarwood production.

Three other *Aquilaria* species are critically endangered. *Aquilaria crassna*, another large evergreen, is restricted to Vietnam, Cambodia, Lao PDR, and Thailand; in Vietnam, its wood is used in traditional medicine to treat a variety of ailments, including nausea and anxiety. It is the preferred species for agarwood used for meditation purposes in Japan, as it has a particular sweetness when burnt.

Aquilaria rostrata is a naturally very rare species from Peninsular Malaysia. Exploitation of this species for its agarwood was thought to have led to its extinction in the state of Pahang, but in 2015, Rozi Mohamed and her team from Universiti Putra Malaysia discovered 50 individual trees at another site 100 km away. At first, the team thought that it was a new species, but after making comparisons with a 100-year-old specimen at Singapore Herbarium, they discovered that it was *A. rostrata*. Unfortunately this newly discovered population is under pressure from agarwood harvesting, with trails to the nearby site of timber logging creating easy access. Fewer than 50 mature individuals are known in the wild.

Aquilaria khasiana is the most severely threatened of the *Aquilaria* species. This evergreen shrub or small tree is endemic to the Khasi hills of northeastern India. It was believed to be extinct in the wild until its rediscovery in 2016—over 70 years since it was last recorded. But the species is not safe—its habitat needs to be strictly protected and the population should be carefully monitored. Potentially, if adequately protected, the species may even become a source of genetic material for making perfumes and medicine.

Although a large part of agarwood comes from the exploitation of wild plants, local communities have also developed various techniques to grow the trees and to artificially induce the generation of agarwood, with varying to degrees of success. Agarwood trees are increasingly being grown in plantations. A drill is usually employed to make holes in the trunks and main branches of mature trees, which are then inoculated with agarwood powder. Generally, agarwood is harvested when the trees are five to 10 years old.

BGCI supports local conservation of agarwood. A joint project with the Research Institute of Science (RIS) in Vientiane, Lao PDR, enabled a national survey and development of a database of wild *Aquilaria* populations in the country. The project also enabled the successful production of nursery stock for plantations of six *Aquilaria* species. The RIS has been

encouraging rural farmers to plant *Aquilaria* in plantations, with over 1000 hectares of plantation established in Bori Khamxay province, Lao PDR. A public exhibition on environmental resources, including a display of agarwood and the inoculation process for plantation trees, helped to raise awareness of the conservation status of agarwood and the need for sustainable management of this valuable natural resource.

BGCI developed an ambitious plan of action for the sustainable use and conservation of agarwood in Lao PDR, Cambodia, and Vietnam. Joachim Gratzfeld explains that its implementation provides "a complementary approach to harvesting wild trees and [relieves] pressure on the remaining highly threatened natural populations of *Aquilaria* and other agarwood-generating species, while supporting those local communities whose livelihoods depend on this precious natural resource." With this and similar initiatives, agarwood production is becoming a success story in Vietnam. People in the Ha Tinh province of Vietnam have been collecting seedlings of *A. crassna* from natural forests since 1986 and planting them in their home gardens; this critically endangered species is also cultivated in large-scale industrial plantations, particularly in Phu Quoc Island and Khanh Hoa province. There are now over 10,000 hectares of *A. crassna* plantations in Vietnam. In Indonesia the planting of *Aquilaria* has taken place since the 1980s, and small-scale planting has gained in popularity; in many parts of the country, local people plant trees in their gardens as a form of shade and also to supplement their income.

There are many advantages to developing agarwood plantations as part of a conservation strategy for the species. As with other tree planting programmes, the plantations can act as carbon sinks to reduce greenhouse gases. Additionally, they boost the financial income of local communities and provide employment. However, plantations have not been a major factor in reducing demand for wild stocks of agarwood. Although more agarwood is available on the market, a high demand for the wild resource continues, as it's considered to be of higher quality or the only genuine agarwood.

Such is the demand for agarwood that substitution and adulteration of the products is rife, and fakes (traded as black magic wood) are commonly available in markets in the Middle East. These are formed of *Aquilaria* wood from non-infected trees that are soaked in the chemical extracts caused by infection and then carved to look like genuine *Aquilaria*.

The source of a fragrant oily resin

Boswellia

FRANKINCENSE, OLIBAN

The resin of *Boswellia* species has been used in religious and cultural ceremonies for centuries and traded in the Mediterranean region since 1700 BCE, initially transported from the Horn of Africa by donkeys and camel caravans. The resin is now also used widely in cosmetics, medicines, and dietary supplements. In ancient times, the burnt remains of the resin was the main ingredient of kohl eyeliner. Tapping *Boswellia* trees for the oily gum resin can be sustainable if the trees are exploited with care and allowed to recover between cutting. The thick, gummy, yellow-brown exudate seeps from the bark when it is cut and hardens upon exposure to air, often producing teardrop shapes. The oliban or frankincense collected is such an iconic product and global ingredient that *Boswellia* trees

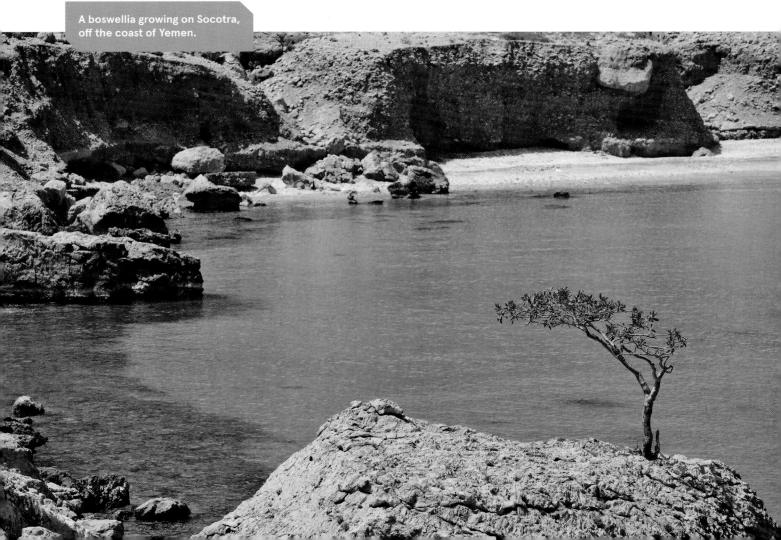

A boswellia growing on Socotra, off the coast of Yemen.

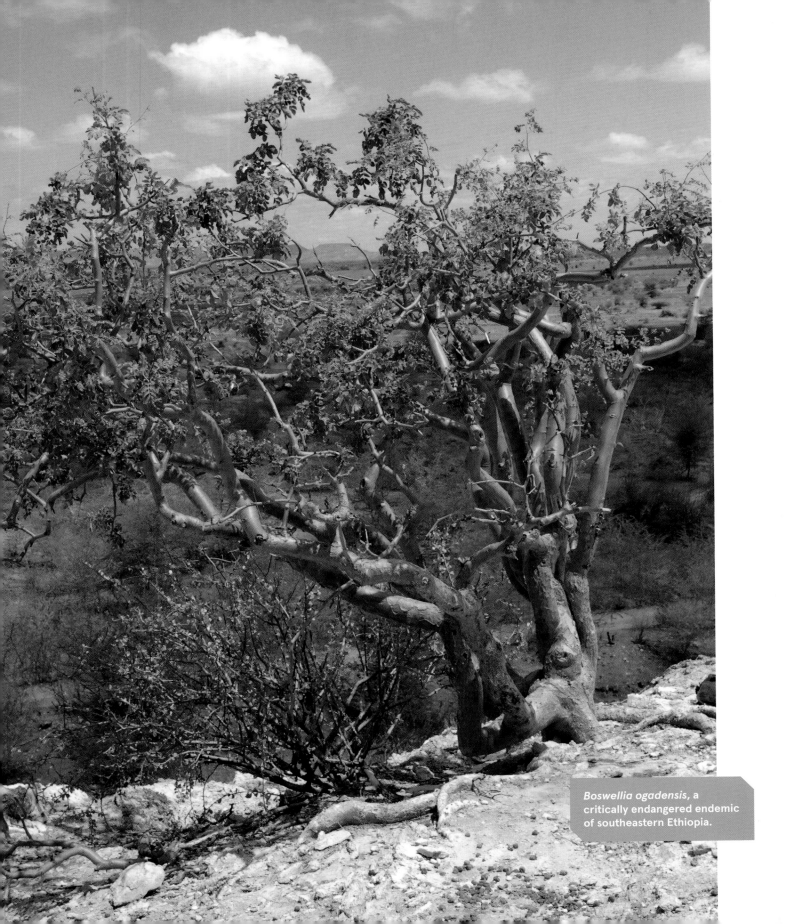

Boswellia ogadensis, a critically endangered endemic of southeastern Ethiopia.

should be protected and allowed to thrive with help from local suppliers and users around the world.

The genus *Boswellia* has 19 species, with frankincense in international trade produced by seven main species. In the past *B. sacra* was the main source of high-quality frankincense. This small tree grows up to 5 metres in arid habitats in Oman, Yemen, and Somalia; it has peeling, papery bark and pinnate leaves clustered at the ends of twigs. Overgrazing, increasing drought, and overexploitation have led to declines in *B. sacra*. It was evaluated as near threatened globally in 1998 and is in need of reevaluation. *Boswellia serrata* (Indian frankincense) is another species that has been important commercially for centuries. This species is critically endangered in Sri Lanka and threatened in parts of India. Some local plantations have been developed in India, but the quality of the resin from cultivated plants is considered to be inferior. The resin is an important ingredient in traditional medicine in India, and the timber is used for a range of local products.

The greatest diversity of *Boswellia* species is found on the Yemeni island of Socotra. In the past, Socotra was a significant source of frankincense traded internationally but now production is very limited. Eight endemic *Boswellia* species occur on the island, which is a UNESCO Natural World Heritage site renowned for its unique arid ecosystems and rich plant diversity. Now the *Boswellia* species of Socotra are seriously threatened by grazing of domestic animals (the main land use on the island), wood collection, soil erosion, and the impacts of climate change.

For the past 20 years, *Boswellia papyrifera* has been the main source of frankincense in international trade. This species is relatively widespread, extending from western Africa across the Sahel to Ethiopia and Uganda, but it is declining in various countries because of increasing trade. It is likely that the rate of decline will qualify *B. papyrifera* as globally vulnerable.

Increasing global demand for the resin from *Boswellia papyrifera* and other species and the resulting impact on species in the wild has recently led to calls for international trade controls through CITES. It is important to ensure that production and trade are sustainable so that local communities can continue to sustain their livelihoods.

Distinctive fragrances and a spice beloved around the world

Cinnamomum

CAMPHOR TREE, CINNAMON TREE

Cinnamon is one of the world's most important spices. Global sales for cinnamon exports by country reach nearly US$700 million annually. Bark and essential oils from *Cinnamomum* trees have been traded around the world for thousands of years. In the Middle Ages, Arabs dominated the trade in this and other important spices. Later, colonial powers fought to control the trade in cinnamon, nutmeg, and cloves.

Cinnamomum verum (true cinnamon) is native to Sri Lanka. Portuguese settlers took control of cinnamon production on the island in the early 16th century. Subsequently the Dutch gained control and maintained their global cinnamon monopoly until the late 18th century; this involved encouraging the belief that wild trees in Sri Lanka produced better medicines than cultivated ones elsewhere, as well as burning European cinnamon stocks to keep prices high. Nowadays, Sri Lanka is still thought to produce the finest cinnamon, whether from wild or cultivated trees. Four of the nine *Cinnamomum* species that are endemic to Sri Lanka are now critically endangered, and two are listed as endangered. Sadly, wild species in other countries of the region are also facing extinction.

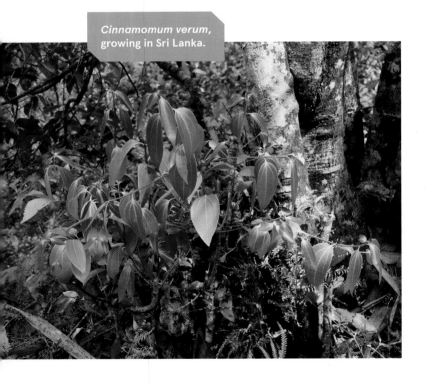

Cinnamomum verum, growing in Sri Lanka.

The genus *Cinnamomum* includes around 300 species, mainly distributed in subtropical to tropical Asia, with a few species in Australia and the western Pacific area. In addition to *C. verum*, various other species are highly prized for their aromatic bark and leaves, which are collected for culinary and medicinal purposes. For example, the widespread species *C. camphora*, *C. parthenoxylon*, *C. iners*, and *C. glanduliferum* are used to make camphor and essential oils for the perfume and pharmaceutical industries. *Cinnamomum iners* is a very common tree in Southeast Asia; its boiled roots are used medicinally to treat fever, and its leaves are applied as a poultice to treat rheumatism. Children relish the fruits.

In India, 26 of the 49 *Cinnamomum* species occur in the Western Ghats. *Cinnamomum*

riparium and *C. malabatrum* play a vital role in the ecology and economy of this global biodiversity hotspot; the bark, fruits, and leaves of these species are harvested for medicine and flavouring, providing important economic and livelihood opportunities. Cinnamon is a commercially important non-timber forest product in India—one that, if harvested sustainably, can be used to support conservation of remaining tropical forests. Unfortunately, overharvesting is a problem. *Cinnamomum riparium* is listed as vulnerable on the IUCN Red List.

The leaves of *Cinnamomum gamblei* are harvested and sold in the local markets of Nilgiri as a flavouring for rice dishes. Fortunately the type locality of this small tree is within Mukurthi National Park, a core area of Nilgiri Biosphere Reserve that protects patches of shola, a type of montane forest. The flagship mammal of the Mukurthi National Park is the Nilgiri tahr, an endemic and endangered species of ibex that once inhabited the slopes and cliffs in huge herds. Because of its location in the national park, it is thought that the endangered *C. gamblei* receives adequate protection. Nevertheless, regeneration rates are quite low, and this species is not recorded in botanic garden collections.

Also found in the sholas of the Western Ghats is *Cinnamomum macrocarpum*, which is recorded as vulnerable on the IUCN Red List. It has a wider distribution than *C. gamblei*, but the combined effects of forest degradation and deforestation have affected it significantly. It is an important medicinal plant for use and trade by local people. The bark, leaves, and oil from the root bark are used in medicine. The powdered bark is mixed with honey and used to treat coughs, diarrhoea, and dysentery. Oil from the root bark and leaves is used to treat rheumatism. A mix of leaves from this and several other *Cinnamomum* species are sold in Bangalore markets.

Cinnamomum macrocarpum appears to regenerate well in the wild and is quite abundant, for example in the Silent Valley National Park in Kerala. One major initiative that has promoted medicinal plant conservation for species such as this vulnerable species of cinnamon is the identification and documentation of forest areas across India as Medicinal Plant Conservation Areas (MPCAs). The Foundation for Revitalisation of Local Health Traditions (FRLHT), based in Bangalore, developed this concept and, since 1993, has worked with state forest departments, botanists, and local communities to identify appropriate sites. The MPCA network is the largest in situ conservation network for the conservation of wild gene pools of medicinal plants in the tropical world. Generally, the sites chosen for MPCAs are relatively undisturbed forest areas that are rich in

Silent Valley National Park in Kerala, India, a Medicinal Plant Conservation Area (MPCA).

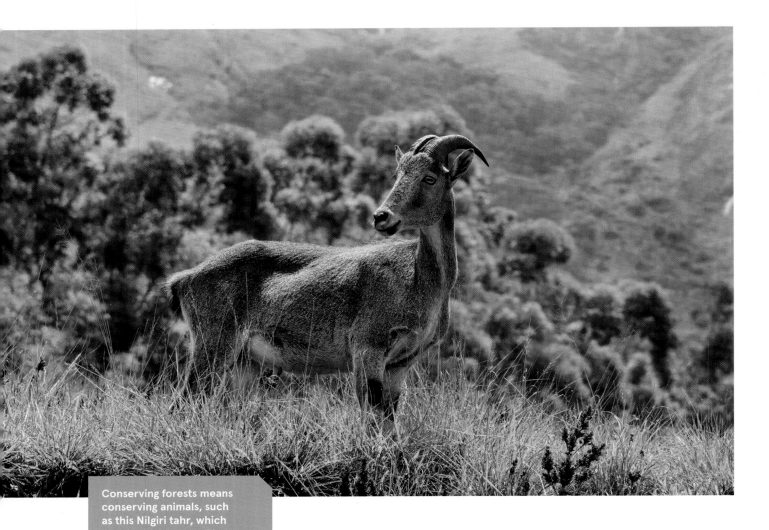

biodiversity and are known locally for the presence of medicinal plants. Designation of these areas has tapped into traditional sources of knowledge concerning medicinal plant diversity and uses. As part of MPCA support, local nurseries are developed, so that medicinal plants can be propagated and sold to provide a source of income.

The Philippines is another country with a rich diversity of *Cinnamomum* species; around 18 of its 25 species are endemic. Cinnamon has been produced and traded in the country for over 500 years, but relatively little is known of the potential of the native species. As in India, there may be possibilities for the development of Philippine cinnamon as a sustainable forest-based livelihood. The Global Trees Campaign has been supporting conservation of cinnamon trees in the Philippines for

Most of the approximately 20 species of cinnamon in the Philippines are found nowhere else in the world.

around 15 years. *Cinnamomum cebuense* (Cebu cinnamon, kaningag) is a medium-sized tree found only on Cebu Island. The species is relatively new to science, first described in 1986. Like its relatives, its bark is used for medicinal purposes. Local people either chew the bark directly or boil it with water to produce a remedy for stomachache. The leaves may be a potential source of spice for cooking.

Loss of habitat due to increasing urbanisation and agricultural development of the densely populated small island is one of the greatest threats to *Cinnamomum cebuense*. Already Cebu is considered one of the most denuded islands of the Philippines, with very little remaining forest cover. Combined with habitat loss, the practice of bark stripping for medicinal use also poses a significant threat to Cebu cinnamon. In 2004, the Global Trees Campaign supported Philippine NGOs and students to conduct a survey of the tree as the basis for developing a species conservation strategy. Prior to this project, only 57 individuals of Cebu cinnamon were known. During the surveys, a further 691 individual trees were discovered. Three local organisations grew and replanted 1100 seedlings, and a further 100 wild-collected seedlings were grown on to a size that gave them a better chance of survival when they were replanted in the forest. It is also extremely important to protect the remaining forest habitat. The forest block at Tabunan is considered a crucial site for biodiversity conservation; it is probably the only remaining original forest on Cebu. Fortunately the area comes within the boundaries of the

The pink-red new leaves of *Cinnamomum cebuense*, which grows only on Cebu Island in the Philippines.

Central Cebu National Park. Another flagship species that occurs there is the Cebu flowerpecker (*Dicaeum quadricolor*), an endemic bird declared extinct in 1906—until its rediscovery in a tiny patch of degraded forest near Tabunan in 1992.

The Global Trees Campaign is working closely with local partners to generate a comprehensive list of endemic cinnamons in the Philippines and prioritise further species for action. The Campaign also works closely with cinnamon resource users to understand bark harvesting trends, with the aim of eventually establishing sustainable uses of Cebu cinnamon. A long-term commitment is required to conserve this precious tree.

The source of dragon's blood resin, aka cinnabar

Dracaena

DRAGON TREE

The dragon tree growing at Icod in Tenerife is a major tourist attraction on the island. With its huge girth and bizarre growth form, this iconic 400-year-old giant is a real crowd-pleaser. The tree has a striking umbrella-like shape and tangled crown of sword-shaped leaves clustered at the end of short branches. The isolated tree at Icod is a relic of the once-widespread *Dracaena draco* (Canary Island dragon tree), which has been in decline in the wild for centuries. The species itself is considered a relic of the Laurasian subtropical flora that flourished millions of years ago in the Pliocene. Dragon trees do not form annual growth rings, so are aged based on their number of dividing branches

Canary Island dragon tree earned its name from Greek mythology. In the eleventh labour of Hercules, the hero was tasked with bringing back three golden apples from the Hesperides guarded by Landon, a hundred-headed dragon. When it was slain, red blood flowed out upon the land and from it sprang the trees we now know as dragon trees.

Dracaena draco is present in five of the seven Canary Islands, with the total population reduced to a few hundred trees in the wild. On other islands of Macaronesia, in arid areas of Madeira, and in neighbouring Porto Santo, this tree was once an important component of the vegetation but only a few individuals remain, mainly due to habitat destruction. A 1996 survey revealed new subpopulations of *D. draco* in the mountainous Anezi region of Morocco, where thousands of individuals exist on steep

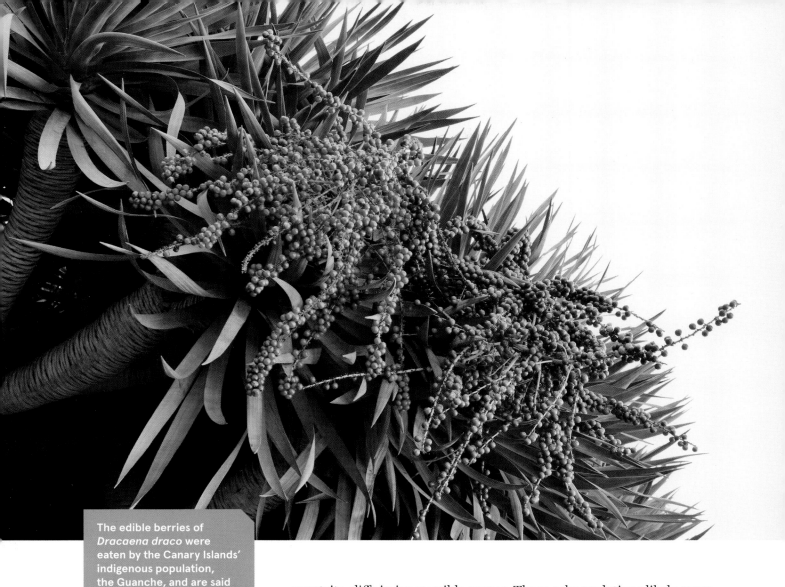

The edible berries of *Dracaena draco* were eaten by the Canary Islands' indigenous population, the Guanche, and are said to taste like cherries.

quartzite cliffs in inaccessible gorges. These subpopulations likely represent *D. draco* subsp. *ajgal*. It has also been suggested that dragon trees growing in the foothills of Caiz in southern Spain and in Gibraltar could have originated in nearby native populations that are now extinct. In Cape Verde, the species is represented by *D. draco* subsp. *caboverdeana*, first described as a distinct taxon in 2012.

The first reports of dragon trees in the Canary Islands came from French explorer Jean de Béthencourt's expedition in 1402. The Guanche (the islands' inhabitants, relatives of the Berbers) used the deep red resin or dragon's blood produced by the tree in mummification processes; the berries of *Dracaena draco* also featured regularly in their diet. Individual dragon trees live to immense ages. When the Prussian naturalist and biogeographer Alexander von Humboldt visited Tenerife in 1799 on his way

to South America, he saw a dragon tree at Orotava which he measured as over 21 metres tall and nearly 5 metres in diameter. The tree was venerated by the Guanche, and Humboldt guessed it was about 6000 years old; the plant was lost in a storm in 1868. The oldest living specimen on the island is now the one at Icod.

Dracaena draco once played an important ecological role. Approximately 500 years ago the fruit of the dragon tree was the staple food of a flightless Dodo-like endemic bird that is now extinct. The processing of dragon tree seeds through the digestive tract of this bird helped stimulate germination, and it is possible that the loss of this bird species has led to a decline in naturally occurring dragon trees. Several extant bird species eat fruit of the dragon tree. One, the white-tailed laurel pigeon (*Columba junoniae*), an endemic of the Canary Islands, helps to disperse the seeds.

Dracaena draco was one of 250 examples of threatened species in the first IUCN Red Data book for plants, published in 1978. Despite its rarity in the wild, the dragon tree is very widely cultivated for its form, curiosity, and symbolic value. Collections of this species in botanic gardens and arboreta provide an important genetic resource for potential restoration efforts. Fine specimens can be seen growing at Lotusland in California.

In Cape Verde, *Dracaena draco* subsp. *caboverdeana* survives in dry forests on steep cliffs and in high mountain habitats, protected under

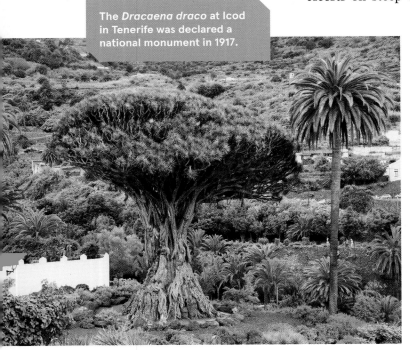

The *Dracaena draco* at Icod in Tenerife was declared a national monument in 1917.

national law from picking and uprooting, and a proposed network of protected areas would offer further refuge for some of the species' populations. FFI has been working with Biflores, Cape Verde's first and only flora-focused conservation NGO, to conserve Cape Verdean dragon trees on the island of Brava, where the species is found in an area of just 16 km².

Of Cape Verde's endemic plants, 78 percent are threatened, and a complex web of factors has contributed to the decline of the dragon tree specifically. Free-roaming domestic animals, with unrestricted access to palatable young plants, seriously affect the species' natural regeneration. Non-native invasive plants bring additional threats by outcompeting the dragon tree, and intentional gathering of tree material, for firewood and other uses, adds to the species' struggle to establish healthy populations. Increasing aridity due to global climate

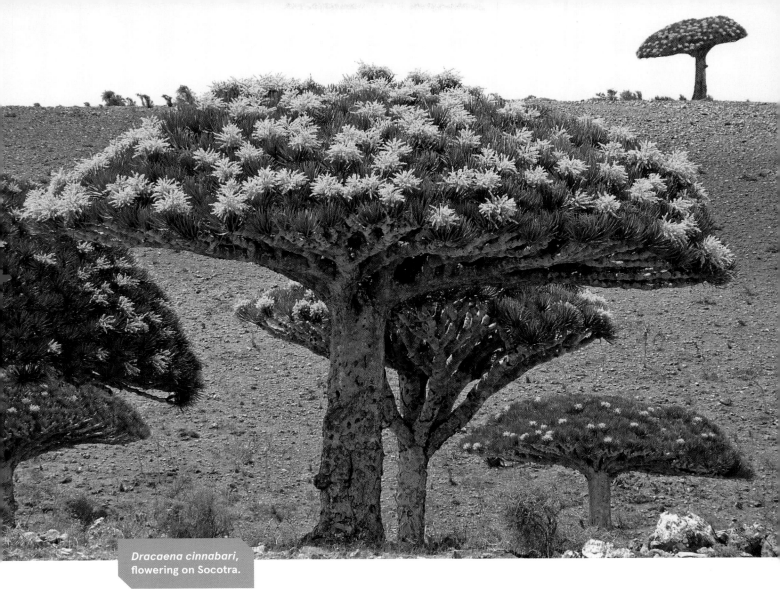

Dracaena cinnabari, flowering on Socotra.

change may limit the area available for dragon trees to thrive, driving the species ever further toward the tops of mountains.

The closest relative of the Canary Island dragon tree is *Dracaena cinnabari*, endemic to Socotra. The island of Socotra was separated from mainland Arabia 34 million years ago, and a unique flora has developed. Nearly 40 percent of the island's plant species are endemic. *Dracaena cinnabari* survives within fragments of forest on the granite mountains and limestone plateaus of Socotra. During the monsoon season, these upland areas are covered by cloud, drizzle, and sea mists, which are absorbed by the dense umbrella-shaped canopy of the dragon trees.

The remarkable Socotra dragon tree has been economically important for centuries. Like its relative in the Canary Islands, it produces a

red resin, known locally as emzoloh. The resin has a range of traditional medicinal uses and has been in trade across Europe and the Middle East for thousands of years. Referred to in ancient times as cinnabar, the resin from *Dracaena cinnabari* has been an exotic ingredient of traditional medicines and dyes. It has also been used as a varnish and antioxidant for iron tools. This dragon's blood dye is thought to have been responsible for the intense colour of Stradivarius violins.

The main livelihood activities on Socotra are nomadic livestock production and fishing. Local people value the dragon tree as a source of food for their domestic animals, as very small quantities of the tree's berries are fed to cows and goats to improve their health.

Dracaena cinnabari is vulnerable in the wild, with an uncertain future. Few populations are regenerating naturally, and young trees often lack the species' characteristic umbrella shape. The most significant threat facing *D. cinnabari* is climate change: Socotra is drying out, with once reliable monsoon weather becoming patchy and irregular. Based on climate modelling, the tree can expect to lose 45 percent of its potential habitat by 2080, and while expanding the Skund Nature Sanctuary could protect two potential refuge areas, this level of conservation work will not save the species.

In total the genus *Dracaena* contains about 180 species growing mainly in tropical forests of Africa and Asia with some scattered species in Micronesia and Macaronesia, the Caribbean, and Central America.

The balm of balsam

Liquidambar

SWEETGUM

Liquidambar trees, familiar in our parks and gardens, have an ancient history. They flourished in the Tertiary Period, growing throughout the northern hemisphere along with magnolias and palm trees. The beginning of this period was very warm and moist, but by the middle of the Tertiary the climate began to cool, leading, over time, to the ice age at the start of the Quaternary. The distribution range of *Liquidambar* species was reduced dramatically by glaciation, and the 15 species that remain are Tertiary relicts.

Liquidambars are similar in appearance to maples and like them are popular for their stunning autumn colours. The shape of their leaves

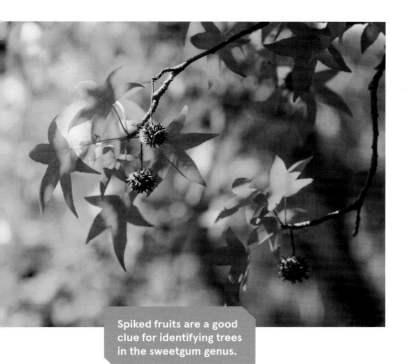

Spiked fruits are a good clue for identifying trees in the sweetgum genus.

is alike, but they are easily distinguished by their fruits: whereas maples have winged "helicopter" fruits, liquidambars have spiky round fruits that have inspired various popular names (e.g., space bugs, gumballs, monkey balls). The corky bark of the sweetgums is another distinguishing characteristic.

Perhaps the rarest liquidambar in the wild is *Liquidambar orientalis* (oriental sweetgum), which is listed as endangered by IUCN. This attractive tree, frequently grown as an ornamental, is restricted in the wild to the Greek island of Rhodes and a small area of southwestern Turkey. This tree has been valued for its products—balsam, sweetgum oil, and incense—since ancient times. Balsam is applied as an antiseptic to heal wounds and burns and used to treat peptic ulcers and various other ailments in Turkish folk medicine. The 17th-century Ottoman explorer Evliya Çlebi wrote of the export of sweetgum oil from the port of Marmaris, destined for Egypt and on to Arabia and India. Now, with advent of synthetic replacements, production is of minor importance—less than 4 tonnes each year. Some incense is still produced from the bark. The main threats to this tree in its native habitats are changes to the water table and clearance of the rich alluvial sites where it grows for farming. Many of Turkey's sweetgum groves have been replaced by fields of oranges and tangerines. The species is also negatively affected by tourism in Rhodes, which is a popular holiday destination.

The forests where *Liquidambar orientalis* grows in Turkey are given special protection. They are located in the southern part of Muğla province along the Mediterranean coast. Sweetgum groves are still associated with the ancient spring festival of Nevruz, where the awakening of nature is celebrated. In Kavakarasi, an area of partially flooded species-rich forest where sweetgum is still harvested, oil production is the main source of income for local people after orange and tangerine production. Villagers collect sweetgum leaves together with herbs and fungi as part of their local cuisine. On Rhodes, the whole area where liquidambars grow falls within a NATURA 2000 site and is also protected by Greek law as a Natural Monument. This area is of exceptional natural beauty and conservation value, attracting many thousands of tourists each year. In late

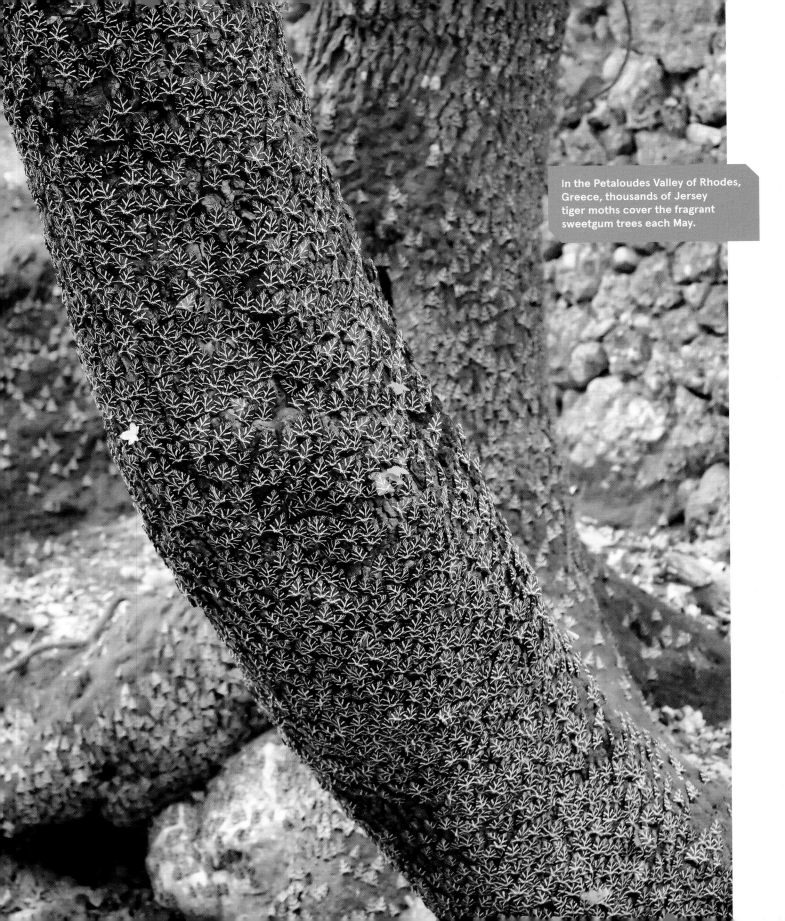

In the Petaloudes Valley of Rhodes, Greece, thousands of Jersey tiger moths cover the fragrant sweetgum trees each May.

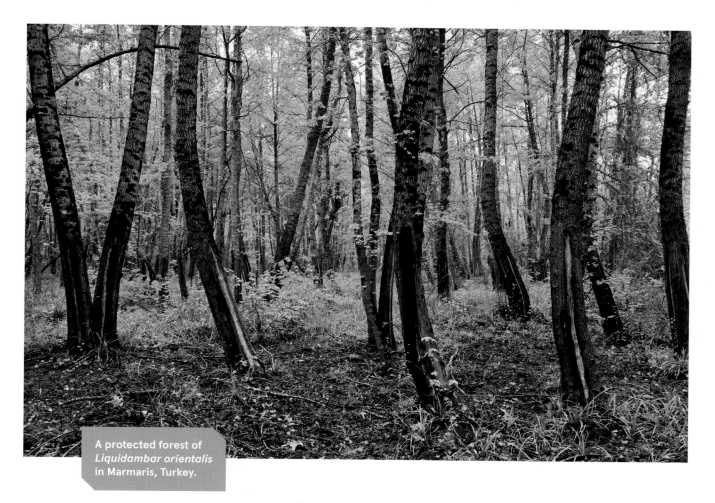

A protected forest of *Liquidambar orientalis* in Marmaris, Turkey.

May thousands of Jersey tiger moths (*Callimorpha quadripunctaria*), attracted by the scent of the oriental sweetgum trees, migrate to the site to reproduce.

Liquidambar styraciflua (American sweetgum, Appalachian gum) is another source of resin and balsam. It is an ingredient in Friar's Balsam, a commercial product used to treat colds and skin problems. American sweetgum has medicinal uses dating back over 10,000 years to the Aztec Empire. The ancient Aztecs collected the sticky, opaque brown liquid released when the tree is wounded and used it to treat skin infections and other ailments, and products of the tree have long been used by the Cherokee, Choctaw, and other Native American people. The hardened resin extracted from the tree was used as chewing gum. Tea was made from both the fruits and the bark. Extracts from the plant were mixed with animal fat and roots of Virginia pennywort (*Obolaria virginica*) to

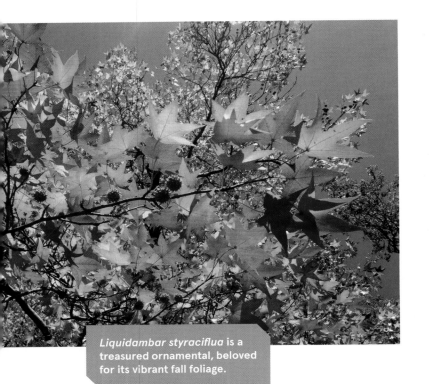

Liquidambar styraciflua is a treasured ornamental, beloved for its vibrant fall foliage.

treat wounds, bruises, and ulcers; they have also been used as a sedative and to "comfort the heart." The sap and inner bark have been used to treat diarrhea and dysentery. The timber of American sweetgum (sometimes traded as satin walnut) is utilised for furniture, boxes, and utensils. In the US, it was the favoured wood for panelling 19th-century railway train carriages.

Liquidambar styraciflua is native to eastern and southeastern US forests and to cloud forest areas in Mexico and Central America. It is a characteristic species of the lower elevation forests of the Appalachians, which are among the most diverse temperate forests in the world. American sweetgum remains common and abundant, growing in a wide range of habitat types. Its seeds are an important food source for many bird species.

The first European reference to this American tree is from Spanish conquistador Juan de Grijalva. In 1517, he told of gift exchanges with the Mayas "who presented them with, among other things, hollow reeds of about a span long filled with dried herbs and sweet-smelling liquid amber which, when lighted in the way shown by the natives, diffused an agreeable odour."

American sweetgum was introduced into the UK in the 17th century by the Oxford-educated clergyman John Banister, who was sent to the Caribbean and the US as a naturalist and missionary by Henry Compton. Banister collected material for the Chelsea Physic Garden and Oxford Botanic Garden, introducing into cultivation many species, including *Magnolia virginiana*, scarlet oak (*Quercus coccinea*), and the beautiful *Liquidambar styraciflua*, the first specimens of which were grown in the Fulham gardens of Bishop Compton's London palace.

A poison that has become a medicine

Prunus africana

AFRICAN CHERRY, KIBURABURA

Prunus africana is a large evergreen tree, often reaching 20 metres in height and occasionally with buttressed roots. Despite having a wide natural range that spans Africa, this species is threatened, being highly sought-after for its medicinal uses; it has been included in CITES Appendix II since 1995. It was previously overexploited for its highly valued timber, which is straight-grained, quite heavy, hard, and strong, with a dark red colour and nice polish. Its wood was used for heavy construction (bridges, decks, flooring) and in the production of poles, carvings, tools, and utensils.

Prunus africana is an important source of income to many people in rural Africa. Its small white fragrant flowers mature to cherry-like fruits that produce a drug for which there is a growing worldwide demand. The species has been highly valued for many generations across Africa, not only for the medicinal properties of its bark and leaves but also for its use as an arrow poison. Traditionally, beliefs and associated taboos of local people protected and controlled the use of this important species, but global demand is now threatening its survival. The bark is harvested in the largest quantity of any tree species, and this has led to international concerns about sustainability.

Prunus africana generally grows in high-altitude, montane forest habitats of Africa, from Equatorial Guinea in the west to Madagascar in the east. These forests are very important for biodiversity conservation, but unfortunately, throughout Africa, montane habitats have been affected by loss of forest for agriculture, logging for timber, and the establishment of exotic tree plantations of fast-growing eucalyptus and pine. The forests and populations of *Prunus africana* are increasingly fragmented, and climate change is now a significant threat. The main pressure on the species, however, is overexploitation. Excessive removal of the bark (often by complete girdling) and the felling and harvesting of immature trees has caused a serious decline in wild populations of *P. africana*. The

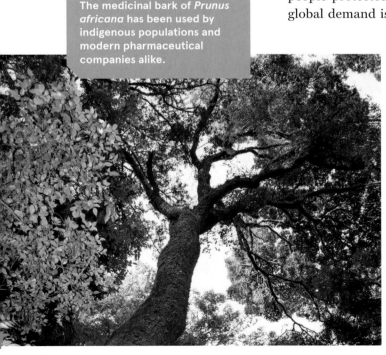

The medicinal bark of *Prunus africana* has been used by indigenous populations and modern pharmaceutical companies alike.

Kibale National Park, in western Uganda, is an important ex situ conservation site for *Prunus africana*.

removal of mature trees also causes reduced seed production and poor recruitment, resulting in a lack of regeneration and few young trees.

Large-scale commercial exploitation of *Prunus africana* for its medicinal bark began in the 1960s, when bark extract was patented as a treatment for benign prostatic hyperplasia, a noncancerous enlargement of the prostate. The involvement of a major French company in exports of bark from Cameroon in the early 1970s transformed the trade. The tree became an important source of income for highland forest communities, especially in Cameroon, which continues to supply about 70 percent of the medicinal bark to the global market. Other countries of export were Madagascar, Democratic Republic of Congo, Kenya, Uganda, and Equatorial Guinea. Growing international demand for the raw material, combined with the economic hardship of many local communities, led to overharvesting. Sustainable management of *Prunus africana* is certainly possible but is not yet a reality. The low prices paid to harvesters still encourage unrestrained and destructive collection in return for short-term financial gain. There has, since the 1960s, been a shift from exclusively wild harvest of the species toward increasing cultivation and domestication, complemented by integrated conservation and development projects.

One of the advantages of cultivation is that the genotype of plants grown for pharmaceutical production can be controlled according to demand. For example, a reforestation and trade programme in Uganda utilised the discovery that trees in the local national parks have the highest concentration of the active pharmaceutical ingredient in the country, and a nursery of superior genotypes was established to supply farmers with the best material for planting. The Nile Basin Reforestation Project in Uganda, which involves *Prunus africana* and other indigenous trees, was launched in 2009. This major initiative aims to generate 700 local jobs and counts toward carbon emission reductions under the Kyoto Protocol.

The most significant constraints on the conservation, cultivation, and reforestation of *Prunus africana* are limited seed availability owing to the late maturity of the plants (approximately 15 years), fluctuating yields, and the intermediate/recalcitrant nature of the seeds. Tissue culture techniques offer a viable solution for cultivation, helping to preserve valuable genetic resources, prevent the destructive sampling of wild populations, and assist in ex situ conservation. There are reported to be healthy populations in Bwindi Impenetrable National Park, the home of mountain gorillas, and also in Kalinzu Forest Reserve, adjacent to Queen Elizabeth National Park. Kibale National Park, in western Uganda, also has trees of *P. africana*.

Tooro Botanical Gardens, in western Uganda, leads community workshops to teach sustainable harvesting methods for *Prunus africana* and produced a manual that shows how to propagate it and a range of other locally valued trees used for medicine. Godfrey Ruyonga, the garden's director, is convinced that involving local communities in conservation is the only way to ensure the recovery of threatened tree species. Tooro Botanical Gardens has worked with support from BGCI to establish three forest restoration sites, all formerly planted with eucalyptus. Seeds of native trees have been carefully collected from Kibale National Park and other forests nearby and propagated in the botanic garden nursery. Initially when the young trees were planted at the restoration sites, neighbouring communities allowed their goats to graze there, resulting in the loss of the newly planted native trees. Godfrey and his team devised a solution to this problem, allowing people to plant leguminous vegetables between planted trees with community members acting as custodians. The scheme has been a great success. In less than 20 years since its establishment, Tooro Botanical Gardens is now recognised by Uganda's National Forestry Authority as the country's leading supplier of native tree seedlings.

A timber tree with medicinal bark

Warburgia salutaris
PEPPER-BARK TREE

The inner bark of *Warburgia salutaris* has a pungent peppery smell (hence the common name). Crushed leaves of this tree also have a distinctive bitter taste, allowing for easy identification. The epithet *salutaris* ("health-giving") references its medicinal properties. The bark is used to treat complaints such as malaria, stomach ulcers, colds, and nightmares. Cooked roots of the tree are used to treat coughs, and the leaves alleviate skin irritation. It is also used for timber and as a chilli substitute; it is eaten by hippos.

Endemic to the forests of Mozambique, South Africa, Swaziland, and Zimbabwe, the pepper-bark tree grows in coastal, riverine, dune, and montane forest as well as open woodland and thickets. As with *Prunus africana*, the main threat to the pepper-bark tree is overharvesting for use in medicine, but in this case the use is mainly within Africa. *Warburgia salutaris* is one of the most frequently used medicinal plants in South Africa and Zimbabwe and has been heavily collected even in protected areas. All four species of *Warburgia* are of great value in traditional muthi medicine, and all are threatened in the wild to varying degrees.

Besides the threat of overcollection, *Warburgia salutaris* is declining as a result of forest degradation, with the expansion of farming and settlements. In Zimbabwe, the species had a limited natural distribution, and traditional healers increasingly relied on imports from Mozambique. In 2008, the pepper-bark tree was listed as extinct in the wild in Zimbabwe. The tree does, however, survive in a few private gardens in the country. As part of the Global Trees Campaign, BGCI is now working with Vumba Botanical Gardens to develop cultivation of the pepper-bark tree in the Mutema Highlands and reintroduce the species back into the wild. This follows on from an earlier pilot project to reintroduce the species carried out by WWF and a local NGO. Writing about the earlier project in the conservation journal *Oryx* in 2011, Alfred Maroyi explained that *W. salutaris* is sold in markets in major cities of Zimbabwe, bartered with neighbours in exchange for other commodities, and given as gifts to neighbours and relatives. He found that this trade and exchange of *W. salutaris* products strengthens family relationships, and sales are important to improve the financial status of families, with cash income used to buy food and clothing and pay school fees.

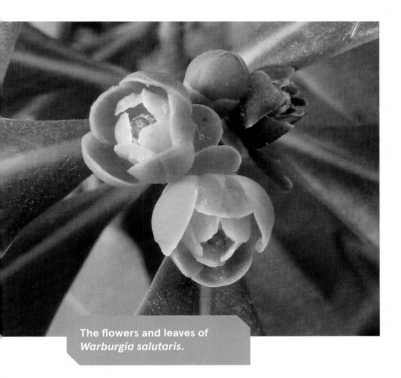

The flowers and leaves of *Warburgia salutaris*.

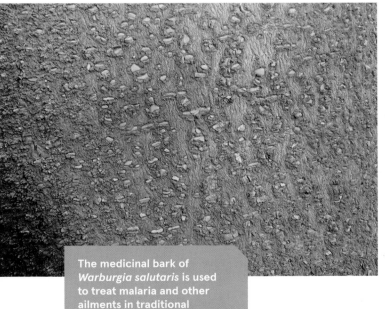

The medicinal bark of *Warburgia salutaris* is used to treat malaria and other ailments in traditional muthi medicine.

Fortunately, pepper-bark tree grows relatively easily and well from cuttings. Representative ex situ collections are being developed at Vumba Botanical Gardens to provide a source of planting material for reintroduction efforts. Global Trees Campaign is working with local communities to help with its cultivation within home gardens. The harvesting and use of leaves rather than bark of the pepper-bark tree is being promoted. Leaves contain the same active chemicals as the bark and can be harvested sustainably.

An early stage in the GTC project was to investigate the genetic diversity of *Warburgia salutaris* in Zimbabwe and South Africa. Research showed no significant difference in the genetic composition of populations in the two countries. As a result it was decided that South African pepper-bark tree seed, which can be sourced sustainably, would be used to grow the supply of *W. salutaris* in Tanganda Holt, close to the Mutema Highlands. Approximately 5000 seeds were planted at Vumba Botanical Gardens in November 2018.

For the genetic analysis, DNA samples were collected from trees in Zimbabwean private gardens. By chance, it was found that a former employee of the National Botanic Gardens in Harare was growing a pepper-bark tree of Zimbabwean origin in his garden. Remarkably this tree is producing seed— the only known pepper-bark tree in Zimbabwe to do so—and 24 saplings have now been propagated. Several of these have been distributed to local community members; the remaining individuals will be used for future reintroduction activities.

In South Africa most of the pepper-bark tree products sold in the traditional medicine markets are also now imported from Mozambique. A pepper-bark tree growing at the entrance of Kirstenbosch National Botanical Garden was planted by Nelson Mandela in 1996, when *Warburgia salutaris* was proclaimed Tree of the Year in South Africa. Thousands of plants have been propagated at the Silverglen

Nursery in Durban. Part of the Silverglen Nature Reserve, the Silverglen Nursery continues to grow pepper-bark cuttings on quite a large scale and helps traditional healers (inyangas) to cultivate their own supplies. The pioneering nursery, established 30 years ago, cultivates and makes available about 120 threatened medicinal plant species in total. Groups of plant gatherers, traders, and inyangas come to the reserve to learn how to collect seed and propagate plants. The intention is that they will return to their communities and spread the word that only by cultivating their own supplies can people continue to make a living from selling medicinal plants in markets like the thriving Durban Station Market.

PRECIOUS TIMBERS AND MUSIC WOODS

The use of wood is universal. From shelters in the rainforest to medieval cathedrals, pencils to totem poles, we live in, are surrounded by, and use wood constantly. The wood of some tree species is used for general purposes, whereas other trees produce wood with particular qualities of strength, density, colour, and lustre that are highly valued for special use. Throughout the ages, some forests have been carefully managed to provide a constant supply of wood for building materials, fencing, and fuel. But more typically over the last century, forest have been "mined" for their timber resources. This has led to the degradation and loss of forests, resource depletion, and potential extinction of species. Island endemics, for example, have too often been reduced to a handful of individuals by centuries of trade. Heavily exploited species face a very real risk of extinction. It is, of course, possible to grow wood, and there are extensive plantations of conifers and eucalyptus around the world. But, with the exception of teak, very few tropical timbers are cultivated at scale.

Heartwoods prized for their hardness and colour

Dalbergia

BLACKWOOD, ROSEWOOD

African blackwood (*Dalbergia melanoxylon*) is a small heavily branched tree that grows very slowly and has a gnarled and twisted appearance. Perhaps not a handsome tree, African blackwood nevertheless has a noble history of use producing royal furniture for the ancient Egyptians and is now prized around the world. It is a characteristic tree of many areas of tropical Africa with a seasonally dry climate, occurring all the way from the Sahel to South Africa and growing in various woodland habitats. Despite its wide geographical range, this species was evaluated as near threatened in 1998 and is under intense pressure in parts of its range. The tree and its timber have many different local and trade names. Mpingo is the Swahili name used in East Africa, and pau preto (from the Portuguese,"blackwood") is the name used in Mozambique. Rosewood and ebony are other names used in international trade. *Dalbergia melanoxylon* is famed for its precious timber, harvested when the slow-growing trees reach an age of 70 years or so. The timber is one of the most valuable in the world.

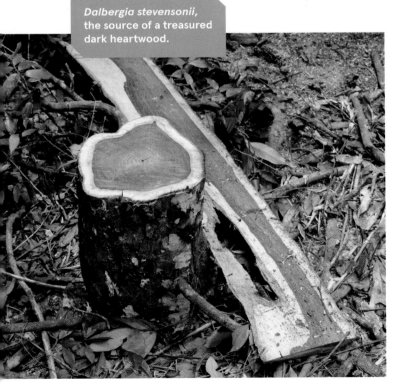

Dalbergia stevensonii, the source of a treasured dark heartwood.

African blackwood produces extremely dark and dense heartwood. It is close-grained and naturally oily and is widely considered by craftspeople to be the finest of all timbers for turning. It can be cut very precisely and finished to a brilliantly polished lustrous surface. African blackwood is the favoured timber of the Makonde people of southern Tanzania and northern Mozambique, traditionally used for their magnificent ceremonial carvings. According to Makonde legend, the first man carved a female figure out of wood. The figure came to life and bore many children. When she died, she became the venerated ancestress of the Makonde. Originally blackwood carvings were made only for local use; now they are an important export industry, mainly sold through Kenya. Most carvings produced within Kenya are actually now made from other woods, sometimes stained to resemble African blackwood, because mpingo

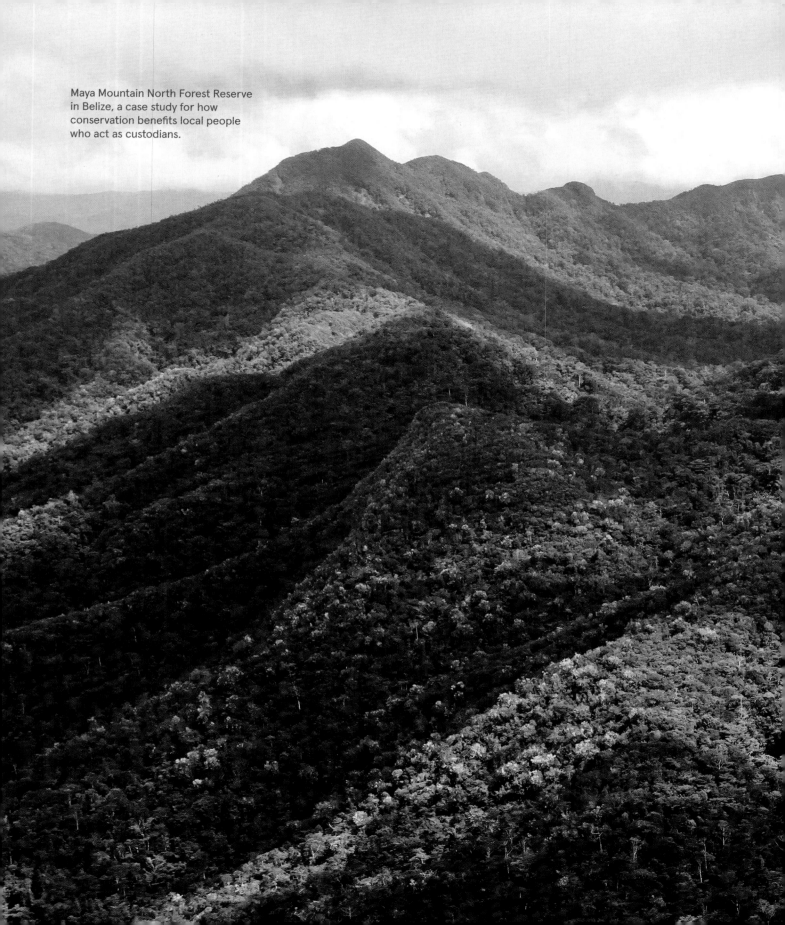

Maya Mountain North Forest Reserve in Belize, a case study for how conservation benefits local people who act as custodians.

A Makonde Tree of Life (Ujamaa) sculpture.

has become commercially extinct in the country. But carvings in Mozambique and Tanzania are still largely made from *Dalbergia melanoxylon*. The Mwenge wood carvers market is a popular destination for tourists and art lovers in Dar es Salaam.

The wood of African blackwood is so hard that it can blunt axes. This has limited its local use for general purposes, although it is sometimes used to make hoes, combs, and other household implements. The tree is rarely cut for firewood. Charcoal can be made from African blackwood, but the species is not usually preferred, as it burns too intensely and frequently damages cooking pots. Roots are used for traditional medicine to treat various ailments, and the smoke is inhaled to treat headaches and bronchitis. The pods and leaves of the tree are used as animal fodder. Because it is so hard to fell trees of African blackwood, other tree species are preferentially used for most local purposes. The result is that African blackwood trees have been left standing in plots otherwise cleared for farming. But increasing international demand is leading to all the blackwood trees being harvested.

External pressures on *Dalbergia melanoxylon* have arisen because of the great value of its wood on the international market. The best-quality timber can sell for up to US$20,000 per cubic metre, double the price of mahogany and teak. For over a century, the single most important export market for African blackwood timber was manufacturers of musical instruments, mainly the makers of woodwind instruments, particularly clarinets. Bagpipes, flutes, and, in lesser amounts, guitars and other instruments (or their parts) also used this iconic timber—around 100,000 clarinets and oboes each year were produced from the best-quality African blackwood as recently as 30 years ago. African blackwood sets the standard for woods considered suitable for woodwinds. The wood needs to be flawlesss, even-grained, and capable of being worked to very fine tolerances. It must also resist the stresses of musical instrument use. When blown into, the air inside the instrument changes in humidity and temperature, creating stresses between the inside and the outside of the instrument, which can lead to distortion or splitting at points of weakness, such as between the keyholes. The dense, close-grained nature of African blackwood and its natural oiliness ensure that it meets these criteria better than any other known timber. Only a few trees are large and straight enough to yield a piece of heartwood of sufficient quality for the production of a clarinet. This contrasts with the skilled Makonde carvers, who can incorporate the natural twists and turns of the wood into their works of art.

Did you know?

Dalbergia melanoxylon provides much of the wood used to make high-quality clarinets, oboes, flutes, and bagpipes.

In addition to its use for musical instruments, African blackwood is also sold internationally for use by specialist craftspeople, both amateur and professional, who make jewellery boxes and other small items and for turnery and inlay work. Until the mid-1970s there was a major market for African blackwood in Japan for the production of sorobans—the traditional Japanese abacus used for financial calculations in shops and elsewhere. It has been estimated that 1000 tonnes of roundwood logs were imported annually by Japan to meet this demand. The introduction of electronic calculators led to the collapse of this market.

Now, China is a major importer of African blackwood, which is listed as one of the highly sought-after hongmu timbers. Traditionally, only royalty and elites in China were privileged to own hongmu, with wood imported from India and Southeast Asia. But over the past 20 years, China's growing middle class has driven up demand for hongmu furniture in the style of the Ming dynasty, resulting in the sector's reaching industrial scales. Rapid growth has created a poorly regulated market and placed intense pressure on African blackwood and other *Dalbergia* species around the world. Now timber from *Dalbergia* species, often traded

Traditionally, woodwind instruments are made from *Dalbergia melanoxylon*.

A 17th-century hongmu
(blackwood) chair.

as rosewood, is the world's most trafficked wildlife product, with a trade value higher than elephant ivory, rhino horn, and tiger parts combined. Timber exports from Mozambique to China have risen substantially over recent years, with 10 percent of them consisting of *D. melanoxylon*. The international demand for African blackwood timber has shifted dramatically from musical instrument manufacture, mainly based in Europe and the US, to the production of furniture in China. Discrepancies between licensed exports from Mozambique and data from Chinese customs indicate that nearly 50 percent of exports to China are unlicensed and therefore illegal.

In the early 1990s, FFI became concerned about the fate of *Dalbergia melanoxylon*. A regional meeting was organised in Maputo, Mozambique, to formulate a sustainable trade plan for the species; this laid the framework for significantly improved local management. Later work by FFI led to a report, *International Trade in African Blackwood*, which emphasised the need for local communities to be fully involved in management of the timber. Workshops were held in Tanzania and Mozambique, the two main countries with commercial stocks of African blackwood, to promote sustainable management and consider the potential for certification of the production of the timber by the Forest Stewardship Council (FSC).

Developing community forestry management for African blackwood and other local timber species involved careful consultation with the villagers. Each village is required to reserve a part of their lands as a Village Land Forest Reserve (VLFR) and to develop a Village Forest Management Plan (VFMP). Under Tanzanian law, control and ownership of all the forest resources within the VLFR is then devolved to the village government. Village communities are allowed to harvest and sell timber and other forest products from their designated land and are exempt from government taxes on the forest products. The villagers are also entitled to patrol their land and, if necessary, to arrest and fine offenders. As of October 2019, 407,258 hectares of forests in 41 villages

is under community protection, with 32 percent of village land set aside by communities for forest conservation. More than 200 forest stewards have been trained.

Other *Dalbergia* species are highly threatened in the wild, with demand for hongmu furniture being the major threat. Illegal logging of *Dalbergia* species has been particularly intense in Madagascar. Trade in the timber remains poorly regulated despite CITES listing and is threatening the survival of many individual species that remain poorly known botanically. Illegal logging of Madagascar's precious timbers, a major problem for around 20 years, has increased over the past decade as a result of political turbulence. This has resulted in unprecedented levels of illegal timber felling in protected areas, particularly in the northeast of the island. Recently 90 percent of the Madagascan species of *Dalbergia* were assessed as threatened, with two species considered critically endangered and five categorised as endangered. There is an urgent need to increase capacity within Madagascar to both manage forests sustainably and regulate the trade.

Dalbergia species are also in trouble in Central America; at a meeting in Costa Rica in March 2019, 18 of the region's 19 *Dalbergia* species were assessed as threatened. Six of these are particularly valued for their attractive timber, with dramatic declines in species population size as a consequence.

Dalbergia retusa (cocobolo) is a large tree native to dry forests of Central America. It is widespread but increasingly scarce across its range, mainly because of overharvesting. The tropical dry forest habitat of cocobolo has also been severely reduced in extent through conversion for cattle-ranching, agriculture, and other uses. International trade for rosewood timber has contributed to this species' becoming commercially extinct in Costa Rica and other areas. In the Darién province of Panama, illegal poaching of the trees is out of control, with many people moving to the area to loot the species. In Guatemala and El Salvador, illegal exploitation is a major problem, with even the roots harvested for their valuable hardwood. Like African blackwood, cocobolo has been used traditionally to make musical instruments, but the main demand is now for hongmu furniture. The dense and highly prized heartwood is said to be the heaviest and darkest of all the *Dalbergia* species. This species is critically endangered, with a 90 percent decline in the size of its population.

Dalbergia stevensonii (Honduras rosewood) is another large tree species experiencing a rapid decline; it too is critically endangered. Its timber—hard, heavy, durable, and resonant—has been highly valued in

international trade for use in musical instrument manufacture. Honduras rosewood has been used to produce the bars of marimbas and xylophones, as well as, to a lesser extent, fine furniture, cutlery handles, and brush backs. Demand from China is now the major threat. More than half of Belize's mature Honduras rosewood trees were harvested following a surge in logging activity in 2008. In 2012, FFI catalysed the Belizean government to place a moratorium on rosewood logging; and in 2017 to amend the Belize Forests Act to increase penalties for the harvesting of rosewood (and five other threatened species) from within protected areas, providing a stronger deterrent to potential loggers.

Dalbergia stevensonii is restricted to the broadleaved evergreen swamp forests of southern Belize and neighbouring regions of Guatemala and Mexico, where it occurs in a limited area. FFI, through a Global Trees Campaign project, is working with a local partner, the Ya'axché Conservation Trust, to improve the conservation status of Honduras rosewood and a range of other tree species in Belize. Ya'axché is directly protecting 61,000 hectares of forest through the management of Golden Stream Corridor Preserve, co-management of Maya Mountain North Forest Reserve, where Ya'axché works with the Belize Forest Department, a local community group, and local farmers. Following the establishment of new patrol routes in protected areas, rosewood logging incidences have ceased. Outside the protected areas, illegal logging is still a common occurrence, and threats from slash-and-burn farming are being reduced by supporting local farmers to adopt agroforestry and other more sustainable land practices. Local communities in eight villages are helping to support Honduras rosewood conservation by collecting seed for growing the species within their agroforestry plots. As with African blackwood, it is important to ensure that conservation of Honduras rosewood also benefits the local people, who are the custodians of the forest and its biodiversity.

In Africa, the work of the Mpingo Conservation & Development Initiative provides useful lessons for tree conservation around the world. Steve Ball, FSC's Deputy Regional Director for Africa, writes:

> Communities do not work for free. Unfortunately tropical timber has gotten a bad name with western consumers, but if we abandon it for alternatives (such as plastic clarinets) then we remove value from those forests remaining as forest, increasing the likelihood and rate of clearance. Because of that bad reputation, many businesses using tropical

timber would prefer to hide that fact than to promote the positive benefits that can be had from engaging constructively with their supply chains. Western timber markets remain highly conservative in which species they will choose to use, often for no better reason than wariness of the unknown. Promoting lesser known timber species, especially those from tropical forests, is thus a key challenge for sustainable use and management of threatened forests across the tropics. . . . African blackwood has been a flagship species for a much broader initiative that is conserving rare and endangered biodiversity across a wide range of taxonomic groups.

The need for action is urgent. *Dalbergia* species will become extinct unless more support is given for their conservation. Governments, forestry departments, local communities, conservation NGOs, musicians, and consumers all need to play their part.

Fruit of the gods— and ebony, too

Diospyros
PERSIMMON

Altogether there are over 700 described species of *Diospyros* (from the Greek, "fruit of the gods"), mainly growing in tropical parts of the world. Three temperate species are grown for their edible fruit. *Diospyros kaki* (persimmon) is a deciduous tree similar in shape to an apple tree. It has hard, oval leaves and separate pink male and creamy yellow female flowers. The persimmon is an important fruit in its native China, where the tree has been cultivated for around 3000 years. It is also used medicinally in China and other parts of Asia. Persimmon was introduced into Europe in the 17th century. Now it is grown commercially in Spain, Israel, Brazil, Republic of Korea, and the US. Fruits are eaten fresh or cooked and are sometimes used in ice creams and jams.

Diospyros virginiana (American persimmon) is a slow-growing, deciduous tree native to the eastern US, where it grows along roadsides and in woods, thickets, and abandoned fields. It is sometimes grown as an ornamental but is generally more appreciated for its fruit. The oval leaves are glossy, and the tree produces fragrant, bell-shaped, creamy yellow

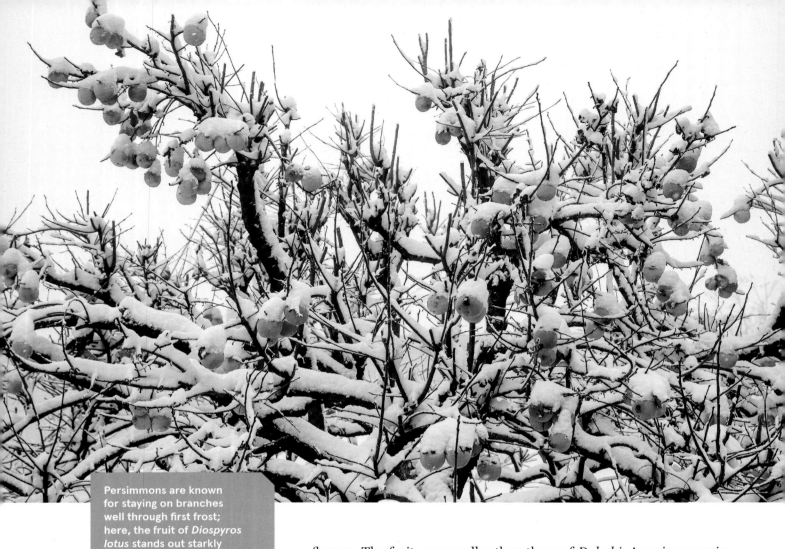

Persimmons are known for staying on branches well through first frost; here, the fruit of *Diospyros lotus* stands out starkly against an early snowfall.

flowers. The fruits are smaller than those of *D. kaki*. American persimmon fruits were eaten by Native Americans and early settlers. They are still harvested from the wild and eaten fresh or used in cakes, puddings, and drinks. The hard, smooth wood is also used.

A third fruit species, *Diospyros lotus* (Caucasian persimmon, date plum), has a very wide natural range, from Turkey and the Caucasus to China, DPR Korea, and Republic of Korea. It is cultivated for its fruit, which is sold fresh or dried (when it is said to taste like dates).

Above all, *Diospyros* species are valued as the source of ebony, an iconic internationally traded precious hardwood that is, however, notoriously heavy, difficult to work, and prone to cracking if not dried with care. As a result, ebony is rarely used in large pieces. Instead, the species tend to be used for smaller items (billiard cues, knife handles, fine carvings), as furniture inlay, and for musical instruments, such as piano keys. Makers of stringed instruments use ebony for fingerboards or chinrests, as

the wood is particularly resistant to wear; on guitars, ebony is capable of holding metal frets in place over time.

Despite these rather limited uses, its exotic black colour has made ebony a coveted wood in international trade for centuries and one that is seriously overexploited in many regions. Various *Diospyros* species are considered hongmu timbers in China, which means they are highly valued and eagerly sought-after for trade. The main commercial timber is *D. ebenum*, a hongmu species native to India and Sri Lanka. Centuries of exploitation for the jet black ebony it produces have reduced stocks in the wild, and this species is now listed as nationally endangered in Sri Lanka. Another celebrated species, *D. celebica*, is endemic to Indonesia, where it grows only in the rapidly declining forests of Sulawesi. *Diospyros celebica* produces a very attractive black ebony wood that is streaked with fine brown stripes. It has been considered Indonesia's most valuable timber, but now stocks are heavily depleted. This species listed as vulnerable by IUCN.

Efforts are underway to assess the conservation status of all *Diospyros* species. The task is complex, as the taxonomy and nomenclature of the genus is confused and many new species are awaiting formal description. George Schatz, a tropical botanist at Missouri Botanical Garden, is coordinating the project—and he is well aware of the progress and pitfalls. One of the species assessed with his help is *D. crassiflora*, the main source of African ebony. *Diospyros crassiflora* is a tall tree with a wide distribution in the African rainforest, from Benin province in southern Nigeria to southernmost Gabon and eastward into the Congo. The trees are harvested for their dark heartwood, west African ebony. Cameroon is the largest exporter of west African ebony, harvesting about 1200 trees each year. The wood has been overexploited in the past. Now the market for ebony is relatively small, mainly to supply guitar and violin manufacturers, and harvesting is no longer the most severe long-term threat. Conversion of the forest for agriculture and grazing and logging of the forest for other commercial timbers are the main reasons for the decline of *D. crassiflora*. Local people still value west African ebony for their own use. The flexible wood of young trees is used in the Republic of Congo to make crossbows. The leaves and bark of the tree are used medicinally to treat a range of ailments.

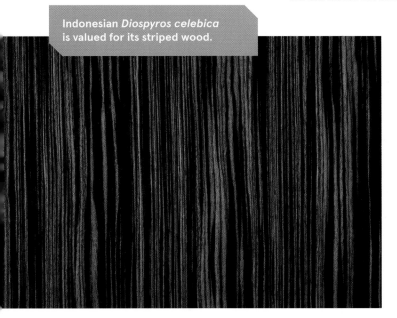

Indonesian *Diospyros celebica* is valued for its striped wood.

An innovative restoration programme has been developed for *Diospyros crassiflora*. The Ebony Project, funded by California-based Taylor Guitars, was established in 2016, with an initial goal of planting 15,000 trees in rural communities in Cameroon. The programme is conducted by the Congo Basin Institute, which works to find solutions to some of the many challenges of this globally important area of tropical rainforest and the people who live there. Ultimately the Ebony Project is looking to develop a scalable community-based restoration model.

Original scientific research under this project is advancing our understanding of the life cycle of *Diospyros crassiflora*, including identification of the insects that pollinate its flowers and mammals that distribute the seeds across the forest floor. At the same time the project is developing propagation methods via seed, cuttings, and tissue culture. Crucial to the initiative is the engagement of local communities who are dependent on forest resources for their livelihood. Native fruit and medicinal trees are provided to participating communities for their own use. The project has attracted widespread attention and is considered a model for practical action, linking livelihoods with forest restoration. Another result: Taylor Guitars has broken centuries of tradition by utilising variegated or marble-coloured ebony for its instrument fingerboards. Jet black ebony had been the accepted standard in the music industry, yet not all ebony found in nature is uniformly black, and there is no practical way of knowing a tree's colour before cutting it.

Madagascar is another source of ebony timber, and the level of exploitation on the island is now a major conservation concern. One species, *Diospyros perrieri*, has long been felled in the dry forests of western Madagascar and exported to Europe. Now there is more widespread and often illegal felling of all ebony species on the island that grow to timber size. All but three of the 91 *Diospyros* species currently recognised in Madagascar are endemic to the country. Recent work by George Schatz and his colleague Pete Lowry has revealed that there are around 165 additional *Diospyros* species growing in Madagascar that are new to science. These need to be formally described and named. Many of the as-yet-unnamed species have been regularly confused with published species, and so it is virtually impossible to track the felling or export of Madagascan ebonies to species level. George explains that, as with *Dalbergia* trees in Madagascar, the names used in published sources and unpublished reports are frequently incorrect and cannot be verified. About 90 of the *Diospyros* species that grow in Madagascar are large enough trees to produce exploitable quantities of ebony wood. Large ebonies are being cut

Ile aux Aigrettes, off the coast of Mauritius in the Indian Ocean, functions as a valuable nature reserve and is home to the endemic *Diospyros egrettarum*.

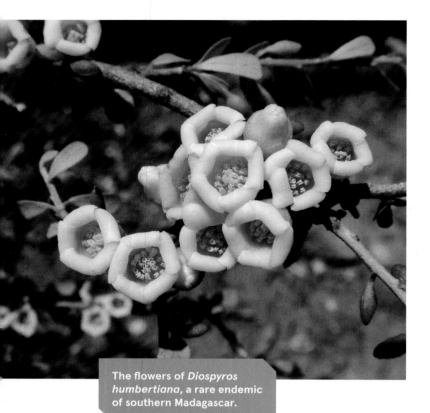

The flowers of *Diospyros humbertiana*, a rare endemic of southern Madagascar.

locally wherever they occur, regardless of whether they produce the desirable black heartwood. The wood is extremely hard and durable and can be used in basic house and furniture construction, despite the cracking and warping, and it is very good fire wood: George recalls that even when it was pouring down rain on the Masoala peninsula, their guides were able to build fires by finding recently fallen dead branches of ebonies.

The island of Mauritius also has endemic *Diospyros* species. One of these, *D. hemiteles*, had been described as the world's loneliest ebony, known only from a single male tree. Fortunately, thanks to the work of Alex Linan and other botanists at the Missouri Botanical Garden, around 50 mature individuals are now known.

Another ebony endemic to Mauritius is *Diospyros egrettarum*, which grows to 5 metres in height. Fewer than 10 individuals remain on the mainland, but a nearby coral island, Ile aux Aigrettes, boasts a larger population. The tree is considered critically endangered on the IUCN Red List. It is found in five botanic garden ex situ collections worldwide. Ile aux Aigrettes has been a nature reserve since 1965, which is helping to protect this species. Like many ebonies, it has been heavily extracted for timber. A ban on logging is now in place. Positive progress on Ile aux Aigrettes has been made to eradicate exotic plants and rats, improving the survival of *D. egrettarum*. Though threatened by invasive exotic plant species, it is also limited by seed dispersal, preventing the forest from expanding. This species relied on animals long extinct, such as the giant tortoise, to disperse its large seeds. Recent efforts to improve the conservation status of this species include the successful introduction of Aldabra giant tortoises to replace their extinct counterparts.

Ironwood indeed, strong enough to protect against tigers and elephants

Eusideroxylon zwageri

BELIAN, BORNEAN IRONWOOD

Eusideroxylon zwageri, a highly valued slow-growing timber tree found in Indonesia, Malaysia, and the Philippines, may live up to 1000 years and reach a height of 50 metres. It is a member of the Lauraceae, a family that includes the avocado, bay laurel, and cinnamon tree. Belian trees grow in lowland primary and secondary forest, often along riverbanks; they have large glossy leaves and when mature produce large fruits, each with a single seed up to 30 centimetres in length. The fruits, although poisonous to humans, are used as a source of medicine. The fruits are also an important food for foraging animals. Natural seed dispersers are rhinos and other large mammals that are now extinct or extremely rare. The belian tree is an important refuge for orangutans that shelter and sleep in its branches.

Belian produces one of the hardest and most durable timbers in the world, with resistance to attack from bacteria, fungi, and termites. It is one of the few timbers that does not float on water. After centuries of commercial exploitation, this valuable tree species is now considered to be vulnerable on a global scale. Some legal protection is in place for belian, with exports generally banned by the government of Indonesia and state government of Sarawak, where it is the official state tree, but illegal logging continues to take its toll. Belian is important commercially, socially, and ecologically. As with many tree species, management of the tree resource, to satisfy all needs, is complex.

Traditionally, communal longhouses in areas with belian were built on stilts made from this wood because of its hardness and durability. The former head-hunting Ono Niha people, from Nias island off the west coast of Sumatra, created a traditional house style for their village chiefs in the village centre. These were built on massive ironwood piles and had towering steeply pitched roofs; they were designed to be impregnable to attack (sole access to each of the chiefs' houses was through a narrow staircase with a small trapdoor

The leaves of
Eusideroxylon zwageri.

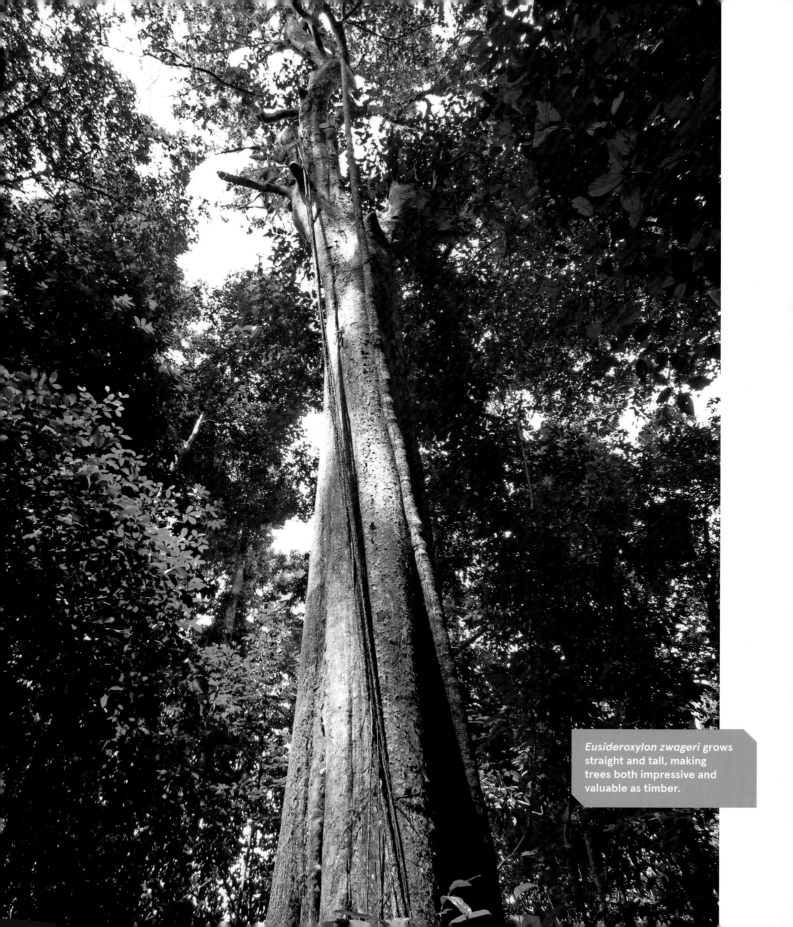

Eusideroxylon zwageri grows straight and tall, making trees both impressive and valuable as timber.

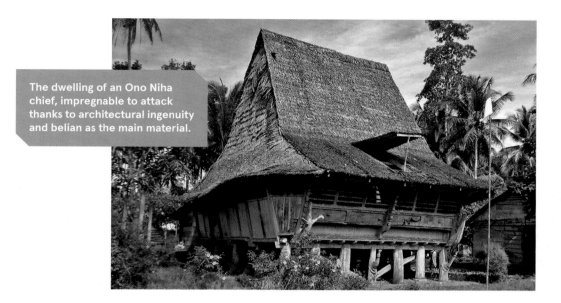

The dwelling of an Ono Niha chief, impregnable to attack thanks to architectural ingenuity and belian as the main material.

above) and proved to also be resistant to earthquakes. Alas, over time these magnificent structures have fallen into disrepair.

Borneo's Dayak people believe the tree protects them from dangerous animals and that its existence alone explains why there are no tigers or elephants on the island. Dayak communities also used ironwood for constructing their homes and for a host of different products, including the poles for spears, blowpipes, roofing tiles, household utensils, and ritual statues. Ironwood charcoal is considered to produce the best ink for Dayak tattoos. In many villages, customary law developed to control exploitation of this sacred species. However, over time the Dayaks' alienation from their former forest land (the result of plantation development, timber company licences, and even the creation of protected areas) has further reduced the availability and accessibility of ironwood. Nevertheless ironwood remains important in Dayak culture.

The Berawan people of Sarawak are the only native community accorded fishing rights in Sarawak's largest natural lake within Loagan Bunut National Park. Belian is traditionally very important to the Berawan for use in burial ceremonies. During secondary burials performed for tribal leaders in ancient days, the remains of the deceased were left on a platform on the top of two poles, or *lejeng*, made from belian tree trunks. Examples of the elaborately carved trunks can still be seen in Loagan Bunut National Park, rising out of the waters of the seasonal lake. It is taboo to touch or disturb these poles. Violators are expected to

(↑) Belian is used in a variety of ritual carvings.

(→) Traditional longhouses were built of durable belian.

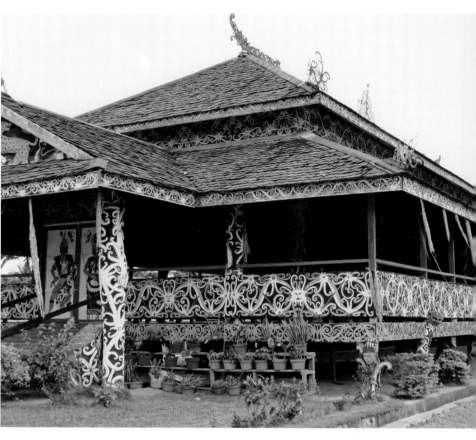

offer a pig as sacrifice or provide material donations to the family of the deceased as compensation. The rarity of belian caused by logging and expansion of palm oil plantations outside the national park territory has had an impact on its use as well as on the skills and traditional knowledge of the Berawan people. Although younger people have lost most of the traditional knowledge of belian, they still consider the tree "important and irreplaceable."

Belian is one of the natural products exported from Borneo for centuries under the influence of ruling sultans and Chinese traders. European traders became involved in the trade in the 16th century. The Dutch colonised Indonesia in 1619, establishing Batavia on the island of Java as the capital of the Dutch East Indies. Gradually the Dutch took control of Java and Sumatra, but the powerful Bugis, originally from Sulawesi, maintained control of trade with the coastal towns of Kalimantan throughout the 18th century. The trade of ironwood timber was determined by the presence of

the Bugis on both Kalimantan and Sumatra. The Dutch became interested in acquiring slow-growing belian for use in heavy construction of wharfs, government buildings, and boats. Taxes demanded by the sultan and colonial powers often included deliveries of this valuable timber. The Dutch attempted to secure ironwood by making up-river Dayak pay taxes in the form of ironwood rafts.

Toward the end of the 19th century, the export of belian to China increased significantly as a result of that country's expansion of railway networks, which raised the demand for ironwood sleepers. The valuable timber was cut by indigenous people and Chinese workers and hauled by the same men (or buffaloes) to the rivers, where it was rafted to Sandakan Bay to be exported. Berau was another important port in northeastern Borneo in the early 1900s, with British, Dutch, and other ships carrying cargo of belian, rattan, gold, bird's nests, and reptile skins. The various territories of Borneo gradually established official forest services to study and map the rich forest resource and to encourage more harvesting of timber for export.

Recently in East Kalimantan, Indonesia, ironwood trees have been cut in order to fulfill the demands not only of traditional use but also of modern processing. The timber continues to be commonly used for the foundations and frame-structure of local houses and for large constructions, such as bridges, quays, and boats. Ironwood is also esteemed by the Chinese for the production of coffins. Producers of ironwood timber can be found throughout Kalimantan, with felling of belian still usually done by hand. Ironwood for construction can be bought at most building material stores throughout Kalimantan.

Local values and customary law may yet protect this majestic tree. In Ketapang, Kalimantan, FFI is helping communities gain management rights for their forests, including such species as *Eusideroxylon zwageri*. At a national level, FFI has convened a forum of more than 30 Indonesian tree conservation experts, from NGOs, botanic gardens, and research institutes, who have focused on identifying priority species, preparing information on their conservation status, and engaging with the Ministry of Environment and Forestry to make the case for increased action. The forum has developed a National Conservation Action Plan for 12 species, including belian, adding them to the list of animal species that are priorities for funding and protection under Indonesian law.

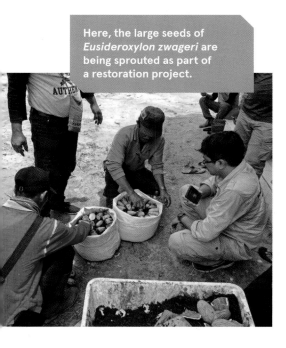

Here, the large seeds of *Eusideroxylon zwageri* are being sprouted as part of a restoration project.

Brazil's national tree

Paubrasilia echinata

PAU BRASIL, BRAZILWOOD, PERNAMBUCO

Brazil has more tree species than any other country in the world. So it is appropriate that this vast and biodiversity-rich country is named after a particularly valued tree. *Paubrasilia echinata* was once so abundant in the Mata Atlântica (Atlantic Forest) of Brazil that 16th-century traders named the country Terra do Brasil (Land of Brazilwood). Early harvesters of the tree were known as brasileiros. The tree was highly sought-after for its red sap, which was used in Europe to dye luxury textiles. In 1789, Lamarck noted that the dye could be used to colour exquisite Easter eggs and to produce rouge for women's faces. Treatments with acid produced a lacquer used to paint miniatures. The timber of this fabled species was also prized for construction, cabinetwork, and fine furniture. Since the early 1800s, the heartwood of pau brasil has been used for making bows for violins, violas, cellos, and basses.

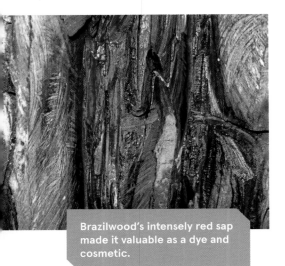

Brazilwood's intensely red sap made it valuable as a dye and cosmetic.

Paubrasilia echinata is a leguminous tree, slow-growing to about 12 metres in height, with attractive yellow flowers. In 2016, this species was placed in its own genus, with the generic name *Paubrasilia* reflecting its centuries-old common name. In the wild, this species is restricted to the Mata Atlântica of Brazil; around half the tree species growing in this global biodiversity hotspot grow nowhere else. Much of this forest has been lost after centuries of logging and the development of plantation agriculture, particularly for sugar and cotton. The pace of deforestation has accelerated dramatically since World War II, with more road building and industrialisation in the region. Trees have been cleared to produce charcoal for the country's steel mills; they have been cut down by farmers to make fields for beans and other staples and by big farming conglomerates to create pastures for beef cattle. Fast-growing *Eucalyptus* plantations have replaced some of the rich natural forests of the Mata Atlântica, and soybean production now takes up an enormous amount of land; less than 5 percent of the original extent of this forest type remains. Enormous quantities of pau brasil were

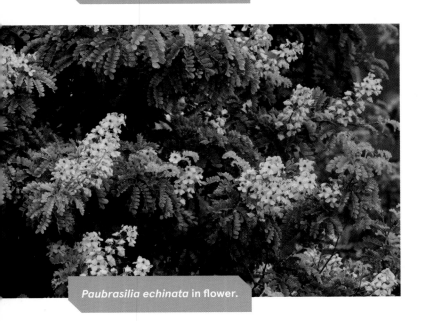

Paubrasilia echinata in flower.

A map of Brazil, circa 1519, by Portuguese cartographer Lopo Homem, showing indigenous people extracting trees, with Portuguese ships waiting to receive them.

exported between 1501 and 1850, contributing to the loss of large areas of forest and also to the enslavement of the Tupi and other local indigenous people. By the time the first synthetic aniline dyes were introduced in 1875 and the market for pau brasil collapsed, dramatic declines of the species had already taken place. Now *P. echinata* is listed as endangered on the IUCN Red List.

Conservation measures for pau brasil have almost as long a history as that of its exploitation. The first attempt to regulate trade in the wood was signed in 1605 by Philip II of Spain. This "Pernambuco Wood Proclamation" was mainly an attempt to protect the crown's monopoly, but it provided some regulation of logging and a body of guards was created to enforce the laws.

The connection between pau brasil and musical instruments brought the species to the attention of FFI's SoundWood Programme. As a consequence, an action plan for pau brasil was developed by FFI through a workshop in Brazil in 1997. Three years later a Brazilian SoundWood volunteer, Rudy Schlaepfer, successfully applied for a small grant to develop an education project for conservation within Brazil's Mata Atlântica. Rudy created a local NGO, Amainan Brasil, to deliver the project. His action was taken in response to recommendations in the FFI action plan for pau brasil calling for greater awareness and education about the valuable species. Rudy returned to Brazil to deliver environmental education workshops to communities living within remote fragments of the Mata Atlântica, initially within São Paulo state. He travelled by boat from Ubatuba to reach tiny coastal fishing villages and extended the project to Paraty in Rio de Janeiro state.

By 2003 Amainan Brasil had secured official NGO status and continued to expand its education work northward to include Cairu in Bahia state; in total the education programme involved 8000 children and 200 teachers. Within Cairu the Projeto Pau Brasil expanded, developing a nursery for pau brasil, a forest regeneration programme, a teacher training course, a grants programme for local environmental projects, and a sustainable livelihoods programme with the local community. In 2003 Amainan launched the Sons da Floresta initiative, again with support from FFI and with funding from the UK Government. This project aimed to increase investment and participation in the long-term conservation of a range of threatened tree species of Brazil used to make musical instruments. It also promoted sustainable use strategies with the music industry of Brazil through the integration of certified forest products. A Sons da Floresta Conference and exhibition was held at the MUBE (Museum of Brazilian Sculpture) in Sao Paulo in October 2003, bringing together major stakeholders in the music instrument manufacture industry. Three lines of certified instruments were developed.

At around the same time as FFI's initial support for the conservation of pau brasil, bow makers involved in the use of the species also decided to take action. In May 2000, the International Pernambuco Conservation Initiative (IPCI) was formed, representing bow makers in 10 countries. Marco Ciambelli was one of the founders of the organisation. His family had been craftspeople working with tortoiseshell in Italy and France for generations before international controls on trade in sea turtle products restricted the supply of raw material. Ciambelli was acquainted with bow makers who had used tortoiseshell in some of their finest bows. He

Did you know?

Brazil has 8847 species of trees, more than any other country in the world. But it also has the most threatened trees.

was concerned that the supply of pau brasil might also be restricted by national and international legislation and urged bowmakers to develop a conservation initiative. In 2001, after many attempts to establish a public-private partnership, IPCI representatives contacted the Comissão Executiva do Plano da Lavoura Cacaueira (CEPLAC), a Brazilian governmental institution under the auspices of the Minister of Agriculture. In 2004, following lengthy exchanges to develop a partnership, the Programa Pau Brasil (PPB) was created and a reforestation project was started in the Brazilian state of Bahia.

The principal objectives of the PPB are the preservation of the genetic diversity of pau brasil and the conservation and restoration of the species. Sustainable use is seen as an important component of the strategy. Contributions to the PPB since 2004 from the bowmaking community worldwide (about 250 bow makers) and from the violin industry have amounted to more than US$350,000. Most of these funds have come from a self-renewing funding mechanism voluntarily adopted by many makers.

Pau brasil trees can be grown quite readily and are often planted as an expression of civic pride in Brazilian towns and cities. But it is not yet clear that timber of sufficient quality is produced for bow manufacture from cultivated trees. The demand for pau brasil from natural forest remains. So far no comparable substitute material has been found with the same desired combination of durability, flexibility, and resonance.

Despite national legislative protection, there is a significant trade in *Paubrasilia echinata* for bow making. This is estimated to be worth millions of (US) dollars a year and is likely to represent significant illegal exploitation. The form of the violin bow we know was first refined by the Parisian-born François Xavier Tourte (1747–1833). Working with pau brasil, Tourte, who trained as a clockmaker, determined that the shape of the bow could be round or octagonal and specified the ideal length and weight, standardising every measurement. Producing bows is quite a wasteful process, with as much as 80 percent of the wood lost when logs are cut into bow "blanks." The same amount is lost as the blanks are carved to produce the bows. A single professional violin bow requires a kilogram of wood and can sell for well over US$5,000.

Legally and illegally, the trade in this valuable tree continues, adding further pressure on both the species and its ecosystem. Surprisingly, many aspects of the biology of *Paubrasilia echinata* and the composition and structure of the plant community in which it occurs are poorly known.

Among the most
valuable timbers
in international
commerce

Swietenia

MAHOGANY

Mahogany has provoked more interest and controversy than any other timber. It has been traded internationally since the 16th century, when stocks of Cuban mahogany (*Swietenia mahagoni*) were cut down in the Caribbean region for export to Europe. Philip II of Spain used Cuban mahogany to decorate El Escorial, his palace near Madrid, in 1584, and in the 16th century there was a royal monopoly on Cuban mahogany reserved for ship building. In the 18th century, mahogany became the timber of choice for furniture makers in England and Ireland, with timber imported first from Cuba and then Jamaica, Belize, and Honduras. Harvesting of mahogany was carried out by slaves, and the international timber trade was closely linked with the shipping of slaves and sugar between continents. Charles Dickens wrote of "old Honduras mahogany, which has grown so dark with time that it seems to have got something of a retrospective mirror-quality into itself, and to show the visitor, in the depth of its grain, through all its polish, the hue of the wretched slaves who groaned long ago under old Lancaster merchants."

Now the name mahogany is synonymous with fine antique timber, and although the deep reddish brown hardwood is less fashionable than in the past it remains a very important commodity harvested from the wild. Centuries of trade have taken their toll on the trees and the forests where they grow. Despite mahogany's importance, management of natural stocks remains generally weak on a global level.

There are three species of true mahogany, in the genus *Swietenia*, all native to the Americas, where they grow in forests from Florida to Brazil. Cuban mahogany (*S. mahagoni*) and West Pacific mahogany (*S. humilis*) from the tropical dry forests of Central America are now insignificant in international trade, as the supplies are so reduced in the wild. In the US, as in the Caribbean region, *S. mahagoni* was heavily logged in southern Florida and is now a threatened species in the state. It is commonly grown as a street tree or to provide shade. Big-leaf mahogany (*S. macrophylla*) is the main species in international trade, with the US the major importer. In addition to *Swietenia*, various other tropical hardwood species from Africa and Asia are also traded as mahogany, with timber traders making use of the traditional cachet of the name.

The library of El Escorial, decorated by Philip II of Spain with *Swietenia mahagoni.*

Swietenia macrophylla is a large deciduous tree, frequently topping 30 metres in height. Individual trees may live for several hundred years. The species has a wide geographical range, distributed from the Yucatán Peninsula of Mexico southward into western South America and extending over a crescent-shaped area across southern Amazonia. It grows naturally in both tropical dry forests and rainforests on a wide variety of soil types. Like most tropical tree species, big-leaf mahogany generally occurs at low densities within the forest, but local abundance is extremely variable.

A groundbreaking study of this species and other so-called mahogany species in trade was commissioned by FFI in 1983, a time of growing

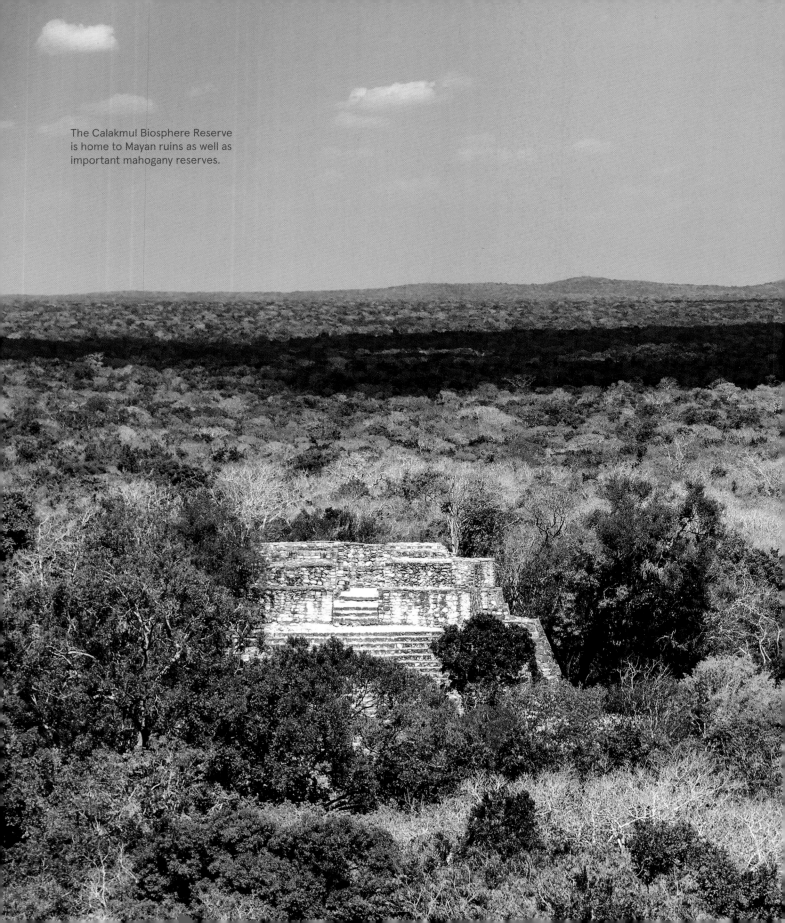

The Calakmul Biosphere Reserve is home to Mayan ruins as well as important mahogany reserves.

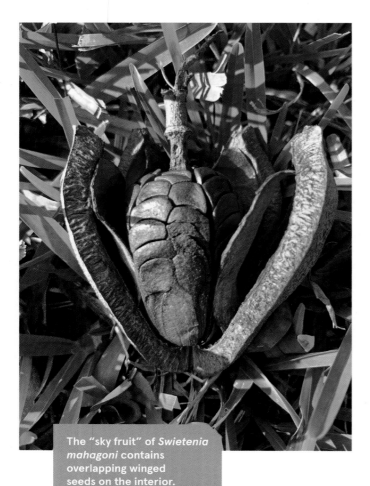

The "sky fruit" of *Swietenia mahagoni* contains overlapping winged seeds on the interior.

concern about the fate of the world's rainforests. In 1992, Friends of the Earth ran a powerful campaign, "Mahogany is Murder," encouraging consumers in the UK and US to stop buying mahogany. This followed an open letter from Brazilian agronomist Jose Lutzenberger, stating that the trade in Brazilian mahogany was out of control and most of the mahogany entering the UK was illegally extracted from Indian reserves. The campaigning strategy included protesters from Norwich "liberating" mahogany furniture from a local department store; they took the furniture to a police station and demanded that the items be investigated as stolen property belonging to the Indian people of Brazil. FOE launched a consumer boycott of mahogany, applied pressure in the retail and timber sector, and lobbied MPs for controls to be placed on mahogany imports. Passions ran high, but the idea of CITES listing for mahogany or indeed any tropical timber was considered highly controversial. Brazil introduced its own measures to restrict the mahogany trade culminating in a ban on all logging and export in 2001. This unfortunately resulted in an increase of illegal trade; mahogany was removed from conservation areas, private land, and indigenous land and exported under the trade names of other timber species. It has also, tragically, been linked with an increase in violent deaths within the remote rainforests.

Managing timber production is complex in tropical regions. Independent forest certification and chain of custody certification for timber such as those under the umbrella of the Forest Stewardship Council (FSC) is another approach to verifying the sustainability of timber production. CITES, although legally binding, arguably sets less exacting standards than those required by FSC, and the two approaches are generally considered to be broadly complementary. But will consumers pay extra costs for sustainable production?

The presence of natural regeneration will depend on the maintenance of seed trees during harvesting operations; often it is the largest trees that produce the most seed, but it is these that tend to be harvested. Mahogany is monoecious, with separate male and female flowers on the

same tree. But it is generally outcrossing—that is, pollen must be carried between trees for fertilization and seed production. This has management implications, as trees that are isolated (such as those left as seed trees after harvesting), or populations where the density of trees has been severely reduced, may fail to produce much viable seed. Seed production naturally varies from year to year. The winged seeds are relatively heavy and generally do not disperse very far from the mother trees. Seeds are viable for only a few months, not long enough for creation of a soil seed bank. Germination is stimulated by rainfall; seeds germinate in the shade of the forest canopy but often grow best when exposed to sunlight. In Central America and Mexico, the pattern of natural regeneration is thought to be linked to seasonal hurricanes. Some hold that in the Amazon basin, natural regeneration is linked to seasonal fires or floods; others argue that no such disturbance is required.

In Guatemala, in the Maya Biosphere Reserve, mahogany is sustainably harvested: nine local communities have been given the right by the national government to make a living from the forest, as long as they do so sustainably. The Rainforest Alliance has been working with these forest concessions since 1999, first to develop certification techniques, and then to develop sustainable forest enterprises to provide local livelihoods. These include harvesting and selling NTFPs, such as nuts and palm fronds for floral arrangements, in addition to extracting timber for export according to the rigorous FSC standard.

The Rainforest Alliance supports certification of mahogany production in Mexico. Researchers have found that the best conditions for development of sustainable mahogany production are in the community forestry ejidos in central and southern Quintana Roo and in the Calakmul region of Campeche. In the Yucatán Peninsula as a whole, over half the land and two-thirds of forests are managed as ejidos or comunidades agrarias under Mexico's system of communal land tenure. Community forest management covers some 7 million hectares of land. Ejidos date back to the redistribution and granting of large landholdings after the Mexican revolution and were enshrined in the country's 1917 constitution. Ejido lands are legally owned by their members, who hold shared rights for management and decision making. Comunidades agrarias are different in that they represent the formal restitution of ancestral land claims to native people, whereas ejido claims did not require prior historical occupation. The Caoba ejido, a forestry cooperative based in the state of Quintana Roo, attained FSC certification in 2013 for the sustainable harvest and processing of its mahogany, or caobo, as it is known in Mexico.

The first direct sale of certified mahogany to the European market took place in 2015, and subsequently the Rainforest Alliance linked the ejido with North American Wood Products (NAWP), a distributor of specialty wood items, based in Oregon. The community now sells its certified wood to the lucrative market for musical instruments, earning up to four times the local price for mahogany.

The Caobo ejido is located next to the 1.73-million-acre Calakmul Biosphere Reserve, which has good reserves of mahogany (together with cedrela and chicle trees) and provides habitat to a wide variety of animals, including jaguars, tapirs, and howler monkeys, and more than 200 bird species. The reserve is also home to ancient Mayan ruins that date back to 364 CE. As ranching, tourism development, and other activities encroach on the region's remaining natural areas, the certified mahogany forests serve as a wildlife corridor and play a vital role in protecting the local water supply and mitigating climate change.

In general the livelihoods of the Yucatán Peninsula's ejidos and indigenous communities are interwoven with the forest, which besides timber provides food, firewood, medicinal herbs, and spiritual resources. The traditional land management system includes farming of several varieties of maize, beans, squash, and other vegetables, integration of fruit trees into fallow forest, beekeeping, and maintenance of forest corridors for hunting, wood, and conservation of native species. Up to 500 species of animals and plants are traditionally used by Maya communities of the Yucatán Peninsula.

The long-term conservation of big-leaf mahogany will depend on having populations maintained in well-managed protected areas and sustainable management of forests that are used for timber production. At the same time, there are large numbers of mahogany trees remaining outside forests in areas that are now pastureland; landscape level conservation is needed for these areas. There is currently little likelihood of *Swietenia macrophylla* facing extinction on a global scale, but a lot of work is needed to ensure that the ecological and livelihood benefits of this important species are recognised and maximised throughout its range. No other tropical tree species has been so intensively studied.

FRUIT AND NUT TREES

Besides providing us with wood, an essential resource for our buildings and energy supplies, trees are also an important source of food around the world, serving up delicious fruits, nuts, berries, cocoa, coffee, olive oil, and spices. We actually rely on an amazingly small number of plants for our daily food. Around 5000 species are utilised as edible plants, of which about 30 are commonly grown crops; of these, citrus fruit trees are the most widely grown fruit crop. A surprising number of food products are still sourced from the wild for local use and for international trade. Many more wild trees have the potential to provide new kinds of food, and the wild relatives of tree species grown for food are of great value for crop improvement. As people increasingly turn to vegetarian and vegan diets, perhaps we will delve even further into the natural food supplies provided by trees. At the same time, we need to ensure that forest ecosystems are well managed, so that they continue to supply natural forest products and act as a reservoir of genetic resources for the future. Equally important is to manage forests sustainably, so that they can continue to help regulate water supplies, prevent soil erosion, and support the pollinators on which agricultural production depends worldwide.

Over a year from pollination to maturity

Bertholletia excelsa
BRAZIL NUT

The Brazil nut, one of many valuable rainforest products, is collected and traded around the world, providing a source of income for local people. Brazil nuts are produced by *Bertholletia excelsa*. Some magnificent specimens of this species, which routinely reaches 60 metres in height, are believed to be 1500 years old. High up in the forest canopy are the tree's leathery, wavy-margined leaves and large, creamy white flowers, each with six fleshy petals. Flowers of the Brazil nut tree are pollinated by large bees, especially those of the tribe Euglossini, which are strong enough to force open the hooded flowers to extract nectar. Euglossine bees in turn rely on flowers of *Stanhopea* and *Catasetum* orchids in order to sustain their populations. To reproduce successfully, male bees visit the orchids to gather fragrant chemicals, which attract the female bees. Without

these orchid fragrances, euglossine bee mating does not take place, and pollination of Brazil nut trees would be much reduced.

Following pollination, the fruit of the Brazil nut tree takes over a year to mature. Each fruit is a large, round capsule with a bark-like appearance containing 12–25 tightly packed seeds. The seeds or nuts are angular, with a hard, woody outer coat and a thin, brown testa or seed coat. The inner white kernel is the familiar edible nut. In the wild, the fruits of Brazil nut trees are split open by animals, allowing the seeds to be released. Usually it is the large rodents known as agoutis (*Dasyprocta* spp.) that gnaw open the fruits once they have fallen to the ground. Other animals, such as squirrels and the paca (*Cuniculus paca*), a relative of the agouti, also extract seeds from the fruits. Monkeys and macaws open the immature fruits when they are still on the tree. Agoutis bury the Brazil nut seeds as a means of storing their food. It is thought that most seedlings germinate from seeds that have been "planted" by agoutis in this way. Agoutis often take the Brazil nut seeds from areas of relatively undisturbed forest to old pastures and disturbed areas. Slash-and-burn farming actually seems to enhance regeneration of the Brazil nut tree by creating gaps in which light-demanding seedlings of the tree can flourish.

Some aspects of the Brazil nut tree's ecology remain unclear. It is thought that many Brazil nut groves were planted by indigenous hunter-gatherer communities, who have lived in the Amazon for over 30,000 years. Some indigenous people, such as the Kayapo of the Brazilian Amazon, continue to produce Brazil nut seedlings in the same way as their ancestors. But the complex ecology of *Bertholletia excelsa* means that commercial plantations have not generally been developed for the species, and most Brazil nuts eaten by people around the world are collected from the rainforest. An important dietary item of the indigenous Indian and local populations, the Brazil nut has been traded with communities in the Andes for centuries. Some Brazil nuts were exported to Europe in colonial times, but the trade expanded considerably after the collapse of the Amazonian rubber trade in the 1920s. The capsules from which the nuts are extracted make useful containers and are sometimes used to collect latex from rubber trees. The Brazil nut tree also produces a fine timber used for ship building, but felling is now illegal in Bolivia, Brazil, and Peru, and the main commercial value lies in the nuts.

The forest areas where Brazil nuts are collected are owned and managed in different ways. In Peru, land where Brazil nuts are collected is divided into small concessions managed by individual families. The current system of Brazil nut concessions, which covers 995,600 hectares,

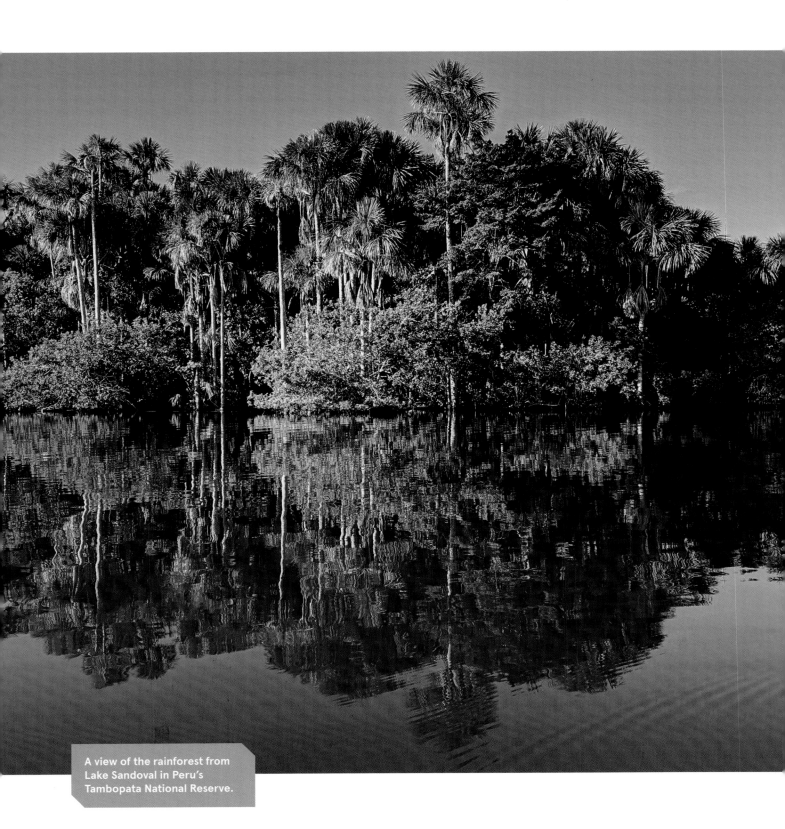

A view of the rainforest from Lake Sandoval in Peru's Tambopata National Reserve.

Rubber

Hevea brasiliensis (rubber) is another valuable tree species native to the Amazon. During the latter part of the 19th century, the international demand for rubber tapped from native trees was huge—in part to support the new craze for bicycles. By the 1920s, rubber plantations in Malaysia and other parts of Southeast Asia, based on rubber seeds smuggled out of Brazil, were so well established that the demand for Amazonian supplies fell dramatically. Nevertheless, rubber tappers continued to make a living in the Amazon forests, supplementing their income by collecting Brazil nuts. Rubber was tapped from April to October; the remaining months of the year were used for collecting Brazil nuts and small-scale farming. This annual agro-extractive cycle of rubber tapping, Brazil nut collection, and subsistence agriculture allowed rubber tappers and their families to stay in the forest throughout the year. The system began to break down as rubber prices decreased in the late 1980s and demand for land for cattle ranching increased, causing rubber tappers to move away from the forest to the cities.

Brazil's National Council of Rubber Tappers (CNS) first proposed the creation of a series of "extractive reserves" in 1985, beginning with areas in two of the states most threatened by deforestation: Rondônia and Acre. At the time Brazil had around 68,000 rubber tapper families who lived very tough lives, often under a form of debt peonage or coerced labour. In contrast to most other Amazonian developments, the extractive reserve proposal originated at the grassroots level under the leadership of Chico Mendes. A rubber tapper, environmentalist, and lands right activist, Mendes successfully campaigned for the social rights of people who were being forced from their land by cattle ranchers in the state of Acre and beyond. Just months before his murder in December 1988, provisions for extractive reserves were included in Brazil's new constitution, which took effect on 5 October of that year. The same constitution recognised the rights of indigenous people to maintain their traditional cultures permanently. The first extractive reserve, Alto Juruá, was created in Acre in 1990, followed soon after by the Chico Mendes Extractive Reserve.

It remains challenging to sustain livelihoods by the sale of Brazil nuts and wild rubber alone. The Chico Mendes Extractive Reserve provides an important case study for understanding the dynamics of agricultural frontiers and the impact of sustainable resource use strategies and incentives. The main forest products extracted in the reserve are Brazil nuts and rubber latex. Sixty percent of the families extract Brazil nuts. What started as localized rubber tapper movements in dispersed areas of the Amazon has become a Pan-Amazonian social movement of diverse groups, working together to maintain traditional livelihood strategies that depend upon access to threatened natural resources.

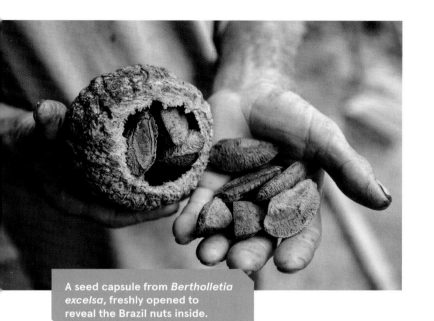

A seed capsule from *Bertholletia excelsa*, freshly opened to reveal the Brazil nuts inside.

was established in 2000 by Peruvian law; it's designed to protect traditional collecting rights. Within the country, the Amazon Conservation Association has worked to protect nearly 2 million acres of rainforest over the past 20 years through the establishment of some 475 Brazil nut concessions. Some of these have benefitted from FSC and organic certification, helping to ensure better prices for the nuts. Indigenous communities along the Tambopata National Reserve buffer zone are involved in the scheme. Research in these concessions has amassed one of the largest Brazil nut databases in existence: data on the age, size, productivity, health, and locations of 84,740 individual trees.

In Brazil, the castanheiros (as the Brazil nut collectors are known) also gather their harvest from land managed in various different ways. Castanheiros traditionally led a very hard life, with insecure livelihoods, often relying on other work such as gold mining or cutting timber for large landowners. Even today, during the early part of the rainy season, the nut collectors live in makeshift huts in the forest, collecting the fallen capsules and opening them with machetes.

The past 30 years have seen major advances in conserving and managing the Amazon forest and its resources—including the Brazil nut tree. But the gains are fragile. The reversal of environmental policies in Brazil under the present administration shows how easy it is to lose environmental gains. Fires have raged out of control, and it is feared that a tipping point will soon be reached, with increasingly hot and dry conditions halting the regeneration of trees in the Amazon. General deforestation (caused by logging, cattle ranching, soybean and cotton production, and mining) was considered the main threat to *Bertholletia excelsa* when it was listed as vulnerable on the IUCN Red List in 1998. A reassessment is needed, recognising any conservation gains as well as increasing threats, chief among them climate change. Collection of nuts for industrial and food purposes is generally sustainable and beneficial but has restricted the recruitment of new individuals at local level. As well as management of the collection of nuts in extractive reserves, conservation in other forms of protected areas is also required. Ex situ conservation of this species in seed banks has not yet proved successful, as the seeds cannot be dried and frozen.

Edible nuts beloved around the world

Juglans
WALNUT

Walnuts are a favourite edible nut, whether enjoyed on their own, pickled, pressed for oil, or used as an ingredient of breads, cakes, and the ever popular Waldorf salad, to name just a few. Every year millions of tonnes of the major commercial species, *Juglans regia* (Persian walnut, English walnut), are grown worldwide. China produces about half of all the world's walnuts. The native range of *J. regia* is Central Asia, where it defines the very valuable and species-rich fruit and nut forests. The walnut of this species, "Jupiter's royal acorn," was introduced to the UK and other parts of western Europe during the Roman Empire.

Of the approximately 22 species in the genus, half have been evaluated for the IUCN Red List, and eight have been categorized as threatened or near threatened. Most grow in the Americas, six in Europe and Asia. The natural range of the genus even extends into the Caribbean, where *Juglans jamaicensis* (West Indian walnut, nogal) is a species of major concern. Cuba is host to one of the richest island floras in the world, supporting 6800 species of flowering plants. Over 50 percent of the plant species are endemic to the island. *Juglans jamaicensis* is a tall charismatic tree, growing from Viñales, Pinar del Río, in the west to Yateras, Guantanamo, in the east of the island. This species is not one of Cuba's endemics but is highly valued. It is reportedly native to other islands of the Greater Antilles, but despite its name does not occur in Jamaica.

Juglans jamaicensis is highly valued for its wood, which is used in carpentry. The leaves and fruits are also useful for medicinal, cosmetic, and nutritional purposes. However, commercial forestry, intensive agriculture, and general development are changing the natural habitat of West Indian walnut, and the species has suffered significant population losses in Cuba and other Caribbean islands. It is critically endangered at a national level in Cuba and endangered in Puerto Rico. An initial step to rescue the species has been to secure it in cultivation and maintain conservation collections in Cuba's highly effective botanic gardens network; this immediate insurance policy allows time for reinforcement planting in situ to stabilise and enhance the remaining natural populations.

Since 2016, the Global Trees Campaign has partnered with the Jardín Botánico de Cienfuegos in central Cuba to carry out field inventories and implement integrated ex and in situ conservation actions for

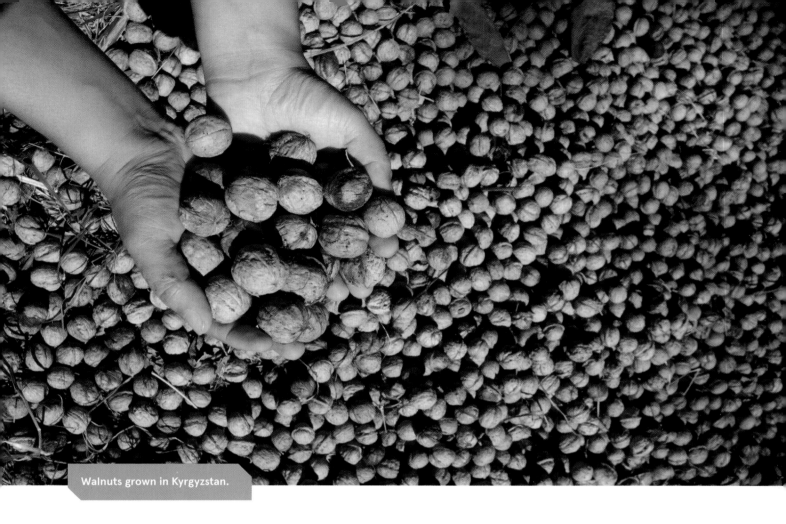

Walnuts grown in Kyrgyzstan.

Juglans jamaicensis. Field surveys carried out in 2016 and 2017 have confirmed its existence in four locations in central Cuba (Cienfuegos, Villa Clara, and Sancti Spiritus provinces), and local farmers in Viñales have identified a further location in western Cuba. It is important to engage local farmers in the survey work and provide training on propagation and cultivation techniques, so that the species can be grown in coffee and other plantations. This methodology has been tested with other globally threatened trees of Cuba, including the endemic magnolias. So far 15 local farmers are involved in saving the West Indian walnut. Seeds were collected from the natural forest locations in central Cuba. As they have a limited storage life, living plants were generated immediately after collection, and saplings are now growing well on the land of the local farmers. In parallel with these practical interventions, a series of educational and public outreach activities have been undertaken, involving local schools and national media, to further promote the conservation need and value of this magnificent tree.

West Indian walnut became so scarce in Puerto Rico during the last century, as coffee plantations expanded on the island, that it was feared extinct. Fortunately, it was found again in 1974, growing west of Cerro La Silla de Calderón. The US Forest Service surveyed the trees in this area in 1992 and found only 14 individuals, the largest over 20 metres in height. The land is now incorporated into a protected area, and some reinforcement of the natural population has been undertaken. Unfortunately, Hurricane María damaged the forest, and some of the mature walnut trees suffered. The survival of West Indian walnut remains precarious in Puerto Rico.

Juglans neotropica (Andean walnut) occurs in Colombia, Ecuador, and Peru, in the mountains of the Andes at elevations of 1800–3000 metres. The timber is attractive, the tree is a source of dye used to colour leather products, and the tough nuts are sold locally on a limited scale. Andean walnuts are delicious, with a deep flavour and large oil content. The nuts are eaten raw or are used in the preparation of nogada, a spiced nougat. Tubs of shelled nuts are sold in Ibarra, Ecuador, together with wooden boxes of nogada. Although its nut was an important part of the local diet during colonial times, *J. neotropica* is now very rare and generally not cultivated, often found only as isolated individuals in agricultural land. In 2009, there was only one small plantation of around 300 trees in the province of Imbabura, Ecuador, and the species is now recorded as endangered by IUCN. The source of delicious and nutritious nuts could so easily be lost.

Trees for bees

Koompassia excelsa
TUALANG TREE

Koompassia excelsa is one of the tallest rainforest trees, towering to 85 metres in height, with a dome-like crown of delicate foliage, smooth greyish bark, and large buttressed roots. It occurs in Indonesia, Thailand, Malaysia, and the Philippines, usually along rivers and in valleys in lowland primary forest. Legends and lore swirl around this magnificent tree. Native people believe it is inhabited by spirits, and so it is often left standing in heavily logged secondary forest areas.

Koompassia excelsa is a traditionally and economically important tree. Tualang ("tree of swarming bees" in Malay) is a preferred host for the Asian giant honeybee (*Apis dorsata*). The bees build their massive honeycombs high in the branches of the tree because its huge, columnar trunks are said to be too slippery for the honey-eating Malayan sun bear (*Helarctos malayanus*) to climb. The nocturnal sun bear, with its long tongue for extracting honey from bee nests, is the smallest, least well-known, and among the rarest of all bear species.

The nests of giant honey bees are up to 1.5 metres wide and 1 metre deep. Each honeycomb can contain over 60,000 bees. The comb is permanently covered by a curtain of aggressive worker bees several layers thick. This natural defensive barrier of bees also protects the nest during heavy wind and rain.

For centuries, local people have faced great risk to harvest honey from tualang trees. Honey gathering is traditionally carried out on a moonless night to minimize the number of flying bees once the colony is disturbed. Makeshift ladders are used to reach the top of the trees with ritual chanting to cajole and soothe the giant bees. A flaming torch is used to knock the bees off the comb. The bees swarm to the ground, following sparks from the torch, and are unable to return to the forest canopy until daylight. A pot of honey is often left at the bottom of the tree as a peace offering. Each season, as much as 150,000 pounds of one of the best wild honeys in the world is harvested. However, there are signs of depletion, with trees that used to house on average 100 hives down to only 80 hives per season. The concern is the logging that has been going on in the area. Many flowering trees and plants have been taken away, thereby reducing the bees' feeding grounds. Honey hunters harvest the whole nest to obtain both the honey and the brood; however, recent conservation efforts are encouraging honey gatherers to cut away only sections of honeycomb instead of destroying the whole colony.

Honey collection is lucrative but is increasingly in competition with timber harvesting. The wood of tualang is hard but decays quite rapidly unless treated and so has not been a preferred commercial timber species; however, as logging has removed virtually all other valuable timbers from the rainforests, *Koompassia* timber is gaining importance in trade.

Tualang trees are protected from cutting in Kalimantan to protect the wild bees. Traditional community law protects the trees and their beehives in Sumatra, as well as about 100 hectares of forest surrounding each tree. WWF-Indonesia is working with local communities in villages

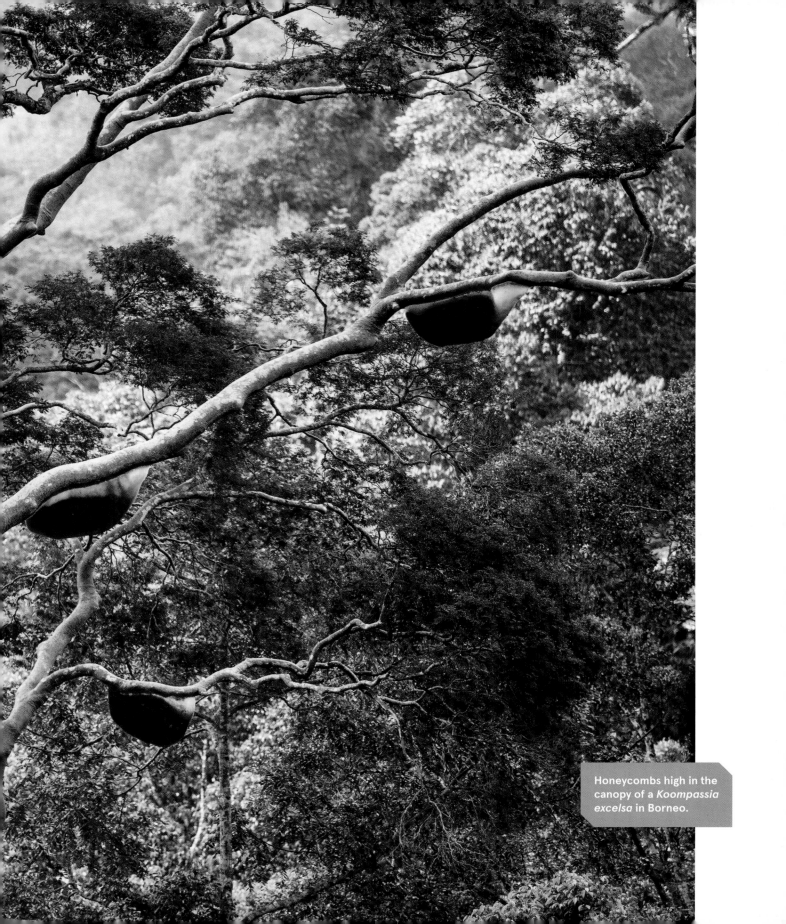

on the outskirts of Tesso Nilo (one of Sumatra's last remaining lowland rainforests) to raise awareness of tualang and the threats to rainforests as a whole. The Logas Tanah Darat ethnic group lives in seven villages, cultivating seasonal crops like rice; they also harvest non-wood forest crops like wild honey. Seventy people are directly involved in and depend on the honey business for their livelihood, but ultimately more than 300 people benefit from this village industry.

Familiar fruit and nut trees, all from the rose family

Malus, Prunus, Pyrus
ALMOND, APRICOT, PEACH, CHERRY, PLUM, PEAR, APPLE

Many of our temperate fruit and nut trees are cultivars of a few species in Rosaceae (rose family). The genus *Prunus* includes almond (*P. dulcis*), apricot (*P. armeniaca*), peach (*P. persica*), cherry (*P. cerasus, P. avium*), and plum (*P. domestica*). The domesticated apple (*Malus domestica*) is in a related genus, as is the pear (*Pyrus communis*). These trees have been widely cultivated for thousands of years. Related species in the wild are of great importance for crop improvement, and some of these are under considerable threat.

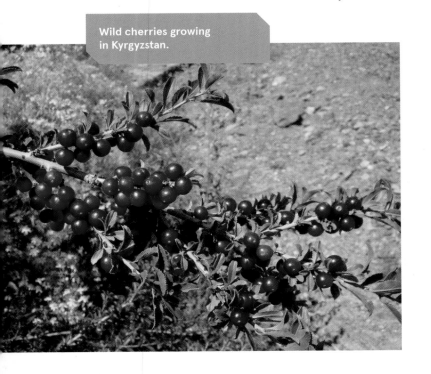

Wild cherries growing in Kyrgyzstan.

Malus niedzwetzkyana is an endangered wild relative of domesticated apples. It is of extraordinary value as a potential source of genetic material for apple breeding programmes. This wild apple, which is rarely cultivated, has iconic pink blossoms and fruit with bright red flesh. The red colouring is caused by anthocyanins, which are being studied for potential health benefits, and in some areas these fruits are eaten, especially by children, because it is thought to prevent cancer. Known from scattered and fragmented populations in Afghanistan, China, Kazakhstan, Kyrgyzstan, and Uzbekistan, this species is of very special scientific and cultural importance and is a global conservation priority—as are the forests where it occurs.

Malus niedzwetzkyana is one of the tree species unique to the extraordinary fruit and nut forests

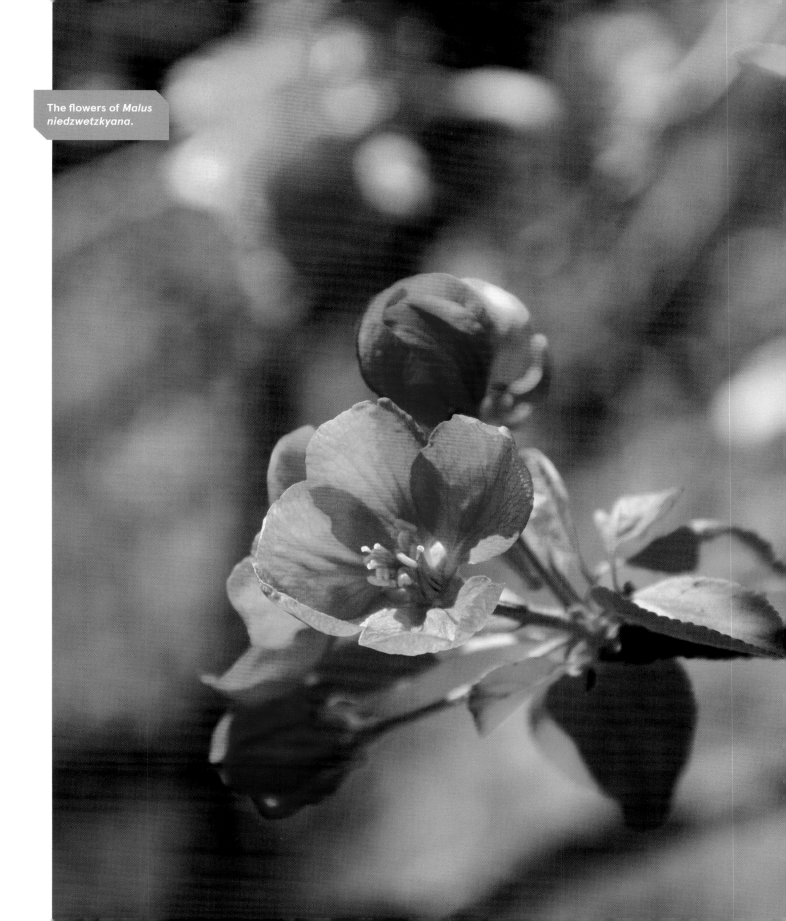

The flowers of *Malus niedzwetzkyana*.

Amygdalus bucharica.

Pistacia vera.

of Central Asia. These forests are home to other wild apples, as well as pears, cherries, apricots, almonds, walnuts, pistachio, mulberry, and black-currants. In total, the mountains of Central Asia support over 300 wild fruit and nut species, and this diversity is recognised in the designation of the Mountains of Central Asia global biodiversity hotspot. The fruit and nut forests of Central Asia have been a particular focus of the Global Trees Campaign, which has focused on a range of flagship species found there.

Amygdalus bucharica. A wild almond, surveyed in Kyrgyzstan, conservation action in Tajikistan. Vulnerable.

Crataegus knorringhania. Endemic to the Fergana valley in Kyrgyzstan. Critically endangered.

Crataegus necopinata. Endemic to Tajikistan. Critically endangered.

Crataegus pontica. A medicinal and edible hawthorn, surveyed in Kyrgyzstan. Least concern.

Malus sieversii. One of the main ancestors of the domestic apple, used to improve disease resistance in the cultivated crop, surveyed in Kyrgyzstan, conservation action in Tajikistan. Vulnerable.

Pistacia vera (pistachio). Surveyed in Kyrgyzstan. Near threatened.

Prunus armeniaca (Armenian apricot). Surveyed in Kyrgyzstan. Endangered.

Prunus tadzhikistanica. Used for firewood, endemic to Tajikistan. Endangered.

Pyrus korshinskyi (Bukharan pear). Tiny, fragmented populations in Kyrgyzstan, Tajikistan, and Uzbekistan. Critically endangered.

Pyrus tadshikistanica. Conservation action in Tajikistan, where endemic. Critically endangered.

Pyrus turcomanica. Uncertain taxonomic status, probably introduced, surveyed in Kyrgyzstan. Data deficient.

Sorbus persica. Used for handicrafts, surveyed and legally protected in Kyrgyzstan. Least concern.

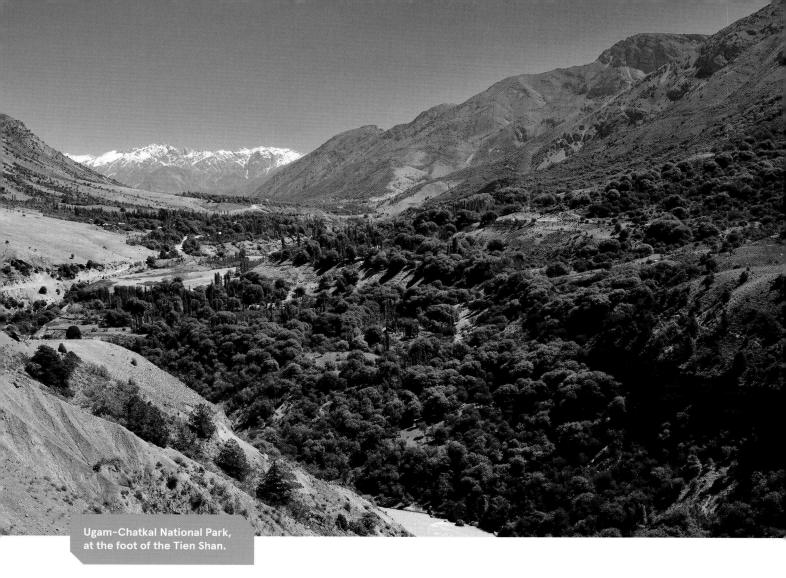

Ugam–Chatkal National Park,
at the foot of the Tien Shan.

Conservation action by the Global Trees Campaign has centered on Tajikistan and Kyrgyzstan. Within Kyrgyzstan, which has the largest remaining extent of Central Asia's fruit and nut forests, the forests are located in the south, growing on the western and southwestern slopes of the Fergana and Chatkal Mountains in the Jalal-Abad region, part of the fabled Tien Shan. These "mountains of heaven," which extend for 2400 km along the boundaries between China, Kyrgyzstan, and Kazakhstan, are rich in biodiversity; the range is still home to the snow leopard and other iconic animal species.

Kyrgyzstan's forests have been exploited very intensively. During the Soviet era, vast areas of the country were used for agriculture, pasture, and mining, leading to significant land use impacts, although management of wild resources was generally quite strict. When the country become

independent from the Soviet Union in 1991, its economy collapsed, and management systems have since diminished. Historical expansion of agriculture and general development across the range of *Malus niedzwetzkyana* have led to the loss of 90 percent of the apple's fruit and nut forest habitat in the last 50 years. Overgrazing of cattle within the remaining forest fragments prevents natural regeneration, as young shoots are eaten before woody stems are established.

So far, in the case of Niedzwetzky's apple, GTC has played a pivotal role in helping to hold the line. It is a very rare species throughout its range, with individuals sporadically distributed in severely fragmented populations; the actual area occupied by the species is very small. In Kyrgyzstan, *Malus niedzwetzkyana* is reduced to less than 200 wild adults. Since the outset of conservation planning, FFI has continued to champion its cause, with the result that communities, forestry workers, and government staff now recognise the species' local, regional, and global importance. In collaboration with Sary-Chelek Biosphere Reserve, FFI's work has ensured that almost 4000 saplings of Niedzwetzky's apple have been grown in nurseries and planted out in their natural habitat. FFI has also developed a monitoring scheme for rare and threatened tree species and trained staff from the Dashman and Sary-Chelek reserves to carry out this work.

Jarkyn Samanchina, Country Director of FFI Kyrgyzstan, is continually struck by the sheer beauty of the Tien Shan: "Kyrgyzstan's walnut-fruit forests are truly a hidden gem. Tucked away on the slopes of looming snow-capped mountains, in a relatively unexposed part of the world, the ancestors of some of the most well-known cultivars thrive. To walk through woodland with wild apples, pears, walnuts, and much more surrounding you is genuinely fascinating. These are the natural orchards of the world, and they urgently need our help."

Jarkyn explains that most of the fruit and nut forest habitat in Kyrgyzstan is state-owned and under the management of the Forest Service, who lease forest plots out to local families. Local people are allowed to use these plots to support their livelihoods, grazing their cattle and horses, making hay, and collecting walnuts and firewood. Unfortunately, the pressures on the fruit and nut forest

A handful of wild apples in Kyrgyzstan.

as a whole, and the threatened tree species they contain, are too strong, and both natural resources and livelihoods are suffering. FFI, leading the Global Trees Campaign action in Kyrgyzstan, is working with government agencies and local communities within the country to improve the situation.

An exciting find resulting from FFI's survey work in Kyrgyzstan has been the discovery of an estimated 100 mature individuals of *Pyrus korshinskyi* (Bukharan pear) in a single location. This has provided a massive boost to the survival prospects of this critically endangered species. The presence of this previously unrecorded population was first brought to the attention of FFI by a local villager. Subsequently, Georgy Lazkov from Kyrgyzstan's National Academy of Sciences accompanied FFI staff on a trip to the Bazar-Korgon region and provided official confirmation of the species' identity. A further 29 new Bukharan pear trees were recorded at other locations during the expedition.

Looking at the bigger picture, FFI is helping to conserve Kyrgyzstan's precious fruit and nut forests, by supporting local community-based organisations to develop sustainable income generating activities, providing training for vocational and entrepreneurial skills, and helping to set up and fund a community association of eco-tourism and a fruit and nut processing facility. Two plots of fast-growing trees have also been established to satisfy local needs for firewood and construction materials in a sustainable way that reduces pressure on the rich natural forest.

A most nutritious fruit

Persea americana
AVOCADO

Now immensely popular around the world, the avocado (*Persea americana*) has its origins in the rainforests of Central America, where avocado trees still grow in the wild. Domesticated several thousand years ago, by the time of Spanish colonisation avocado was grown from Mexico to Peru. The natural range of avocado extends from the central highlands of Mexico to the tropical forests of northwest Colombia. Its common name is derived from the Nahuatl word *ahuácatl* ("testicle"), a reference to the shape of the fruits. This association led to the avocado being considered a fertility food. The nutritious fruit contains more protein than other fruits

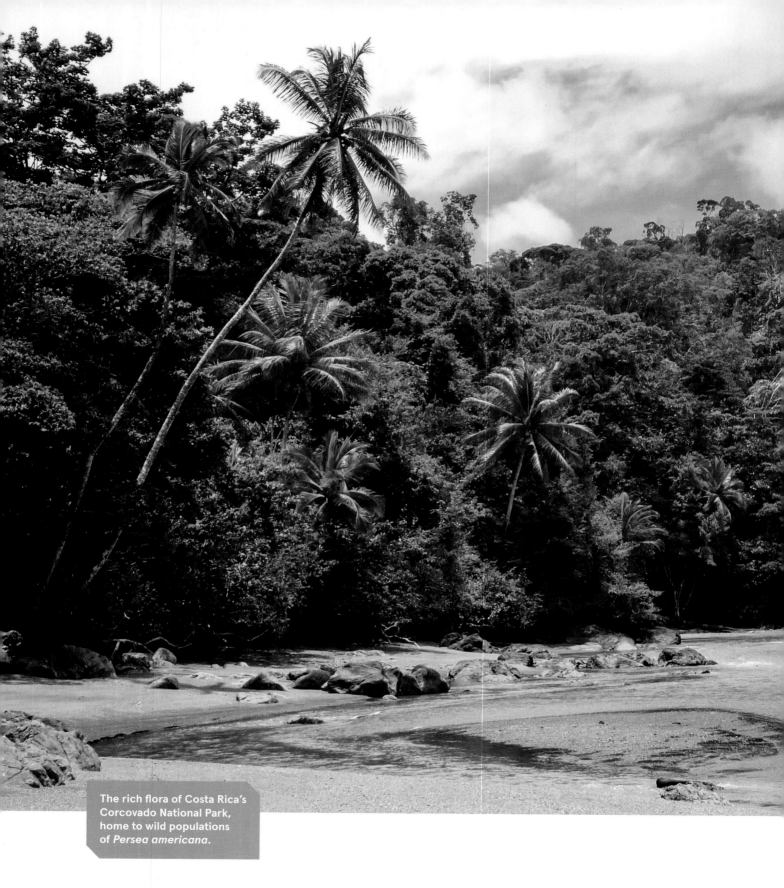

The rich flora of Costa Rica's Corcovado National Park, home to wild populations of *Persea americana*.

as well as up to 25 percent fat. The avocado fruit is produced after the inconspicuous greenish yellow flowers have been pollinated by insects and possibly bats.

An avocado planting boom began in California in the early 1900s, using a cold-tolerant variety introduced from Mexico, and avocado production globally increased significantly in the 1970s with new production techniques developed in Israel. The avocado became fashionable at dinner parties, and avocado green became a fashionable paint colour! The real global boom in avocado production and consumption is a 21st-century phenomenon. World avocado production has risen to about 5 million metric tons each year and is increasing annually by about 200,000 metric tons. Mexico is the major producer, supplying about one-third of all the world's avocados; demand for this delicious fruit is unfortunately having a negative impact on forest biodiversity within that country.

In the wild, *Persea americana* can still be found in habitats from sea level up to 3000 metres. Trees grow to 20 metres in height in high-rainfall areas with dry winter and spring seasons. There are various natural varieties: a West Indian variety grows in low-altitude forests along the west coast of Central America; *P. americana* var. *guatemalensis*, with large woody fruits, grows in highlands; and a Mexican variety, with small black or green thin-skinned fruits, can be found in both tropical highland and cool subtropical habitats in evergreen forest, cloud forest, and pine-oak forests. A recently proposed new variety occurs in the mountains of Costa Rica. Wild populations of *P. americana* are very important as primary sources of genetic diversity, with traits such as disease resistance having potential for improvement of the cultivated crop. Local communities also value wild avocado as a medicinal plant and source of timber. Sadly, wild avocados face an increasing threat from introduced pests and diseases. Conservation of genetic diversity in the wild is very important for such a valuable tree species.

Persea americana occurs in various protected areas in Mexico, including eight biosphere reserves, and national parks in Costa Rica, such as the Carara and Corcovado. Several major ex situ collections worldwide store germplasm of *P. americana*, sourced from the wild and cultivation; these include the National Germplasm Repository, Miami, Florida, and the Avocado Germplasm Collection, University of California in Irvine.

Some of *Persea*'s 108 species are very important as near relatives of the avocado and may have great value in breeding programmes. Some are under serious threat in the wild. *Persea schiedeana* (coyo) is a majestic long-lived tree that occurs from southern Mexico to Panama. Its large

fruits are said to have a flavour of coconut and are popular with local people. When the forests are felled, this tree is often left standing so that the fruits can be gathered. It is also used as a shade tree in coffee plantations and is sometimes cultivated as an ornamental. *Persea schiedeana* is a Tertiary wild relative of avocado (meaning that gene transfer is possible but not straightforward) as well as a source of graft stock for the crop. One of its great potential values is that it is resistant to *Phytophthora cinnamomi*, the fungus responsible for root rot in avocado plantations.

In the wild *Persea schiedeana* grows in both lowland and montane tropical deciduous rainforest at elevations of 500–2800 metres. It is now endangered, partly (and ironically) because its habitat is being cleared for cultivation of its avocado relative and also for coffee. Exploitation of wild specimens by local communities may also be reducing genetic diversity: the fruits of the best trees are collected, whereas poorer specimens are cut for wood.

Persea donnell-smithii (aguacatillo) is native to southern Mexico, Guatemala, Honduras, Nicaragua, and Costa Rica. It is another avocado relative that is in trouble in the wild, mainly as a result of forest loss for agriculture and grazing. Listed as vulnerable by IUCN, fortunately this species grows within the El Triunfo Biosphere Reserve in Chiapas and in La Amistad in Costa Rica. A park established near Purulha, Guatemala, to protect the endangered quetzal (*Pharomachrus mocinno*), that country's national bird, also protects *P. donnell-smithii*, whose fruit is relished by the quetzal.

As avocado production increases in Mexico, there are major concerns about the impact of plantations on native forests and the rare tree species they support, including coyo and other avocado relatives. Large areas of natural forest are being cleared for avocado monoculture. Production of this crop consumes vast amounts of water, and large quantities of pesticides are used to the detriment of local biodiversity. Most avocado production takes place in the states of Michoacán, Jalisco, and Mexico. Over the past 10 years or so, the number of avocado orchards has increased dramatically—by 162 percent in Michoacán, over 500 percent in the state of Mexico, and around 1000 percent in Jalisco. US consumption is driving this demand, and drug cartels are reportedly controlling the avocado supply. Per historical trade agreements, Michoacán is the only Mexican state that can export the crop to the US. Approximately 20,000 hectares of forest in Michoacán are converted to agricultural use each year. A significant proportion of this is for lucrative avocado production supported by Mexican government subsidies.

Persea schiedeana for sale in a market in Xalapa, Mexico.

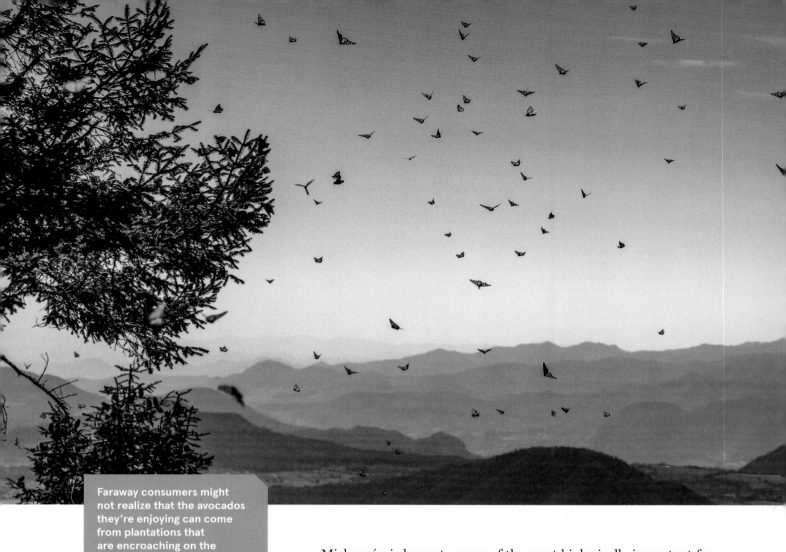

Faraway consumers might not realize that the avocados they're enjoying can come from plantations that are encroaching on the Monarch Butterfly Biosphere Reserve in Michoacán, altering the life cycle of the migrating population.

Michoacán is home to some of the most biologically important forests in Mexico. The Monarch Butterfly Biosphere Reserve there is one of the major overwintering sites for the migratory monarch butterfly (*Danaus plexippus*). Millions of monarch butterflies fly back to it every year, some travelling over 3200 km from southeastern Canada. This natural phenomenon is an exceptional experience, attracting thousands of tourists to Michoacán. Sadly, avocado production is having a negative impact on the reserve. Satellite imagery shows that forest clearance to establish avocado plantations has pushed right into the reserve boundaries and is now the main threat to the integrity of the site.

Esteban Martínez Salas of the National Herbarium of Mexico has done extensive floristic research in the Monarch Butterfly Biosphere Reserve. He has observed that the butterflies are more active than generally assumed during their hibernation in the area. When the young adult butterflies arrive from the north, they have been increasing their

weight following their emergence from the pupa, and they continue to gain weight during their first six weeks in the reserve. In the months of November and December, they go down from their colonies to the tropical deciduous forest, which is in full flower by then. Interestingly, the whole area is characterised by a gradient of vegetation, temperature, and humidity: the *Abies* forest, where the butterfly colonies sleep and where temperatures decrease below zero every night during their stay; a narrow zone of *Pinus* and *Cupressus* forest; a broad zone of cloud forest, which offers humidity for the butterflies so that they do not get dehydrated; and finally the tropical forest, where they nectar. The cloud forest is the vegetation lost to avocado cultivation; as a result, the humidity of the area decreases, and the butterflies are further threatened by the pesticides used in the avocado plantations.

Some sustainable certification schemes have been developed to ensure that global demand for avocados does not destroy important areas for biodiversity.

ORNAMENTAL TREES

Some of our best-loved ornamental tree species, planted to improve the aesthetics of gardens worldwide, are endangered in the wild. Many are threatened by their very beauty—their colourful flowers, their beautiful foliage, their delicious fruit, their attractive bark; and demand for certain species has led to unsustainable collection or harvest.

Planting a rare ornamental sourced from cultivated stock is a small step toward ensuring that the species is preserved while increasing awareness of the fate of its threatened brethren in the wild. By growing such trees in gardens, we keep them from extinction and ensure their story is told. Trees are an essential part of all gardens. We include them not only for aesthetic reasons but also for their ecological role in supporting a wide range of wildlife. Various selection criteria are needed for ornamental trees. Street trees and trees used in parks and other public spaces must establish well, not grow too slowly (or quickly), require little pruning, and withstand high levels of pollution.

Ornamental plants have been big business for centuries. It began in the 1800s, when having a remarkable collection of plants in your garden was a sign of wealth. Rich landowners were trying to outcompete each other by getting novel and fascinating trees into their gardens and greenhouses.

Did you know?

Rhododendron kanehirae would be extinct were it not for collections made by botanic gardens.

Cedrus libani was one of the first trees imported to the United Kingdom for ornamental use.

Plant hunters were employed across the world to bring back species previously unknown to the science, taxa that would be an exotic addition to their gardens. Landowners wanted ornamental trees that were rare and showy but that would survive their new growing conditions—traits that are very like what many modern gardeners want from their trees. Some of our favourite trees come from these early introductions. Botanic gardens were established for a range of reasons, but these public gardens were also a great way to showcase novel trees and show the public which trees could be grown in their climate. In addition, botanic gardens have been used for the acclimatization of ornamental as well as major crop plants from overseas.

One example of an early introduction, *Cedrus libani* (Lebanese cedar), has been a feature of British gardens since the mid-1600s. These majestic conifers can still be found, ornamenting larger gardens and parks. In the wild, however, this conifer is at risk of extinction. Lebanese cedars are originally from Cyprus and mountains on the Mediterranean coasts of Turkey, Syria, and Lebanon; however, their natural distribution is now restricted, and trees are lost to grazing, fire, selective felling (urbanisation and recreation), and disease. Many *C. libani* forests are in protected areas, yet still they suffer from degradation. In Lebanon, laws forbid damaging the cedars, but there is little enforcement. In Turkey, extensive planting projects have enhanced the native population. In Cyprus, all human activities and grazing are excluded from the native stands; there is an effective fire protection system in place and a permanent monitoring plan. Gene banks have also been established in the form of ex situ conservation plantations.

Many other conifers were brought into cultivation in the Victorian era as status symbols for the wealthy. In the same way, fine collections of flowering trees were established in cultivation, including camellias, magnolias, and rhododendrons, to name a few. Conservation was probably not a consideration at the time, but now the value of exhibiting, recording, and propagating a wide range of ornamental trees is increasingly recognized.

Over the past century, plant hunting has changed. International and national laws control access to and trade in species; yet even now, botanists are discovering new species, and the horticultural industry remains interested in novel plant introductions. Relatively few of the newly discovered species are trees—probably because they are more conspicuous than other species. However, new tree species that get incorporated into the ornamental trade are still being discovered.

Ornamental species that have been completely removed from the wild habitats where they originally grew avoid complete extinction thanks to the efforts of people that keep them alive in cultivation. We know of 24 of these extreme cases: tree species that are extinct in the wild but persist in cultivation. If these species were to die in cultivation, the species would be lost forever. Harvesting trees from the wild should be avoided at all costs, unless part of a well-managed ex situ conservation project. The priority remains to conserve trees in their native habitats, where they are part of an integrated ecosystem playing important functional roles. But where species are on the brink of extinction, cultivation of trees ex situ is a vital part of the toolkit to conserve rare and threatened trees.

Acer griseum, new leaves and spring blossom.

Acer griseum
PAPERBARK MAPLE

Maples (*Acer*) are an example of an entire tree genus whose members are highly valued for their autumn colour and relative ease of cultivation, which has made them extremely popular with gardeners around the world. In addition to their horticultural importance, maples also provide us with beautiful timber and maple syrup. As with many other tree species, however, maples are under threat in the wild, primarily as a result of forest degradation and destruction. Climate change adds further pressure to maples that are naturally rare or restricted to high elevations. China is the most species-rich country when it comes to maples, with 92 of the world's 160 species. Over the centuries, the natural diversity of maples has been enhanced by the work of horticulturists, who have developed thousands of different cultivars, particularly of Japanese maple (*Acer palmatum*), for our gardens.

Acer griseum, fall colour.

Acer griseum, an increasingly popular ornamental maple, was introduced from China to Europe by Ernest Wilson in 1901. It is a very striking species, with attractive peeling bark and beautiful autumn colour. The species has horticultural value in China; outside of its native range, it is often planted in gardens and is a common street tree in North America.

Paperbark maple is threatened in its native habitat. It is hoped that ex situ collections of this species could help conserve it; however,

unpublished data indicates that the vast majority of cultivated and commercially available plants of *Acer griseum* represent only one introduction from China. In order to better conserve this globally threatened species in horticultural collections, further genetic diversity is needed.

Acer griseum is a small tree that grows on dry, exposed, rocky sites. It is endemic to China, where it is found in various provinces; despite this, the species has a fragmented population and is subject to ongoing decline. Wild subpopulations are isolated and restricted, growing in narrow altitude bands; most contain fewer than 10 individuals, with only one site approaching 100 individuals. There are concerns that there is a lack of regeneration and recruitment of the species, which could result in further decline.

Awareness of its plight in the wild should spur stronger conservation action. Botanic gardens, working together, can play a part in helping to ensure that greater genetic diversity is introduced to ex situ collections, including the focused collection of material from unprotected and unrepresented sites.

Aloidendron dichotomum

QUIVER TREE

Aloidendron dichotomum is a southern African succulent tree species characterised by its forked branching pattern. It can grow up to 9 metres tall. The tree is found in very dry habitats in Namibia and South Africa and provides food and shelter for many insects, mammals, and birds. The San people used its hollowed branches to make quivers for their arrows (hence the common name); it is also used medicinally to treat asthma and tuberculosis. Its striking appearance and yellow flowers make it a highly valuable ornamental.

The quiver tree is protected by law in South Africa; the law forbids removing plants from the wild or collecting seeds without a permit. Nevertheless, juvenile plants are sometimes taken to grow as garden ornamentals. Climate change is another threat; recent studies have suggested that the tree's range is contracting rapidly, and it has not yet been found in areas expected to become suitable with the changing climate.

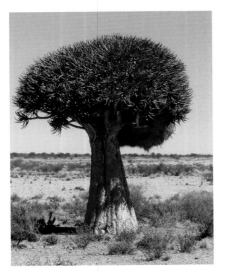

Aloidendron dichotomum is endemic to Namibia and South Africa.

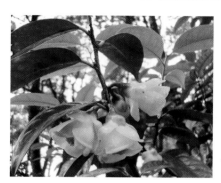

The flowers of *Camellia nitidissima* are favored for their yellow colour, which is rare in the genus.

Camellia nitidissima

GOLDEN CAMELLIA

Camellias have been grown for their ornamental characteristics for millennia, and more than 40,000 cultivars have been developed in that time. The genus contain 153 species, 70 of which are threatened. *Camellia amplexicaulis* is already listed as extinct in the wild.

Camellia nitidissima and *C. euphlebia* are endemic to Guangxi province in southeastern China. Both species have high ornamental, medicinal, and nutritional value, and because of their ornamental and socio-economic importance, they are now threatened by the extensive removal of seedlings in the wild and the overharvesting of both flowers and leaves.

Plants in the wild have low fruit set and poor seed germination; the population is steadily decreasing, affecting the reproductive capacity of the species further and thereby limiting natural regeneration. In order to remove pressure on wild populations, conservation work has focused on establishing populations of these species in nurseries. The work, supported by the Global Trees Campaign, has had three objectives: to secure these species in ex situ collections, to restore their habitats, and to reinforce populations in situ as well as improve local livelihood.

Three nurseries were created, and a stock of 15,000 cuttings, 4000 seedlings, and 1000 grafted plants was established. Two ex situ conservation collections held around 2500 seedlings of *Camellia nitidissima*. A 12-hectare restoration demonstration plot was demarcated to enhance the recovery of vegetation near the protected area. Several thousand seedlings and cuttings of golden camellia, as well as associated plant species, were planted in the restoration site to assist natural regeneration.

To expand the cultivation area of golden camellia, local communities were encouraged to engage in a broad partnership made up of researchers, the private sector, and farmers. Interested households signed agreements with a corporate enterprise that raises and provides seedlings to local people free of charge for cultivation on privately owned land. The farmers collect the flowers and leaves from the plants once mature; these are then purchased and processed by the company. Experts provide technical advice on propagation and cultivation—knowledge that is disseminated through a series of capacity-building activities—and training materials

are distributed to local communities and enterprise staff. Local farmers who benefitted from the training have planted golden camellias on their land and are earning an income from selling their leaves and flowers; they have seen their living standards and livelihoods greatly improved. Further households are eager to become partners in the project, which is also expected to reduce the migration of local villagers to urban centres in search of other income opportunities. In short, the project not only alleviated the pressure on wild populations, it enhanced the conservation of the species and increased the livelihood of local communities—a conservation success.

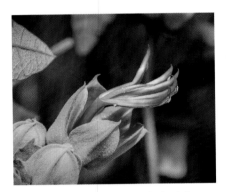

Chiranthodendron pentadactylon has "five-fingered" flowers (hence the common name).

Chiranthodendron pentadactylon
DEVIL'S HAND TREE

Chiranthodendron pentadactylon, found in Guatemalan and Mexican cloud forests and oak forests at elevations of 1830–2740 metres, is best known for its striking red and yellow "five-fingered" flowers, which makes it a popular ornamental in gardens worldwide. The bright red flowers are used medicinally as a traditional remedy for some heart diseases. The bark is used as rope, and the large leaves are used to wrap food. The tree also had religious significance to the pre-Columbian Aztec people.

The species' native cloud forest habitat is threatened by extremely high deforestation rates and, increasingly, climate change. As temperatures rise, cloud forest trees will be forced to migrate up mountain slopes to find favourable conditions, leading to a gradual decline in available habitat.

Restoring populations with planted seedlings and saplings offers some hope for the species. Seeds must be collected from slightly open fruits on the distal parts of the tree's branches; they are then germinated by placing them on damp soil beds with a thin litter cover.

Davidia involucrata.

Davidia involucrata

HANDKERCHIEF TREE, DOVE TREE

Davidia involucrata is characterised by large white floral bracts, which hang from the tree each spring like so many fluttering handkerchiefs. This species is a deciduous tree up to 20 metres tall, with (besides its striking floral display) heart-shaped leaves and attractive bark. It is native to central and southern China and is grown as an ornamental in parks and gardens worldwide.

The generic name honours French priest and naturalist Armand David, who first described the species in 1868. A year before, he had described the giant panda, the first westerner to do so. The handkerchief tree is the only species in the genus, and its uniqueness was alluring to plant collectors of the time. In 1899, a young Ernest Wilson was tasked with finding the species and bringing back seeds to the UK; however, when reaching the remote place in China where the single known tree was said to be, he found that it had been cut down to build a house. Fortunately, further trees were later discovered, and material was taken to Europe. Wilson ended up spending several years in China and discovered hundreds of other plants. He became one of the most famous plant collectors working in China. *Davidia involucrata* has been grown at the Royal Botanic Gardens, Kew, since 1903.

Dipteronia sinensis.

Dipteronia sinensis

CHINESE MONEY MAPLE

There are currently only two species in this genus, *Dipteronia sinensis* and *D. dyeriana*, both found in China; an additional species is known only from fossil material in North America. *Dipteronia* ("two wings") is a reference to the seeds, which have two wings, not one as in the closely related *Acer* (maples).

Dipteronia sinensis is a small tree or multistemmed shrub up to 15 metres in height, native to central and southwestern China, at elevations of 1000–2400 metres. This attractive species, discovered by Augustine

Henry in 1888 and introduced to cultivation by Ernest Wilson circa 1900, has elegant foliage and interesting seeds. It is hardy and easy to propagate.

The mature trees are cut for timber, but this use is in decline as not many large trees persist. The species is now mostly chopped for firewood and is also threatened by forest clearance. It is found extensively in gardens and arboreta around the world; however, in the wild, it requires protection if the number of individuals is to increase. *Dipteronia sinensis* requires better monitoring, a full population census, and an investigation into the impact of deforestation to ensure effective conservation action.

Franklinia alatamaha

FRANKLIN TREE

In October 1765, father-and-son botanists John and William Bartram encountered a tree they could not identify in a sandhill bog along the Altamaha River in southeastern Georgia, about 50 km from the coast. To solve the mystery, they made several return trips to the location, timed with the tree's presumed flowering or fruiting; finally, in 1776, William collected seeds from the tree and sent them to his father's botanic garden, Bartram's Garden, in Philadelphia.

All modern specimens of *Franklinia alatamaha* derive from the two plants grown at Bartram's Garden after 1777. From there live plants were shipped to London, where they were introduced to the horticulture trade. Records show the species was being grown in European gardens in the 1850s, but it did not produce seeds and was therefore propagated by cuttings, so likely all material in cultivation is from the single original plant.

Only a limited number of people visited the original site, and the last documented scientific collector to the wild stand was Stephen Elliott, who collected *Franklinia* specimens in 1814. By 1881, no wild trees could be found, despite numerous attempts to relocate the species. Now, it is considered extinct in the wild, but it persists in gardens around the world. As you'd expect of a tree that evolved on the eastern coastal barrens of North America, *F. alatamaha* grows best in very acidic, moist sandy soils and is dependent on a mycorrhizal association for healthy growth. Plants can be raised freely from seed or cuttings, but young plants are susceptible to fungal diseases.

The white flowers of *Franklinia alatamaha*, popular in gardens, extinct in the wild.

Ginkgo biloba

MAIDENHAIR TREE

Ginkgo biloba has a long history of cultivation: trees have been cultivated in China since about 1120 and were introduced to cultivation in DPR Korea, Republic of Korea, and Japan some 500 years after that. It appeared in European gardens in the 18th century, an introduction from cultivated specimens from Japan, not from its native China. Ginkgos are now very popular ornamental trees, but despite being common in gardens and cities worldwide, in their original habitat in China they are now very rare and planted so widely, their wild origin is uncertain. It has even been debated if any remaining wild trees still stand, as many old ginkgos are found to have been planted near sacred sites for their ornamental and spiritual importance. A population of ginkgos in the Dalou Mountains of southwestern China is believed to represent the last threatened wild fragment, although it is possible that even those trees have been aided by people.

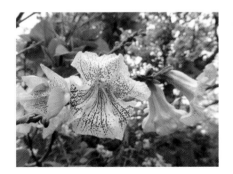

A towering *Ginkgo biloba* at the Royal Botanic Gardens, Kew.

Paulownia kawakamii

SAPPHIRE DRAGON TREE, FOXGLOVE TREE

Paulownia kawakamii, with its attractive blue flowers and large leaves, is a popular ornamental tree in many gardens. In naming the genus, Franz von Siebold honoured both Anna and Maria Pavlovna, two of the six daughters of Paul I of Russia. As with other paulownias, *P. kawakamii* is fast-growing and therefore popular for some timber use and also for roadside planting in China.

Paulownia kawakamii is one of two *Paulownia* species native to Taiwan, China. In Japan, *P. tomentosa* (empress tree, princess tree) is traditionally planted for luck and protection when a daughter is born; when she marries the tree is cut down, and her wedding chest is then made from the valuable timber.

Despite its popularity as an ornamental and timber species, *Paulownia kawakamii* is at extremely high risk of extinction in the wild. Only

Paulownia kawakamii's flowers do indeed resemble foxgloves in shape (hence one of its common names).

a handful of mature trees remain in the mixed evergreen forests where it grows; they have been destroyed to make way for apple and peach orchards. Decline of the species is also attributable to its being overexploited for its valuable timber in the past.

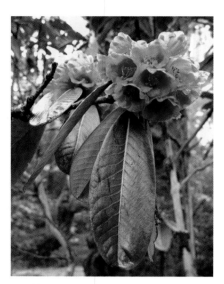

Rhododendron hodgsonii.

Rhododendron

AZALEA, RHODODENDRON

Rhododendrons, including azaleas, are a well-known group of plants with a long and rich horticultural history. Centres of diversity for the genus are the Himalayas and the mountains of New Guinea, Borneo, Sulawesi, Sumatra, and the Philippines. Rhododendrons, from low creeping plants to 30-metre-tall trees, generally grow in temperate climates with high rainfall and high humidity, with acidic soils preferred. In the wild, they fulfill vital ecosystem services, such as soil stabilisation and watershed protection—particularly important in the Himalayas, where so many of Asia's major rivers start.

Their preference for temperate climates, together with a natural diversity of forms and an ability to form hybrids, has made rhododendrons incredibly popular with horticulturists for centuries, and many thousands of cultivars are now being grown around the world. Specialist gardens in temperate regions draw visitors in huge numbers each spring to view colourful swathes of flowering rhododendrons in their prime, as do the natural and naturalized populations in the forests of North America, Europe, and Asia.

Rhododendrons are also important to the local communities where they grow naturally. They are valued for their medicinal properties, reportedly serving as antibiotics, anti-inflammatories, and a treatment for diarrhoea. In some communities they are used for firewood, timber, teas, honey, wine, and jams and as a source of insecticides.

For all these reasons and with huge potential to raise wider awareness of the threats facing biodiversity, rhododendrons are excellent flagship species for conservation. There are over 1000 *Rhododendron* taxa; of these, two species are extinct in the wild but remain in cultivation, and over 300 are threatened, requiring conservation action at the global scale. Fortunately, 67 percent of threatened rhododendrons are represented in documented collections maintained by botanic gardens.

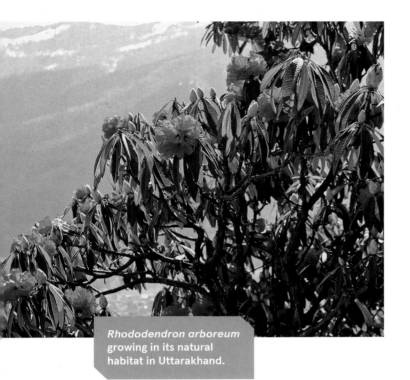

Rhododendron arboreum growing in its natural habitat in Uttarakhand.

Rhododendron arboreum (tree rhododendron) is one of the largest and most impressive species, growing to over 12 metres tall in the Himalayas, from Kashmir to Bhutan, and in the hills of Assam and Manipur. It is mainly found at elevations of 1500–2500 metres, in temperate forest, much of which has been destroyed by fire. Trees can survive on cleared slopes and in secondary forest, but whether they are capable of regenerating in such habitats is not clear. This was the first of many rhododendrons to come into cultivation from southern Asia. A Captain Hardwicke encountered it in 1799; it was formally described and named in 1804 by James Smith, from Hardwicke's notes and drawings, and introduced to cultivation in Europe from India after that. With its tall stature and blood-red flowers, it is a popular ornamental. The religious significance of *R. arboreum* is documented as far back as the 12th century. Even today, it is considered sacred and offered in temples.

Rhododendron hemsleyanum (Hemsley's rhododendron) grows as a shrub or small tree up to 9 metres tall, bearing fragrant white flowers and thick leathery leaves. It is found only on Mount Emei in Sichuan, China, where Ernest Wilson first encountered it in 1900; however, it was not cultivated widely until the 1960s, when it was distributed in the US. The wild population is very small, consisting of only a couple of hundred mature specimens, and confined to a very small range that is degraded and threatened by construction projects. The species is therefore at risk of extinction in the wild, despite being grown widely in our gardens.

Rhododendron hodgsonii (Hodgson's rhododendron) is appreciated in our gardens for its large glossy leaves, up to 24 centimetres long. In the wild it grows in forests in the Himalayas from Nepal to Bhutan, at elevations of 3000–4000 metres. The species epithet honours Bryan Houghton Hodgson, a 19th-century British amateur naturalist and East India Company resident in Nepal. It was introduced to cultivation by Joseph Hooker, who described it as follows:

It is found alike at the bottom of the valleys, on the rocky spurs or slopes of the hills, in open places, or in the gloomy pine-groves, often forming an impenetrable thicket, not

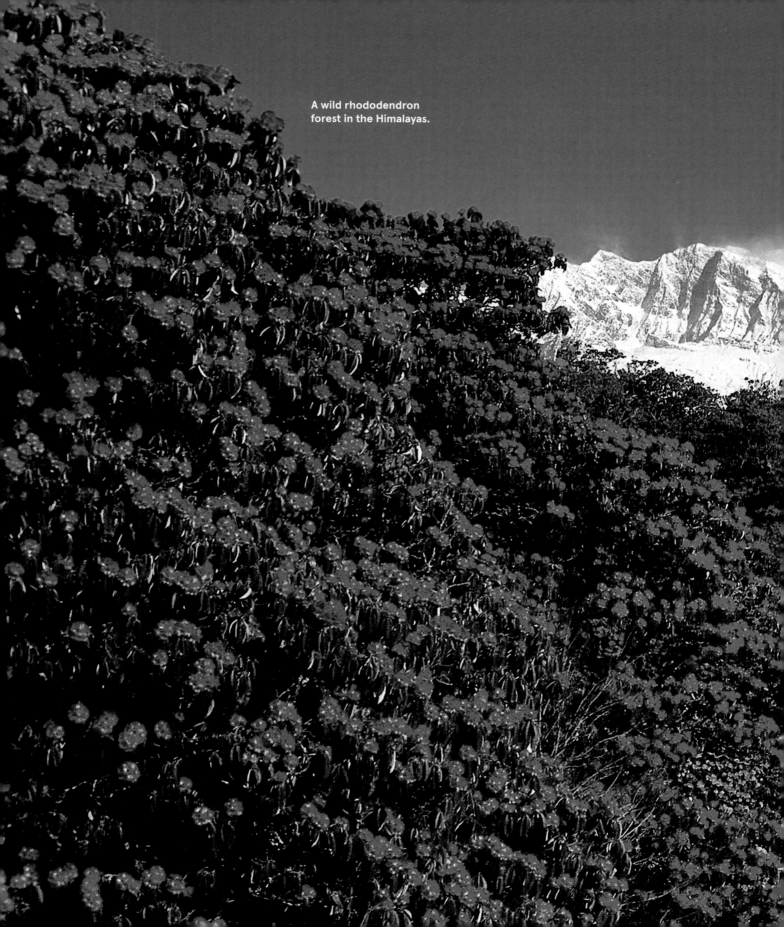

A wild rhododendron
forest in the Himalayas.

merely of twigs and foliage, but of thickset limbs and stout trunks, only to be severed with difficulty, on account of the toughness of the wood. As it is easily worked, and not apt to be split, it is admirably adapted for use in [this] parched and arid climate [,] and the Bhoteas make from it cups, spoons, and ladles, and the saddle by means of which loads are slung upon the "yak." The leaves are employed as platters, and serve for lining the baskets which contain the mashed pulp of *Arisaema* root (a kind of Colocass); and the customary present of butter or curd is always enclosed in this glossy foliage.

The leaves of Hodgson's rhododendron are still used by local people for a range of purposes; however, in China, it is very rare, with less than 1000 mature individuals, and its habitat quality and extent has been declining.

Sorbus bristoliensis

BRISTOL WHITEBEAM

Around the world, initiatives encourage the planting of threatened trees at schools, not only to educate students and others but to safeguard these species in their local environment. One example of this is One Tree per Child, a project that planted one specimen of *Sorbus bristoliensis* at various schools in Bristol, UK. University of Bristol Botanic Garden was involved in growing the saplings and in developing educational material to help teach children about this native tree, which is endemic to both sides of the Avon Gorge, near Bristol. The distribution of this long-lived species is extremely small; just over 300 trees were known in 2016, one of which was more than 227 years old.

Sorbus bristoliensis is an attractive tree with creamy white flowers. A variety of birds and small mammals eat its fruits. The trees are apomictic hybrids, meaning that they produce seeds without sexual reproduction (i.e., they are clones). The species grows on rocks and quarries, screes and slopes, and also occurs in woodland as a tall tree. On the Bristol side of the gorge, it is scattered in secondary woodland and scrub.

Several very rare *Sorbus* species share a preference for rocky slopes.

Cones on *Wollemia nobilis*, a true living fossil.

Wollemia nobilis

WOLLEMI PINE

Wollemia nobilis, long considered extinct, was rediscovered in 1994 by David Noble, an officer with the New South Wales National Parks and Wildlife Service. He was hiking in the Blue Mountains, not far from Sydney, when he came upon a tall tree he did not recognise. He carried some material back to botanists, who confirmed this was a species new to science—and named it in his honour. Wollemi pine is often called a living fossil, as its closest relative dates back over 65 million years ago. Taxonomically, it belongs to the Araucariaceae, the same family as the monkey puzzle (*Araucaria araucana*), another tree that was around in the time of the dinosaurs.

Wollemia nobilis is an extremely long-lived species; the oldest standing tree, "King Billy," is thought to be over 1000 years old. The main threats to the species are its very small population size (fewer than 100 adult trees in the wild) and restricted distribution, which make it is very susceptible to the effects of human activities or stochastic events such as fires; indeed, in 2020, Australian firefighters went to great lengths to save the existing grove from surrounding wildfires. Other threats include exotic pathogens, exotic weeds, trampling, and other forms of disturbance associated with unauthorised access. Changes in rainfall and temperature patterns associated with climate change represent further potential threats.

Wollemia nobilis is protected in Australia (the population is located within the Wollemi National Park). An ex situ conservation and research programme includes commercial propagation and sale of plants worldwide. Initially, Wollemi pines were propagated vegetatively from a limited stock of seeds taken from the wild and then released for sale worldwide in 2006. Propagation since has been from cultivated material. Royalties from sales are used to support conservation of this iconic species, and—most important of all—making Wollemi pines commercially available helps protect wild stands from illegal collections.

The attractive flowers of
Xanthostemon verdugonianus.

Xanthostemon verdugonianus

MANGKONO, PHILIPPINE IRONWOOD

Xanthostemon verdugonianus is a Philippine endemic, occurring on the islands of Sibuyan, Samar, Leyte, Homonhon, Dinagat, Hinatuan, Bucas Grande, Siargao, and Mindanao. The species grows abundantly in its locality of distribution, but large specimens are increasingly scarce; the southern side of Mount Guiting-Guiting has the largest remaining old-growth stand, with 500 mother trees.

The wood of this species, the hardest of the Philippine hardwoods, is used in making high-quality chairs and tables. Its survival is threatened by mining activities; happily, the Philippine government is now strictly regulating mining operations, and no new applications are allowed. Nevertheless, illegal poaching is still very common. It is estimated that over the last three generations, *Xanthostemon verdugonianus* has experienced a population reduction of up to 50 percent due to felling for timber and habitat lost to mining activities.

In the Philippines, *Xanthostemon verdugonianus* is now a flagship species for conservation, and mangkono saplings are planted in more than 150 institutions (mostly schools and parks) all over the country. Around the world, it is increasingly recognized for its ornamental value and is more and more seen in urban landscaping.

Special Tree Groups

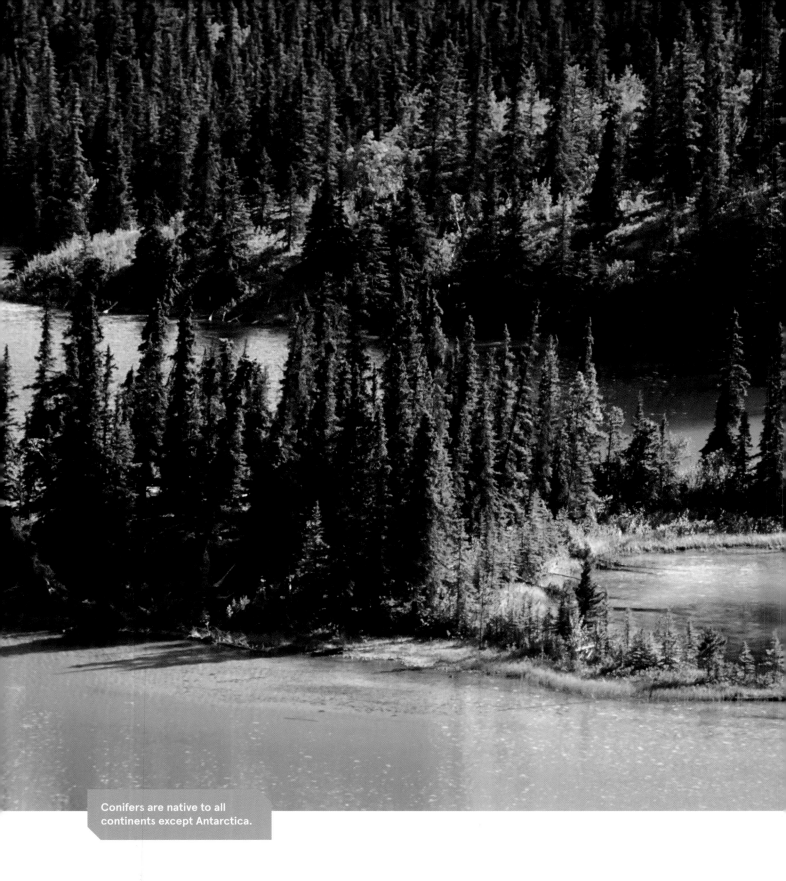

Conifers are native to all continents except Antarctica.

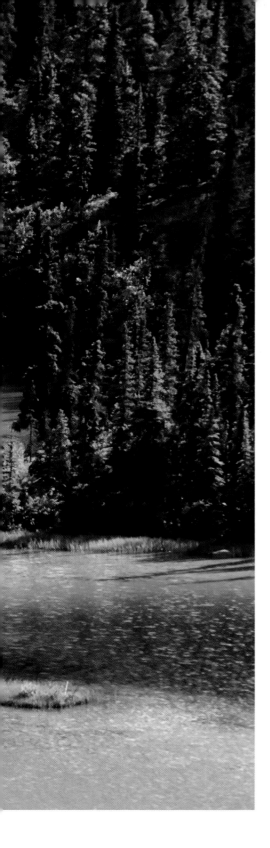

Conifers

Conifers are such familiar trees, associated with alpine vistas, Christmas celebrations, the imposing trees growing in our parks and gardens, and extensive forests in the northern parts of America and Eurasia. Plant collectors of the Victorian era introduced new conifer species to the country estates of Europe, with many fine specimens surviving today. There are around 630 different conifer species in total, with a surprising diversity of around 200 species growing in tropical parts of the world. Some species are very widespread; others are narrow endemics, clinging to survival in tiny forest patches. The diversity and distribution of conifers reflects their long history, one that dates back to the time of the earliest trees to evolve as land plants, 300 million years ago. Conifers represent one of four distinct lineages of surviving gymnosperms, the other three being *Ginkgo* (with only one species), gnetophytes (112 species), and cycads (339 species). Sadly over one-third of all conifer species are now threatened, as a result of logging pressures and forest clearance, including some species that have only recently been scientifically described.

Conifers are classified in eight families. The largest is the Pinaceae (pine family), with 231 species, including pine, spruce, larch, and fir trees—all found in the northern hemisphere. The Podocarpaceae (podocarp family) has 174 species, mainly of the tropics, with some species in temperate mountainous regions of the southern hemisphere. The Cupressaceae (cypress family) has 135 species distributed in both temperate and tropical regions. The other five families are Araucariaceae (monkey puzzles), Cephalotaxaceae (plum-yews), Phyllocladaceae (celery pines), Sciadopityaceae (umbrella pines), and Taxaceae (yews).

Because of their great international interest as economically and culturally important trees, conifers have inspired major conservation efforts. All species were assessed for the IUCN Red List in 2013, a major effort coordinated by Dutch botanist Aljos Farjon, as Chair of the IUCN/SSC Conifer Specialist Group, and jointly undertaken with staff at the Royal

Botanic Garden Edinburgh. The action plan that resulted has been a source of inspiration and guidance for subsequent conservation efforts.

The International Conifer Conservation Programme (ICCP) is a very important global initiative to conserve threatened species. Established at RBG Edinburgh in 1991, the ICCP continues to flourish, integrating ex situ and in situ conservation approaches. It combines research on taxonomy, genetics, conservation techniques, and cultivation methods with international capacity building to further conifer conservation. Coordinator Martin Gardner explains:

> Since the outset we have worked in more than 50 countries around the world, focusing on hotspots for conifer diversity and threat—Chile, New Caledonia, Laos, Vietnam, China, and

Word from Bedgebury National Pinetum

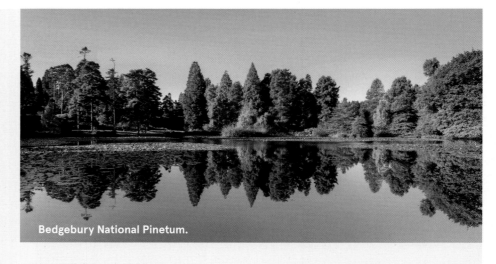

Bedgebury National Pinetum.

Dan Luscombe of the Bedgebury National Pinetum in the UK is a conifer enthusiast who has helped to rescue endangered species by studying them in the wild and nurturing them in cultivation. His passion for conifers developed at an early stage in his career when he trained in horticulture in the grounds of country estates, first at Killerton House and then at Saltram, both in Devon in southwest England. "Both these gardens have rich collections of trees and shrubs, which I personally prefer to herbaceous plants," says Dan. "I then studied for an advanced qualification in Horticulture at Bicton College, which has the longest avenue of monkey puzzle trees in the UK. This really fired my interest and enthusiasm for conifers. Now I have my dream job living and working in Bedgebury as the pinetum's Collections Manager."

other parts of Southeast Asia. Our activities include establishing new protected areas and a basic inventory of conifers in poorly known or remote areas, restoring degraded forests, and enhancing depleted populations. We have initiated programmes for sustainable utilisation of economically important species which include ex situ conservation and propagation. These activities build on RBG Edinburgh's core skills, including essential taxonomic research to understand and describe conifer diversity; our scientists describe new species and revise poorly known groups, such as the Podocarpaceae, using both traditional herbarium and modern taxonomic methods.

At an ex situ level, the aim of ICCP is to maintain representative collections of conifers that are threatened in the wild, ensuring that the collections contain a broad genetic base so that they can be used for effective research and to support the restoration of depleted wild populations. RBG Edinburgh has one of the world's most comprehensive collections of conifers in cultivation, with around 550 taxa growing in its four gardens in Scotland. Large collections of conifers grown from wild material collected in Chile are, for example, grown at Benmore, which boasts a 150-year-old avenue of redwoods.

Supplementing the collections at RBG Edinburgh, ICCP has developed a network of "safe sites" to accommodate large numbers of space-demanding conifer trees. Dispersing rare conifers to different ex situ sites helps to reduce the risk of trees being affected by losses from pests and diseases or extreme weather conditions. The network consists of 230 sites supporting 15,800 individual plants of 255 conifer species and varieties. This amazing network is mostly spread throughout Britain and Ireland, with some sites in Belgium, France, and Malta. For the more tropical conifer species, a network of sites in the US Southeast is coordinated through Montgomery Botanical Center and Atlanta Botanical Garden.

The Global Trees Campaign too has championed action for conifers that are in trouble in the wild. For the past 20 years, the Campaign has focused on high-profile species in a range of countries. There have been some impressive conservation and restoration success stories, but there is still plenty of work to do to ensure that all conifers survive the continuing onslaught of global threats.

CONIFERS IN THE AMERICAS

Abies fraseri

FRASER FIR

Abies fraseri is an attractive conifer native to the US. With its elegant form, excellent retention of the needle-like leaves, blue-green to silvery-green colour, and tremendous scent, it has been a popular Christmas tree in the US since it was first sold commercially in the 1940s. Fraser fir frequently appears as the official Christmas tree in the annual White House decorations, chosen more often than any other species. Its popularity and familiarity in commercial settings may make it seem unlikely to land on an endangered species list, but although endemic to the US, this species is found only on the highest slopes and summits of the Appalachian Mountains in southwestern Virginia, western North Carolina, and eastern Tennessee, where it is restricted to six disjunct populations.

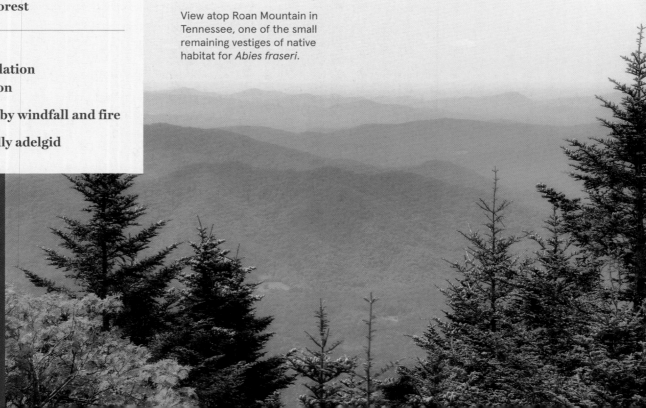

View atop Roan Mountain in Tennessee, one of the small remaining vestiges of native habitat for *Abies fraseri*.

Young cones growing on *Abies fraseri*.

Populations of Fraser fir are susceptible to destruction by windfall and fire; however, by far the most damaging threat to this species is the tiny sucking balsam woolly adelgid (*Adelges piceae*), first introduced from Europe around 1900. Once infested, the tree, no longer able to transport water and nutrients, ultimately starves. By the 1980s, millions of Fraser fir trees had died in America, with only one population remaining largely unaffected. This species is now listed as endangered on the IUCN Red List.

Natural regeneration of this species in areas affected by the balsam woolly adelgid has been rapid, thanks to a lack of canopy cover, and healthy young trees are regrowing where mature forests once stood. These seedlings are infested but appear to be overcoming the effects. The continuing presence of Fraser fir in natural forests depends on the seedlings reaching reproductive age. It is hoped that eventually trees will develop resistance to this destructive pest.

Unfortunately, however, *Abies fraseri* is also considered by scientists to be one of the tree species at greatest risk of extinction within the Appalachian forests as a result of climate change. It shares this fate with two other conifers, *A. balsamea* var. *phanerolepis* (intermediate balsam fir), which is listed as data deficient by IUCN, and *Tsuga caroliniana* (Carolina hemlock), listed as near threatened.

The demise of the Fraser fir forest also has implications for other rare species that rely on it, for example, the endangered Weller's salamander (*Plethodon welleri*) and rock gnome lichen (*Gymnoderma lineare*).

Abies guatemalensis
GUATEMALAN FIR

NATURAL RANGE

El Salvador, Guatemala, Honduras, southern and central Mexico

PREFERRED HABITAT

Subtropical to tropical moist montane forest

THREATS

Housing and urban sprawl

Clearing for crops

Livestock farming and ranching

Gathering for decorative use and charcoal production

Logging

This conifer, found in the cloud forests of Mexico, Guatemala, El Salvador, and Honduras, has the most southerly distribution of its genus. It is a large tree with a long history of exploitation for charcoal, pulp, plywood, and rough timber (such as shingles), thanks to its straight stems and relatively soft wood. Harvesting of the species is prohibited by national law in Mexico and Guatemala.

Harvesting of *Abies guatemalensis* as a Christmas tree has taken place since the 1960s, with branches of adult trees and entire young trees being removed from the forest. With the rising demand for Christmas trees in Guatemala, plantations have been developed; but practical knowledge of cultivating *A. guatemalensis* remains limited, and production is currently dominated by just a few commercial plantations. Studies investigating the use of *A. guatemalensis* in the Christmas tree trade estimated that over 100,000 illegally sourced wild trees were sold in 2005 compared to only 5000 nursery-grown trees. High prices, poor shape, and difficulty in locating sellers were given as the main reasons illegally sourced trees were chosen over nursery-grown trees. Ideally, local communities should work together to set up additional *A. guatemalensis* Christmas tree plantations to provide an alternative sustainable source of income and to help alleviate pressure on the tree in the wild. Local people could also be trained in professional shearing techniques to improve the appearance of nursery-grown *A. guatemalensis* and encourage more Guatemalans to buy their Christmas tree sustainably.

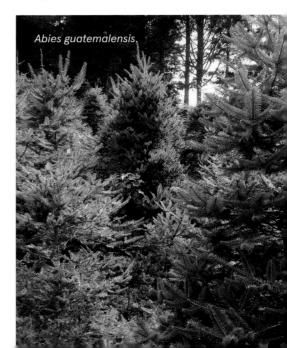

Abies guatemalensis.

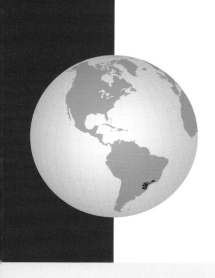

Araucaria angustifolia

PARANÁ PINE

IUCN RED LIST CATEGORY

Critically Endangered

NATURAL RANGE

Southeastern Brazil, adjacent Argentina and Paraguay

PREFERRED HABITAT

Subtropical forest

THREATS

Timber exploitation

Fruit and seed collection for human consumption

Population fragmentation due to forest clearance

Faster-growing monoculture species

Araucaria holds 20 species, two in South America and the rest native to Norfolk Island, Australia, New Guinea, and New Caledonia. Described as living fossils, members of this genus were previously much more widespread, providing an important source of food for the dinosaurs. At the end of the Cretaceous, when dinosaurs became extinct, the Araucariaceae also became extinct in the northern hemisphere.

Araucaria angustifolia is a towering species, to 40 metres tall, with a flat-topped crown and thick scale-like triangular leaves. It occurs in Brazil (primarily in the states of Paraná, Santa Catarina, and Rio Grande do Sul, and sparsely in São Paulo, Minas Gerais, and Rio de Janeiro), Argentina, and Paraguay. In Argentina, small relict populations, covering less than 1000 hectares, are found in northeastern Misiones. The Paraguay population of *A. angustifolia* is small (confined to Alto Paraná), with few trees that produce seed. Paraná pine is a dominant tree in the species-rich forests of the mountain landscapes, forests which are a relict of a once-widespread ecosystem of mixed coniferous and broadleaved trees.

Oliver Wilson, a PhD student at Reading University in the UK, is researching southern Brazil's highly biodiverse but threatened *Araucaria* forests and their relations with people and climate through time. He explains:

> Fossil pollen studies show that *Araucaria* forests expanded rapidly over surrounding grasslands around 1000 years ago, at a time when archaeological evidence shows the indigenous Southern Jê people were thriving. *Araucaria angustifolia* was (and is) a cultural keystone species for these groups, playing a key role in their diets and ritual life. My research aims to disentangle the roles people and climate changes played in driving past expansions of

Araucaria forest, so we can better understand how these iconic, diverse, and fragile ecosystems will cope with changing conditions in the 21st century and beyond.

The original extent of *Araucaria* forest was an estimated 200,000 km²; it is believed to have declined from this by more than 97 percent in the last century as a result of commercial logging and clearance for agriculture. In the past, Paraná pine was one of Brazil's most important timbers, and as recently as 30 years ago it was sold around the world as domestic staircases and other products. In addition to the massive exploitation for timber, large quantities of the cones and seeds are still collected each year for food. In 2017, 9293 tonnes were collected with a value of over US$5.5 million. The pinhões (seeds) are boiled or roasted before consumption and are so popular that the annual Festa do Pinhão, in Lages, Brazil, is held to celebrate them. The pinhões remain an important local food source today, with 3400 tonnes collected each year. Other parts of the tree are also utilized—for example, preparations of the tree's leaves, bark, and resin are used in traditional medicine to treat a range of ailments, including rheumatism, anaemia, open wounds, and sexually transmitted infections.

Araucaria angustifolia suffered a dramatic population decline during the 20th century and is now considered critically endangered by IUCN. It is included on the official list of threatened Brazilian plants compiled by IBAMA, giving it legal protection at the national level, with logging of the species now banned. Nevertheless, the forests continue to be cleared for wheat, soybean, and corn production. Together with Paraná pine, 72 of the native tree species in the region are threatened or extremely rare. In the face of extreme habitat loss, many threatened species are failing to regenerate naturally and are in need of active conservation support.

Now restoration of the *Araucaria* forests, which grow in the Andes at elevations of 600–1800 metres, is starting to gain momentum. There are major plans to restore forests across Brazil, with the Brazilian government committed to restoring 12 million hectares of forest by 2030 in response to the Bonn Challenge. To ensure that biodiversity conservation is adequately addressed as part of restoration, it is important to ensure that a large diversity of native and threatened species are included in the tree planting schemes. FFI is helping to make this happen in the *Araucaria* forests of southern Brazil. Working with a local partner, Sociedade Chauá, the strategy is to catalyse a change in restoration practice, engaging with the nurseries and planting organisations working in the *Araucaria* forest to increase the number of threatened tree species they grow and plant.

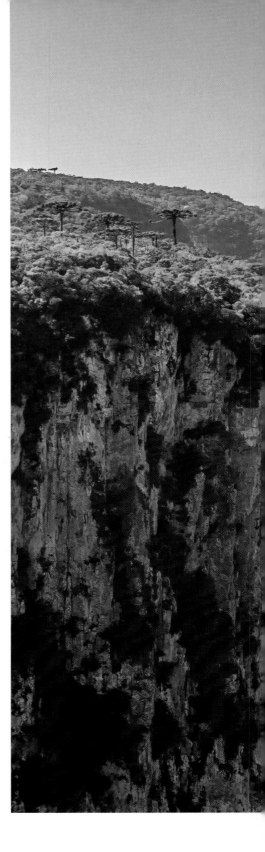

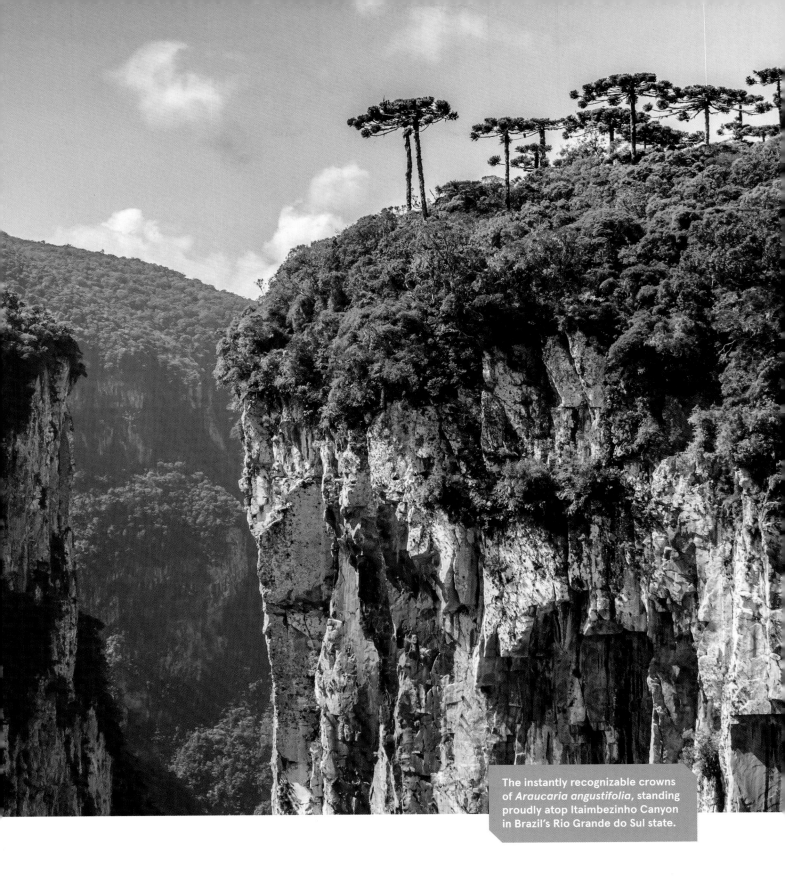

The instantly recognizable crowns of *Araucaria angustifolia*, standing proudly atop Itaimbezinho Canyon in Brazil's Rio Grande do Sul state.

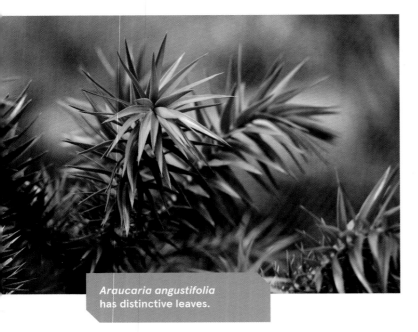

Araucaria angustifolia
has distinctive leaves.

This involves tackling the issues that currently limit the use of threatened species, including the highly important *A. angustifolia*. To do this, knowledge on how to grow a range of species needs to be made widely available. The supply of seed needs to be increased along with building awareness and motivating the groups buying trees for restoration.

Researchers working since 2011 have located mother trees in the wild as a source of seed and worked out when seed should be collected. Threatened trees are grown in Chauá's nursery for planting out across the *Araucaria* forest, providing an example for others to follow. Training is provided to other nurseries, helping them to grow more threatened tree species and increase the supply of seedlings available for tree planters. Pablo Hoffmann of Sociedade Chauá explains:

Our work is leading to real changes in restoration practice in southern Brazil, with more than 20,000 seedlings, from 40 different threatened species, planted out across the region by 25 other planting projects. These are run by farmers, NGOs, businesses, and universities, and through our engagement, these groups have shifted from growing a small selection of common species to a wider selection of threatened species. Now, 11 other tree nurseries have added threatened species into their production, following training from Chauá. In total we have more than 130 different species (more than one-third of the region's entire tree flora) growing in this nursery, and we are constantly learning more about how best to grow and plant them.

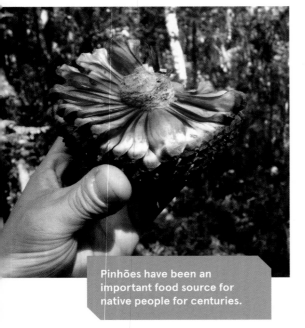

Pinhões have been an important food source for native people for centuries.

Restoration work will also need to consider climate change and how to build ecological resilience into the forest. Oliver Wilson's work, looking at the impact of climatic and human factors in the past, is helping to develop models that predict how the critically endangered and iconic *Araucaria* trees will respond to future climate change. So far his work indicates that only 3.5 percent of the forest fragments where Paraná pine occurs will remain as suitable habitat by 2070 as a result of climate change. Non-forested areas in the highlands of the Campos might be the most suitable refugia for this iconic species in the future.

Araucaria araucana

MONKEY PUZZLE

IUCN RED LIST CATEGORY

Endangered

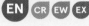

NE DD LC NT VU **EN** CR EW EX

NATURAL RANGE

Southern Chile and Argentina

PREFERRED HABITAT

Temperate forest, mountainous areas

THREATS

Deforestation from fire, logging, overgrazing

Severe population fragmentation

Exotic species plantations

Araucaria araucana, the other South American species in the genus, grows in temperate rainforests of southern Chile and adjacent areas in Argentina, attaining heights of up to 50 metres. Monkey puzzle trees are adapted to survive in volcanic soils, growing with various *Nothofagus* species. In Chile, where it is the national tree, the species also occurs in the Coastal Range, together with the South American puma, Darwin's fox, and pudu deer.

Araucaria araucana is familiar to many people in Europe and the US as an ornamental, and it is also well represented in botanic gardens. The first European to describe it was an employee of the Spanish government, Don Francisco Dendariarena, in 1780. Plants were brought to Europe in 1795 by Archibald Menzies, the naval surgeon aboard Captain Cook's ship *Discovery*. Menzies was served monkey puzzle seeds by the governor of Chile, as a dessert. He took some of the seeds back to the *Discovery*, sowed the seed into frames, and managed to raise five seedlings. On his return to England, three of the seedlings were given to Joseph Banks at the Royal Botanic Gardens, Kew; one survived and thrived for nearly a century. William Lobb, a Cornish plant collector who worked for the famed James Veitch and Sons nursery, collected seed from Argentina in 1842 and is credited with the start of the monkey puzzle craze.

This iconic tree species is of great historical and social importance in its native range. The edible seeds or piñones are an important food source for the indigenous Araucanos of Chile and Argentina, who consider monkey puzzles to be sacred. The seeds, very rich in carbohydrates and proteins, are roasted and dried to make flour; they have a taste similar to that of chestnuts.

In the wild, *Araucaria araucana* is highly threatened in its native range. Its natural ecology is related to disturbance, with the species naturally adapted to cope with the effect of volcanoes, fire, landslides, snow avalanches, and wind—it is often one of the first "colonists" of rocky sites

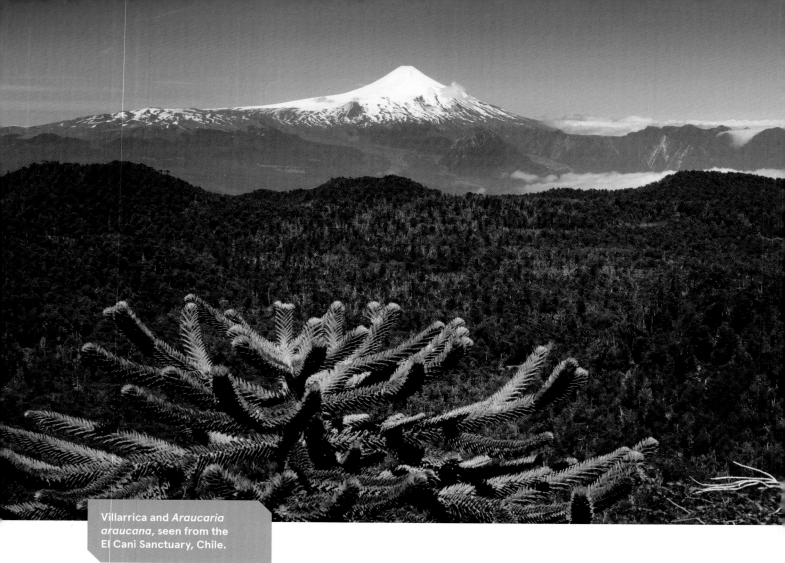

after a burn event or other disruption. Yet this ancient tree, with a history dating back 200 million years, has not been able to cope with the onslaught of human threats. Logging of monkey puzzle is a direct threat; its soft, medium-weight wood is prized for its durability and resistance to fungal decay. Historically felling has been for timber production, with early use in Chile for pit props; the wood has subsequently been used as beams in buildings, flooring, furniture, veneer, plywood, paper pulp, and ship masts. Replacement of natural forests with exotic timber plantations of eucalyptus and Monterey pine (*Pinus radiata*) has been another major threat. In Chile, there are now 2 million hectares of pine compared to just 253,713 hectares of *A. araucana* forest. Ironically, given its natural adaptation to cope with fires in the dramatic volcanic landscape, burning over the past century has been another significant threat. The frequency of fires increased during the 20th century as land was cleared for farming

and livestock production, leading to severe fragmentation of *Araucaria* forests. In Chile, major fires in the summer of 2001–02 destroyed 30,000 hectares of native forest; in Malleco National Reserve, one of the three reserves affected, 71 percent of the monkey puzzle area was destroyed. Some of the monkey puzzle trees were over 2000 years old. In 2014 a national emergency was declared in Chile when intense fires burned through more than 6000 hectares in at least three national parks. Conservationists feared for the ancient trees within the sites, which contain the only officially protected individuals in the country. In Argentina, over 40 percent of the *Araucaria* forests have been lost.

In 2013, *Araucaria araucana* was upgraded from vulnerable to endangered on the IUCN Red List. The small remnant populations remain vulnerable to persisting threats of deforestation, grazing, seed collection, and expansion of exotic timber plantations. These threats are all exacerbated by natural and anthropogenic fire and low levels of natural regeneration. Under natural conditions, regeneration follows a "pulse" pattern of highly productive seed years followed by less productive ones. Each cone releases 120–200 seeds. Seed is gravity-dispersed or assisted by austral parakeets (*Enicognathus ferrugineus*) and other animals. Seed

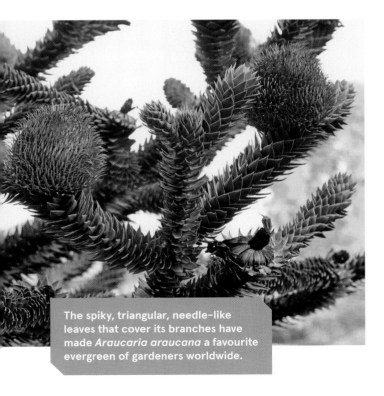

The spiky, triangular, needle-like leaves that cover its branches have made *Araucaria araucana* a favourite evergreen of gardeners worldwide.

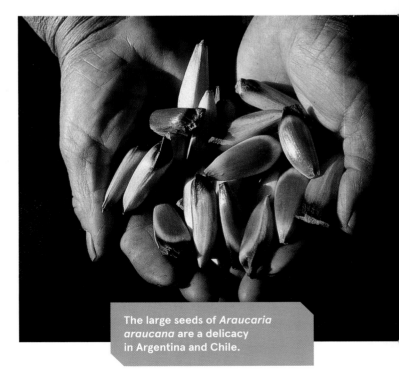

The large seeds of *Araucaria araucana* are a delicacy in Argentina and Chile.

New Caledonia: Land of Ancient Araucarias

Like their relatives in South America, araucarias on the small South Pacific island of New Caledonia are also under threat. Incredibly, this small French-administered territory of just 18,576 km² hosts 14 of the world's 20 *Araucaria* species. The main island of Grand Terre is considered to be an original piece of Gondwanaland, which separated from Australia 85 million years ago. Seventy-five percent of all plants that occur in New Caledonia are endemics, including all the araucarias and over 20 other conifers. The uniquely remarkable flora of New Caledonia is a top global priority for conservation. General habitat destruction is a major threat to the vegetation, and open cast mining is a specific threat: as of 2022, New Caledonia holds 10 percent of the world's nickel deposits.

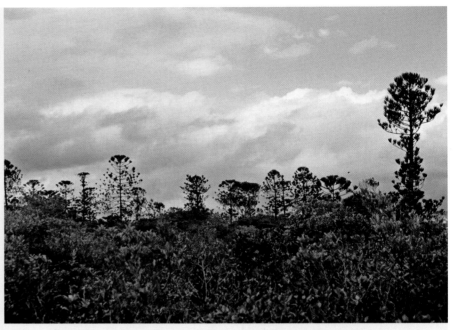

The critically endangered *Araucaria nemorosa* lives exclusively at the southern tip of New Caledonia.

Fire is another major problem for the araucarias, which are found in habitats ranging from sea level to the tops of the highest mountains.

Eleven of the 14 *Araucaria* species of New Caledonia are recorded as threatened by IUCN, and one of those, *A. nemorosa* is critically endangered. The total population of this tree is less than 5000 mature individuals, over 90 percent of which are found in small fragments in coastal lowlands around Port Boisé in southern New Caledonia. Here the tree is mainly threatened by fire. The species is also found a little way inland at Forêt Nord, where nickel mining is being developed. Genetic research indicates high levels of inbreeding as a result of fragmentation. Natural regeneration is very low; the species sets few seed, and it is very rare in cultivation. Fortunately attempts to restore this extremely rare araucaria are underway: a corridor connecting the sites of the few remaining trees is being created, and the ICCP is supporting this vital work.

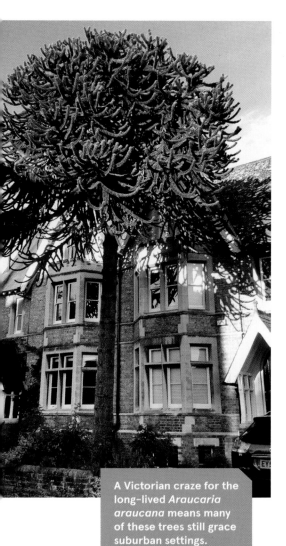

A Victorian craze for the long-lived *Araucaria araucana* means many of these trees still grace suburban settings.

is relatively heavy and tends not to disperse over large distances. More typically, regeneration is by sprouting from the roots of the tree.

Despite all these challenges, conservation action on a range of fronts is well established. In 1990 *Araucaria araucana* was declared a national monument, a legally protected species in Chile, forbidding its logging. International trade in timber and seeds of the species is also regulated by CITES; any international trade in timber taken from the wild is now banned.

Cristian Echeverria has been involved in conserving the tree flora of Chile throughout his career. He pioneered a technique for mapping the fragmentation of the native forests using remote sensing from satellite images. These maps have been used to monitor ongoing forest loss. Reconstructed maps show that in 1550, when the Europeans arrived, virtually the entire country of Chile was covered in forest. Cristian has also been involved in many practical efforts to conserve araucarias and also Chile's endemic trees. He believes that education of the private landowners is key to the survival of wild forest. "Chile has a good transport infrastructure and is particularly inviting for ecotourists wanting to visit South America," he explains. "The forests of the Andes have a rare beauty and could be a considerable attraction for travellers. Already several Chilean private initiatives are helping to protect *Araucaria* forests, and these include Parques para Chile and Reserva Nasampulli." In Chile, the Villa Las Araucarias forest restoration project restored a severely degraded 4-hectare site with support from FFI in the early days of the Global Trees Campaign; educational programmes were also conducted. Follow-up surveys conducted in 2013, more than a decade after 2000 monkey puzzle seedlings were planted in the wild by the GTC, found that 90 percent of the seedlings had survived.

Protection of *Araucaria* forests in both Argentina and Chile is vitally important. In Argentina, most stands have some form of protection, especially in Parque Nacional Lanín and Nahuel Huapi; however, small and fragmented stands toward the eastern range in Argentina, which are as genetically diverse as those on the Andes, occur outside protected areas and deserve particular attention. In Chile, approximately 66 percent of the forests in the Coastal Range are within private properties, and the State (SNASPE) protects 34 percent. The Nahuelbuta National Park is another site for conservation of the monkey puzzle and other rare species in this region.

Anyone who is lucky enough to see *Araucaria araucana* in its natural setting cannot fail to be impressed: the monkey puzzle forests

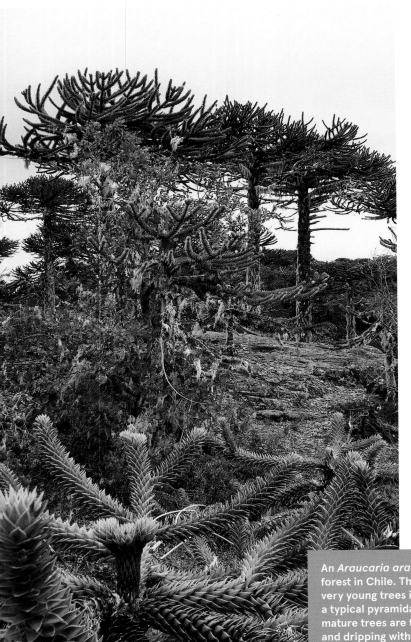

are not dark and oppressive but filled with soft shades of grey and green. Even if you haven't had the opportunity to visit the monkey puzzles of Argentina and Chile, they continue to inspire and thrill people wherever they have been planted. Sarah Horton, for example, is a keen gardener who lives in Liverpool. Her love for these extraordinary trees led to her personal mission to catalogue and map all known monkey puzzle trees. Initially, the Monkey Map was just for the UK, but it expanded and inspired people from all around the world. In three years, Sarah collected almost 4000 trees from her own observations and from many others who supported the Monkey Map. As she explains, "The project showed that there is a real love of the monkey puzzle tree, as well as how projects like this can gain public support for the natural world and the plight of endangered species by encouraging people to join in and look around their own environments."

An *Araucaria araucana* forest in Chile. The form of very young trees is that of a typical pyramidal conifer; mature trees are top-heavy and dripping with lichens.

Fitzroya cupressoides

PATAGONIAN CYPRESS, ALERCE

IUCN RED LIST CATEGORY

Endangered

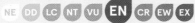

NATURAL RANGE

Southern Chile and Argentina

PREFERRED HABITAT

**Temperate rainforests
with volcanic soils**

THREATS

Livestock farming and ranching

Logging and wood harvesting

Fire and fire suppression

Fitzroya cupressoides, the only species in its genus, is evolutionarily distinct from other species in the Cupressaceae. The name, chosen by Joseph Hooker, honours meteorologist Robert FitzRoy, captain of Darwin's HMS *Beagle*. Endemic to the temperate rainforests of Chile and southern Argentina, this species has a discontinuous distribution in the Coastal Cordillera, the mountain chain that runs along the Pacific coast, the Chilean Central Valley, and the Andes. Its genetic distinctiveness is just one of the reasons it deserves conservation attention.

Fitzroya cupressoides is a massive evergreen, the largest tree species in South America. Individuals up to 70 metres in height have been recorded, with trunks up to 5 metres in diameter. Like the giant redwoods, it is a very long-lived, slow-growing tree. In 1993, the oldest known specimen in Chile was estimated to be 3622 years old, making it the second-oldest living tree species in the world, after the bristlecone pine. The bark of alerce is brownish red, deeply furrowed, and fibrous. Its leaves change shape throughout its life; they are long and flattened initially, arranged in alternating whorls of three, becoming ovate and scale-like as the tree matures.

Alerce grows in areas of volcanic activity, in the forests of Chile and Argentina; the trees grow on poorly drained soils derived from volcanic ash. Despite the heavy rainfall associated with them, these ancient forests are fire dependent. *Fitzroya cupressoides* benefits from burning episodes, which it often follows with a period of high growth, frequently colonising the bare volcanic soils. Seed production is highly variable; like the monkey puzzle, alerce has "pulses" of seed production, with trees able to sustain 5- to 7-year periods of low to no production. The suppression of forest fires may contribute to poor species regeneration; at the same time, major fires have caused significant losses to the alerce forests.

Alerce is a very valuable timber with a beautiful red grain; it is elastic and light and strongly resistant to rot. It is thought to have been used

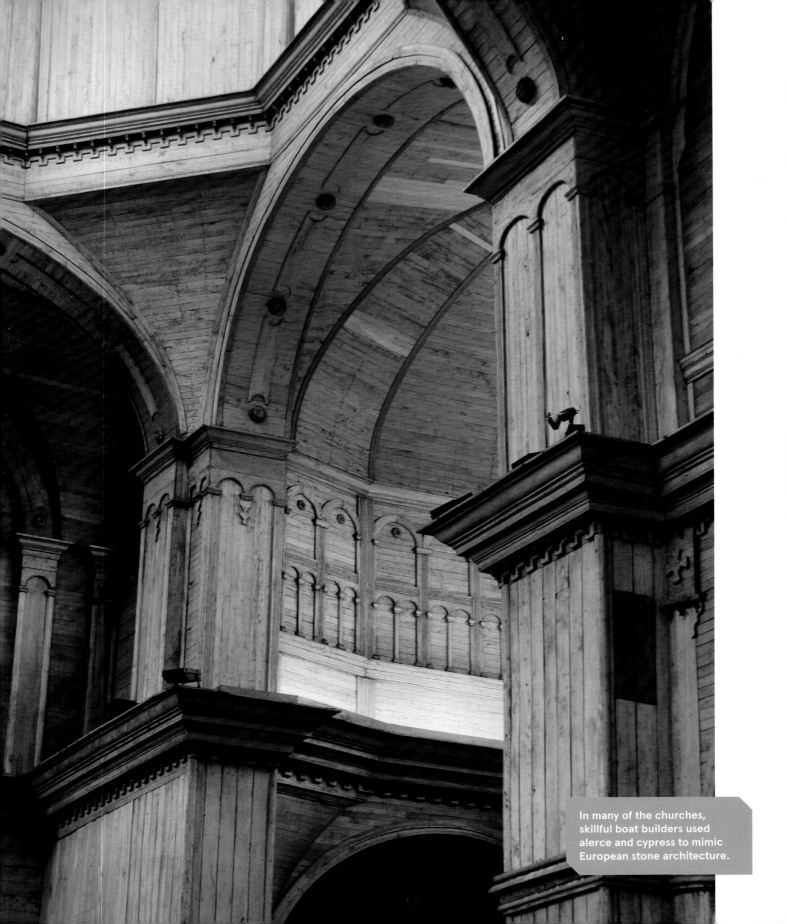

In many of the churches, skillful boat builders used alerce and cypress to mimic European stone architecture.

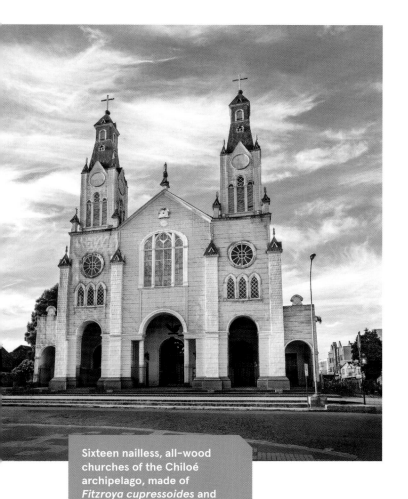

Sixteen nailless, all-wood churches of the Chiloé archipelago, made of *Fitzroya cupressoides* and cypress, have been standing since the 1700s, thanks to the strength and natural durability of the wood.

on a small scale for at least the last 13,000 years; however, it is only in the last three centuries or so that *Fitzroya cupressoides* has suffered from over-exploitation. During this time, its highly prized wood has been used to make fine furniture, musical instruments, and boats. In southern Chile, the production of roof tiles or shingles has created a typical style of architecture for homes and churches. The export of *F. cupressoides* was an important part of the economy of Chiloé Archipelago, which in the colonial era used a currency made from its wood, the *real de alerce*. The 16 wooden churches of the archipelago are a World Heritage site. Entire logging communities developed near the alerce groves in southern Chile during the 19th century, with alerce exports a highly lucrative business for the remote settlements. During many years of uncontrolled forest harvest, alerce was the most extensively logged conifer in Chile.

Alerce was listed in CITES Appendix I in 1975, affording it the highest degree of protection. The following year, Chile declared the species a national monument, giving it legal protection. In 1979 *Fitzroya cupressoides* was included as a threatened species under the US Endangered Species Act; this prohibited import of wood to the US, which had previously been a significant importer. Despite national and international legal protection prohibiting the exploitation of live trees, logging has continued in a limited scale courtesy of various legal loopholes, such as the sale of "dead specimens" from forests that have been burned. According to Cristian Echeverria, "The long-term conservation of *Fitzroya* forests remains a great challenge that depends on bringing people together with active participation of individuals, indigenous communities, private companies, and government agencies. We need to both protect undisturbed areas of forest and restore areas that have become degraded by human use. We also need to understand the implications of climate change for this tree, which is so important for our cultural and ecological heritage."

In Chile, around 20 percent of *Fitzroya* forests are now protected within national parks and national reserves, with the remaining forests

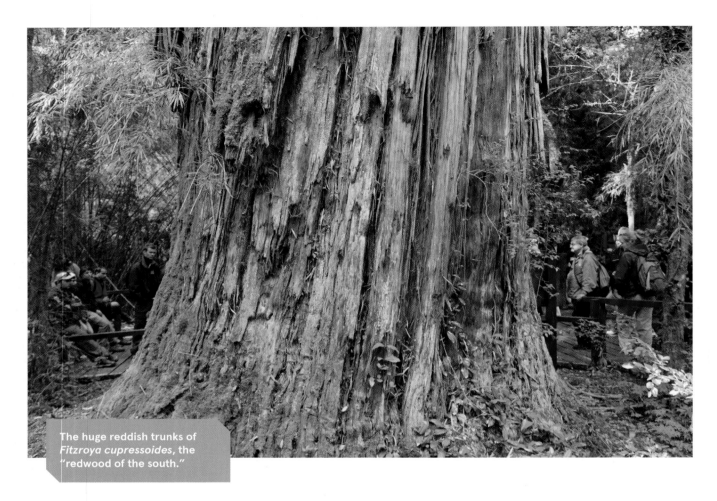

The huge reddish trunks of *Fitzroya cupressoides,* the "redwood of the south."

mainly found within private properties. The largest such area is Pumalín Douglas Tompkins National Park, which protects 715,000 acres of Valdivian temperate rainforest with magnificent alerce trees. The Pumalín Project began in 1991, when Douglas Tompkins, founder of the North Face and Esprit clothing companies, acquired 17,000 hectares in the Reñihué Valley to protect its temperate forest, which was threatened by logging. The project grew to 293,000 hectares, which were ultimately donated to the government of Chile. The park now has a network of trails, campsites, information centres, and tourist amenities, enabling visitors to enjoy the wild landscape of forests and snow-clad mountain peaks. Community projects promote environmental and agroecological education.

Ecological restoration is now taking place in the alerce forests of Chile. Researchers from Universidad Austral de Chile are restoring areas

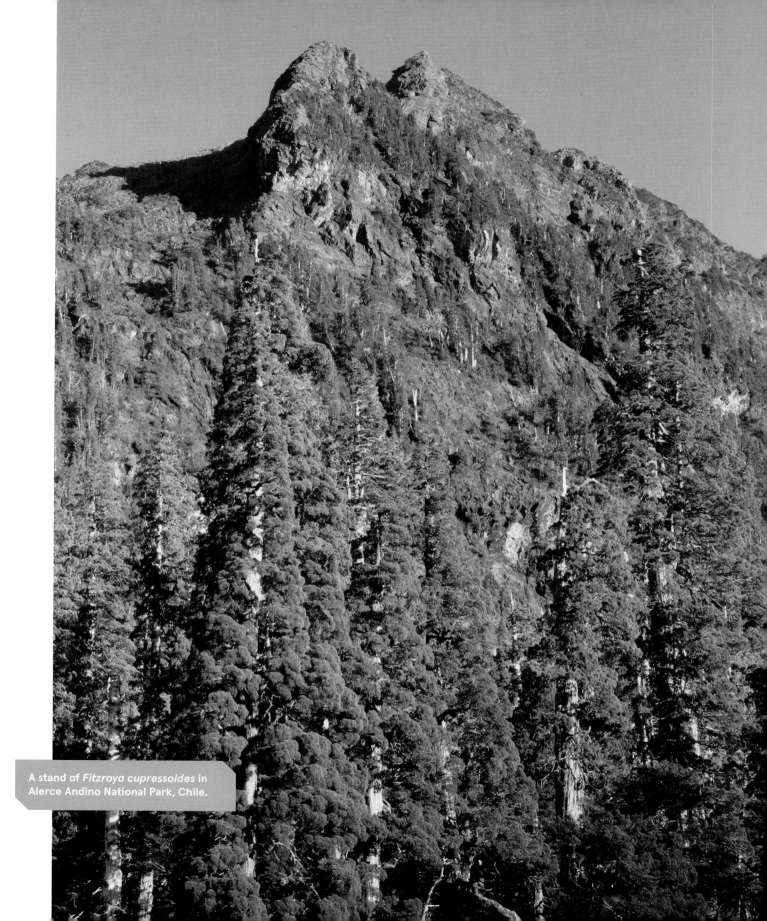

A stand of *Fitzroya cupressoides* in Alerce Andino National Park, Chile.

of alerce in the Chilean Central Valley, where *Fitzroya cupressoides* has been nearly wiped out. There is only one protected site, Monumento Natural Lahuen Nadi, and the cities of Puerto Montt and Puerto Varas continue to expand, putting pressure on natural forest habitats. The researchers are working with a local landowner and the regional office of CONAF, the Chilean Forest Service. They are using nursery-grown seedlings of local provenances. This exciting work is supported by the ICCP, which adopted *F. cupressoides* as a flagship species at the outset.

In Argentina, over 80 percent of *Fitzroya* forests occur in protected areas. Los Alerces National Park, a World Heritage site, is located in the Andes of northern Patagonia with its western boundary along the border with Chile. This protected landscape of 259,822 hectares was shaped by successive glaciations that created spectacular features, such as moraines, glacial cirques, and clear-water lakes. The vegetation is dominated by dense temperate forests, home to 36 percent of all Argentina's alerce trees. Population research has shown, however, that two remote southern Argentinean populations (Río Tigre and Lago Esperanza) are genetic hotspots for alerce. These sites are considered very important for the conservation of the species, as they are almost untouched and are representative of *Fitzroya* forests prior to European colonisation. Currently outside protected areas, protection of both sites is urgently needed.

Fitzroya cupressoides was first introduced into cultivation by William Lobb in 1849, following his second expedition to South America. Molecular research by the ICCP conducted 20 years ago demonstrated that virtually all specimens of the species in cultivation in the UK are clones of that original introduction. Attempts have subsequently been made to broaden the genetic basis of *F. cupressoides* in cultivation, for use in conservation programmes. As well as in the UK, the species is represented in botanical collections internationally, with 63 ex situ collections recorded in the BGCI PlantSearch database.

In the long term, a landscape approach is best for the conservation of *Fitzroya cupressoides*. Buffer areas, with sympathetic land management, are needed around the fragmented patches of natural forest. Restoration will help to boost the remnant trees, so that *Fitzroya* forests continue to flourish after centuries of decline.

Botanical drawing of
Fitzroya cupressoides.

Juniperus barbadensis var. *barbadensis*

BARBADOS CEDAR, PENCIL CEDAR

 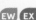
NATURAL RANGE

Saint Lucia

PREFERRED HABITAT

Rocky outcrops of Petit Piton

THREATS

Exploitation for fuel wood and timber

Fire (in Cuba)

Competition from invasive species

Urbanization

The 67 species of the genus *Juniperus* mainly grow in the northern hemisphere, where they are well known as garden plants and as the flavouring for gin. One species is found only in the Caribbean, *J. barbadensis* (West Indies juniper), recorded as vulnerable by IUCN. Centuries of use for timber, fire, urbanisation, tourism development, and the introduction of invasive alien species—the scourge of so many island floras—have led to its decline. This species has two recognised varieties. The more widespread *J. barbadensis* var. *lucayana* grows in the Bahamas, Cuba, and Jamaica; it is extinct in Haiti. Sadly the other, *J. barbadensis* var.

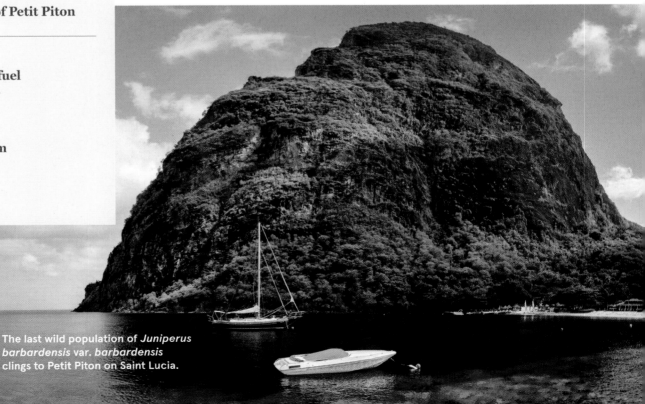

The last wild population of *Juniperus barbardensis* var. *barbardensis* clings to Petit Piton on Saint Lucia.

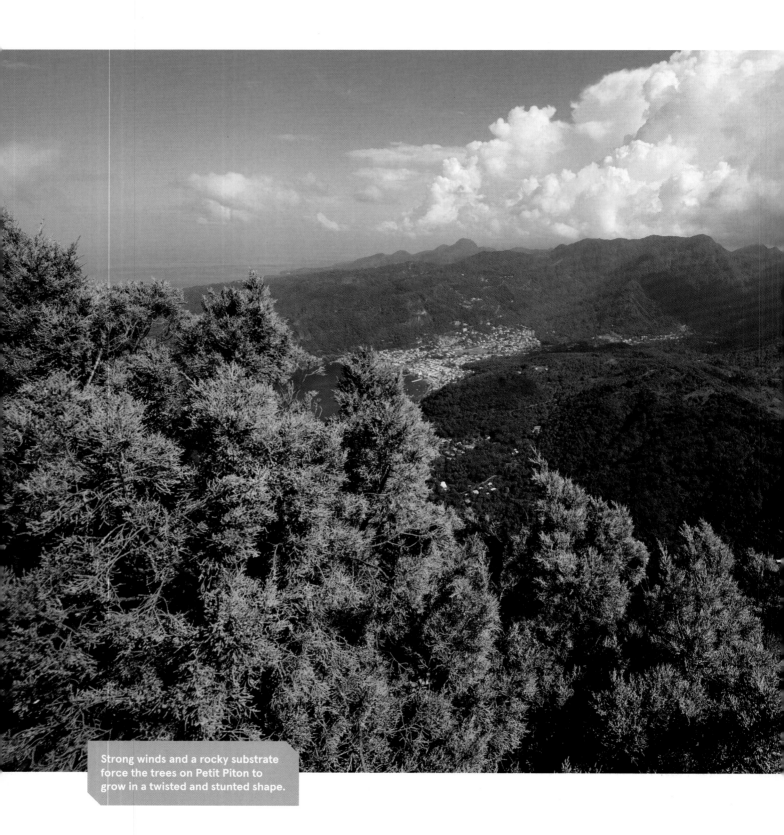

Strong winds and a rocky substrate force the trees on Petit Piton to grow in a twisted and stunted shape.

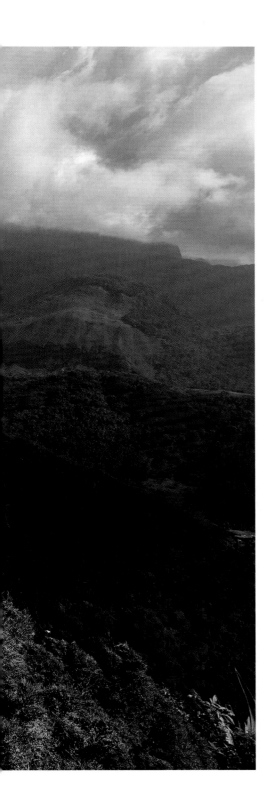

barbadensis, once relatively common on the islands of Saint Lucia and Barbados, is extinct on Barbados as a result of habitat destruction and the spread of invasive species and close to extinct on Saint Lucia—its final refuge. The entire global population of *J. barbadensis* var. *barbadensis* is confined to less than 50 mature specimens on the picturesque peak of Petit Piton (700 metres). This area is included in the Pitons Management Area, a UNESCO World Heritage site, recognised for its outstanding natural beauty, volcanic features, and rich biodiversity. In less extreme environments, the tree naturally grows into a tall conical shape, like any other Christmas tree; on Petit Piton, it is stunted and twisted by the wind.

The Pitons Management Area is part privately owned, part government land. A management plan with zoning accommodates both limited resource use and nature conservation. The rugged terrain helps protect the native flora, but with such a small population , Barbados cedar is far from secure. Climate change is one potential threat. Now, through the Global Trees Campaign, FFI is working with the Saint Lucia Forestry Department to propagate *Juniperus barbardensis* var. *barbardensis* in its tree nurseries. The plan is replant the taxon in the lowland forests where it once thrived. The nursery is also making plants available to the public for use as Christmas trees. By encouraging people to buy a native conifer instead of introduced species and to plant out their trees in gardens and farms once the festive season is over, the project aims to create a new Christmas tradition, one that will help secure the future of Saint Lucia's native tree.

Pinus albicaulis

WHITEBARK PINE

IUCN RED LIST CATEGORY

Endangered

NATURAL RANGE

Canada (Alberta, British Columbia), US (Idaho, Washington, Montana, Wyoming, California, Nevada, Oregon)

PREFERRED HABITAT

High, rocky inland cliffs and mountain peaks

THREATS

Pathogens and pests

Wildfire

Shifting habitat due to climate change

Pines are among the world's most important softwoods. As well as sourcing timber from natural forests, pine plantations have been established worldwide for timber production, unfortunately quite often at the expense of native trees. At least 19 *Pinus* species are invasive, rapidly colonising disturbed sites. Pines may appear to be tough and resilient, sometimes growing in dense stands in harsh conditions and living to a great age. But some pines are suffering in the wild, with 33 species listed as threatened or near threatened on the IUCN Red List.

Pinus albicaulis is a relatively widespread pine native to the northwestern US and neighbouring parts of Canada at elevations of 900–3600 metres. Despite its wide distribution (mainly in two broad areas, one extending across the British Columbia Coast Ranges, Cascade Range, and Sierra Nevada; the other in the Rockies), *P. albicaulis* has suffered major population declines and is listed as endangered by IUCN. It is also a high-priority candidate species under the US Endangered Species Act, and the Bureau of Land Management (BLM) is managing whitebark pine as a special status species. It is clearly important to conserve *P. albicaulis*: not only is it a characteristic element of the landscape where it grows, it is a keystone species within the environment. In subalpine high-elevation mountain sites, whitebark pine helps to protect watersheds, the shade of its canopy regulates snowmelt runoff, and its extensive roots stabilise rocky and poorly developed soils, preventing soil erosion. It also sustains a range of birds and mammals that depend on the tree as an important source of food.

Pinus albicaulis belongs to the stone pines, a group of five species; the other four are the European *P. cembra* (arolla pine), *P. sibirica* (Siberian pine), *P. pumila* (dwarf Siberian pine), and *P. koraiensis* (Korean pine). Stone pines differ from all other pines in that their cones are indehiscent: their scales do not open when the seeds are ripe, so the seeds are retained with the cone. The seeds are removed from cones by the three

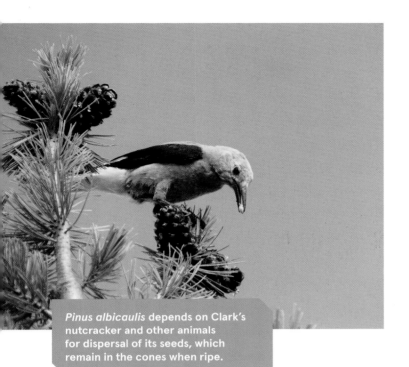

Pinus albicaulis depends on Clark's nutcracker and other animals for dispersal of its seeds, which remain in the cones when ripe.

worldwide species of nutcrackers (*Nucifraga*) with which the stone pines have co-evolved. Stone pines have wingless seeds and therefore rely on animal dispersal rather than wind. One of the main distributors of the whitebark pine is Clark's nutcracker (*N. columbiana*). Clark's nutcrackers are attracted to the purple cones of the whitebark pine and have strong bills that can extract the seeds, which they eat straightaway or bury in caches. Mature birds can store around 89,000 seeds each year, and research has shown that they remember where they are buried! If the stored seeds are not eaten by the time the snow melts, they may germinate and become established as seedlings. This is the only way that the whitebark pine regenerates in nature.

The large nutlike seeds of *Pinus albicaulis* are high in fat and protein and are an important food source, not only for nutcrackers but for around 20 birds and mammals; they are, for example, a major source of nourishment for grizzly bears. Female bears that have fattened during the previous autumn on good pine seed crops typically produce litters of three cubs, compared to twins or singletons produced after years with low seed production; what's more, the cubs of fatter females are born earlier in the winter den and grow faster because the mother produces more milk.

Individual whitebark pines can live for more than 1000 years. Some are shrubs pruned by the wind at high altitudes; others are towering 30-metre forest trees. The oldest known tree is found in Idaho in the Sawtooth National Forest, which was created in 1905 by proclamation of President Theodore Roosevelt at a time of heightened concern about logging of the rich conifer forests of the American West.

Whitebark pine was important economically, supporting the Montana mining industry. Between 1860 and 1940, the wood was cut extensively to supply fuelwood in smelters and to heat miners' homes. Harvesting is now very restricted, and the tree is valued mainly for its ecological services.

The dramatic decline in whitebark pine populations has been caused by two main anthropogenic factors, the introduction of white pine blister rust fungus (*Cronartium ribicola*) and the changes in fire regimes. Sixty years of fire suppression has led to whitebark pine stands being replaced by Engelmann spruce, mountain hemlock, and other more shade-tolerant,

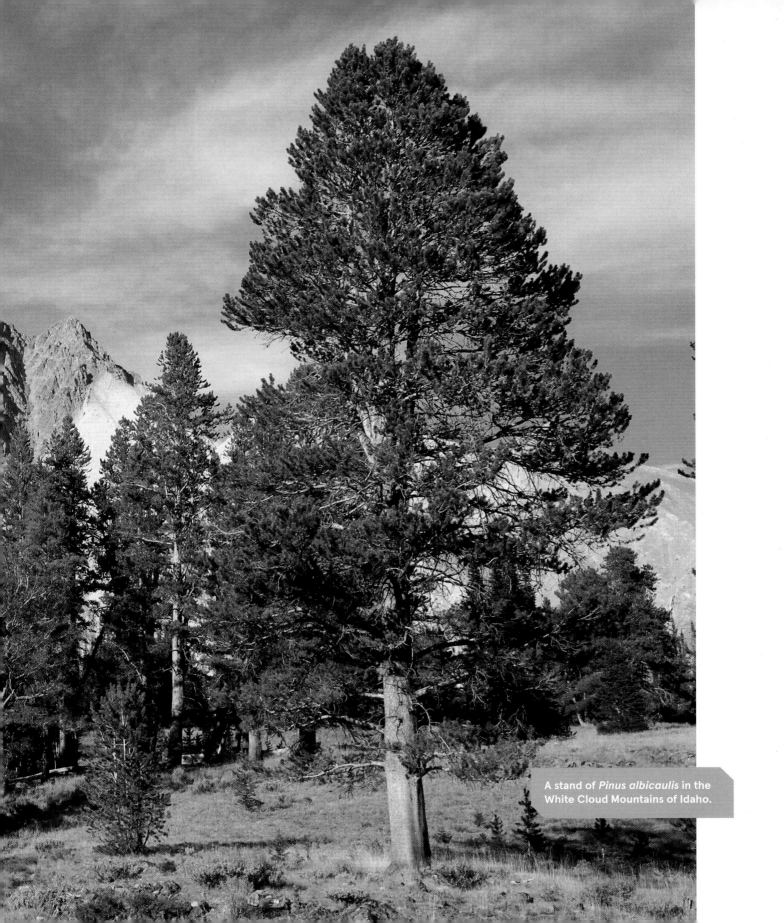

A stand of *Pinus albicaulis* in the White Cloud Mountains of Idaho.

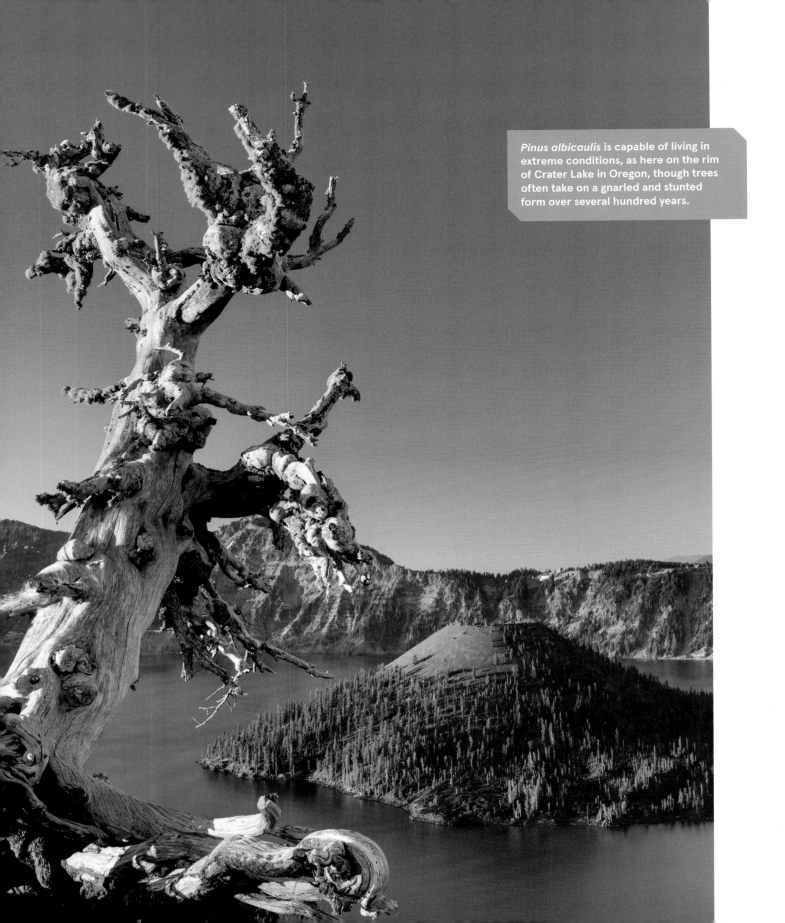

Pinus albicaulis is capable of living in extreme conditions, as here on the rim of Crater Lake in Oregon, though trees often take on a gnarled and stunted form over several hundred years.

fire-intolerant species. The threats from rust fungus and fire suppression are complicated further by climate change and increases in the native mountain pine beetle (*Dendroctonus ponderosae*) populations.

White pine blister rust, introduced into Canada from Europe in the early 1900s, has spread throughout the whitebark pine forests, causing dieback and mortality. There is as yet no way to stop the spread and effects of this rust fungus, but a small number of trees in most populations show some resistance to the disease. More recently, *Pinus albicaulis* mortality has been caused by three major outbreaks of the mountain pine beetle.

The impacts of warming temperatures and decreased precipitation due to climate change are likely to result in increased mountain pine beetle activity as well as declines in suitable habitat for whitebark pine regeneration, an increase in the number, intensity, and extent of wildfires, and an increase in blister rust fungus. Bioclimatic models predict *Pinus albicaulis* will diminish to an area equivalent to less than 3 percent of its current distribution, especially in forests at the lowest elevations. In its favour, genetic studies have shown that whitebark pine has moderate to high levels of genetic variation in key adaptive traits, an overall lack of inbreeding, and one of the highest levels of genetic diversity, shared by two other five-needle pines, Great Basin bristlecone pine and limber pine.

Conservation measures for *Pinus albicaulis* are in place. Over 90 percent of whitebark pine forests are federally managed, occuring on public lands in the US and Canada. Genetic programs have been set up to identify, harness, and deploy rust resistant individuals, and over 1500 hectares have been planted with rust resistant seedlings; prescribed fire is used for site preparation and to enhance natural regeneration. Verben-one, an anti-aggregate pheromone, is used to protect trees against damage from the mountain pine beetle. Studies into the effects of white pine blister rust fungus and mountain pine beetle on Clark's nutcracker are ongoing; initial research indicates that when the whitebark pines decline in number, a point is reached where Clark's nutcrackers will not visit a site, thereby reducing the natural regeneration of whitebark pine.

Pinus maximartinezii

BIGCONE PINYON PINE

IUCN RED LIST CATEGORY

Endangered

NE DD LC NT VU **EN** CR EW EX

NATURAL RANGE

North-central Mexico

PREFERRED HABITAT

Shallow, rocky mountain soils

THREATS

**Erosion from fire
and overgrazing**

**Intensive harvesting
of seeds and cones**

Mexico has a rich diversity of pine species, which together with oaks form one of the dominant forest types of the country. *Pinus maximartinezii* is a Mexican species that occurs at elevations of 1800–2400 metres, in areas with 700–800 mm of annual precipitation, which mainly arrives during the four months of summer monsoons. This species was first described by Mexican botanist Jerzy Rzedowski, who was intrigued by the huge pine seeds he saw on sale in a local market. He asked the villagers to show him the trees that produced the seed. Rzedowski recognized the trees growing in the area, Cerro de Piñones in southern Zacatecas, as a new species. A second site at La Muralla in Durango was discovered in 2010.

The cones of *Pinus maximartinezii* can weigh as much as 2 kg; they have been described as woody pineapples hanging from the short bushy trees. Exploitation of the large (22–24 mm long) nutritious seeds may have some impact on the pine; other more significant threats are grazing and fires.

Ex situ conservation efforts are well underway, and you can now see specimens of bigcone pinyon pine in over 20 arboreta and botanic gardens around the world. But protection of the trees in their native habitat remains vitally important.

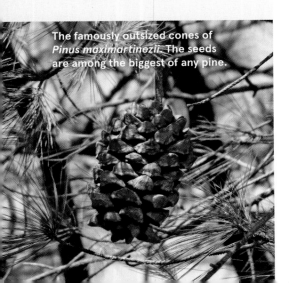

The famously outsized cones of *Pinus maximartinezii*. The seeds are among the biggest of any pine.

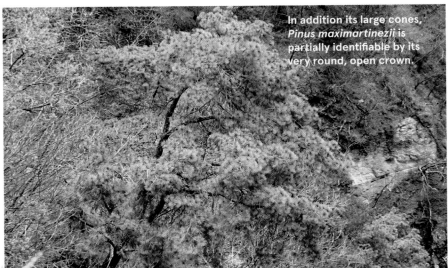

In addition its large cones, *Pinus maximartinezii* is partially identifiable by its very round, open crown.

Sequoiadendron giganteum
GIANT REDWOOD, GIANT SEQUOIA

IUCN RED LIST CATEGORY

Endangered

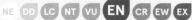
NE DD LC NT VU **EN** CR EW EX

NATURAL RANGE

US (California)

PREFERRED HABITAT

Mixed conifer forest

THREATS

Fire risks due to past land mismanagement

Genetic crossbreeding

Of all the mighty conifers, with their prehistoric history, domination of landscapes, and value to people, *Sequoiadendron giganteum* is the most extraordinary. Placed in its own monotypic genus, its closest relative is *Sequoia sempervirens* (coast redwood), which is also the only species in its genus. The giant redwood was discovered some 60 years after the coast redwood, with sightings by the Joseph R. Walker exploration party in 1833 in the area of Yosemite National Park and publicized in the journal of the expedition, which was printed in 1839. Rediscovered in the 1850s, the giant redwood soon became legendary for its sheer size, typically 60–83 metres tall with trunks 6–8 metres wide. In fact, when the bark of one tree was stripped and sent back east for display at a major exposition, people suspected it was a hoax until an entire tree was felled and put on display. The largest individual giant redwood is the world-famous General Sherman, which has a circumference near the ground of 31.1 metres; it is often referred to as the largest living thing on earth. It is neither the tallest tree nor the thickest at the base; rather, it gets its title from its total trunk volume.

Sequoiadendron giganteum has a large conical crown with upright branches at the top of the tree and hanging branches lower down. The needles are small and scale-like, and the reddish brown bark is fibrous, so soft it is easily punched with a fist (hence the nickname boxing tree).

The early fame of the giant redwood led to attempts to log all the trees, and logging continued for the next century. The trees, though of high timber quality and rot resistant, often shattered on impact after felling. What wood could be used was mainly put into building applications, and many larger houses in the San Francisco Bay Area were built of its timber. Its fibrous wood was also fashioned into such products as fenceposts, grape stakes, shingles, novelties, patio furniture, and pencils. In the end, the brittle wood was less sought-after than that of other conifers. *Sequoiadendron giganteum* is now restricted to a limited area

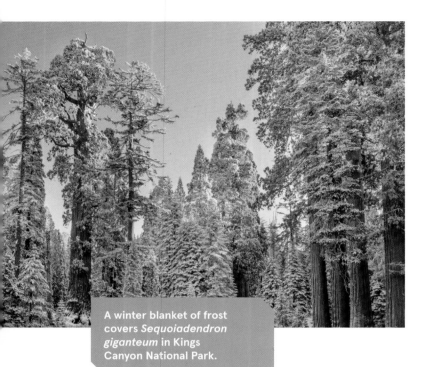

A winter blanket of frost covers *Sequoiadendron giganteum* in Kings Canyon National Park.

of the western Sierra Nevada, California, where it grows at 830–2700 metres. It is listed as endangered by IUCN; the population is declining rapidly, as the species is having difficulty reproducing in its natural habitat. Seeds grow only in full sun, mineral-rich soils, and areas free from competing vegetation. Giant redwood groves represent a fire climax community whose stability is maintained by frequent fires. Periodic wildfire is required to clear competing vegetation. Without regular ground fires, litter accumulates on the forest floor and limits germination and establishment of seedlings. These fires no longer occur naturally in many groves due to fire suppression efforts and livestock grazing.

Almost all known groves of *Sequoiadendron giganteum* are in protected areas attracting millions of visitors each year. Concern about widespread logging in the 19th century inspired the public to call for the protection of the giant redwood. On 25 September 1890, President Benjamin Harrison signed legislation establishing Sequoia National Park (America's second), specifically to protect the magnificent giant redwoods from exploitation. There and in Kings Canyon National Park, iconic giant redwoods grow interspersed with a range of other trees in a mixed conifer forest of white fir, sugar pine, incense-cedar, red fir, and ponderosa pine, among others. Yosemite is another national park with impressive groves of *S. giganteum*, and the Giant Sequoia National Monument was designated by President William Jefferson Clinton in April 2000. There, the Forest Service manages 33 giant redwood groves and other sites of interest for their protection, restoration, and preservation. In total, three national forests, three national parks, and various California state holdings protect giant redwoods in their natural habitat. Fire management is still required, and different approaches have been used to address this. Controlled burning and selective logging have been applied on different lands to stimulate regeneration but have not yet been fully effective.

Sequoiadendron giganteum is recorded in 181 ex situ collections worldwide. The species was introduced to cultivation by William Lobb, who travelled, to California this time, collecting seeds for James Veitch and Sons nursery. In 1852, he came upon a stand of giant redwoods in

Did you know?

The coast redwood (*Sequoia sempervirens*) is the tallest tree on Earth, growing to a staggering 115 metres high.

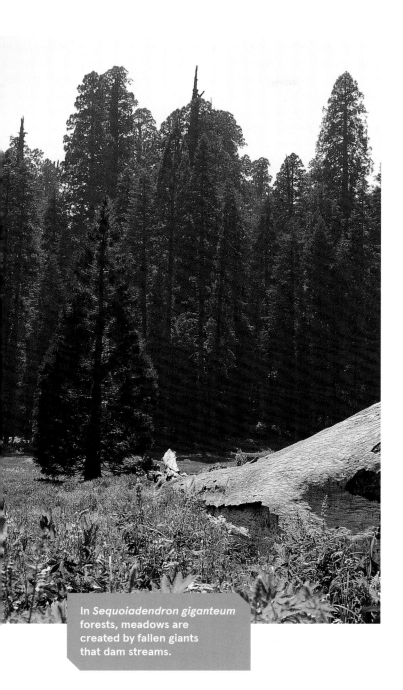

In *Sequoiadendron giganteum* forests, meadows are created by fallen giants that dam streams.

Calaveras Grove. At the time, conifers were in vogue among the wealthy gardening community in Britain for enhancing their country estates. Lobb, recognising the market potential of his new find, cut short his trip and returned home with seeds of the giant redwood. Within a year, Veitch's was offering seedlings for sale, and Cambridge University Botanic Garden was among the earliest recipients of these plants; visitors were and are impressed by the sheer grandeur of the majestic trees, which continue to flourish in the Main Walk there, the tallest trees in the garden.

Two weeks after Lobb returned to England in 1853, John Lindley described the new species as *Wellingtonia gigantea*. He created a new genus for the "mammoth tree," in honour of the Duke of Wellington who had died the previous year; the specific epithet refers to the tree's size. Lindley's publication caused outrage among American botanists, who were furious that the world's largest tree had been named for an English war hero by a botanist who had never seen the tree. In 1854, French botanist Joseph Decaisne decided that the new species belonged to the same genus as the coast redwood and renamed it *Sequoia gigantea*. The generic name is thought to honour Cherokee polymath Sequoyah, who had died in 1843. Finally, the name *Sequoiadendron* was coined in 1939.

Torreya taxifolia

STINKING CEDAR

IUCN RED LIST CATEGORY

Critically Endangered

NE DD LC NT VU EN **CR** EW EX

NATURAL RANGE

US (Florida, Georgia)

PREFERRED HABITAT

Limestone bluffs and ravines along the Apalachicola River

THREATS

Reproductive failure due to pathogens

Rubbing by deer

Changes in surrounding land use and fire regimens

Torreya taxifolia, one of the rarest conifers in the world, is listed as critically endangered by IUCN—but there is a difference of opinions on how best to save it from extinction. The species was once a prominent tree in ravine forests along the Apalachicola River through the Florida panhandle in the US. The tree grew with massive southern magnolias, fan-leafed palmettos, and other subtropical plants mixed with more northerly forest trees (e.g., beech, hickory, maple) that retreated south to the panhandle when glaciation took place in the north. Both leaves and cones have a strongly pungent odor if crushed (hence the common name).

The timber was used make fenceposts and shingles and to fuel the steamboats that travelled along the Apalachicola. Sometime around World War II, the remaining trees were attacked by a fungal blight and began their catastrophic dieback. Since the 1950s, all stinking cedars of reproductive age have died, leaving only seedlings in the forest. Before the start of the decline in the early 1950s, the population was estimated to have been more than 600,000. The current population, about 550 trees, clings to survival in a few ravines in northern Florida and southern Georgia. Of these, less than 10 are known to produce male or female cones (this species is dioecious). Individuals persist as stump sprouts. The ultimate cause of this catastrophic decline is still unexplained, but *Torreya taxifolia* has been subjected to changes in hydrology, forest structure, heavy browsing by deer, and most significantly a stem canker disease resulting in dieback. Individuals are top-killed before they reach reproductive size. Plant pathologists have identified the disease-causing agent as *Fusarium torrayae*.

Torreya taxifolia, listed as federally endangered in 1984 under the US Endangered Species Act, has been the focus of extensive conservation interventions. The majority of its range lies within protected areas; however, in situ preservation appears unlikely to be completely successful, as plantings are susceptible to infection and, as yet, no naturally resistant

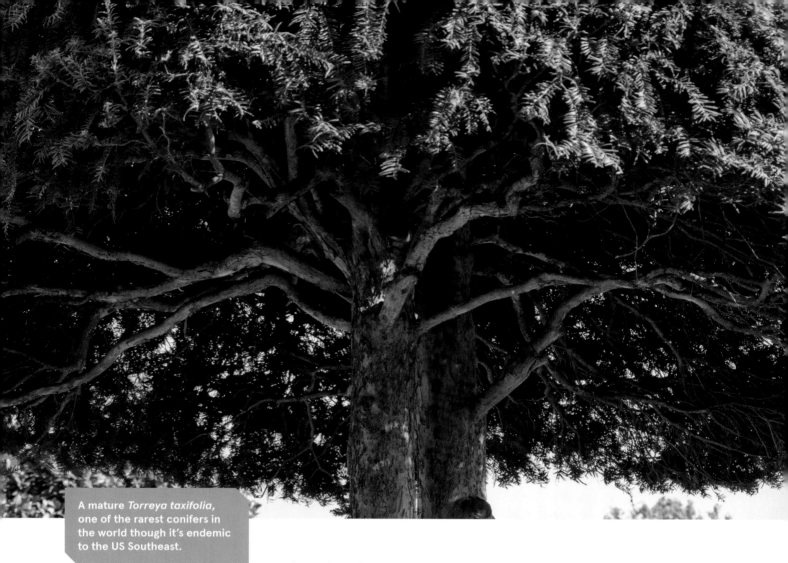

A mature *Torreya taxifolia*, one of the rarest conifers in the world though it's endemic to the US Southeast.

clones have been identified. Regular censuses are carried out to monitor the state of the remaining trees. Some reintroduction work has been attempted within its natural range, but this has not been successful to date. Field surveys have found that stem damage from deer antler rubbing is a significant source of stress in addition to disease. Any future reintroductions will therefore need caging to protect the new trees from damage.

Until damage from deer and stem canker can be controlled, recovery of the species is dependent on ex situ conservation efforts. An ex situ programme was developed in the 1980s, and clonal collections have since been established in several areas away from its native habitat. The biggest challenge with ex situ conservation is the inability to use conventional seed storage techniques, as the seeds are recalcitrant and cannot be dried for storage in freezers.

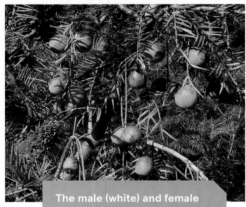

The male (white) and female (green) cones of the *Torreya taxifolia* in cultivation at the Atlanta Botanical Garden.

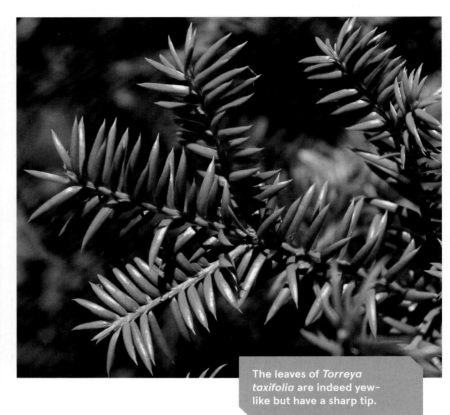

The leaves of *Torreya taxifolia* are indeed yew-like but have a sharp tip.

Atlanta Botanical Garden has been leading conservation efforts for this species for more than 20 years. Their work includes tissue culture research and a feasibility study to identify if assisted migration to habitats free from deer and disease is a suitable measure to save this species from extinction. The idea of assisted migration has proved controversial. Some consider it to be tinkering with nature, which may have unanticipated outcomes. Others see it as the best hope for *Torreya taxifolia* and other species that are so close to extinction. Bedgebury National Pinetum is one of many sites in the British Isles that is working with the ICCP to help cultivate this species.

CONIFERS IN EUROPE

Abies nebrodensis

SICILIAN FIR

IUCN RED LIST CATEGORY

Critically Endangered

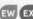

NE DD LC NT VU EN CR EW EX

NATURAL RANGE

North-central Sicily

PREFERRED HABITAT

Shrubland

THREATS

Logging

Fire and fire suppression

Abies nebrodensis is one of Europe's rarest tree species. It is restricted to steep valleys on rocky, calcareous soil in the Madonie Mountains of north-central Sicily. The secondary maquis with which Sicilian fir is associated is dominated by holly oak (*Quercus ilex*). There are only 32 mature trees of Sicilian fir in the surviving relict population, and one old tree survives in the picturesque medieval village of Polizzi Generosa. The species was considerably more abundant in the past and may have occurred in the Appenines of mainland Italy in Calabria. The decline of the Sicilian fir is thought to be due to changes in the soil resulting from deforestation and possible climatic changes. Logging most probably played a part in the past, with the timber known to be used for doors and church roofs. Natural regeneration of the fir has been hindered by drought, soil erosion, and livestock grazing. Fire remains a persistent threat. The species is now listed as critically endangered both nationally and globally. *Abies nebrodensis* has been the focus of both in situ and ex situ conservation efforts, with funding from both the EU and the Italian Government.

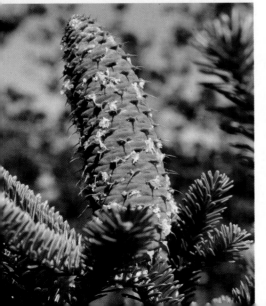

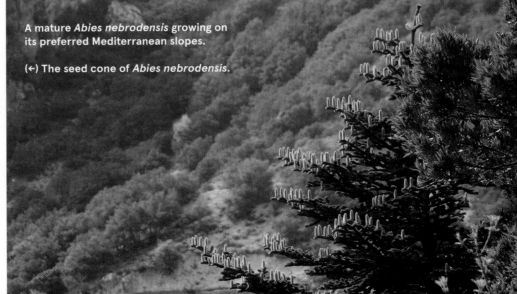

A mature *Abies nebrodensis* growing on its preferred Mediterranean slopes.

(←) The seed cone of *Abies nebrodensis*.

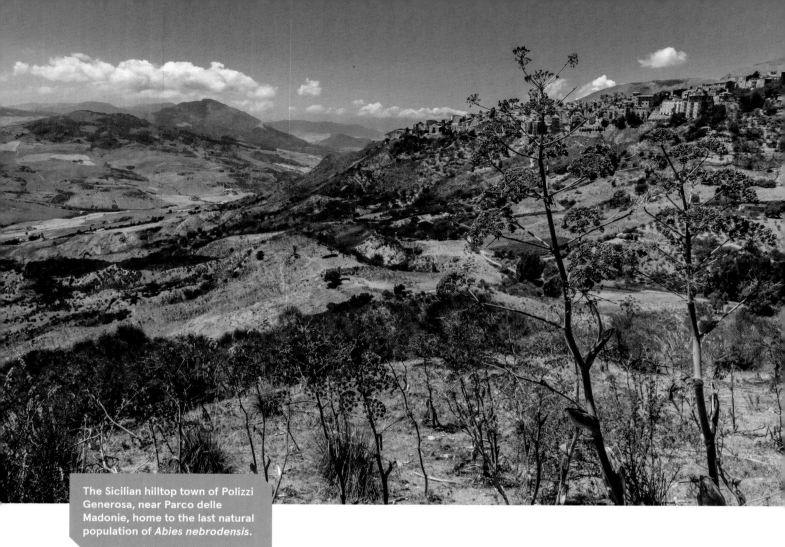

The Sicilian hilltop town of Polizzi Generosa, near Parco delle Madonie, home to the last natural population of *Abies nebrodensis*.

Conservation action has involved stabilizing the tiny natural population in Parco delle Madonie and improving the survival rate of natural seedlings. Reinforcement of the population has also been undertaken, using trees raised as part of an ex situ programme. Wider aims are to eliminate non-indigenous fir species and restore the natural ecosystem. The number of trees increased from a low of 24 to 32 since action began in 2001, while natural seedlings have increased from 30 to 155. These are still immature. Conservation reafforestation activities have extended the distribution of this species at 700–2000 metres.

An extensive ex situ programme for the Sicilian fir has been in place for a number of years, with trees planted in the Botanical Garden of Palermo as well as in summer villas and second homes in the Madonie Mountains, slightly outside their natural area of distribution. Seedlings have also been distributed to other botanic gardens and arboreta in Europe. BGCI records *Abies nebrodensis* in 44 ex situ collections.

Picea omorika

SERBIAN SPRUCE

IUCN RED LIST CATEGORY

Endangered

NATURAL RANGE

Bosnia and Herzegovina, Serbia

PREFERRED HABITAT

Rocky forest areas such as inland cliffs and mountain peaks

THREATS

Terrestrial plant gathering

War and military exercises

Fire and fire suppression

Omorika (Serbian for "spruce") represents slenderness in Bosnian and Serbian folklore. *Picea omorika* is an endangered spruce native to limestone mountains on the border between Serbia and Bosnia and Herzegovina, at 700–1500 metres. Its exaggeratedly narrow form is a response to the steep slopes and dense forests of its native habitat. The species was widespread in Europe millions of years ago, but following the Pleistocene glaciations, it survived only in this refugium in the Balkan Peninsula of southeastern Europe. Now *P. omorika* occurs in forest fragments within a tiny area where the rugged habitat protects it from extensive logging.

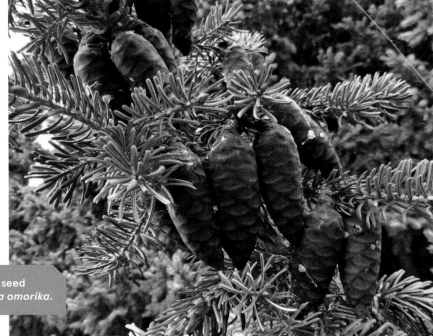

The very dark seed cones of *Picea omorika.*

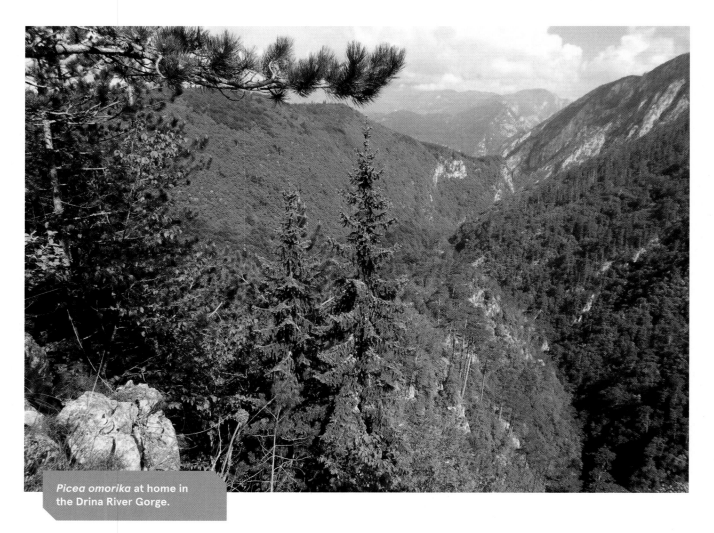

Picea omorika at home in the Drina River Gorge.

Until the middle of the 19th century, Serbian spruce had a more continuous distribution.

Picea omorika is a very distinctive species with a slender, pyramidal shape, growing to a height of 30 metres. Despite its rarity in the wild, this conifer is a popular ornamental tree, widely grown in gardens around the world. It is grown to a limited extent for Christmas trees, timber, and paper production, particularly in northern Europe, but its slow growth generally makes it less important than Sitka spruce or Norway spruce in commercial forestry.

In the past the wood was used for roofing and to make a special container for storing cheese. Forest clearance and land use changes also decreased the populations of this species as well as preventing further

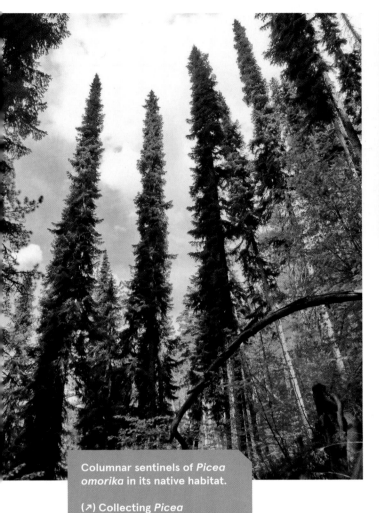

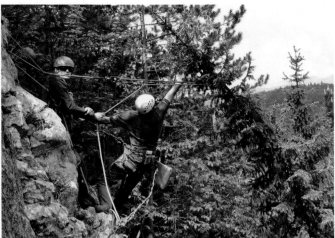

Columnar sentinels of *Picea omorika* in its native habitat.

(↗) Collecting *Picea omorika* seeds in Bosnia.

regeneration. Other trees (*Abies alba*, *Fagus sylvatica*, *Picea abies*) are better able to thrive in the former areas of Serbian spruce.

Fire is now the biggest threat to *Picea omorika*. In Serbia, sites where it grows are now protected within Tara National Park, which covers an area of mountains, caves, and the Drina River Gorge. The brown bear, another threatened species strictly protected by legislation in Serbia, also finds refuge in the park. Outside the scenic national park, on private land, owners are not allowed to cut trees of this species. In Bosnia and Herzegovina all stands are protected by national legislation.

Serbian spruce is grown in over 200 botanic gardens. Bedgebury National Pinetum has young trees grown from seed collected in Serbia and Bosnia in 2007 and 2010 in association with ICCP. The collections undertaken by ICCP in collaboration with national agencies in Bosnia and Herzegovina were designed to broaden the genetic base of the trees grown in cultivation. A well-coordinated ex situ conservation programme remains vital; it helps conserve the genetic diversity of this threatened species and will enable Serbian spruce to survive the impacts of global climate warming. There is thought to be high genetic differentiation among the surviving fragmented populations of *Picea omorika* in the wild. Ideally, seed for ex situ conservation should be collected from all remnant populations.

CONIFERS IN ASIA

Abies ziyuanensis

ZHIYUAN FIR

Abies ziyuanensis is a rare Chinese species, first described in 1980. This large tree grows to 25 metres in height and can be recognised by its oval crown, cylindrical cones with rounded tips, and smooth grey bark, which, in later years, slowly decomposes under the thick layers of epiphytic plants. This species is listed as endangered on the IUCN Red List; it is now known from only four sites in Guangxi and Hunan, China, where it grows at 1400–1800 metres and helps to form a rich evergreen and deciduous forest that covers a dense undergrowth of bamboo. The very small distribution of the Zhiyuan fir is due to heavy logging in the past, and less than 600 mature individuals remain in the wild. Current threats are landslides and overgrazing by sheep and cattle.

IUCN RED LIST CATEGORY

Endangered

NE DD LC NT VU **EN** CR EW EX

NATURAL RANGE

China (Guangxi, Hunan)

PREFERRED HABITAT

Cool, very wet temperate forest

THREATS

Livestock farming and ranching

Logging and wood harvesting

Avalanches and landslides

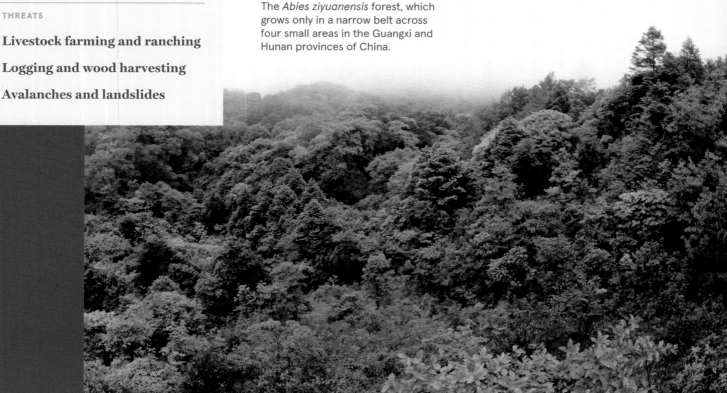

The *Abies ziyuanensis* forest, which grows only in a narrow belt across four small areas in the Guangxi and Hunan provinces of China.

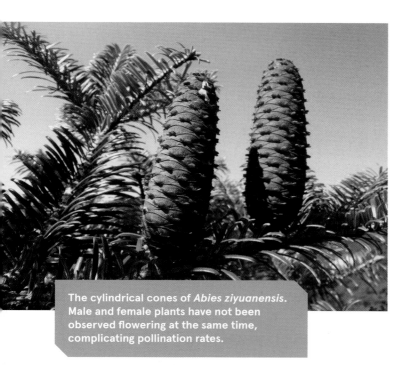

The cylindrical cones of *Abies ziyuanensis*. Male and female plants have not been observed flowering at the same time, complicating pollination rates.

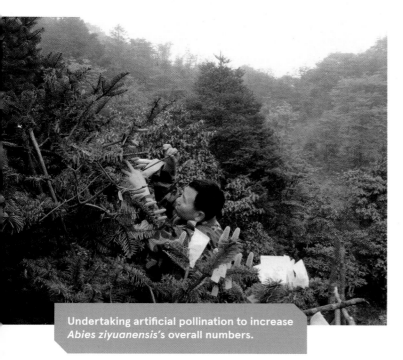

Undertaking artificial pollination to increase *Abies ziyuanensis*'s overall numbers.

Fortunately the survival of *Abies ziyuanensis* is enhanced by the attention it has received from FFI China, the Guangxi Biodiversity Research and Conservation Association, and the Guangxi Institute of Botany, through a Global Trees Campaign project at Yinzhu Laoshan Fir Reserve. The population there is under particular threat, having declined dramatically from an estimated 2500 individuals in 1979 to 50 in 2012. In 2014, the GTC project facilitated thorough surveys of Yinzhu Laoshan Fir Reserve, which revealed new individuals, increasing the known population in this reserve to 71 trees. One of the primary issues was the lack of natural regeneration within the population. In 2012, no seedlings were observed in the field; natural regeneration was clearly not taking place. Natural regeneration is limited because the species produces seeds only every few years, and seedlings grow slowly. Adding to these issues was the widespread problem of grazing in the forest. The GTC project has worked with the reserve authorities and local communities to reduce grazing pressure, and by 2018, this threat was reduced by 50 percent compared to 2015 levels as a result of the project interventions.

To further address the issue of low natural regeneration, Guangxi Institute of Botany led research into biological causes and possible solutions, including trialling artificial pollination of Zhiyuan fir flowers. Following this work, wild seedlings were observed for the first time since 2015. Research will continue to refine propagation methods for the future. Despite the good progress made, this conifer remains in need of ongoing conservation action to secure its long-term survival.

Cupressus cashmeriana

BHUTAN WEEPING CYPRESS, KASHMIR CYPRESS

IUCN RED LIST CATEGORY

Near Threatened

 NE DD LC NT VU EN CR EW EX

NATURAL RANGE

Bhutan, northeastern India

PREFERRED HABITAT

Subtropical to tropical moist montane forest

THREATS

Logging and harvesting

Cupressus cashmeriana is a beautiful weeping tree, by some considered the most desirable of all conifers in cultivation, with glaucous aromatic foliage. It grows well in gardens in the southern UK, the southern half of the US, Australia, and New Zealand. In the wild, this species is restricted to Bhutan and to Arunachal Pradesh in India. It is now considered near threatened by IUCN, but that status may change when its nomenclature, status, and decline in natural habitats are better understood.

Cupressus cashmeriana provides excellent timber that is highly durable and resistant to rot fungi and borer insects. For these qualities and its long significance to the Buddhist religion, its timber is highly sought-after for the construction of dzongs (temples) and monasteries in Bhutan. Within that country, where it is known as tsenden, *C. cashmeriana* is the national tree; it is sacred in Bhutanese culture and religion.

It is Buddhist belief that *Cupressus cashmeriana* was first brought to Bhutan by Guru Rinpoche, an 8th-century Indian Buddhist master, in the form of his walking stick. Alongside naturally occurring strands, trees have been widely planted close to Buddhist temples and monasteries. Many of these trees have now grown to spectacular heights and are associated with important Buddhist spiritual masters and scholars. *Cupressus cashmeriana* is also associated with Buddhist sites in Nepal, India (Sikkim), and China (Xizang).

Over centuries of utilisation and general pressures on Himalayan forests, *Cupressus cashmeriana* has declined in the wild. Construction and renovation of dzongs and other important buildings in Bhutan continues to put pressure on wild stands, and Bhutan's national tree is now threatened by unsustainable logging rates. Many of the more accessible trees have been felled, with tsenden forests remaining only in remote valleys away from settlements and roads.

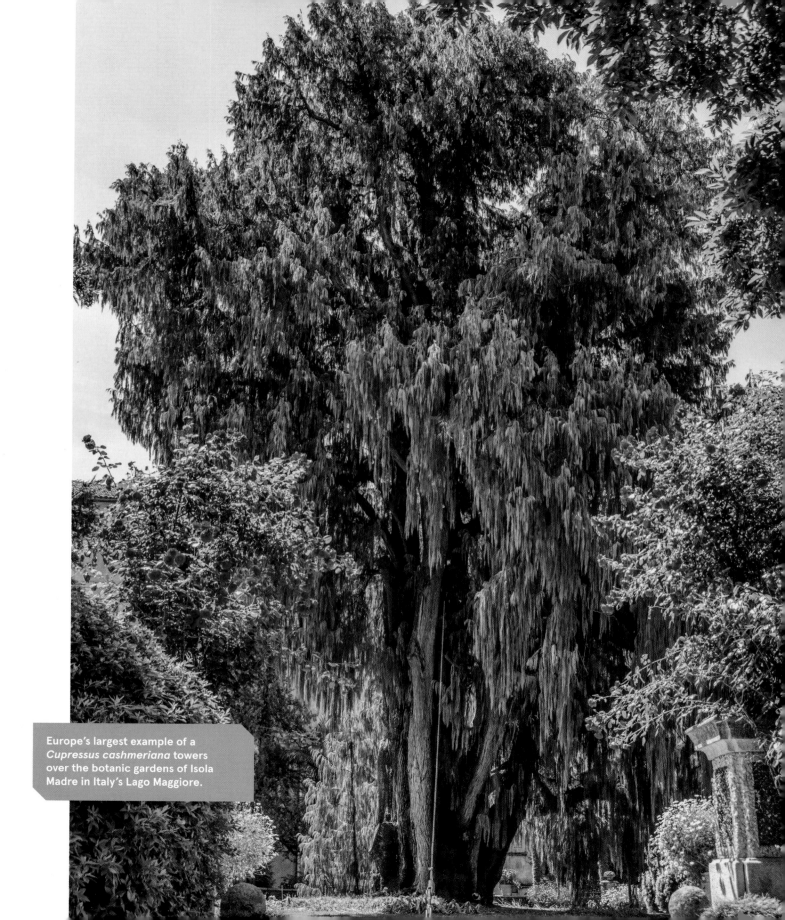

Europe's largest example of a *Cupressus cashmeriana* towers over the botanic gardens of Isola Madre in Italy's Lago Maggiore.

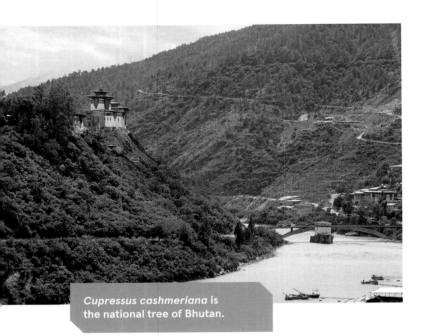

Cupressus cashmeriana is the national tree of Bhutan.

The largest population of *Cupressus cashmeriana* in Bhutan is in the Dangchu valley. Logging, both legal and illegal, has taken place in the valley. In recent years, timber was harvested to rebuild the Wangdue Phodrang Dzong, which had been destroyed by fire. This led to local people of Dangchu valley becoming concerned about the disappearance of their culturally important tree. The mayor of the Dangchu valley, with the help of his constituents and the Forestry Department, decided to establish a nursery to grow tsenden seedlings. In a GTC project, BGCI worked with RBG Edinburgh to help the people of Dangchu village with the development of their tree nursery. Seed was collected in 2016 and 2017 from as many mother trees as possible to increase the stock and genetic diversity of the plants in Dangchu valley nursery. In 2017 and 2018, approximately 41,000 seedlings from the nursery were planted across over 12 hectares of the valley. Fencing was installed in 2018 to exclude livestock, and regular maintenance of the planted plots is ongoing by the community.

This project has generated new knowledge about the growing conditions needed for *Cupressus cashmeriana*. In the long term, restoration of populations of tsenden in the Dangchu valley should create revenue for local people and provide a sustainable source of tsenden timber. Given that the trees take around 70 years to reach a harvestable size, the Dangchu valley residents are undertaking the project very much with future generations in mind.

Another part of the project has been to build awareness of the local flora. At the Royal Botanic Garden, Serbithang (RBGS), a special exhibition has been created, informing people about Bhutan's native plants, including the flagship tsenden, and the need for conservation of the flora. BGCI's education team kickstarted the process in November 2016 by running an interpretation design workshop at RBGS.

IUCN RED LIST CATEGORY

Endangered

NATURAL RANGE

China (Guangxi), Vietnam

PREFERRED HABITAT

**Ridges and summits
of cloud forest**

THREATS

Logging and wood harvesting

Cupressus vietnamensis

VIETNAMESE GOLDEN CYPRESS

The Vietnamese golden cypress was first encountered in 1999 on a high ridge in the Bat Dai Son mountains of northern Ha Giang province, Vietnam. In the first rush of excitement, the new species was placed in a new genus, *Xanthocyparis*, but it has since been reassigned to *Cupressus*. Following the original discovery, very small subpopulations were found in two other provinces in northern Vietnam, Cao Bang and Tuyen Quang. In 2012 a single tree was reported from the Mulun Nature Reserve in Guangxi, China. Additional surveys in China in 2014, supported by the Global Trees Campaign, found 17 new individuals of this species, 15 adult trees and two seedlings. The extent of its distribution in China is currently unknown. Without doubt, this is a rare species; experts suggest no more than 1000 individuals remain in Vietnam, where it is known locally as bach vang.

Cupressus vietnamensis grows 10–15 metres high. It has a pyramidal shape when young and a broad, flattened crown when mature. It occurs in species-rich mixed conifer and broadleaved cloud forest with a subtropical climate. Below the canopy are species of *Eriobotrya*, *Sorbus*, and *Schefflera*, among many others, along with abundant orchids, ferns, and bryophytes. The limestone ridges on which it occurs are highly eroded, composed of resistant, marble-like rock outcrops interspersed with thin soil pockets.

Cutting of the tree for timber is thought to be the most serious threat to this species. The yellow-brown timber is very hard and scented, which makes it an attractive material for local construction; however, most trees are relatively small and contorted and this, combined with the difficulty of transporting timber from inaccessible habitat areas, limits its attractiveness for wider timber trade. There is some evidence that it has been cut for firewood in some areas.

As *Cupressus vietnamensis* is found only on high, inaccessible ridges, the threat from agricultural expansion is limited. The tree has not

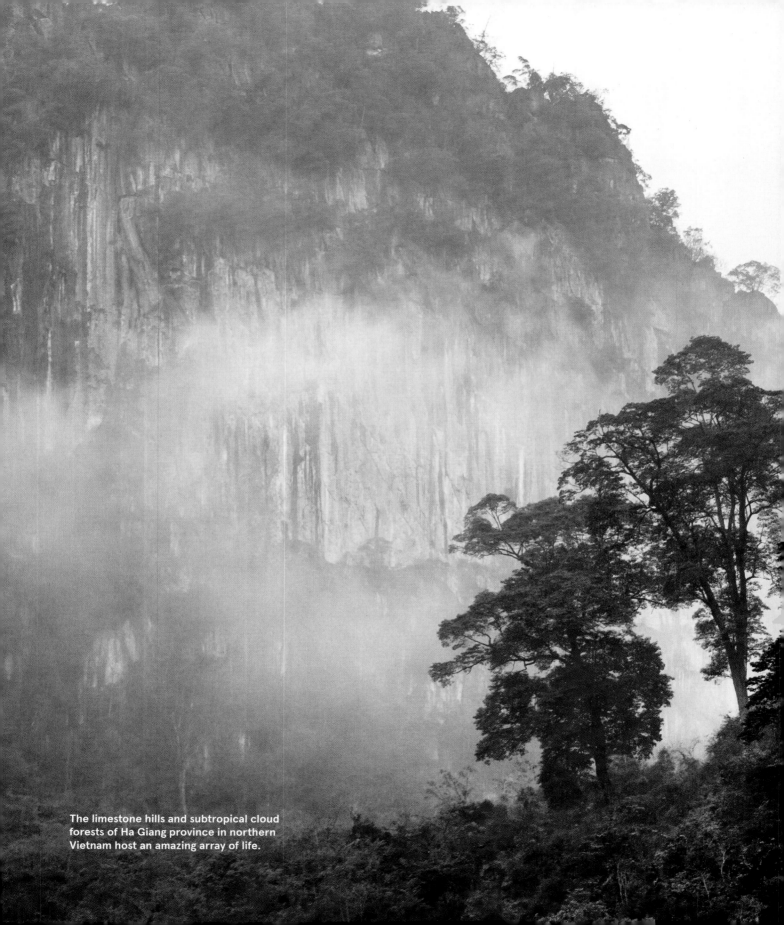

The limestone hills and subtropical cloud forests of Ha Giang province in northern Vietnam host an amazing array of life.

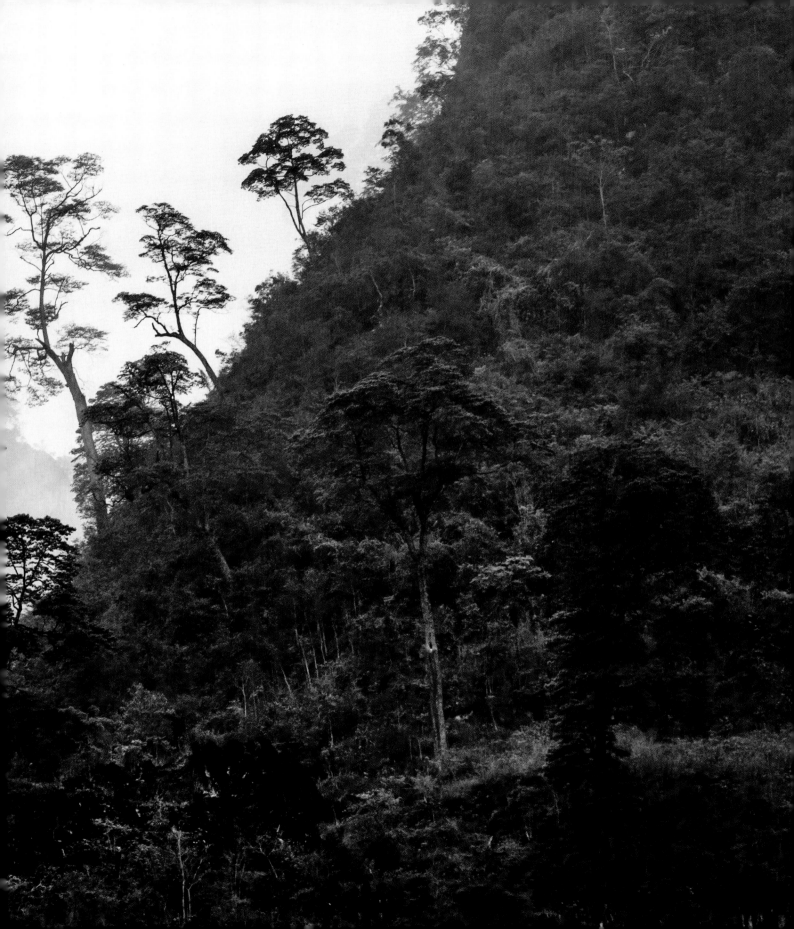

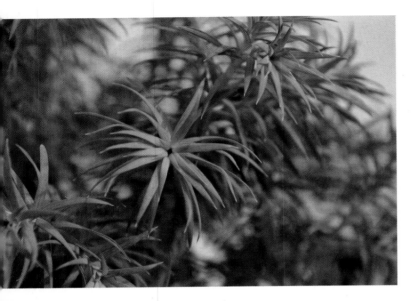

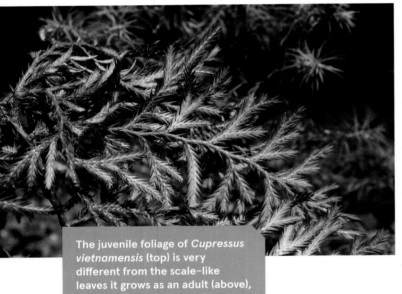

The juvenile foliage of *Cupressus vietnamensis* (top) is very different from the scale–like leaves it grows as an adult (above), although it produces both on even mature specimens.

been found in intact forest on lower slopes within its range, and it is believed to be naturally confined to the higher altitudes. Although this protects the conifer from clearance for farming, it does make it susceptible to climate change. The tree is very slow growing, and regeneration is limited. The rich forest habitat in the main area where Vietnamese golden cypress occurs falls within the Provincial Protected Area of Bat Dai Son, but further protection is needed to ensure the species survives.

FFI has played an important role in supporting the conservation of Vietnam's rare conifers and species-rich forests. A GTC report highlighted the unique and valuable conifer species that occur in the country and set out the priority actions required for conservation of the 22 globally threatened and seven nationally threatened taxa of the country; the conservation actions proposed in 2004 have helped to ensure the long-term survival of the species and their habitats and contributed to the livelihoods of rural people who utilise these important trees in a variety of ways. More broadly, FFI's forest conservation work has ranged from supporting ecotourism initiatives, supporting better protected area management, and piloting REDD+ and Payment for Ecosystem Services approaches to sustainable management.

As a conservation insurance policy, developing ex situ collections of rare conifers also remains very important. *Cupressus vietnamensis* was introduced into cultivation by RBG Edinburgh in 2002 and is found in 17 collections worldwide, but all these trees are grown from cuttings, making them clones with limited genetic diversity. Recently, Bedgebury National Pinetum has been successful in growing these trees from seed, giving hope to this rare species.

Glyptostrobus pensilis
CHINESE SWAMP CYPRESS

IUCN RED LIST CATEGORY

Critically Endangered

 NE DD LC NT VU EN **CR** EW EX

NATURAL RANGE

Southeastern China, Laos, Vietnam

PREFERRED HABITAT

River floodplains

THREATS

Other non-timber crops (e.g., coffee)

Renewable energy development

Logging and wood harvesing

Fishing and aquatic resource harvesting

Dams and water management

Once widespread in China, Vietnam, and likely Laos, natural populations of *Glyptostrobus pensilis* are now on the brink of extinction. The species is, however, widely cultivated in China at 500–700 metres along paddies, rivers, and canals, primarily for timber production. With its extensive root system, it is also planted to stabilise river banks. The timber—durable, resistant to insects, and easy to work—is highly valued; it is used to make roof shingles, musical instruments, and furniture. The roots are very light and are used to make buoyancy floats in China as well as bottle corks. Tannins extracted from the bark and cones are used in tanning, dyeing, and fishing nets. In China, *G. pensilis* has a strong feng shui association, and young trees were often given as gifts to people building new houses.

Despite its many uses and cultural value, the future of *Glyptostrobus pensilis* is far from secure. This conifer is critically endangered on the IUCN Red List. It has a very small population size in the wild, the level of natural regeneration is low, and wetland habitat conversion (mainly for agriculture) is a major threat across its natural range. Recent surveys in China report only about 300 trees, scattered in around 50 locations from Fujian to Yunnan. A similar number of trees survive in the wild in Vietnam but at fewer sites; these have been affected by the development of coffee plantations, which have altered the water table. There have also been reports of illegal logging. Three of the Vietnamese localities have less than 10 trees each, and no seed is being produced; fortunately, some trees are found within the Earal and Trap Kso nature reserves—but these protected areas are small, and local fires have been a problem. In Laos, six stands were located, the first in 2006, during surveys of the Nakai plateau. The largest of these sites was inundated at the completion of the Nam Theun hydroelectric scheme. Recent efforts have concentrated on surveying the watersheds of the Nakai-Nam Theun National Protected Area, in the Annamite mountain range in central Laos, to locate previously undocumented populations of this beautiful tree.

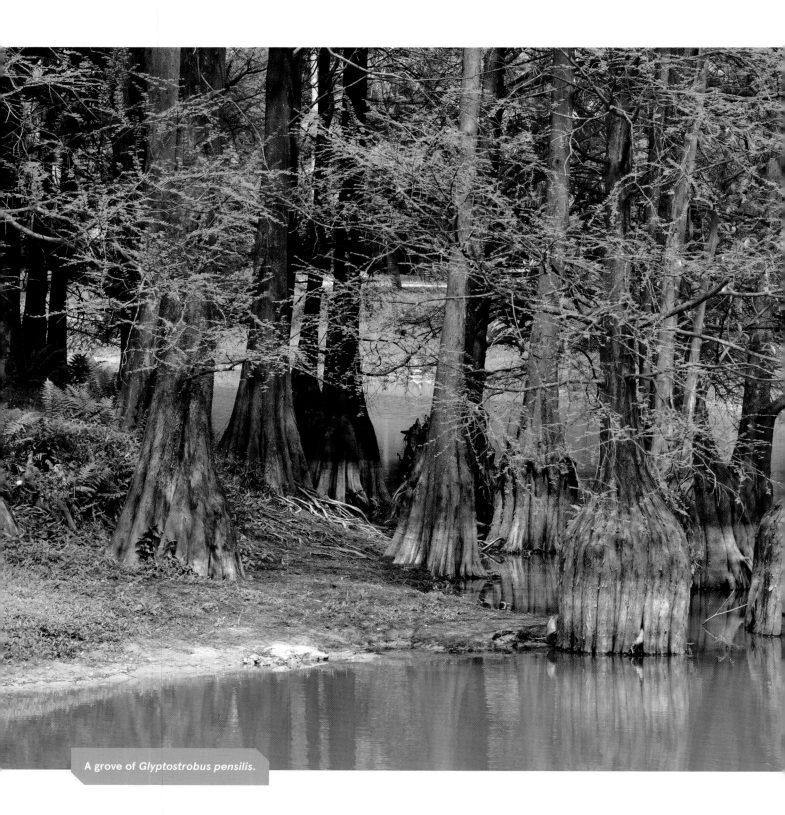

A grove of *Glyptostrobus pensilis.*

It will take heroic efforts to save natural populations of Chinese swamp cypress, but these are now underway. The urgent need for conservation is recognised in China, where *Glyptostrobus pensilis* is included as a Grade I species in the List of Wild Plants under State Priority Conservation. Bringing together partners from the three countries where the species survives in the wild, BGCI has since 2017 coordinated surveys to establish the true extent of the tree in China and Vietnam, giving a clearer picture of the population size; in Laos, investigation of the wild population, seed collection, and development of working relationship between PTK Botanical Garden and the local management authority of *G. pensilis* habitat are the main project activities.

Glyptostrobus pensilis is widely grown in botanic gardens around the world. But Jean Linsky, who worked on a project for this species, adds a caveat:

> The genetic diversity of cultivated trees is very low. We are undertaking genetic analysis of wild populations to better understand the natural diversity, so that we can effectively sample for ex situ conservation. Propagation of plants from natural populations is very challenging because of the very limited availability of viable seed. Our best hope now is that propagation trials using grafting will prove to be successful. We are aiming for an integrated approach to conservation of natural populations with both ex situ conservation action as well as reinforcement of remnant populations in situ.

Metasequoia glyptostroboides

DAWN REDWOOD

IUCN RED LIST CATEGORY

Endangered

NE DD LC NT VU **EN** CR EW EX

NATURAL RANGE

China (Hunan, Hubei, Chongqing)

PREFERRED HABITAT

Forested temperate valleys and ravines

THREATS

Intensively cultivated countryside

Population fragmentation due to farming

Metasequoia glyptostroboides is an important living fossil, the last surviving member of an ancient genus of about 10 species that grew in the northern hemisphere until the Quaternary ice age. Like *Sequoia sempervirens* (coast redwood) and *Sequoiadendron giganteum* (giant redwood), which grow in the western temperate forests of the US, it is in the cypress family. Although smaller than these massive conifers, *M. glyptostroboides* can still reach heights of 60 metres and more. Its bark and foliage are very similar to the American redwood species, but unlike them, it is deciduous—its needles turn from green to a foxy reddish brown in autumn before being shed. Its beautiful autumn foliage is one of the reasons dawn redwood has become so popular in cultivation.

Endemic to central China, *Metasequoia glyptostroboides* was first discovered in 1941, near the remote village of Modaoqi, in what is now Hubei province, by Chinese forester T. Kan. The tree was known locally as *shuishan* ("water fir"). A few years later, the largest population was felled for timber. After World War II, more trees were found in the area of the original collection. Seed collections made in collaboration with the Arnold Arboretum have helped ensure the survival of the species. By the end of the 1940s, the dawn redwood had been described scientifically, its similarity to known fossil records determined, and its cultivation worldwide begun. Large trees grown from the original seed collections can be seen at the Missouri Botanical Garden in the US and Cambridge University Botanic Garden and Oxford Botanic Garden in the UK. In fact, this is the most common threatened conifer in ex situ collections, with 316 collections globally, and a good example of international collaborative efforts in ex situ conservation. Unfortunately, as so often happens, the trees in cultivation have limited genetic diversity compared to the wild populations.

In the 1950s and 1960s, China was largely closed to outside collaboration, but botanical exploration was very active within the country. The

The cones of *Metasequoia glyptostroboides* are surprisingly small for such a large tree, only about an inch long.

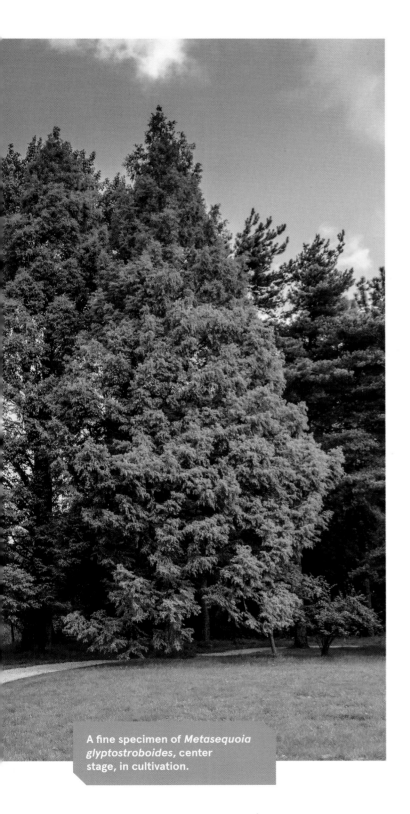

Chinese government gave protection to the few remaining trees and propagated tens of thousands more to be planted as street trees throughout the country. Bill McNamara, travelling with botanists from Kew and Lord Howick from the Howick Arboretum, was one of the first western botanists to visit China when botanical exploration again became possible in the 1980s; this trip was the first of a series of seed-collecting expeditions. On a 1996 trip, Bill saw a single specimen of dawn redwood growing at Modaoqi; it was protected by a lightning rod and concrete wall, a remnant of its former glory.

It is unlikely that *Metasequoia glyptostroboides* will become extinct, due to its wide use as an ornamental tree and presence in many ex situ collections around the world, but wild populations remain at risk and conservation measures in situ are a high priority. Since the early 1980s, it has been listed as a Grade I species in China's List of Wild Plants under State Priority Conservation. This special tree is a riparian species that occurs only in a limited region in the border area between Hubei and Hunan and in Chongqing municipality, Sichuan. In the past it probably grew in more extensive floodplain forest, with other species adapted to periodic flooding. It has been difficult in some cases to distinguish with certainty which individuals are truly remnants of the natural population and which have been planted.

Traditionally, Chinese farmers used dawn redwood timber for construction and for firewood. Rural iron smelting was an additional threat. Now the few remaining subpopulations are all reduced to a few mature individual trees with little chance of natural regeneration due to changes in land use. The trees are scattered in hilly areas farmed for rice production, occurring at about 18 sites. Large mature trees (such as the one at Modaoqi) have all been afforded some level of protection, but efforts to protect—or to restore—the species more widely

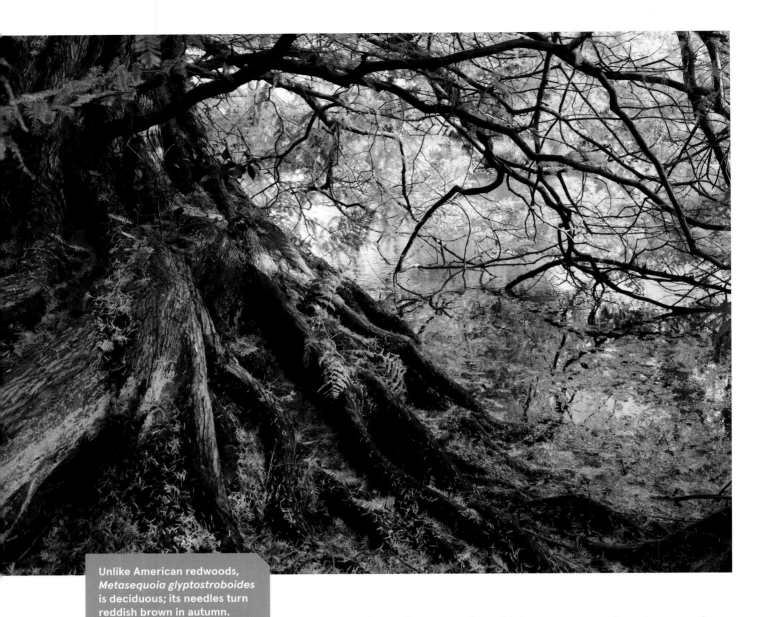

Unlike American redwoods, *Metasequoia glyptostroboides* is deciduous; its needles turn reddish brown in autumn.

have been limited. Dawn redwood is known to occur in at least one forest park, but these trees may have been planted before the scientific discovery of the species.

The best hope for *Metasequoia glyptostroboides* may be to establish circa situm (farmer-based) conservation collections using local seed to boost populations close to their remnant sites. Meanwhile, dawn redwoods in botanic gardens tell a potent story about a survivor from the ice age that could easily be lost without our vigilance.

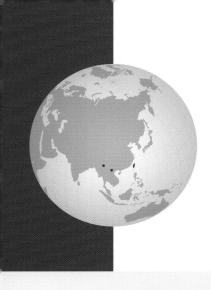

Taiwania cryptomerioides

COFFIN TREE

IUCN RED LIST CATEGORY

Vulnerable

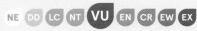

NE DD LC NT **VU** EN CR EW EX

NATURAL RANGE

China (Guizhou, Yunnan, Sichuan, Hubei, Taiwan), Myanmar, Vietnam

PREFERRED HABITAT

Cool, temperate coniferous montane forest

THREATS

Deliberately set fires to convert land to grazing areas

Logging for high-quality timber

A giant of the tree world, *Taiwania cryptomerioides* can grow to 70 metres high and 3 metres across with a smooth pale grey trunk supported by large buttressed roots. Native to eastern Asia at elevations of 1400–2950 metres, this species has a disjunct distribution in the mountains of central Taiwan and mainland China (mainly in the southern parts of the Gaoligong Mountains and adjacent areas of Myanmar), with a tiny population in Vietnam. These regions are all rich in biodiversity and are considered refugia from past glacial periods. The current distribution in China reflects a history of intense exploitation over the last century.

The highly valued timber of *Taiwania cryptomerioides* is easy to work, light, and durable, with an attractive spicy scent. It is used to make various high-quality products, including furniture, bridges, and boats, but it is particularly sought-after for coffins (hence its common name). Coffin makers in China are heavily reliant on the timber, and the loss of the species would have a huge impact on their livelihoods. One large tree can provide timber for a dozen coffins. The wood is usually felled and cut into planks in the forest; in the past these were carried out of the forest by mule or local porters, or floated downstream to a convenient landing place.

Taiwania cryptomerioides was first described in 1906 by botanist Bunzo Hayata, who was investigating the flora of Taiwan, China. One of the unique features named in the new genus *Taiwania* is the tree's two distinct forms of foliage. Like other conifers, coffin tree has needle-like leaves, but after it reaches the century mark, its leaves undergo a gradual transition, eventually turning into scales.

Logging and general forest clearance have led to a major decline in the number of coffin trees in recent decades, and the species is now listed by IUCN as vulnerable. Poor regeneration also contributes to the vulnerability of the tree. *Taiwania cryptomerioides* is long-lived, routinely attaining an age of 1600 years and often more; it belongs ecologically to those conifers that, through longevity and canopy emergence, survive all

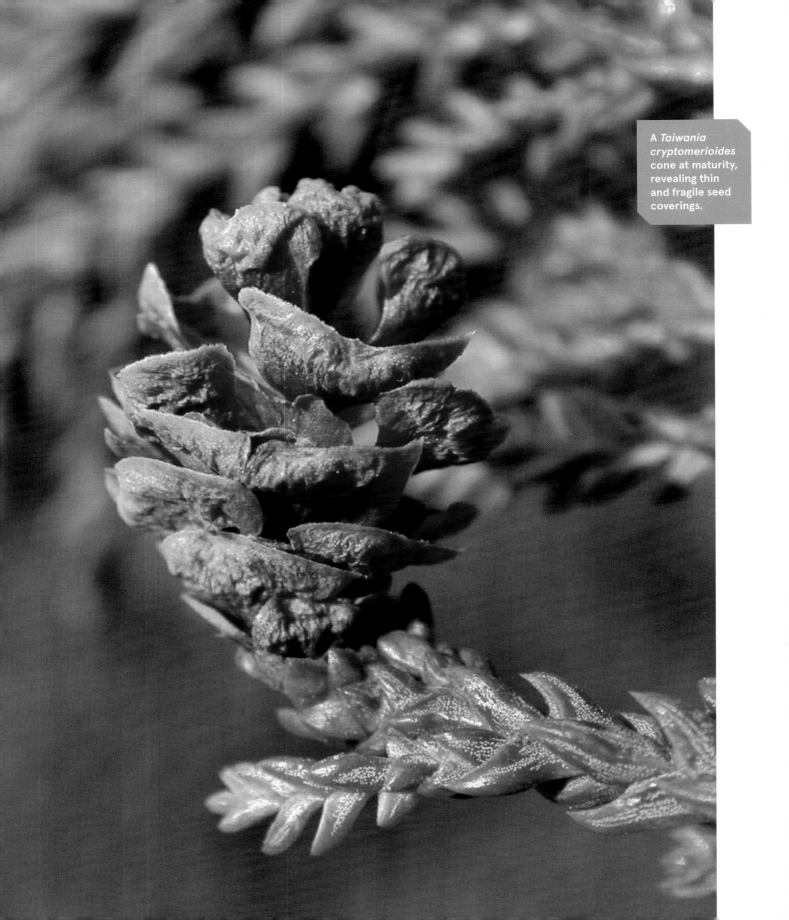

A *Taiwania cryptomerioides* cone at maturity, revealing thin and fragile seed coverings.

other forest trees, "waiting" for episodal forest disturbance (most likely fire but possibly also landslides to create open areas of bare ground) to regenerate. The absence or extreme scarcity of seedlings and young trees, commented on for many years, is quite typical of conifers.

Logging of *Taiwania cryptomerioides* has been banned in China but is thought to continue in Myanmar. It is sometimes cultivated in China, notably in Guizhou, Hunan, and Taiwan, as a forestry plantation tree that in time may supply the coffin industry. The majority of natural stands are now protected within national parks, such as the Gaoligong National Nature Reserve in Yunnan. A recently discovered subpopulation of some 1000 mature individuals in southern Taiwan is relatively secure, thanks to its extreme inaccessibility and the fact that the lake area where it grows is considered a holy land by the local people.

The relict population in Vietnam is found at 1800–2100 metres in the Hoang Lien Son range near the Lao Cai province of Van Ban district, in the north of the country. Fewer than 100 mature trees remain, thought to be part of a larger population that was reduced as new settlers cleared the formerly pristine forest. This tiny remnant was discovered in a remote valley by Vietnamese biologists working on a gibbon survey in October 2001. The following year, FFI called on Aljos Farjon to verify the discovery, confirming its status as a truly native tree. It was the early days of the Global Trees Campaign, and FFI sought advice from Aljos on the conservation of all the rare and threatened conifers in Vietnam—including the imperilled population of taiwania. Aljos travelled to Vietnam, where the coffin tree is scattered in remnants of montane evergreen forest dominated by Fagaceae, Lauraceae, and some Magnoliaceae. Only one other large conifer, *Fokienia hodginsii*, is locally more common (and also considered vulnerable by IUCN). Both the taiwania and the fokienia are used by the Hmong for roofing shingles and house construction. Some of this wood is beautifully marked with red and pale yellow annual rings (late and early wood, respectively) and prized for furniture.

FFI began collaborative work on *Taiwania cryptomerioides* in 2001 as part of a broader project. Through this community-based conservation of the Hoang Lien Son ecosystem, integrated solutions were sought, working with the local community to preserve the trees, surrounding forest, and local livelihoods. Helping to conserve the magnificent conifers has subsequently involved assessing the potential of non-timber forest products for income generation, which is sorely needed by the Red Dao, Hmong, and Tay people. Supplementing the cultivation of rice and maize, over 1000 plant and insect species have been recorded in local use for food

(e.g., bamboo shoots and honey), medicines, dyes, and a whole host of other purposes. The decline of the forests can have major impacts on the supply of these useful species. Developing sustainable livelihoods and protecting biodiversity in this remote part of Vietnam are long-term goals. In the short term, work by FFI and its partners has contributed by collecting baseline information, raising awareness, and supporting local involvement in conifer conservation.

FFI's support for conifer conservation was undertaken in partnership with the Vietnamese Centre for Plant Conservation. The work involved helping local families in Co Thai village in the Mù Cang Chải district manage a wild population of *Taiwania cryptomerioides*. The small cones were collected, each containing two seeds. From these, tree seedlings were successfully grown in the nurseries and, with the help of local communities, used to reinforce the wild population of the tree. In addition to reinforcement, all known wild trees were measured and tagged for monitoring purposes. The inclusion of the species as an official government reforestation species is an ultimate objective; this designation would allow communities to generate income from sustainable seedling production, to increase populations and sites for the species. The Van Ban district where *T. cryptomerioides* occurs was declared a provincial Nature Reserve in 2007.

The Global Trees Campaign has continued to work on *Taiwania cryptomerioides*, and in 2007 helped establish the Conifer Conservation Centre (CCC) within Vietnam. In the UK, Bedgebury National Pinetum is looking after 30 trees donated to them by ICCP.

Botanical drawing of *Taiwania cryptomerioides*.

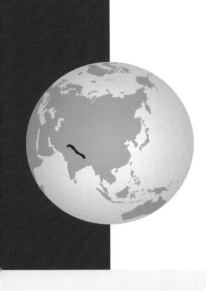

Taxus contorta
WEST HIMALAYAN YEW

IUCN RED LIST CATEGORY

Endangered

NE DD LC NT VU **EN** CR EW EX

NATURAL RANGE

Afghanistan, China (Xizang), India, Nepal, Pakistan

PREFERRED HABITAT

Mid-altitude conifer forest

THREATS

Logging and wood harvesting

Collection for fuel, food, and medicine

War, civil unrest, and military exercises

Taxus contorta is a widespread species, growing at elevations of 1700–3100 metres in the mountains of Afghanistan, Pakistan, northwestern India, Nepal, and Xizang, China. Nevertheless, global demand for Taxol, a key anticancer drug extracted from its bark, has triggered a rapid and dramatic decline of this slow-growing yew in its natural habitats. It is now endangered at a global level, having suffered a population decline of at least 50 percent over the whole of its range due to overexploitation associated with medicinal use.

The bark, leaves, and twigs of *Taxus contorta* have a range of traditional medicinal uses, but it is the particular use of its bark in the

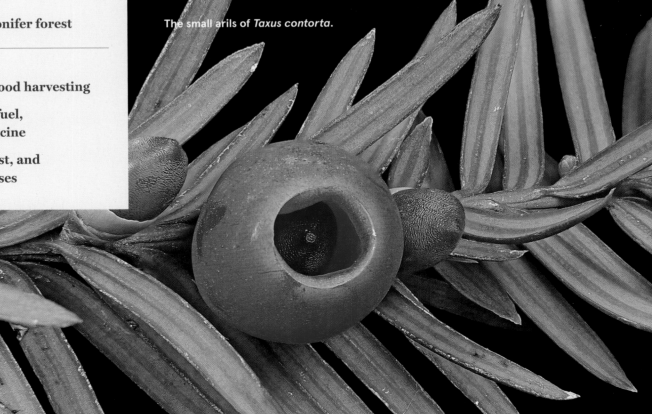

The small arils of *Taxus contorta*.

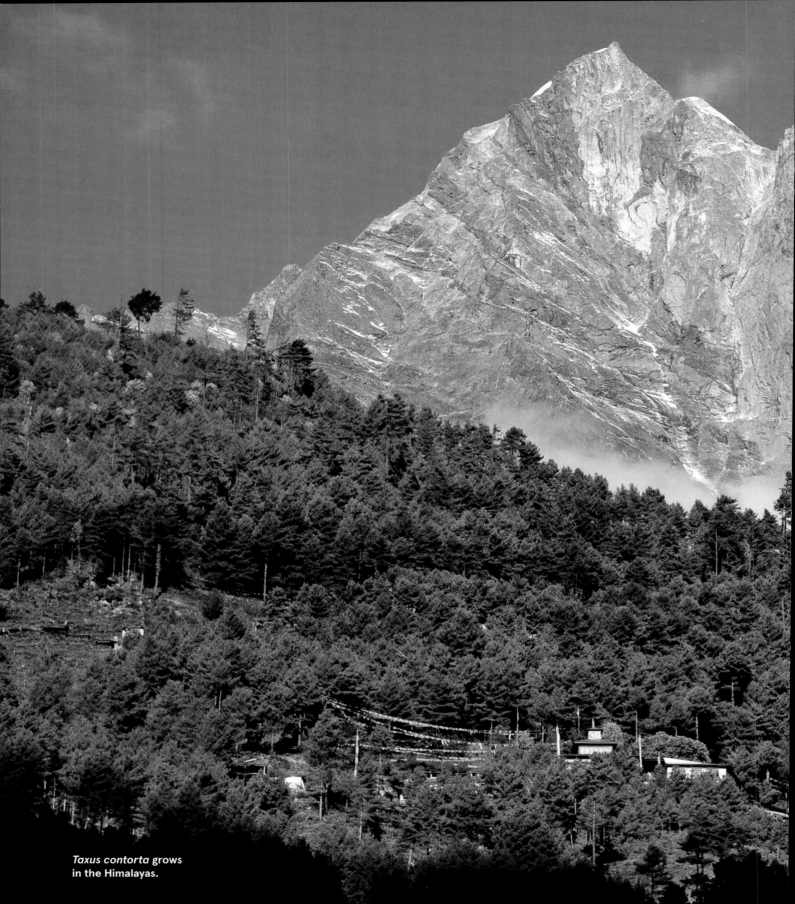

Taxus contorta grows
in the Himalayas.

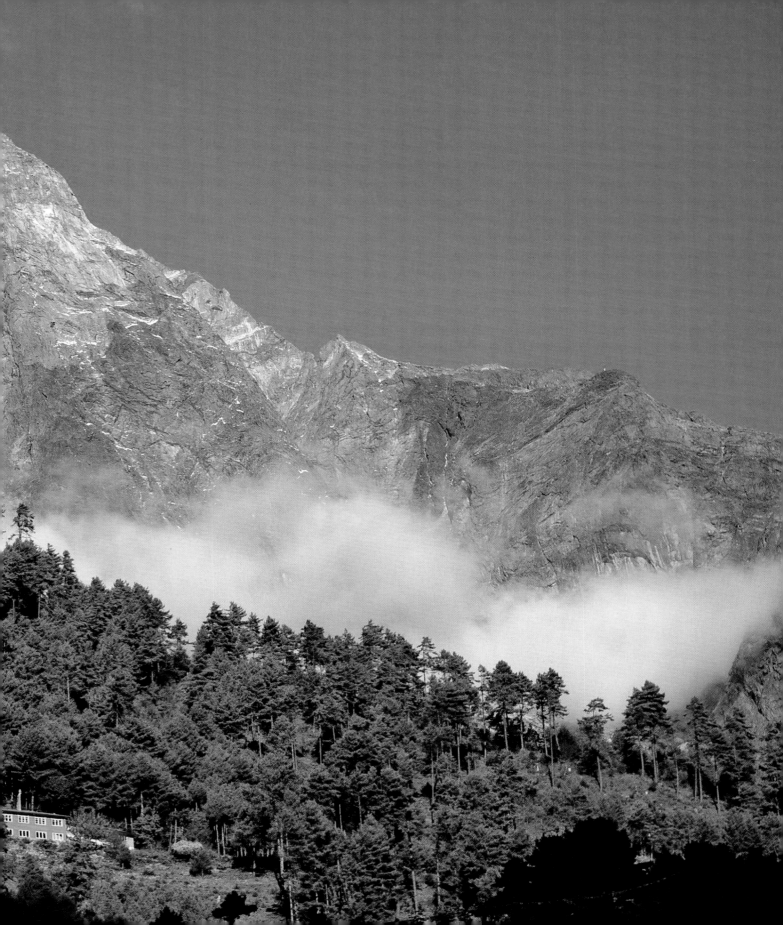

commercial production of Taxol that has been the main cause of its dramatic decline in India and Nepal, with up to 90 percent loss at a national level. In 1967 the huge medicinal importance of *Taxus* was first realised. In that year, the anticancer compound paclitaxel was isolated from *T. brevifolia* (Pacific yew), which grows in Canada and the US. The discovery was part of research by the US National Cancer Institute, which screened a wide range of wild species for medicinal properties. Exploitation of the Pacific yew, to produce Taxol, gradually stopped as exploitation shifted to Asian yew species, and alternative methods for Taxol production have now been developed.

Taxus contorta is a source of taxanes, from which paclitaxel is derived, together with *T. brevifolia*, the widespread *T. baccata* (English yew), and its close relatives *T. wallichiana* and *T. chinensis*. Concern about the international trade in *T. wallichiana* led to its listing in CITES Appendix II in 1995. At the time *T. wallichiana* was thought to be the only species of yew in the Himalayas, but the taxonomy has since been revised. Currently four additional Asian yew species are included in CITES Appendix II: *T. chinensis*, *T. cuspidata*, *T. fuana*, and *T. sumatrana*. *Taxus contorta* is not listed but is covered by CITES regulations as a synonym—a somewhat contorted situation! Problems with CITES implementation for *Taxus* species remain; there is a generally low level of effort for medicinal species, and the *Taxus* products in trade are very difficult to identify.

Harvesting *Taxus* on a commercial level is no longer necessary: the cancer treatments can be made by industrial production based on plant cell culture, and new forms of production, such as engineering of microbial production hosts, are being developed. The shift from harvesting to industrial production has been accompanied by attempts to conserve *Taxus* species in the wild, but exploitation continues to be an issue. According to Teresa Mulliken of TRAFFIC International, "A strong economic incentive for wild harvesting and the purchase by manufacturers of wild-harvested products is likely to persist even within countries [that] ban such harvests. It is understandable that local people want to benefit from the sale of a wild plant resource, and so we need to look at holistic solutions."

The timber of West Himalayan yew is used for the construction of houses and is sought-after for use in temples and monasteries as well as for making furniture, grave coverings, and beehives. In Pakistan, the wood is often collected for fuel, and the foliage is harvested as fodder for livestock. In Afghanistan, up to 50 percent of the forests where *Taxus*

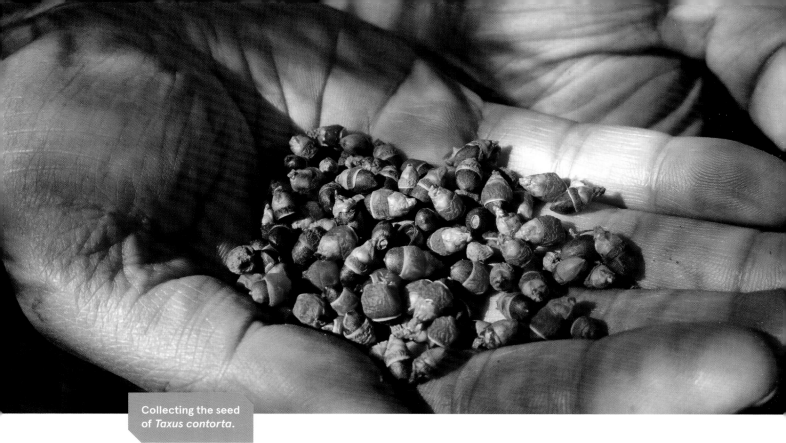

contorta occurs have been destroyed or heavily logged for timber over the last 30 years.

If the West Himalayan yew is to survive in the wild, it will need careful management to replace the current unsustainable levels of exploitation. Extraction methods are needed that do not kill the trees in the wild, and harvesting of cultivated material should over time supplement or replace collection from wild populations. Plantations are gradually being established to encourage private or community cultivation, and programmes to encourage its protection in the wild are in place. A further reason for hope is that numerous sacred sites occur in the region where *Taxus contorta* is protected. Conservation ethics are part of the culture and tradition of local people, who believe that cutting trees from sacred sites may harm their families.

In Nepal a project is underway for the three *Taxus* species that occur there: *T. contorta*, *T. wallichiana*, and *T. mairei*. All three are heavily exploited for use in Taxol production. The project, undertaken with support from the Conservation Leadership Programme, assesses the harvesting methods of these species and works with local harvesters to improve sustainability, ensuring long-term viability of their wild populations in the country.

Dacrydium nausoriense

YAKA, TANGITANGI

IUCN RED LIST CATEGORY

Endangered

NE DD LC NT VU **EN** CR EW EX

NATURAL RANGE

Fiji

PREFERRED HABITAT

**Subtropical to tropical
moist upland forest**

THREATS

Livestock farming and ranching

Logging and wood harvesting

**Local use as a Christmas
tree, firewood**

Invasive species

Dacrydium nausoriense, a tropical conifer first described in 1969, is one of 20 species in a predominantly Asian genus that extends from China to New Zealand. It is found only in the upland forests of Fiji, a biodiversity hotspot with about 600 endemic tree species. The remnant native vegetation there is highly disturbed as a result of logging, exotic timber plantations, and agriculture. *Dacrydium nausoriense* is a valuable timber species and has been heavily exploited; it is also used locally as a Christmas tree and is, unfortunately, considered good firewood.

At a red list workshop held in Fiji in 2016 as part of the Global Tree Assessment, *Dacrydium nausoriense*, known locally as yaka, was evaluated as endangered, and priority conservation actions were identified. The workshop brought together foresters, botanists, and conservation

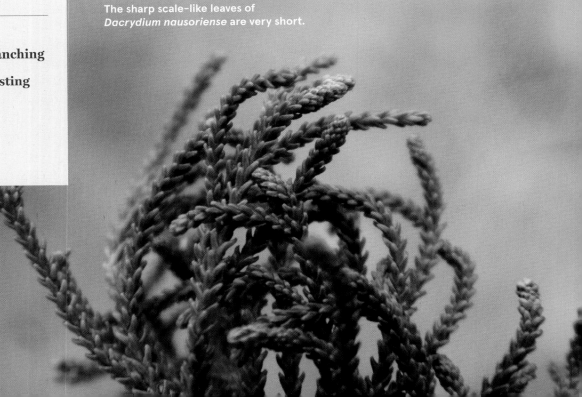

The sharp scale–like leaves of
Dacrydium nausoriense are very short.

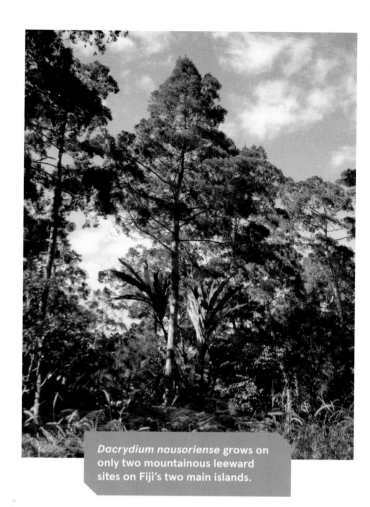

Dacrydium nausoriense grows on only two mountainous leeward sites on Fiji's two main islands.

experts from across Fiji. Participants learned that yaka is not known to occur in any protected areas, although some sites within its range have been identified as priority areas for conservation. Faced with a range of direct threats and habitat loss, this species now requires urgent conservation action to prevent extinction, including further field surveys to establish the size of the remaining population, more details of its distribution, and its status. Currently *D. nausoriense* is listed under Schedule 2 of Fiji's Endangered and Protected Species Act (2002), which provides some protection against excessive exploitation. The establishment of a nursery to sell Christmas trees and ornamentals should help to reduce the need to exploit it in the wild, and a project has been initiated to develop ex situ conservation for yaka in combination with protection of the remnant native vegetation. Ongoing actions to raise awareness in local authorities and promote alternative species for firewood will help protect this important conifer species.

In common with yaka, many of Fiji's trees are poorly known and in need of more field survey. BGCI continues to work with a range of local organisations to red list and conserve some of the country's most threatened trees.

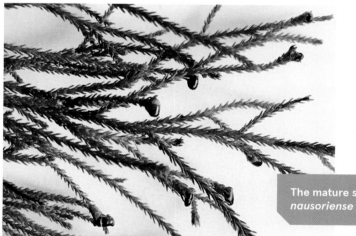

The mature seeds of *Dacrydium nausoriense* are dark and smooth.

Widdringtonia whytei

MULANJE CEDAR

IUCN RED LIST CATEGORY

Critically Endangered

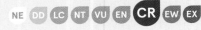

NATURAL RANGE

Malawi

PREFERRED HABITAT

Mount Mulanje

THREATS

Logging to near extinction

Increased fire frequency

Smallholder farm expansion

Competition from plantation species

Open bauxite mining

Invasive pests

Widdringtonia is a conifer genus with four species, all found in southern Africa. *Widdringtonia whytei* is endemic to Malawi's Mount Mulanje, known locally as *chilumba mu mlengalenga* ("island in the sky"), which rises up out of the surrounding plains to a height of 3000 metres. Much of the area of its natural distribution is gazetted as the Mount Mulanje Forest Reserve, established under British colonial rule. Mulanje cedar grows in the Afromontane forest, along with *Podocarpus milanjianus*, a common African conifer, and other tree species. Mount Mulanje is very important for biodiversity conservation and also culturally as a site where ancestral spirits are believed to reside. It is an internationally recognised biosphere reserve.

Widdringtonia whytei was declared Malawi's national tree in 1984. As well as being very important ecologically, Mulanje cedar has been a highly valued timber, durable and termite-proof, used for construction and wood carving. It used to provide an important source of income for local communities, favored for its strong and spicy aroma, but unsustainable harvesting has led to its demise as a livelihood resource. People are even dismantling bridges originally made of Mulanje cedar; nothing is left untouched.

It was estimated in 2013 that cedar forest cover had declined by 37 percent as a result of overexploitation, fire, and the impact of invasive species. The steep decline in Mulanje cedar resulted in a loss of income for communities living around Mount Mulanje, together with increased soil erosion and floods due to rapid water run-off during rainy seasons. Its rapid population decline also resulted in the Malawian Forestry Department producing a new Cedar Management Plan (2014), which recommended that logging of the tree on the mountain be prohibited for at least the next five years and that large-scale ecological restoration of the cedar should be undertaken. The proposed five-year logging moratorium, unfortunately, was not respected. With no mature trees, the only hope

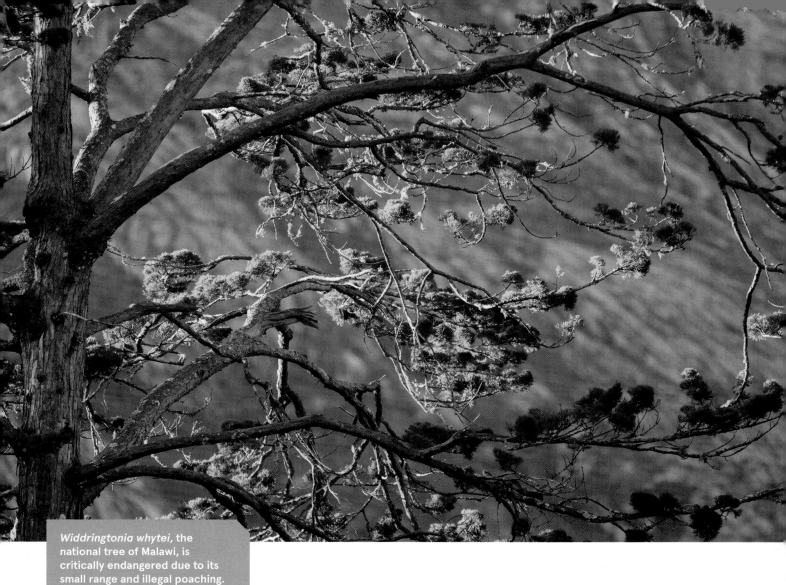

Widddringtonia whytei, the national tree of Malawi, is critically endangered due to its small range and illegal poaching.

is replanting as part of forest restoration. Previous attempts to restore cedar forests and to grow the species more widely have been limited by its poorly understood ecology, pathology, and horticulture.

The Global Trees Campaign is working with partners in Malawi to try to address these challenges and secure a future for *Widddringtonia whytei* in its natural habitat. Small plantations have been established elsewhere in the country, on the Zomba and Viphya plateaus, and 10 community nurseries have been set up and nursery management and propagation training delivered by Dan Luscombe. The 150 community members who work in the nurseries have propagated more than 300,000 Mulanje cedar seedlings to date. In addition, eight test sites for planting Mulanje cedar have been established across Malawi to investigate if the cedar will grow well in areas outside the Mulanje Mountain Biosphere

Tea estates surround the delicate ecological habitat of Mount Mulanje, the only home for *Widdringtonia whytei*.

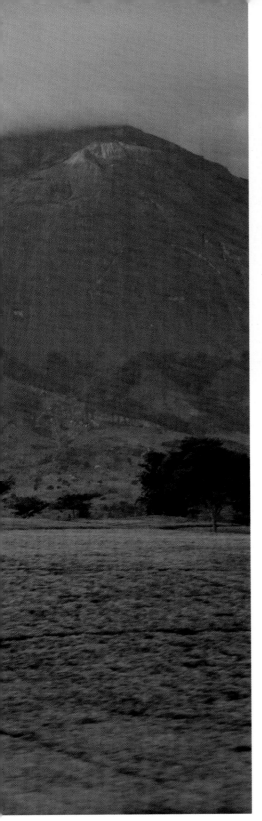

Curios made from the wood of *Widdringtonia whytei* were long a source of income for local residents.

Reserve. Ultimately the seedlings grown in the nurseries could be used to restore an even wider area. BGCI has been working on an education campaign in collaboration with Bedgebury National Pinetum and the NGO Starfish Malawi, teaching children in Malawi about the importance of conserving their national tree.

Widdringtonia whytei is now listed by IUCN as critically endangered and may even be extinct in its natural habitat. But the fragrance that fills the air near the remnants of the once majestic Mulanje cedar may help in the fight to save it from extinction; research will help us to understand whether its essential oils could have economic uses—for example, in aromatherapy, medicines, or pesticides. As with so many tree conservation efforts there is no quick fix. But as long as there are seeds and people willing to try, there is a chance to save the Mulanje cedar.

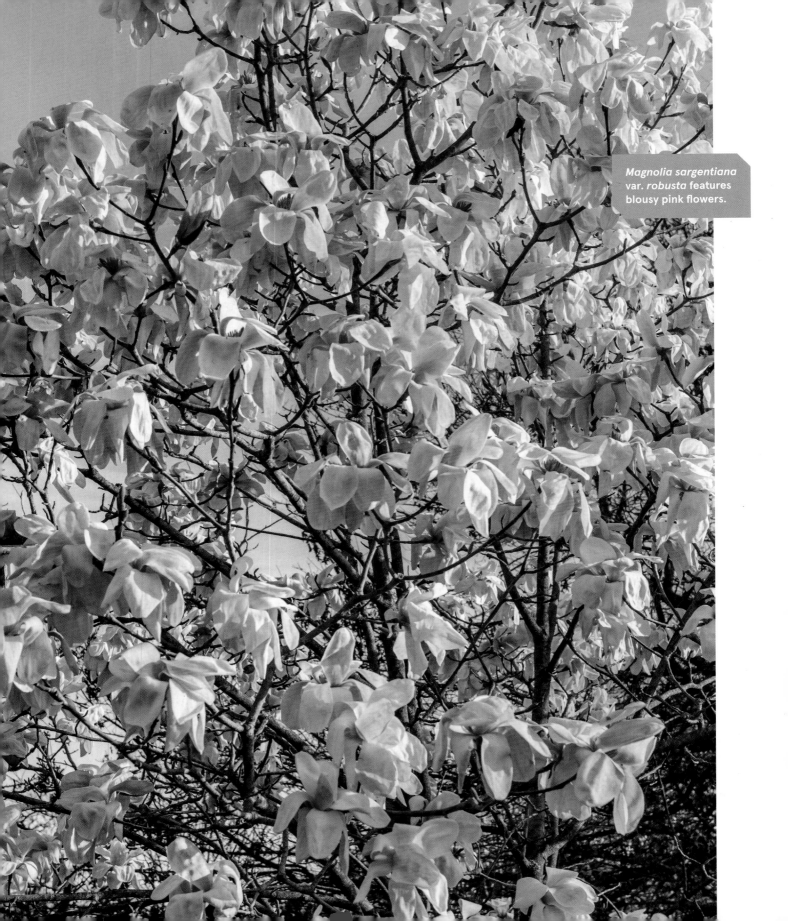

Magnolia sargentiana var. *robusta* features blousy pink flowers.

Magnolias

Magnolias are ancient trees that inspire and delight gardeners, their profusion of variously coloured flowers heralding the start of spring in temperate countries around the world. Ernest Wilson had it right: "No group of trees and shrubs is more favourably known or more highly appreciated in gardens than magnolias and no group produces larger or more abundant blossoms."

There are about 300 species in the magnolia family (Magnoliaceae). Most botanists recognise just two genera, *Magnolia* and *Liriodendron*. *Liriodendron tulipifera* (tulip tree) is widespread in southern Canada and eastern US, and its only close relative, *L. chinense*, occurs in China and Vietnam. This pattern of distribution is mirrored for *Magnolia*, which has two major areas of diversity in East Asia and the Americas. Magnolias are of great evolutionary interest, representing some of the most ancient flowering plants. In the late Cretaceous and Tertiary periods, magnolias grew throughout the northern hemisphere. Climatic and geological changes then led to major changes in their distribution patterns.

Magnolias have long been celebrated for their beauty and planted as holy trees in ancient China. They have a range of other uses. Many species, including those of the Caribbean and Central America, produce fine timber; others are valued for their medicinal products. The bark of *Magnolia officinalis* has, for example, been used in Asian traditional medicine for thousands of years to treat a range of ailments, including anxiety and asthma. Magnolia products were also used medicinally by American Indians.

Nowadays magnolias are in trouble in the wild. They face threats of general deforestation, logging for their timber, and collection for medicine and ornamental horticulture; increasingly, they are threatened by climate change. Many *Magnolia* species also face natural problems of regeneration due to small population size, decline of their insect pollinators, and other biological factors that are not yet fully understood. "Most

Did you know?

Nearly half the world's *Magnolia* species are threatened with extinction, and one-third are still too poorly known to make a conservation assessment.

magnolias take a long time to start flowering, and until then they are not reproducing, which means they are very vulnerable to overexploitation," adds Georgina Magin, FFI's Global Trees Campaign coordinator. One species, *M. pseudokobus*, native to Tokushima Prefecture, Shikoku, Japan, is already extinct in the wild and survives in only a few local private gardens.

The Global Trees Campaign has prioritised work on magnolias from the outset. An assessment of the conservation status of all known species, carried out with Red List information, was published in 2007. Since then, 93 new *Magnolia* species have been described, additional information on existing species has been published in botanical literature, and new threats to species have emerged. A revised Red List was produced in 2016.

Word from Cuba

Planta! volunteers in action.

Cuban botanist Luis Roberto González-Torres is working tirelessly to conserve the threatened trees and other endemic plants of Cuba. Luis and his colleague Alejandro Palmarola Bejerano coordinate Cuba's red listing for plants, manage the *Magnolia* conservation project, and promote the importance of the Cuban flora to a global audience. Together with other Cuban botanists, Luis and Alejandro formed a new organisation, Planta!, to expand their conservation work. As Luis explains,

"Alejandro and I share similar interests and enthusiasm. As we became more involved in plant conservation, initially under the guidance of Angela Leiva, we realised that the only way to succeed is to engage and involve as wide a range of people as possible. We cannot conserve Cuban magnolias without the coffee farmers and others who depend on the forest."

China, with around half of all species, is the main centre of species diversity for Magnoliaceae. The second centre of diversity is the neotropics, where a large number of new species have been recently described and published. A large-scale research project at the Ghent University Botanical Garden, Belgium, in cooperation with the Instituto de Ecología, Mexico, aims to untangle the evolutionary history of New World magnolias, including the Caribbean ones, and apply conservation genetic studies on selected species of the region to inform conservation actions undertaken by local people. Surprisingly, throughout the whole area, the taxonomic delimitation of many species of this flagship genus, including those with medicinal uses (such as the different taxa surrounding *Magnolia mexicana*, all termed "flower of the heart" in Spanish and local languages), is still very doubtful, complicating protection actions as their units for conservation are not yet well defined. Nevertheless, we already know that the neotropics has the highest number of species facing extinction: 75 percent of the magnolias of Central and South America are under threat.

Red listing has helped set conservation priorities for magnolias in their natural habitats and spurred important ex situ collections of them. Botanic gardens and arboreta have a key role to play in the conservation of magnolias, as these beautiful trees are often included in their grounds. A survey of ex situ Magnoliaceae collections carried out in 2016, however, showed that only 43 percent of threatened *Magnolia* species were represented, and most threatened *Magnolia* species are found in fewer than five collections, which is worrying given the fragility of many wild populations. Further work is needed to ensure that botanic gardens are providing an effective insurance policy for the future of all threatened magnolias, ideally working together in a coordinated way.

MAGNOLIAS IN ASIA

Conservation of threatened magnolias in their natural habitats remains a top priority. In 2004, with support from FFI, the IUCN/SSC Global Tree Specialist Group held a workshop in Kunming, China, both to look in detail at the conservation status of magnolias and to prioritise action. Experts at the workshop agreed that further fieldwork was necessary to check the distribution and conservation needs of Chinese species and that information needed to be shared with all who could help plan and carry

out conservation action. New partnerships were needed both within China and with experts in Vietnam and other neighbouring countries. Five species were identified at the workshop as priorities for urgent conservation efforts: *Magnolia sinica*, *M. grandis*, *M. sargentiana*, *M. fistulosa*, and *M. coriacea*. All have benefited from international collaboration in conservation efforts in the years since, together with over 20 other *Magnolia* species for which action has been taken by the Global Trees Campaign. Magnolias are the subject of major conservation efforts by Chinese institutions, and both FFI and BGCI are also supporting a range of different local partners to secure the future of these charismatic flowering trees. It may not be possible to halt the current impact of climate change on these species, whose ancestors flourished in the era of dinosaurs, but the

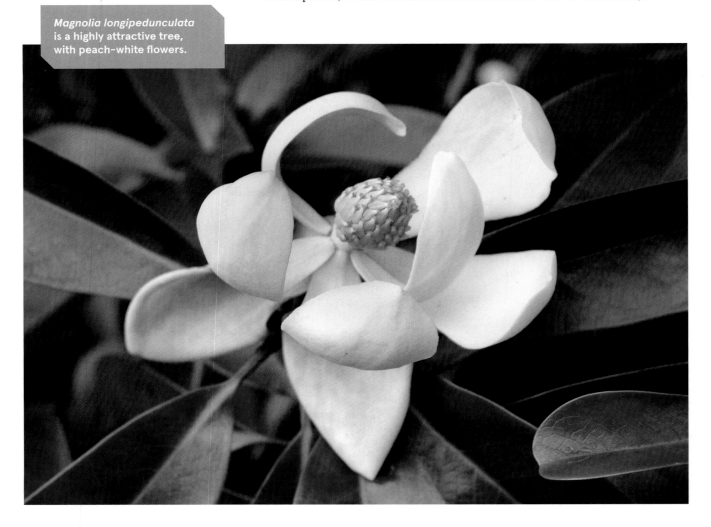

Magnolia longipedunculata is a highly attractive tree, with peach-white flowers.

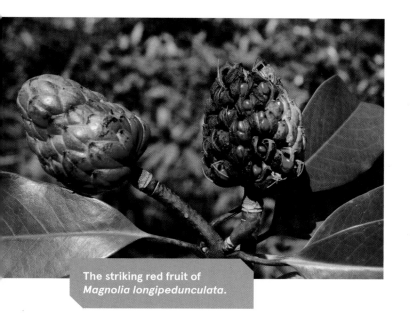

The striking red fruit of *Magnolia longipedunculata*.

resilience of natural populations is being strengthened through a combination of research, public awareness, reinforcement of natural populations, strengthening of nature reserves, and maintenance in botanic gardens.

China has an extensive network of over 160 botanic gardens and arboreta. They are generally designated by the government as research and development centres for plant diversity conservation and sustainable utilization. Most botanic gardens are found in central city locations, where they provide great opportunities for public education. Some of China's leading botanic gardens, including the internationally renowned Kunming Botanical Garden, are fully engaged in the GTC, working with BGCI and FFI and facilitating links with local communities. The South China Botanic Garden in Guangzhou has a major collection of *Magnolia* species, including 13 endangered and 10 critically endangered Chinese species. One of these is the critically endangered *M. longipedunculata*, a species first discovered in 2004. Only 11 wild individuals remain, scattered across broadleaved evergreen forest in Nankunshan Nature Reserve, Guangdong. All the remaining individuals have resprouted from stumps of trees that were logged many years ago for their high-quality timber. Unfortunately *M. longipedunculata* trees seem to be unable to reproduce naturally in the wild. This is thought to be due to the tree's short flowering period and a shortage of insect pollinators.

Since 2008, the Global Trees Campaign has been working with botanists at the South China Botanic Garden to implement an integrated conservation action plan for *Magnolia longipedunculata*. To overcome the species' reproductive barriers, the team have been carrying out artificial pollination and propagating seedlings, to establish ex situ living collections and to carry out reintroductions in the wild. The team's reintroduction projects have taken possible effects of climate change on the species into account. As well as bolstering the current wild population at Nankunshan, work is underway to establish new populations at sites which, in future climate conditions, may provide suitable sanctuaries for *M. longipedunculata*. One such site is Tianxin Nature Reserve, where seedlings have already been successfully established.

Magnolia coriacea

IUCN RED LIST CATEGORY

Endangered

NE DD LC NT VU **EN** CR EW EX

NATURAL RANGE

China (Yunnan), Vietnam

PREFERRED HABITAT

Subtropical to tropical forests on limestone mountain slopes

THREATS

Poor fruiting and low natural regeneration rates

Magnolia coriacea occurs in small populations scattered across south-eastern Yunnan province in China and northern Vietnam at elevations of 1200–1700 metres. It grows within evergreen woodlands on limestone mountain slopes. In Malipo County, China, local people believe that the tree is a symbol of good luck. Chinese experts at the 2004 workshop estimated that fewer than 200 wild trees survived there. As a result of their concern, field surveys were undertaken by the GTC the following year, which identified further scattered individuals. A 2010 survey, completed across the border in northern Vietnam, led to an exciting discovery: an additional 100 individuals of *M. coriacea* were found in three separate locations. Unfortunately, in both China and Vietnam, most remaining individuals occur in degraded habitats outside nature reserves.

Magnolia coriacea regenerates poorly and rarely bears fruit in the wild. With support from the GTC, Kunming Botanical Garden has been experimenting with hand pollination and germination techniques to increase propagation of the species by botanic gardens. This is only one of the ways botanic gardens contribute to the conservation of tree species.

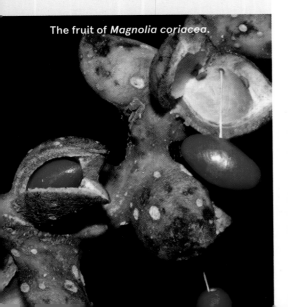

The fruit of *Magnolia coriacea*.

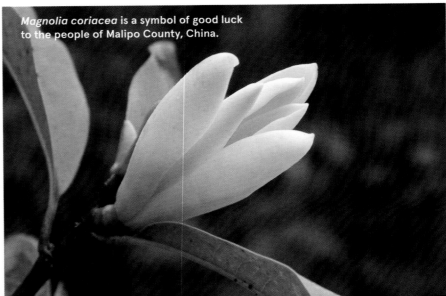

Magnolia coriacea is a symbol of good luck to the people of Malipo County, China.

Magnolia delavayi

IUCN RED LIST CATEGORY

Least Concern

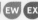

NATURAL RANGE

China (Yunnan, Sichuan, Guizhou)

PREFERRED HABITAT

Forests, limestone areas, wet slopes

THREATS

Not currently known

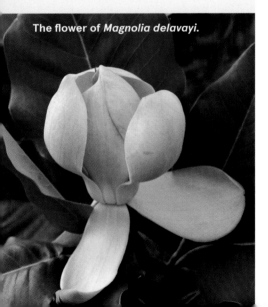

The flower of *Magnolia delavayi*.

Magnolia delavayi can be either a large shrub or a small tree. It has fragrant cup-shaped white flowers, each with nine tepals; the outer ones are greenish white, and the inner six are creamy white. We need better data to judge how it is doing in its native habitats, typically at elevations of 1500–2800 metres; it has, however, been grown for centuries in China, and in Yunnan, 800-year-old specimens are associated with temples. Now, this magnolia is becoming increasingly popular in cultivation outside China, particularly the new red forms. This species will flower from seed in three to five years if conditions are right.

Yunnan's Gaoligong National Nature Reserve includes some 2700 hectares of temperate forest, half of which is owned collectively, half managed at the household level. Disputes over tenure boundaries, deforestation, and transformation of large parts of the forests into plantations have led to a significant decline in important native tree species, including *Magnolia cathcartii* and *M. doltsopa*. Through its partner, Yunnan Institute of Environmental Science, the Global Trees Campaign is working to raise awareness among the local community and authorities of the ecological significance and economic potential of the forest's native plant diversity.

Work by the Global Trees Campaign on magnolias in China shows the range of different approaches that can be employed to save a tree species. Field survey is essential to find out basic information on the distribution, population size, and ecology of the species and the threats it faces. Protecting wild populations requires collaboration both with nature reserve managers and local communities. Georgina Magin considers that successful conservation must result in thriving magnolia populations in the wild, supported by the people who live in and around the forests where they occur. "This is not always easy to achieve, but FFI believes this approach is essential for the long-term survival of these species."

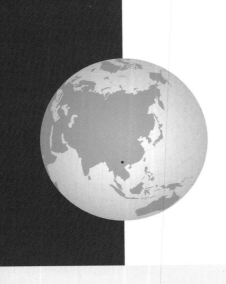

Magnolia grandis

DAGUO MULIAN

IUCN RED LIST CATEGORY

Critically Endangered

NE DD LC NT VU EN **CR** EW EX
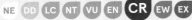

NATURAL RANGE

China (Yunnan, Guangxi), Vietnam

PREFERRED HABITAT

Subtropical to tropical valleys within limestone mountains

THREATS

Habitat clearing for agriculture

Logging and wood harvesting

Magnolia grandis is one of the world's most threatened trees, with fewer than 120 adults remaining in the wild. It is also one of the most beautiful, boasting dark red flowers and long leathery leaves. The large fragrant flowers appear terminally in late spring. Until recently *M. grandis* was thought to occur only in Yunnan and Guangxi at elevations of 800–1500 metres, with fewer than 50 trees restricted to a few patches of limestone forest. Bill McNamara has been fortunate enough to see *M. grandis* in situ: "The few trees that I have seen in the wild were on the edges of agricultural fields or in small remnant forests near villages. These remnant forests offer some degree of protection, although they are usually too small and have too few individuals to offer a viable future for this endangered magnolia."

However, experts were aware that the distribution of several *Magnolia* species in southern China stopped abruptly at the border with Vietnam, even though there was known to be similar habitat in the hills of northern Vietnam. FFI has, therefore, supported groundbreaking magnolia surveys on the Vietnam side of the border, carried out by a team composed of Chinese magnolia experts and Vietnamese botanists. These surveys found small numbers of *M. grandis* and other rare *Magnolia* species thought previously to be confined to China occurring in northern Vietnam, offering new hope for their conservation. Since that time, FFI, working with their local partner in Vietnam, the Centre for Plant Conservation (CPC), has been supporting local communities and nature reserves to protect, manage, and restore these rare trees, as well as conducting surveys to locate more adult trees in the surrounding landscape. One of the strategies used is Community Conservation Teams (CCTs), where individuals from local villages are involved in patrolling the area where the trees occur to deter logging, as well as monitoring the individual trees and assisting with reinforcement planting. Lam Van Hoang, Country Programme Manager at FFI Vietnam, is cautiously optimistic, with reason: "Involving

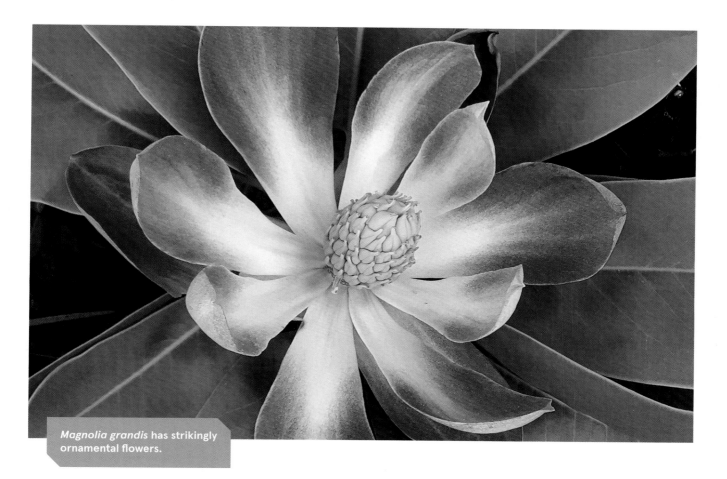

Magnolia grandis has strikingly ornamental flowers.

local inhabitants in protecting these rare trees helps to develop local understanding and pride in their importance, which is so vital to secure the long-term survival of these species." Another Chinese species benefitting from the Global Trees Campaign is *M. sargentiana*, which occurs in Sichuan and northeastern Yunnan. Only a few large trees are known to remain in the wild. It is horticulturally important and has been identified as a priority for field study by Weibang Sun, one of China's leading tree conservation experts, and Magnolia Society International. Scientists at the Kunming Botanical Garden are working with FFI to conserve this species.

Botanic gardens are also working to ensure that ex situ collections of *Magnolia grandis* are maintained outside its natural habitat as a conservation backup. The species is currently found in five ex situ conservation collections, in China and also at California's Sonoma Botanical Garden, which has fine specimens initially grown from seed collected in Yunnan. It would truly be a tragedy to lose this beautiful species.

Magnolia omeiensis

With their beautiful flowers and attractive foliage, magnolias seem made for the well-manicured parks and landscaped gardens in which they've become so popular. So it might be surprising to learn that this magnolia lives out its life clinging to the edges of mountain cliffs, at elevations of 1000–1200 metres. Collecting seed from it definitely requires a head for heights!

Magnolia omeiensis is found only on Mount Emei, known for the largest carved stone Buddha in the world and several temples, in China's Sichuan province. This site is one of the four sacred Buddhist mountains of China and is recognised as a UNESCO World Heritage site. Surrounding areas have been heavily logged, and so the temperate forests of Mount Emei provide the only natural sanctuary for *M. omeiensis*. Only 74 individuals survive in the wild. No special protection measures have been put in place for the species, but since 2016, the GTC has been supporting conservation measures to help prevent its extinction. *Magnolia omeiensis* shows only limited natural regeneration, partly as a result of its tiny population size. Research carried out by Emeishan Botanical Garden has further found that pollen produced by the remaining trees is not viable and that their male and female flower parts are not developing in synchrony. A decline in pollinating insects is also contributing to the species' reduced reproductive capacity. The odds are stacked against this very rare species, but there is some hope. Some 1100 seedlings already exist in ex situ collections, and current efforts are focused on increasing the value of these collections for conservation and for reinforcing wild populations. Research into the genetic diversity within the species is informing further development of the ex situ collections and selection of seedlings for wild population reinforcement programmes.

As well as reinforcing populations of *Magnolia omeiensis* in the wild and in botanic gardens, artificial pollination trials are underway, with botanists assisting reproduction by manually transferring pollen between wild trees. This aims to boost the species' seed production and potential germination rates. Grafting is also taking place and is showing

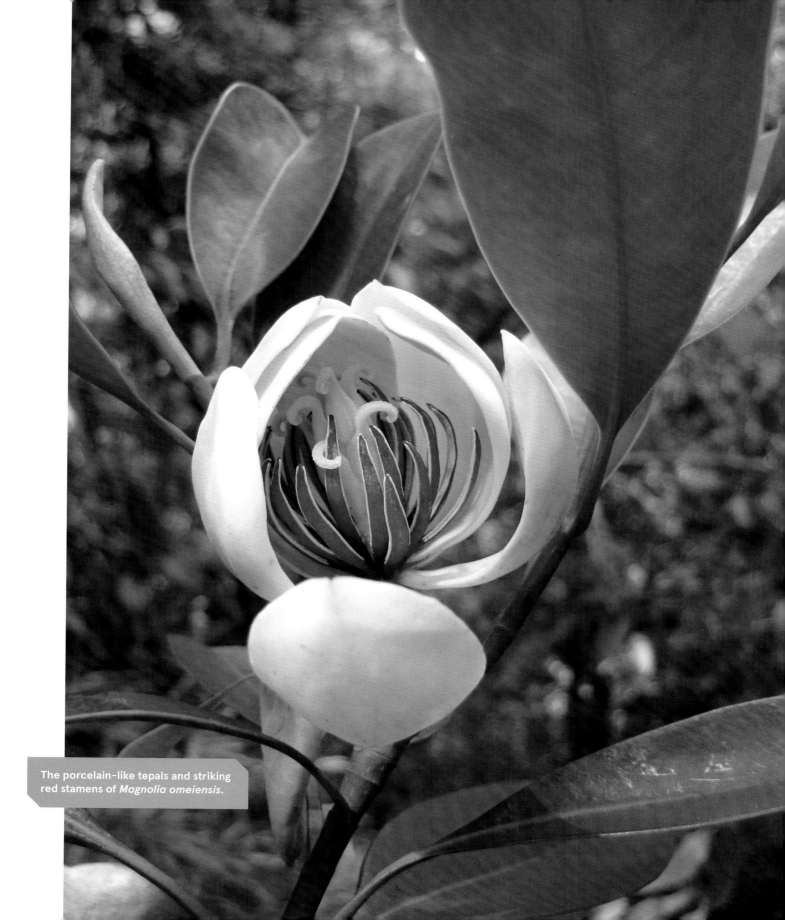

The porcelain-like tepals and striking red stamens of *Magnolia omeiensis*.

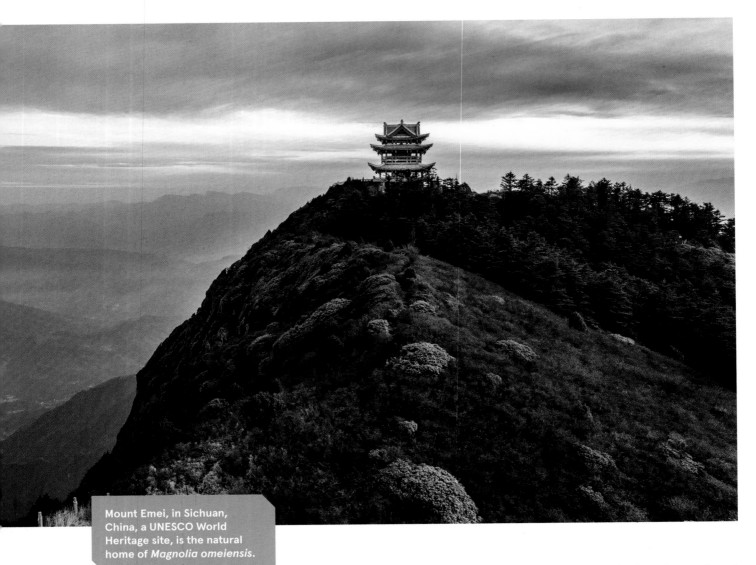

Mount Emei, in Sichuan, China, a UNESCO World Heritage site, is the natural home of *Magnolia omeiensis*.

good results. Of 500 grafted plants, 70 percent survived and were found to grow much faster than saplings grown from seed.

With intensive efforts to build populations of *Magnolia omeiensis* both in situ and ex situ, GTC and its partners are giving this species the best chances to regain a foothold in its mountain habitat. It is even possible that this attractive species with its striking flowers will provide a source of income for local communities involved in the conservation efforts.

Magnolia sinica

HUAGAIMU

IUCN RED LIST CATEGORY

Critically Endangered

 NE DD LC NT VU EN **CR** EW EX

NATURAL RANGE

China (Yunnan)

PREFERRED HABITAT

Subtropical to tropical moist montane slopes

THREATS

Logging and wood harvesting

Poor natural regeneration rates

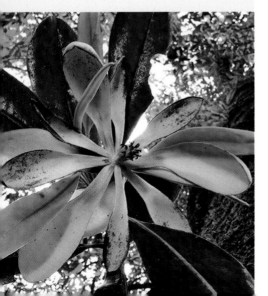

Magnolia sinica is a large, straight-trunked species from southern Yunnan province, where it grows in broadleaved forests at 1300–1600 metres. Experts at the 2004 workshop warned that individuals remaining in the wild were threatened as a result of logging for timber and destruction of the forest habitat for agriculture. Overcollection of seeds for horticulture was a further threat to the species' survival because, despite its extreme natural rarity, *M. sinica* is a supermodel among ornamental trees, prized for its large, fragrant, white or reddish flowers and glossy deep green leaves.

Following the 2004 workshop, surveys for wild plants of *Magnolia sinica* showed an estimated wild population of around 50 trees, the largest population occurring within Xiaoqiaogou Nature Reserve. This population is protected by the reserve, but other individuals scattered in the countryside remain at risk; however, seedlings of this species occurred in local ornamental plant nurseries. GTC has worked with local partners, including the Kunming Institute of Botany, to reinforce the wild population within the reserve, with 400 seedlings planted and being cared for by reserve staff. What's more, improved management of the habitat of wild trees at Xiaoqiaogou (e.g., by removing non-native plants that were covering the forest floor) increased survival rates of any naturally generated seedlings. Awareness-raising activities have taken place in surrounding communities to increase local pride in this very special tree, and training by GTC is building local skills.

Magnolia sinica is far from secure, but Xiaoya Li, formerly of FFI China, is hopeful, believing that it is an excellent flagship species for conservation. Building on the experience with *M. sinica*, FFI has gone on to work with experts from universities and botanic gardens across China to provide training and mentoring to staff from more than 60 nature reserve managers, helping them to protect the magnificent *M. sinica* and a wide range of other globally threatened trees.

Very few mature *Magnolia sinica* trees are left in the wild.

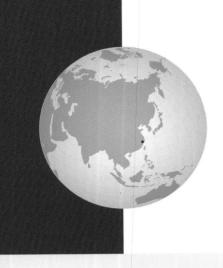

Magnolia sinostellata

IUCN RED LIST CATEGORY

Endangered

NE DD LC NT VU **EN** CR EW EX

NATURAL RANGE

China (Zhejiang)

PREFERRED HABITAT

Open forest or shrubland on mountainsides and valleys

THREATS

Deforestation

Plants being dug up and moved to nurseries for sale

Low reproductive rates

Naturally occurring in mixed coniferous and deciduous forests, wild *Magnolia sinostellata* specimens have been widely sought-after as ornamental plants, valued for their fragrant flowers, attractive habit, and ability to tolerate wet conditions with moving water. Flowers are chrysanthemum-like, with many white or pink slender tepals. Unfortunately, its beauty has significantly contributed to the species' decline, and plants are being dug up for sale by commercial nurseries.

Described in 1989, from Caoyutang Forest Farm in Jingning County, this shrub or small tree is known from only a handful of scattered locations in southern Zhejiang province at elevations of 700–1250 metres. The taxonomic validity of *Magnolia sinostellata* was at first questioned because of its similarities to *M. stellata*; however, DNA research led by Fairylake Botanic Garden in China proved this was indeed a separate species. Another partner in the conservation of this species, Zhejiang A&F University, has continued to investigate its genetic diversity and population structure. Generally, genetic diversity between *M. sinostellata* populations has been found to be high, and it is vital to ensure that this diversity is captured in representative ex situ conservation collections.

Different propagation methods have been explored to boost the recovery of *Magnolia sinostellata*, and the 2500 saplings produced over recent years are now being used for reinforcement plantings. About 200 individuals occur in the scattered wild population at Caoyutang Forest Farm; the population here produces few flowers and rarely yields fruit, so very few seedlings can be found. Attempts are now being made to boost this population with nursery-grown plants. Fortunately, the species has also been found in a few more localities in southern Zhejiang province. The first is in Songyang County, where about 300 individuals grow in open forest and scrubland along a valley; individuals here produce some fertile seeds, and young seedlings can be seen in some places. Another fragile wild population, near the top of an 885-metre mountain in Wenzhou County, has only five plants, all less than 1.5 metres tall but attractive, as they produce root sprouts and form big clumps with many

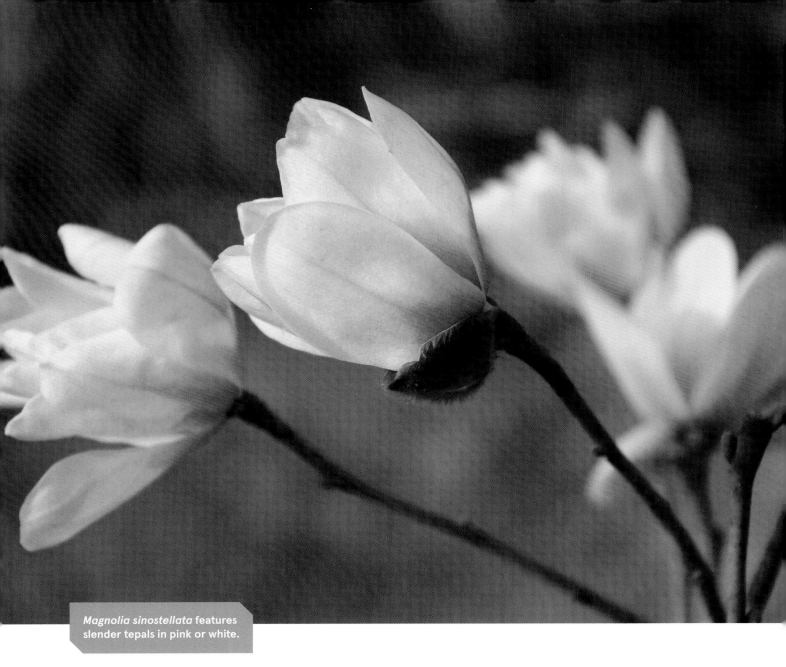

Magnolia sinostellata features slender tepals in pink or white.

flowers. Only two individuals remain at another site in Yandang Mountain Forest Park. Survey and inventory work resulted in the discovery of two previously unknown populations in Liandou and Qingtian.

To boost conservation efforts, three cultivars of *Magnolia sinostellata* chosen for their ability to bloom during the summer and their abundance of red flowers are now being cultivated at local nurseries. These will be sold to provide an alternative source of income for local communities. More than 100 local farmers have been trained to propagate and cultivate

Magnolia stellata

The star magnolia (or shideko-bushi, as it is known in its native Japan) is widely grown in gardens around the world as an ornamental tree. Its occurrence as a wild plant has been doubted in the past, but there is growing evidence that the populations in Mie, Gifu, and Aichi prefectures of central Honshu, Japan, do represent naturally occurring plants. *Magnolia stellata* grows on gently sloping land on hills and valley plains and also in riverbeds or shallow gorges. It prefers sunny sites with a slight water flow. The wild plants are threatened by indiscriminate commercial collection and urban development, and the species is considered endangered in the wild.

Magnolia stellata at the Scott Arboretum in Swarthmore, Pennsylvania.

M. sinostellata, providing an opportunity for additional income through the sale of plants.

Educational events are being held in the region to show the value of conserving *Magnolia sinostellata*. Displays of living plants and interpretation panels are used to raise environmental awareness, and handouts highlighting the conservation of *M. sinostellata* have been distributed to local forestry department staff and farmers. A ceremony marking the reinforcement planting of *M. sinostellata* saplings within the species type locality in Caoyutang, Jingning County, was held in 2017, followed by a workshop where staff from local forestry departments presented their work on the status of wild populations and best practice propagation techniques. Interest generated by the workshop led to the formation of an online discussion group and conservation network to exchange information on *M. sinostellata* conservation issues and to share future progress and photographic evidence.

MAGNOLIAS IN THE AMERICAS

BGCI has extended its collaborative work on South American *Magnolia* species. In Ecuador, work is underway to save eight threatened magnolias from extinction. Action is concentrated on in situ conservation and restoration of three species in the Río Zuñac reserve, Tungurahua province: *M. vargasiana*, *M. llanganatensis*, and *M. mercedesiarum*. In 2016, work continued to locate the target magnolias and collect propagation material. To this end, Fundación EcoMinga purchased climbing gear, to reduce the risky practise of free-climbing to sample plant material as well as to allow for better monitoring of the flowering and fruiting phenology. Propagation and cultivation trials have been initiated with the collected seed and cuttings, both at the reserve's research station and at the Universidad Estatal Amazónica, which has an in vitro micropropagation facility. Given the considerable horticultural challenges involved, further consultative meetings were held with the project partners to plan a dedicated training course on the propagation and cultivation of magnolias, capitalising on the wide range of experiences in neighbouring Colombia. In collaboration with Quito Botanic Garden and El Refugio, Dagua, Colombia, a training course covering practical conservation techniques was held in November 2017.

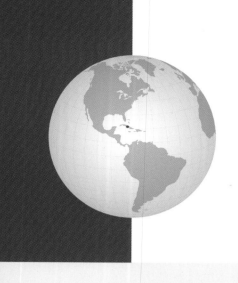

Magnolia cubensis

CUBAN MAGNOLIA

Magnolia cubensis is found nowhere else in the world but Cuba, at elevations of 700–1800 metres. It is one of seven *Magnolia* species and subspecies that are native to the island. *Magnolia cubensis* differs from other magnolias in its flower structure: uniquely in the genus, its flowers have three stipules in the petiole and a sessile ovary, making them of great botanical interest. One subspecies, *M. cubensis* subsp. *acunae*, is listed as critically endangered on the Cuban Red List; it is extremely rare, scattered in the montane rainforests of the Guamuhaya Mountains, in a narrow altitudinal band at 700–950 metres. It occurs in less than 15 known localities, with just a few individuals remaining and very few young trees. All the forests where this tree grows are fragmented or degraded. The largest population is within farmed land that is at risk of further forest clearance. Large areas of its range have already been converted into coffee

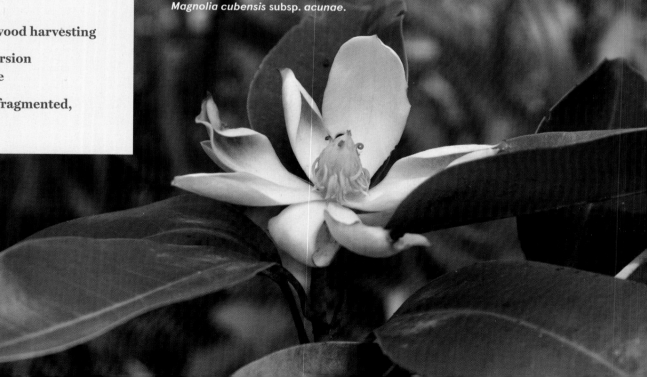

Magnolia cubensis subsp. *acunae*.

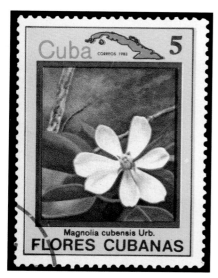

A stamp featuring *Magnolia cubensis*.

The flowers of *Magnolia cubensis* appear in November.

plantations, and this subspecies is severely threatened by deforestation and low natural regeneration. Some in situ conservation is provided by the Alturas de Banao Ecological Reserve, but further conservation action is needed to keep this tree safe from extinction.

The rapid decline of *Magnolia cubensis* subsp. *acunae* and other local trees has wider repercussions for local ecosystems and the communities living within them. The Guamuhaya rainforests, of which *M. cubensis* subsp. *acunae* was once a major component, play an important ecological role, capturing rainwater and humid air and thus helping to control soil erosion, run-off, and flooding further down the watershed. These ecosystem services are vital to the sustainability of the local coffee industry, but with the disappearance of much of the native rainforest, such systems are at risk of breaking down altogether.

Since 2009, BGCI has been working with the National Botanic Garden in Havana and the Cuban Society of Botany to address the decline in coverage and quality of the rainforests in Guamuhaya. As a previously dominant structural rainforest taxon and a highly attractive tree valued locally for its timber, *Magnolia cubensis* subsp. *acunae* acts as a strong flagship tree for this project. Extensive field surveys have been carried out to map the full distribution of this subspecies and to collect propagation material for establishing ex situ collections of it. A major challenge in establishing ex situ collections of this and other rainforest species is that they require very different conditions to those found within the lowland botanic gardens in Cuba. A local solution needed to be found. This involved winning the cooperation of local farmers and working with them to establish native plant nurseries in the highlands. Nurseries were established on coffee farms, with training given to coffee farmers and farm workers to enable them to propagate and grow *M. cubensis* subsp. *acunae* and other threatened native trees. The programme expanded rapidly, and by 2013, propagation efforts of 12 local nurseries had raised over 1500 individuals of *M. cubensis* subsp. *acunae*. One of the key focuses of the training workshops was to emphasise the importance of native tree species and habitats for local communities. This has resulted in the farmers being willing to control and eradicate non-native invasive trees in coffee plantations. Project staff and local farmers have worked together to reinforce wild populations of *M. cubensis* subsp. *acunae* by planting out nursery-grown trees on the coffee plantations, filling the gaps left by the non-native tree species.

In addition to practical interventions to restore *Magnolia cubensis* subsp. *acunae*, project partners have worked hard to raise awareness

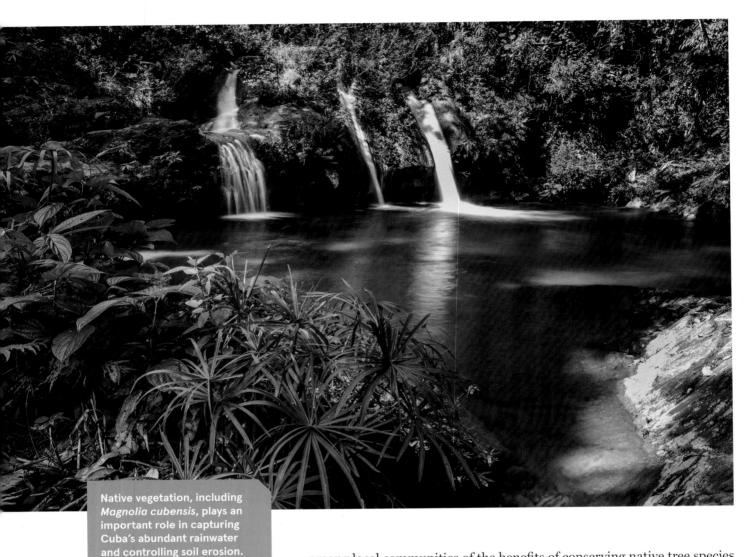

Native vegetation, including *Magnolia cubensis*, plays an important role in capturing Cuba's abundant rainwater and controlling soil erosion.

among local communities of the benefits of conserving native tree species and forest habitats. In August 2013, an environmental festival was held in Topes de Collantes to celebrate the importance of plants for people, highlight the special value of the unique local flora, and to communicate the threatened conservation status of many native plants in the region, including *M. cubensis* subsp. *acunae*. Work to conserve this subspecies and its native habitat continues. One of the latest developments has been the provision of toolkits to coffee farmers to help them manage their native tree nurseries independently. Two project workers continue to be available to provide advice, but it is the farmers and their communities who will lead the work to conserve *M. cubensis* subsp. *acunae* into the future.

Magnolia wolfii

HOJARASCO DE SANTA ROSA

IUCN RED LIST CATEGORY

Critically Endangered

NATURAL RANGE

Colombia (Risaralda)

PREFERRED HABITAT

Sub-Andean cloud forests

THREATS

Coffee plantations/cultivation

Nearly all Colombia's 33 *Magnolia* species, many of which are endemic, are threatened as a result of habitat loss and extraction for their high-quality timber. BGCI has been working with Jardín Botánico de Medellín Joaquín Antonio Uribe and other local partners to counteract the impact of these threats through a series of integrated in situ and ex situ conservation measures. Since 2013, work has focused on *M. hernandezii*, *M. gilbertoi*, *M. jardinensis*, *M. silvioi*, and *M. wolfii*. All have restricted distributions and extremely small populations, but none more so than the critically endangered *M. wolfii*.

Magnolia wolfii is known only from a single location in the Risaralda department of western Colombia at 1800 metres, an isolated forest fragment within extensive coffee plantations that was down to only three mature individuals. The original habitats of this region are in a constant state of deterioration; the forests are severely fragmented, and the patches very small and surrounded by coffee plantations.

The leaves of *Magnolia wolfii* are very thick and do not decompose very easily; each adult plant is therefore surrounded by thick leaf litter. Despite its conservation status, work carried out by BGCI and its local partners is helping to ensure that *M. wolfii* will have a more secure future. Propagation material collected from the wild population has been used to establish ex situ seed and living plant collections at five botanic gardens in Colombia. During initial surveys, project staff discovered another three mature *M. wolfii* trees—a vital boost to the species' tiny population.

In addition to building up ex situ collections, work is underway to reinforce existing wild populations of *Magnolia wolfii*. In 2013, 400 nursery-grown seedlings were transferred to Marsella Botanical Garden, which is close to the location of the only known wild population. Botanists have carried out trials to evaluate the species' growth responses under different habitat and light conditions. This work involved the cooperation of local farmers, who planted 5000 saplings of *M. wolfii* and

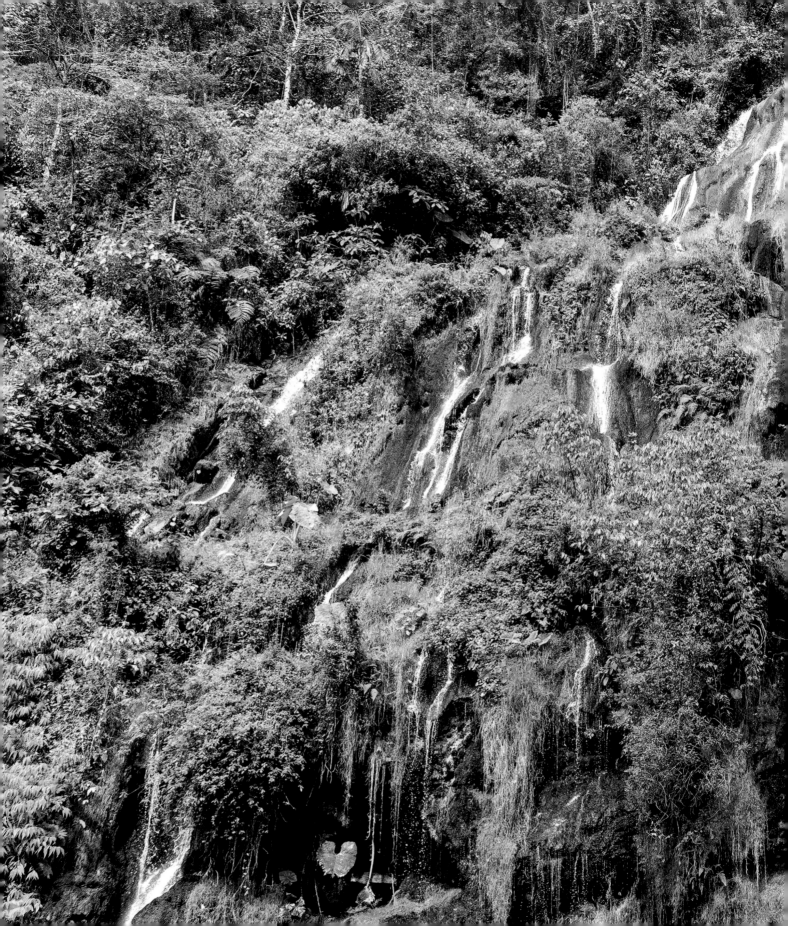

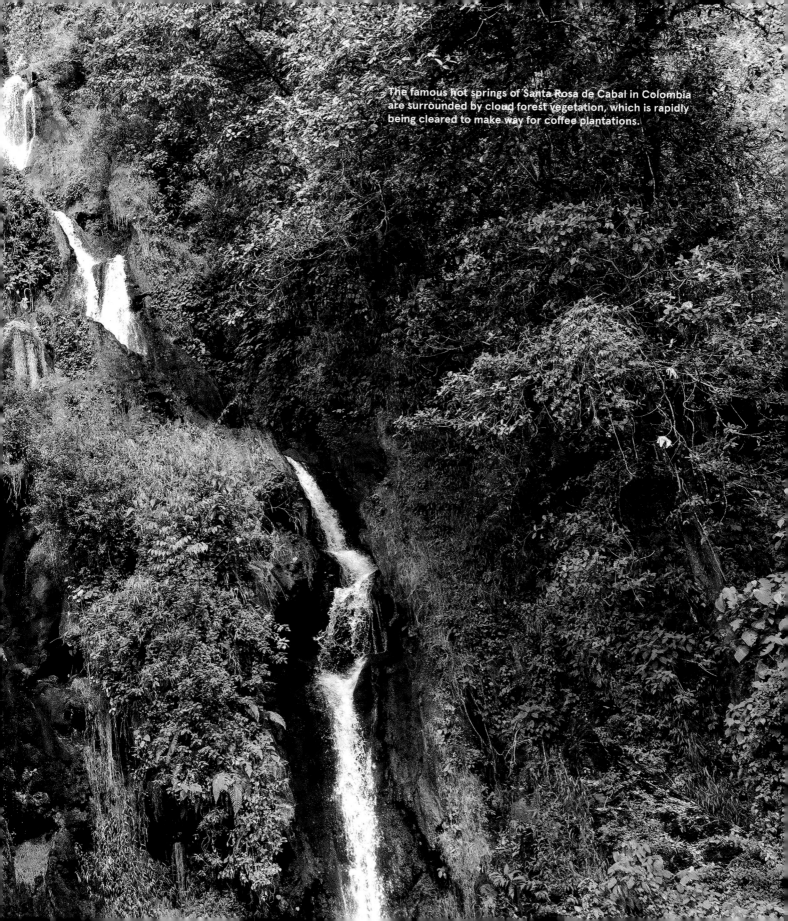

The famous hot springs of Santa Rosa de Cabal in Colombia are surrounded by cloud forest vegetation, which is rapidly being cleared to make way for coffee plantations.

Magnolia jardinensis

Magnolia jardinensis (magnolio de Jardín) is known only from a single montane population in the municipality of Jardín in Colombia. This endangered species is a canopy tree of humid forests, growing on steep slopes at elevations of 1900–2800 metres; surveys estimate that no more than 250 mature individuals are extant. The species is threatened by habitat conversion and habitat fragmentation. In addition, it is targeted for selective logging; however, loggers have commented on how few individuals are now left in the wild, and consequently the exploitation is less frequent.

(↑) Mature seeds of *Magnolia jardinensis*.

(→) The escuda (coat of arms) of Jardín, Colombia, showing *Magnolia jardinensis* (upper left).

Since being described as a new species in 2009, this magnolia has become the emblematic tree of Jardín, and in August of that year it was even included in the municipality's new coat of arms.

other *Magnolia* species on their land. During the trial plantings, farmers and staff took part in workshops to learn about collection, propagation, and recovery techniques for magnolias. A broader education campaign at Jardín Botánico Universidad Tecnológica de Pereira communicated Colombia's unique Magnoliaceae diversity and the need for its conservation to the 10,000 visitors the botanic garden receives each year.

Fortunately, the Colombian botanic gardens involved in the magnolia conservation project have succeeded in securing the inclusion of a 140-hectare area of tropical forest, located on the eastern slopes of Colombia's Western Cordillera, within the Colombian Association of Civil Society Natural Reserves. This area was identified during field surveys as a hotspot for *Magnolia* species, and it is hoped that its designation will continue to encourage local participation in developing and implementing conservation measures for *M. wolfii* and Colombia's other threatened magnolias.

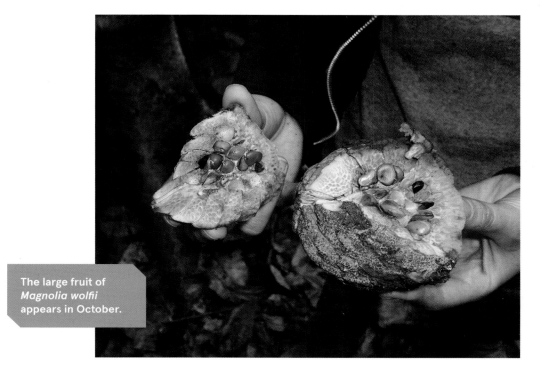

The large fruit of *Magnolia wolfii* appears in October.

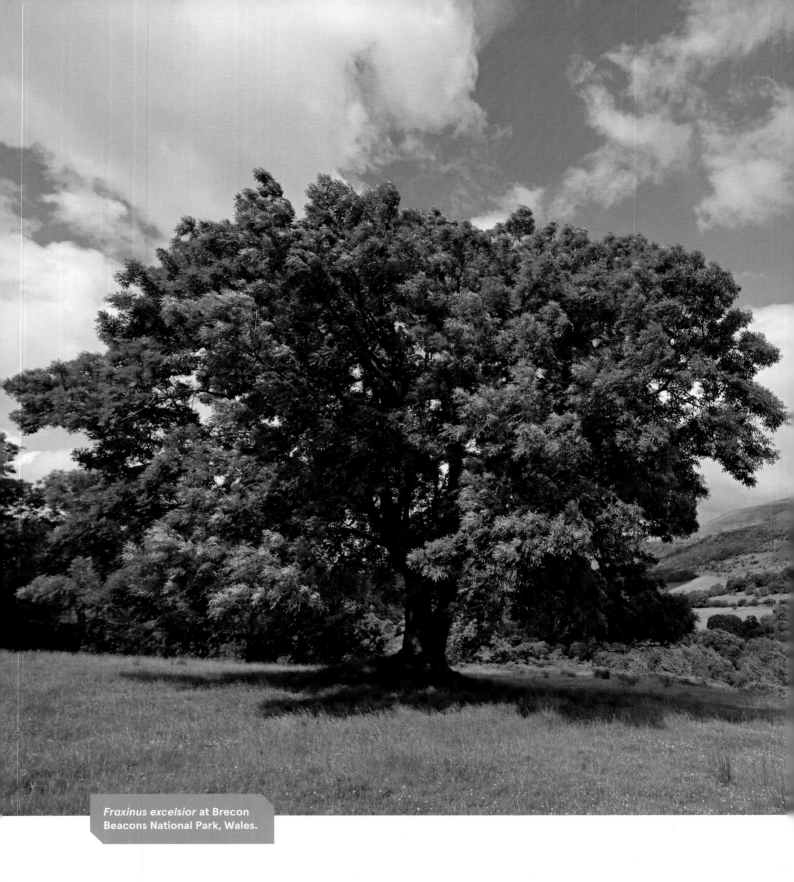

Fraxinus excelsior at Brecon Beacons National Park, Wales.

Ashes

Fraxinus, the genus of ash trees, is a member of the olive family (Oleaceae), which includes lilac, jasmine, and many other ornamental trees and shrubs. Ashes make up significant parts of many temperate forests and woodlands, where they perform important ecosystem functions, forming habitats with many other hardwood species and providing shelter and fodder for native wildlife.

Ashes are found in botanic gardens across the northern hemisphere and are among the most familiar trees growing in Europe and North America, where they are common street trees. In the UK and Ireland, the native *Fraxinus excelsior* (European ash) is a very common tree, recorded from more hedges than any other species except for hawthorn. It is a survivor, spreading rapidly from seed carried by the wind, growing on poor, degraded soils, and frequently found in urban environments. In North America, there are nine native ash species, of which *F. americana* (white ash) and *F. pennsylvanica* (green ash) are the most widely distributed. These two species are common (although not dominant) in most forests of the eastern US and into Canada; they also make up a large proportion of trees in the riparian lands and shelterbelts of the Midwest and occur in urban areas across the country. In total it has been estimated that 8 billion ash trees (from all *Fraxinus* species) live in US forest land. Ashes have been part of our cultures for centuries; but over the past decade, ash trees in Europe and North America have been seriously affected by the unprecedented spread of introduced pests and diseases. The decline of such familiar landscape trees continues to cause public concern on both continents. The plight of ash trees highlights a growing threat to tree species worldwide. Given the levels of global trade in trees and wood products, invasive pests and diseases are much more problematic than in the past; and climate change is enabling different distribution patterns for insects and microbial species.

The genus *Fraxinus* consists of over 50 species of temperate trees and shrubs distributed in Europe, Asia, and North America. All have recently been evaluated as part of the Global Tree Assessment, and although the majority of ash species are widespread, the conservation assessment has shown the need for monitoring and conservation action for those that are of considerable ecological, cultural, and economic significance. Eleven species are now listed as threatened at a global level, three species are near threatened, and seven species are data deficient. The spread of invasive pests and diseases is the main threat to *Fraxinus* worldwide.

Emerald ash borer (*Agrilus planipennis*) was introduced from Asia to Detroit, Michigan, in the 1990s as a stowaway in packing material. Since then this pest species has spread rapidly and is now detected in 30 US states and two Canadian provinces. It is feared that it will spread into Europe, but so far, the major invasive species threat to European *Fraxinus* species is *Hymenoscyphus fraxineus*, which causes ash dieback. This fungal pathogen also originates in eastern Asia, where its host tree species are *F. mandshurica* and *F. chinensis*. The common ash of Europe, *F. excelsior*, remains widespread and abundant, growing from Ireland to Iran, in all European countries except Portugal. It is nevertheless evaluated as near threatened on the IUCN Red List because of the impact of *H. fraxineus*, which is spread by wind. Already *F. excelsior* is nationally threatened in a range of countries, and spread of ash dieback is relentless. First detected in central and northern Europe in the early 1990s, ash dieback has since spread to 24 countries.

A variety of other pests and diseases may pose a threat to different ash species, particularly when introduced outside their native range to regions where native species do not have natural resilience. *Hymenoscyphus albidus*, for example, is indigenous to Europe; although it's in the same genus as the fungus that causes ash dieback, it does not harm *F. excelsior*—but it could affect *Fraxinus* species in other countries.

An extremely important role of the living collections of *Fraxinus* in botanic gardens is to enable the monitoring of invasive pests and diseases. The International Plant Sentinel Network has been set up to act as an early warning system for detecting new and emerging plant pests and pathogens. Identifying potential threats to native trees before an organism is actually introduced can drastically improve the chances of eradication or control, or, even better, prevent the introduction in the first place. Over 50 botanic gardens around the world form part of this important network.

ASH TREES IN NORTH AMERICA

The ash species of North America are so widespread and so important ecologically and economically, it is hard to imagine the combined impact of so many trees disappearing. It has been estimated that over 100 million ash trees have already been lost in 31 states since the 1990s. Tackling the devastation caused by the emerald ash borer is a major challenge. The usual approaches of in situ and ex situ conservation applied to threatened species are simply irrelevant in the face of the specific threat posed by this invasive insect. Many agencies are involved in searching for solutions. Government organisations, local municipalities, universities, and botanic gardens are all playing a part. There is now a lot of knowledge about the life cycle and dispersal of the emerald ash borer, how it infests and kills host trees and which factors influence ash susceptibility in the wild. Biological control and insecticides have been trialled, and breeding programs are underway, using the few ash trees that have managed to survive and are thought to show resistance to the pest; so far these attempts have not proved successful. What has been achieved are efforts to slow the spread of the emerald ash borer through management of forests and urban areas. Countywide quarantines are in place across many states in the eastern US to prevent wood movement and slow the spread of the devastation. Public awareness campaigns have been launched, encouraging people not to move ash firewood to new locations where the disease might not yet be present. Research continues, and it is hoped that botanic gardens and seed banks growing or storing seed of *Fraxinus americana* outside the US and Canada may be able to help restore the species.

Other species that are critically endangered by the emerald ash borer are *Fraxinus pennsylvanica*, *F. nigra* (black ash), *F. profunda* (pumpkin ash), and *F. quadrangulata* (blue ash), none of which have natural resistance to the pest. It is hoped that the southernmost populations of ashes in the US and Mexico will not be affected by the emerald ash borer, which requires cold periods during its life cycle. For example, about half the range of the endangered *F. caroliniana* (Carolina ash) is tropical, and the emerald ash borer may not survive; Carolina ash is therefore less severely threatened but still at considerable risk.

Fraxinus americana

WHITE ASH

IUCN RED LIST CATEGORY

Critically Endangered

NATURAL RANGE

Eastern US, northeastern Canada

PREFERRED HABITAT

Rich, moist, well-drained forest soils

THREATS

Emerald ash borer

Fraxinus americana is one of the species suffering the devastating impact of emerald ash borer, which has rapidly spread across much of its native range. Unfortunately the insect, which is native to the Russian Far East, north and northeastern China, Japan, and Republic of Korea, shows no sign of stopping. In its native range, host ash trees for this beetle include *F. chinensis*, *F. lanuginosa*, and *F. mandshurica*. Emerald ash borer weakens individual trees of these host species but does not have a significant impact on their survival or their role in native forests. Some studies suggest that a very small portion of white ash's native range may fall outside the suitable habitat for emerald ash borer; all experts agree that the overwhelming majority of ash populations will quickly suffer from infestation by the pest species. The rate of population decline of *F. americana* (and expected continuing decline) has led to the species being listed as critically endangered on the IUCN Red List.

The emerald ash borer infests all the North American ash species that it has so far come into contact with. The larvae of the beetle feed in the phloem of the wood, the tissue that transports nutrients through the plant; this effectively "girdles" the trees, leading to death within five years of infestation. The infestation causes almost complete mortality in *Fraxinus americana* populations. White ash is unable to persist for very long through vegetative reproduction, and seeds remain viable in the soil seed bank for only a handful of years, so regeneration after infestation by the emerald ash borer is minimal, if it happens at all. To make matters worse, the beetle persists in forests in low population densities after major ash population crashes, so any seedlings of white ash that do remain are quickly infested as soon they reach a suitable size.

(→) *Fraxinus americana* in autumn.

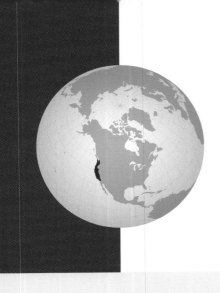

Fraxinus latifolia
OREGON ASH

IUCN RED LIST CATEGORY

Near Threatened

 NT

NE DD LC NT VU EN CR EW EX

NATURAL RANGE

US (West Coast), Canada (southwestern British Columbia)

PREFERRED HABITAT

Wooded wetlands, lake shores, riparian habitats

THREATS

Urban expansion and logging

Invasive pests

Fraxinus latifolia is abundant in the western US and southwestern British Columbia. So far Oregon ash has escaped the ravages of the emerald ash borer; however, it is susceptible to the pest, and there are real concerns that this widespread species may feel its impacts in the future. Oregon ash is a useful timber species. The wood splits easily and has high heat value, so it is favoured as fuel wood. The wood is also traded commercially for use in flooring, furniture, tool handles, sports equipment, and crates. Oregon ash is an attractive tree that is planted as an ornamental tree and a street tree in cities of Europe and North America.

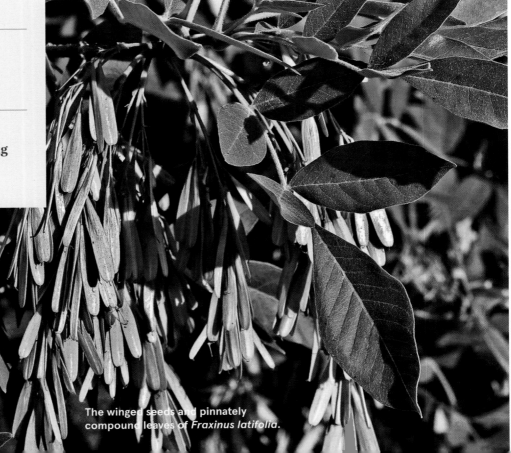

The winged seeds and pinnately compound leaves of *Fraxinus latifolia*.

Fraxinus potosina

Fraxinus potosina is one of the few naturally rare species of ash. It owes its rarity to its preference for gypsum soils, where it not only survives but thrives. It grows in a small part of San Luis Potosí in desert scrub, along with *Verbesina potosina*, *Sisyrinchium zamudioi*, and many other local endemics. The habitat is unprotected, and mining is a major risk to this species and the other rare plants.

IUCN RED LIST CATEGORY

Endangered

NATURAL RANGE

Central Mexico

PREFERRED HABITAT

Dry scrubland on gypsum soils

THREATS

Commercial mining

The diminutive leaves of
Fraxinus potosina.

ASH TREES IN ASIA

Overexploitation for timber is a major threat to several globally threatened *Fraxinus* species. The main internationally traded species are North American and European species, and, in Asia, *F. mandshurica*. In the main, the trade is not having a major impact, and climate change is having an increasing impact. Botanic gardens and arboreta have an important role in the ex situ conservation of threatened *Fraxinus* species, with scope to carefully plan safe havens for species outside the range of pests and diseases. Based on information within BGCI's PlantSearch database, the majority of *Fraxinus* species are recorded in ex situ collections. One exception, despite its use in horticulture, is the endangered *F. hubeiensis*, a large ash endemic to the Chinese province of Hubei, where it has a very restricted distribution. In situ protection remains of fundamental importance, particularly for restricted-range species that are threatened by habitat destruction; however, presence within protected areas does not guarantee the conservation of widespread species that are threatened throughout their range by the spread of invasives, and new solutions are urgently needed if the world's ash trees are to be saved.

Fraxinus mandshurica

MANCHURIAN ASH

IUCN RED LIST CATEGORY

Least Concern

NE DD LC NT VU EN CR EW EX

NATURAL RANGE

China, Japan, DPR Korea, Republic of Korea, southeastern Russia

PREFERRED HABITAT

Slopes and open valleys of montane regions

THREATS

Overexploitation and deforestation

Development of cities and agricultural lands

Fraxinus mandshurica is a popular ornamental, grown in many botanic gardens. Although it is not under threat in a significant portion of its range in Japan, DPR Korea, and Republic of Korea, logging elsewhere is a major threat. Logging and deforestation to meet the increasing need for timber has led to its becoming increasingly threatened in China; it is listed as vulnerable on China's plant red list and is a nationally protected species. Fortunately, it occurs in some Chinese protected areas and is now grown in commercial plantations in northeastern China. Logging for international trade is a very significant threat for Manchurian ash in the remote forests of the Russian Far East. Small-scale enterprises in Suifenhe city, Heilongjiang, the northernmost province of China, import Manchurian ash from Russia for use in the manufacture of flooring and furniture.

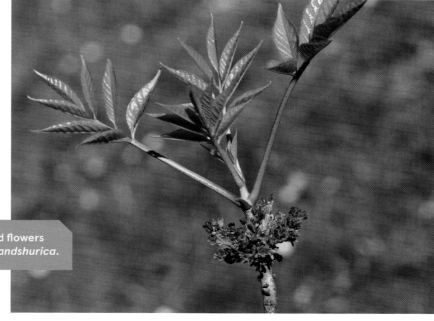

New leaves and flowers on *Fraxinus mandshurica*.

Oaks

O aks are of major cultural significance around the world, evoking myths and symbolism perhaps more than any other group of trees. Oak is the national tree of 15 European countries, a symbol of strength and survival, and was named the national tree of the US in 2004 following a popular vote. Mexico, the global hotspot for oak species, features oak leaves in its ornate coat of arms. The oak has been sacred in Europe since ancient times, linked to the Greek god Zeus (Jupiter of Roman mythology) and the Celtic deity Dagda. Druids frequently practised their rituals in oak groves and cherished the mistletoe associated with oak trees. Roman emperors were presented with crowns of oak leaves during victory parades, and royalty has retained its association with this powerful tree.

In prehistoric times, acorns were an important source of food, collected and processed into flour for bread making. With the domestication of wheat production 10,000 years ago, the use of acorns for food declined, except in times of war or famine. In California, the abundance of oak trees allowed native people to flourish; acorns were for them a major staple food. The Gabrielino-Tongva tribe of southern California prepared acorns by pounding them in stone mortars, leaching tannins from the resulting powder, and eating the wet flour as a form of porridge. Oaks and the acorns they provided were so essential to life that indigenous communities of California recognised them in their creation myths. Nowadays acorns are rarely eaten by people except in DPR Korea and Republic of Korea, where acorns are collected from the wild, or imported, and processed to make a variety of foods, including acorn tofu, pasta, and pancakes. The distribution of oaks has, however, been linked to prehistoric movements of people carrying supplies of acorns as a staple food. As well as providing nutrition, oak trees have traditionally been a source of medicinal products, with the leaves, bark, and acorns all used to treat a variety of ailments. Of course, oaks have also been a major source of hardwood timber, traditionally used in ship building, and *Quercus suber* (cork

Did you know?

Cork comes from *Quercus suber*, an oak found in Spain, Portugal, Italy, France, and northern Africa.

oak) has been economically important for centuries. More surprising oak products include oak gall ink, which was the main writing and drawing ink in Europe from Roman times until the 19th century.

As well as the direct values of oak trees, oaks are of immense ecological importance around the world. There are an estimated 450 species of oaks worldwide, including both trees and shrubs, with centres of diversity in Mexico and China. Globally, oaks are keystone species in a wide range of habitats, including oak savannas in the US Midwest, oak-pine forests and cloud forests in Mexico, and subtropical broadleaved evergreen forests in Asia. They perform critical ecosystem functions, and provide food and shelter for countless species of animals. In North America, native oak species are host to 534 different species of Lepidoptera (moths and butterflies), making *Quercus* the most ecologically valuable plant genus for this major order of insects.

Oaks are symbols of longevity and strength. And yet, globally threatened oak species are increasingly dependent on human interventions for their survival. There is a lot to learn about the basic ecology and resilience of oaks and how best they can be conserved. Ideally, the magnificent and ancient oak forests of Europe, Asia, and North America must be allowed to flourish in as many natural areas as possible, so that they can continue to sustain functioning ecosystems, support nutrient and water cycles, and play host to a rich diversity of species.

OAKS IN THE UNITED STATES

Like so many other tree species, oaks are now threatened worldwide, and oak-dominated ecosystems are in decline. Entire oak ecosystems have been decreasing in the US, for example, for the past century. The causes of this decline are still not fully understood but include suppression of natural fires, increased consumption of acorns and seedlings by growing populations of deer and other mammals, sudden oak death (pathogen: *Phytophthora ramorum*) and other introduced pests and diseases, and climate change. The threats to individual US oak species are similar, including habitat destruction for farming and urbanisation. The longevity of oaks and slow reproductive rates make them particularly susceptible to the effects of a rapidly changing climate.

Murphy Westwood, director of global tree conservation at the Morton Arboretum, fills out the picture: "Oaks in North America have more

Various rare oak species being propagated at the Morton Arboretum.

biomass and number of species than any other tree group; they are the backbone of many different forest communities. As oaks disappear, there will be a tangible, negative impact on the surrounding wildlife, potentially upsetting the balance of our forest habitats. They also sequester an immense amount of carbon, so the loss of oak forests would exacerbate the effects of climate change." The Morton Arboretum is near Chicago, Illinois, in the US Midwest, an area where oak savannas flourished in the past, occuring in a transitional zone between the prairies and eastern temperate forests. At the time of European settlement of North America, oak savanna covered some 20 million hectares, stretching along the eastern

edge of the Great Plains from southern Canada to Texas. Oak savannas were among the earliest areas in the Midwest to be settled by Europeans. Trees were logged for timber; and even when they were not cut down, their roots were frequently damaged by disturbance for agriculture and their branches removed for firewood. The savannas were heavily grazed and the herbaceous layer cleared to suppress tall "weeds." By the second half of the 19th century, much of the savanna vegetation was destroyed. Today, midwestern savannas amount to only about 1200 hectares of small isolated patches, most of which are degraded.

The Morton Arboretum is actively involved in restoring oak savanna habitats in the Chicago region and, over recent years, has stepped up its commitment to the conservation of threatened oak species worldwide. In 2014, the arboretum launched a collaborative effort with BGCI to develop a portfolio of integrated research and conservation projects targeting oaks, in support of the Global Trees Campaign. One component of the arboretum's important work was a commitment to assess the conservation status of all 450 of the world's oak species, a process that now provides the framework upon which to develop strategic conservation projects.

The first stage in the Morton Arboretum's global assessment of oak species was to research the distributions, population trends, and threats facing all 91 native oak species in the US. The results of this work showed that a quarter of the country's oak species are of conservation concern. Sixteen species of oaks, all in the southern and western US, are classified as critically endangered, endangered, or vulnerable on the IUCN Red List, with another four species listed as near threatened. Murphy explains, "The essential information we have gathered forms a baseline from which we determine how best to conserve oaks and reverse the trend toward extinction for these important trees."

Strategies to conserve threatened oaks include strengthening protection of the habitats where they occur and reducing the threats that they face. Research is often an important component of conservation action, and oak experts at the Morton Arboretum deploy taxonomic, genetic, and horticultural skills in the fight to save oak diversity. Adding to the problems faced by oak species in the wild is the fact that acorns cannot be seed-banked through conventional preservation methods. Oaks remain challenging to propagate from anything other than seeds owing to their high tannin content. Growing oaks in living collections in botanic gardens is therefore extremely important to support long-term conservation, research, and restoration. The Morton Arboretum is part of a coordinated network of gardens growing and conserving threatened oaks, propagating

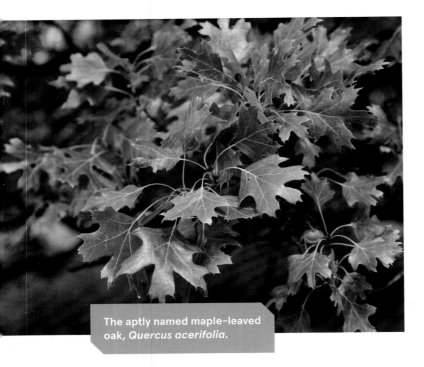

The aptly named maple-leaved oak, *Quercus acerifolia*.

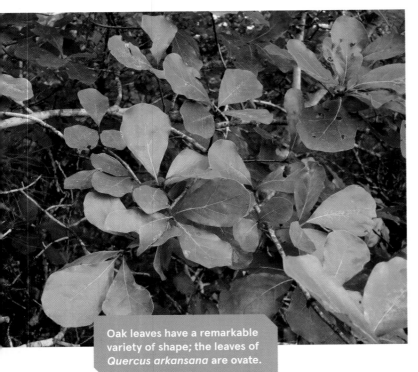

Oak leaves have a remarkable variety of shape; the leaves of *Quercus arkansana* are ovate.

thousands of plants on its grounds and distributing plants across the garden network. With the changing climate and models suggesting Illinois will eventually be similar to today's Arkansas or even Texas, the Morton Arboretum and other public gardens may become critical refuges for oaks of the South in the future.

Oaks in botanic gardens are of variable conservation value. BGCI, along with several partner gardens including the Morton Arboretum, recently completed a three-year research study to understand and improve the conservation value of current living collections of four threatened oak species. The species selected for genetic analysis were *Quercus acerifolia* (endangered), *Q. arkansana* (vulnerable), *Q. boyntonii* (critically endangered), and *Q. georgiana* (endangered). BGCI's PlantSearch database was used to locate the species in ex situ collections. One of the aims of the project was to determine and compare the genetic diversity of wild populations with that contained in living collections so that collaborative collection planning could be enhanced with genetically appropriate material sampled for conservation. The results? None of the oak species sampled across botanic garden collections were sufficiently genetically diverse for conservation and restoration purposes.

Nevertheless, the species that had the strongest collection for conservation was the most threatened: *Quercus boyntonii*. This is because it had the greatest number of wild-collected plants with full provenance known (91 percent of the 22 plants identified, curated at eight gardens), which represented a collecting effort that had been explicitly designed to improve the conservation value of living collections. The results of this study revealed that in order for the botanical community to effectively and efficiently preserve the genetic diversity of threatened trees, metacollections (consortia of scientifically informed, networked

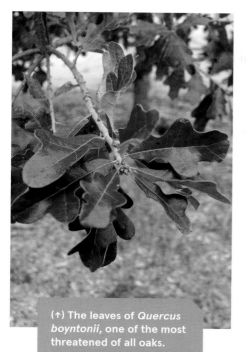

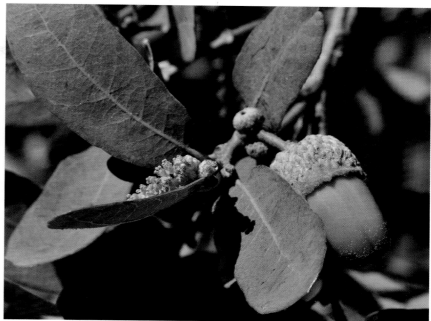

(↑) The leaves of *Quercus boyntonii*, one of the most threatened of all oaks.

(↗) *Quercus engelmannii*, native to California and the Baja Peninsula, features oblong, dusty green leaves.

collections) must be established. The Morton Arboretum is leading this charge, creating and coordinating a Global Conservation Consortium for Oak, set up to address the gaps and needs in conservation collections of threatened oaks.

Another species that concerned Murphy and her colleagues is *Quercus engelmannii*, a rare oak of California and adjacent Baja California. Engelmann oak has very particular habitat requirements, with natural population scattered at restricted sites, mainly on Black Mountain. Current threats to *Q. engelmannii* are various, including fragmentation due to suburban sprawl and human-induced wildfires.

Quercus georgiana

GEORGIA OAK

NATURAL RANGE

US (**Alabama, Georgia**)

PREFERRED HABITAT

Isolated granite outcrops and shallow "soil islands" in the Piedmont Plateau

THREATS

Recreational activities

Problematic native species/diseases

Shifting habitat due to climate change

Droughts

Quercus georgiana, first discovered in 1849 at Stone Mountain, Georgia, is one of the species selected for conservation action. It is restricted in the wild to small populations and is now found in only three counties in Alabama and 14 counties in Georgia, following local extinction in North and South Carolina. This attractive small tree has horticultural value, with its glossy green leaves, vibrant autumn colours of purples and reds, and hardiness to drought and heat. It also provides food for wildlife; its leaves are a food source to larvae of the red-spotted purple butterfly, luna moth, and southern hairstreak butterfly, and its acorns are a food source to deer, small mammals, and various birds, including woodpeckers and the yellow-bellied sapsucker.

Quercus georgiana has a multistemmed growth habit.

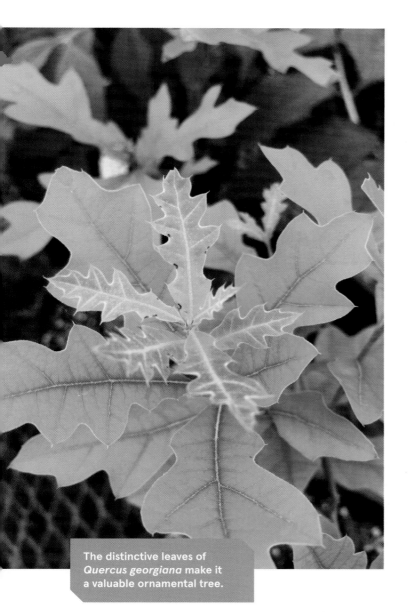

The distinctive leaves of *Quercus georgiana* make it a valuable ornamental tree.

Tourism and recreation are major threats to the habitat of *Quercus georgiana*. This species is restricted to intermittent granite outcrops and shallow soils overlying granite in the Piedmont Plateau of the southeastern US. These discontinuous pockets of soil, sometimes referred to as "soil islands," allow little interconnectivity for migration. Georgia oak specimens have been reported growing in a soil depth of only 50 centimetres at Arabia Mountain. Foot and vehicle traffic are very damaging to the soil of granite outcrops, causing soil erosion and compaction.

Quercus georgiana is highly susceptible to compacted soils, and many occurrences lie within state parks and nature preserves, particularly at Stone Mountain, where plants grow alongside popular hiking trails. Additional threats to Georgia oak include climate change and drought. The latter poses a considerable threat to the species, given its restriction to very thin soils on granite flat rocks, which provide little or no access to groundwater. Severe drought has been reported as an inciting factor in the phenomenon of oak decline, occurring when typically non-lethal stresses, such as drought, defoliating pests, or fungal pathogens, are combined under certain conditions and effectively overwhelm oaks' defences, resulting in potentially widespread mortality. Fortunately, recent molecular analysis of Georgia oak's genetic diversity revealed evidence of gene flow and low genetic isolation between subpopulations; however, this apparent gene flow could be a relic of past interconnectedness, and negative consequences of fragmentation may remain to be seen. *Quercus georgiana* is an exceptional species—its seeds cannot be stored in seed banks. Research is being undertaken to find other appropriate methods of ex situ conservation for it, and ongoing conservation action includes developing ex situ collections of living trees as part of a metacollection of the species.

Quercus oglethorpensis

OGLETHORPE OAK

IUCN RED LIST CATEGORY

Endangered

NE DD LC NT VU **EN** CR EW EX

NATURAL RANGE

US (South Carolina, Mississippi, Georgia, Alabama, Louisiana)

PREFERRED HABITAT

Heavy chalk or rich limestone soils with high clay content, mainly of the Piedmont Gabbro Upland Depression Forest

THREATS

Commercial and industrial development

Fire and fire suppression

Dams and water management/use

Droughts

Storms and flooding

Wood and pulp plantations

Invasive species

Quercus oglethorpensis is an endangered species with a patchy distribution in the wild. It is known from a few counties in the Piedmont of northeastern Georgia and neighbouring South Carolina, and from scattered localities in Alabama, Louisiana, and Mississippi. This species grows on moist, heavy chalk or limestone soils. Oglethorpe oak was first described in 1940, and it is thought that much of its habitat was lost before then. From 1940 to 1990, about 10 percent of known *Q. oglethorpensis* trees were lost to habitat destruction and disease. Extensive agriculture within the Piedmont region prior to the 1950s had mostly

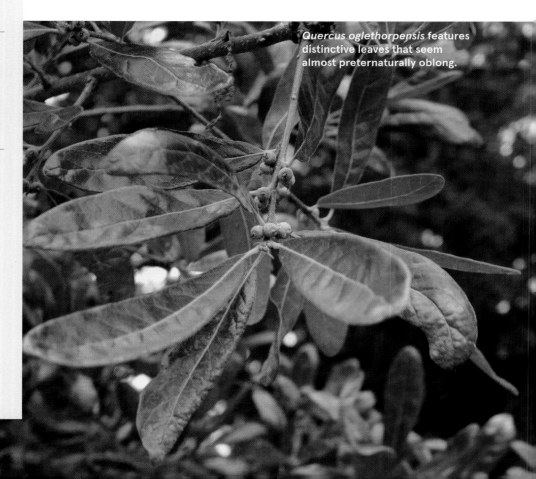

Quercus oglethorpensis features distinctive leaves that seem almost preternaturally oblong.

restricted *Q. oglethorpensis* to roadsides and old fencerows found outside protected areas. This likely means that Oglethorpe oak had a denser population before colonial settlement.

Ongoing threats include habitat loss and modification, but most areas that could be cleared for agriculture, silviculture, or urban development have already been converted, leaving wetter areas or roadside occurrences remaining. Damming and flooding in some areas have changed the floodplain ecosystems where the species is found. Dry-season fires pose a further concern, since Oglethorpe oak seedlings and saplings are fire intolerant.

Invasive woody plants such as Japanese honeysuckle (*Lonicera japonica*) and autumn olive (*Elaeagnus umbellata*) compete with Oglethorpe oak seedlings. Poor seed viability and chestnut blight are additional problems. It is estimated that fewer than 5000 individuals exist in the wild. *Quercus oglethorpensis* is in cultivation and is quite hardy. The US Forest Service and American Public Gardens Association jointly supported an ex situ conservation project in spring 2015 to collect wild seeds and scion wood for propagation. The Morton Arboretum is one of the botanic gardens supporting the long-term conservation of this species.

OAKS IN MEXICO

Mexico has the greatest oak diversity of any country, with around 160 native species. As elsewhere in the world, oaks are of huge ecological, social, and economic importance in the country, and just about all parts of oak trees are used there in different ways. Acorns of *Quercus leiophylla* are, for example, collected in the Huatusco region of Veracruz, to create religious and decorative objects. The bark of *Q. sapotifolia* is used for tanning leather and dyeing textiles. Many species are used for timber and firewood. Unfortunately, many oak species in Mexico are threatened due to habitat loss, climate change, and increased human use. Mexican oaks were one of the first groups of trees considered appropriate for the attention of the Global Trees Campaign; Sara Oldfield elaborates: "When we first had our ambitious idea to save the world's threatened trees from extinction, we looked for examples of species that would resonate with wide audiences. Oaks have it all! Because they are so important in Mexico, we wanted to pick projects there." Oak expert Allen Coombes and his wife, Maricela Rodríguez-Acosta of the University of Puebla, started the

ball rolling with a project on *Q. hintonii* (Hinton's oak), a small tree that is of great value to the people of Tejupilco.

Quercus hintonii is found only in the dry montane forest of southeastern Mexico at 1300–2000 metres. Allen and Maricela's study found that this deciduous species covers approximately 46,000 hectares, distributed across three highly disturbed populations in Mexico State, between Temascaltepec and Tejupilco, Sierra de Goleta, and Sierra de Nanchititla. The species forms part of the traditional culture of the Tejupilco people, used locally primarily for firewood but also for tool handles, beams, and fencing poles. The wood is traditionally used to bake a bread of fine herbs, the characteristic taste of which is imparted by the smoke. Despite its value, populations of *Q. hintonii* have decreased dramatically as a result of habitat loss, and the species is evaluated as endangered. Agriculture (predominantly maize, fruit trees, and coffee plantations) and road construction have contributed to its decline. The species has also been highly affected by grazing, which prevents regeneration.

Based on the work by Maricela and Allen, a conservation strategy was developed for the species, which was presented to the regional education co-ordinator, the presidents of municipalities, and the authorities in charge of reforestation. In addition, an educational guide to the conservation of the species was produced, and an agreement was reached to provide local training in oak propagation techniques. The conservation involvement of local authorities and landowners was strengthened, but conservation efforts still need to be increased, especially for protection in the wild. Much of the area where Hinton's oak occurs is being converted into avocado plantations and human settlements. *Quercus hintonii* is grown in three botanic gardens in Mexico as well as in overseas collections. Although this species shows a good germination rate, the success of its adaptation to cultivated conditions has been limited, and work to address this challenge continues at the University of Puebla's botanic garden.

Collaboration on the conservation of Mexican oaks has increased significantly since the launch of the GTC. An exciting recent development has been the formation of a new alliance, the Oaks of the Americas Conservation Network (OACN). This alliance aims to protect the threatened oaks of the Americas, especially in Mexico, using scientifically informed conservation strategies. The consortium includes experts from the green industry, universities, botanic gardens, arboreta, conservation NGOs, and government agencies, all of whom are dedicated to protecting threatened oak species from extinction.

Quercus brandegeei

BRANDEGEE OAK

IUCN RED LIST CATEGORY

Endangered

NE DD LC NT VU **EN** CR EW EX

NATURAL RANGE

Southern Baja California

PREFERRED HABITAT

Sandy soils adjacent to seasonal riverbeds

THREATS

Tourism and recreation areas

Logging and wood harvesting

Livestock farming and ranching

Droughts

Quercus brandegeei is one of the Mexican endemic oaks that OACN is helping to conserve. This species is found only in a very small range on the southern tip of Baja California, growing in ephemeral stream-beds that fill up after hurricanes. *Quercus brandegeei* has very elongate acorns, which are harvested on a small scale to supplement local diets. Based on life cycle estimates for its close relatives, *Q. oleoides* and *Q. virginiana*, researchers estimate that *Q. brandegeei* trees can live up to 800 years. In addition to its limited distribution, another factor that seriously threatens the survival of this species is a lack of regeneration in the wild. Extensive surveys have revealed that no new seedlings have established in at least 100 years, but why remains a mystery. One suspected problem is animal grazing. This *encino arroyero* ("stream oak") occurs along rivers, which are also desirable locations to establish ranches. Ranchers have cows, sheep, and pigs roaming free on the streambanks, where they can take advantage of the water availability and forage on native vegetation, including oak leaves and acorns. To test the effects of these animals on oak regeneration, tree conservation ecologists at the Morton Arboretum are conducting an experiment consisting of tracking seedling survival in grazer excluded plots versus unexcluded areas. They are also working with local researchers, students, and ranchers to take science-informed conservation actions that will help prevent extinction of this important species.

In addition to in situ conservation work, the team collected acorns from 11 populations of *Quercus brandegeei* in Baja California Sur, covering the entire range of the species, which they sent to 12 botanic gardens in Mexico and the US in order to build ex situ collections of this endangered species. Murphy Westwood is excited about progress with the project and future prospects: "Working together has been such an enriching experience. Each species of oak has unique requirements, but the more we learn through practical work and exchange of ideas, the

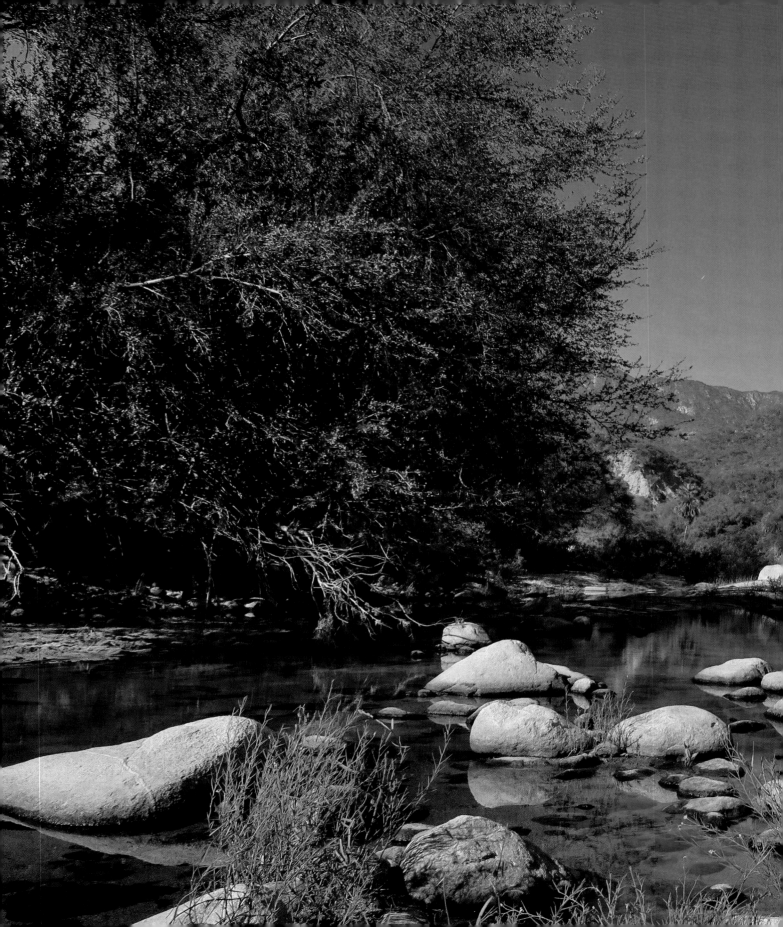

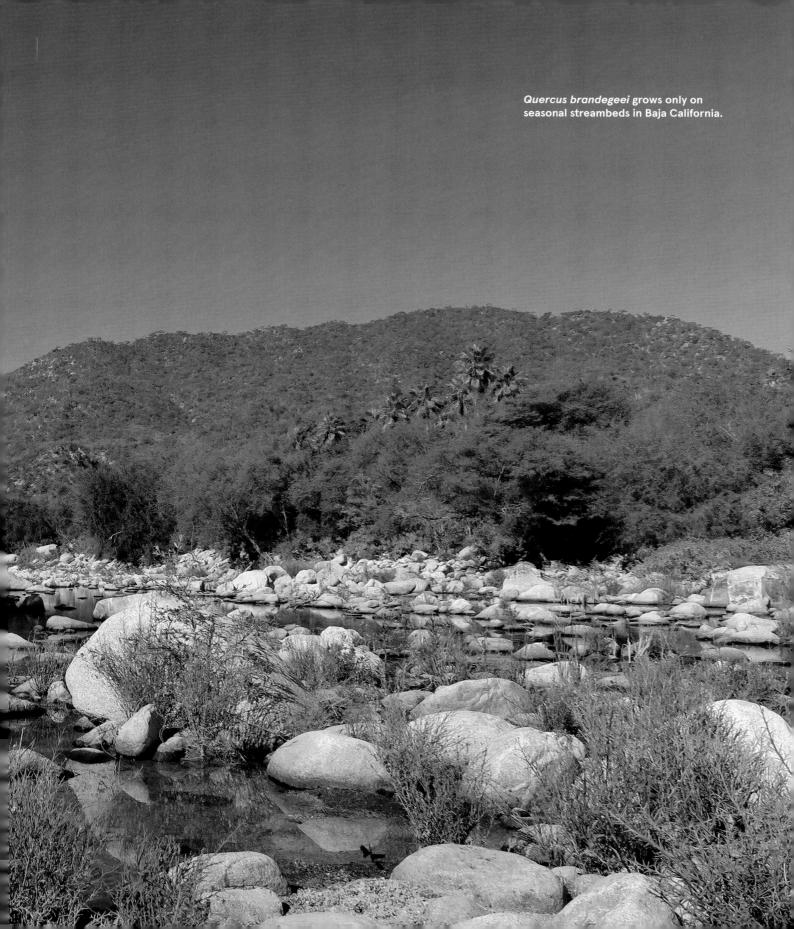

Quercus brandegeei grows only on seasonal streambeds in Baja California.

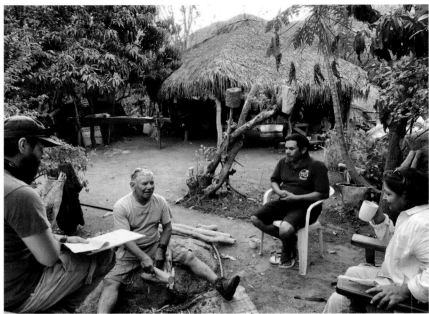

(↑) Measuring the distinctive acorns of *Quercus brandegeei*.

(↗) Interviewing farmers within the habitat of *Quercus brandegeei*.

greater our chances of success. The next stage in our work on *Q. brandegeei* is to engage with local ranchers and land managers to establish a *Q. brandegeei* reintroduction initiative campaign, and, based on our scientific research, establish clear guidelines to promote regeneration of the species in the wild."

OAKS IN CHINA

Its vast geographical extent and complex topography mean that China is home to a wide range of climatic conditions, from tropical to subarctic. As a result the country features most vegetation types, from rainforest, subtropical, and temperate forest to steppe, desert, and alpine ecosystems across an enormous altitudinal range, from 155 metres below sea level (Aiding Lake, Xinjiang) to over 8800 metres above sea level at the peak of Mount Everest. With virtually all major biomes of the world to be found in China, the country features the most diverse flora of any of the nations in the northern temperate zone. More than half of its 33,000 native vascular plants are endemic and do not occur naturally anywhere else in the world.

China is particularly rich in oaks, with over 100 species. There is much botanical conservation expertise within the country, but the race is on to prevent losses in the face of rapid development. Even in remote forest areas road building is encroaching on oak habitats that have already been reduced and fragmented by centuries of logging and clearance for agriculture.

Quercus sichourensis (Xichou oak) is one of China's rarest oaks, surviving at only three localities very close to villages in southeastern Yunnan and one in southwestern Quizhou. In total, less than a dozen mature trees remain in the wild. The main threats to this fragile species have been habitat loss and fragmentation together with very poor natural regeneration. Fortunately, a small protected area has been established for Xichou oak in Funing County. Kunming Botanical Garden has ex situ collections in conservation research plots and ornamental landscaping. Reintroduction is being carried out at two sites with semi-natural habitat, and the species has been planted at the Zhibenshan conservation base, where rare trees are grown for conservation and research.

Weibang Sun has worked intensively at Zhibenshan in recent years and leads the various research and conservation efforts for *Quercus sichourensis*. He explains that a recent comprehensive survey of the woody flora of the Zhibenshan mountains, undertaken with support from the GTC, documented over 300 species. Numerous very rare endemic species are being propagated, and ex situ collections have been developed at Kunming Botanical Garden and in the conservation trial plot in Zhibenshan. These will provide an important resource for species recovery work in the future. Besides Xichou oak, the conservation trial plot has been planted with over 2000 individuals from 19 species, including *Magnolia hebecarpa* and *M. sinica*. Although protection status has not yet been assigned to the most biologically valuable areas of the Zhibenshan mountains, increased governmental awareness of the biological diversity of the region has been achieved as a result of discussions with the Yunnan Forestry Bureau.

OAKS IN EUROPE

Wherever oaks occur around the world, they face varying degrees of environmental problems. In Europe, there are 25 species of oak, with 12 species occurring in Spain. Surprisingly some of the European oak species remain poorly known. *Quercus canariensis* (Algerian oak), for

example, is a charismatic tree of the southern Iberian Peninsula and North Africa, from Morocco to Tunisia. It is vulnerable in the Spanish region of Andalucia and near threatened on a European scale due to population decline and the threat of increased drought across the Iberian Peninsula. Although the species has a wide range, the population size and status across the range is not known. Further information on population decline across the species range, especially in North Africa, is needed, and the cause of this decline also requires better understanding. Protection within Europe, where decline is known to be occurring, is a priority.

Another little-known European oak is *Quercus pauciradiata*, which is endemic to northeastern León province in northern Spain. It is very restricted in the wild; some trees grow within Rebollares del Cea, but a small population in the Picos de Europa National Park is now extinct. Threats to the species include poor regeneration, habitat reduction, and fairly ready hybridization with other oaks, which makes the taxonomic identity of this species somewhat uncertain. More work is needed to clarify the taxonomic status and extinction risk of this species, but it is clear that the majority of the flowers these trees produce are male, and that when seeds do develop, they are often not viable.

Quercus pyrenaica is a large tree of the Mediterranean region, with 95 percent of its population occurring within the Iberian Peninsula and the rest in Morocco. The population is currently large and stable;

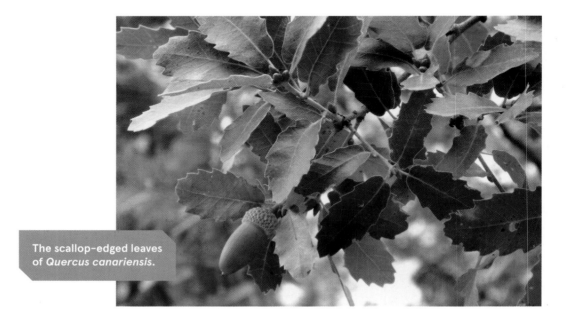

The scallop-edged leaves of *Quercus canariensis*.

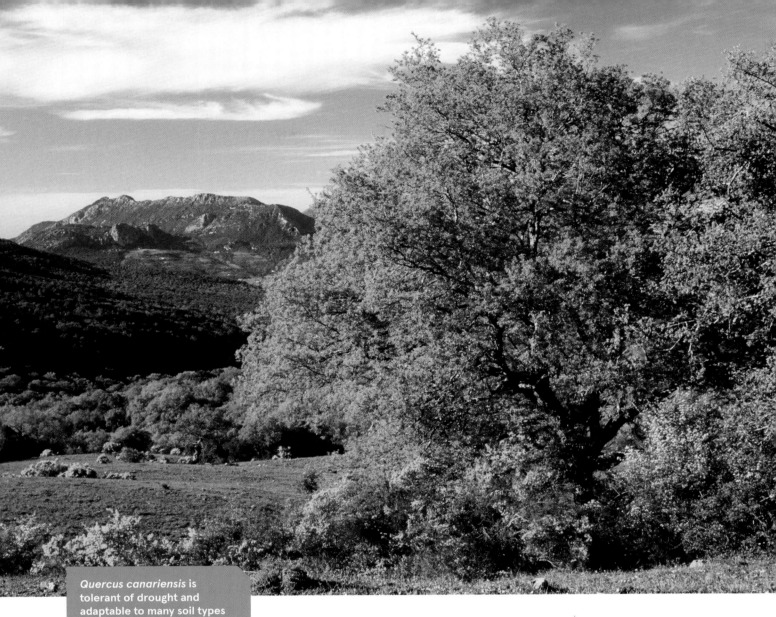

Quercus canariensis is tolerant of drought and adaptable to many soil types and even to arid areas, as here in the Cádiz province of southern Spain.

however, the species has been subject to historical declines. Because it has a high resprouting capability, many of the trees in a given area (e.g., an estimated 43 percent of *Q. pyrenaica* forests in Spain) may be clonal, potentially making the population more susceptible to pests and pathogens, and these threats may increase with climate change. Similarly, wildfires allow repopulation by *Quercus* species better able to compete in this area. Acorns yields are also in decline, and those that do grow are overforaged by herbivores from surrounding farms and ranches. This species is currently listed as least concern but requires monitoring in the face of climate change, and more information is needed on its status in Morocco.

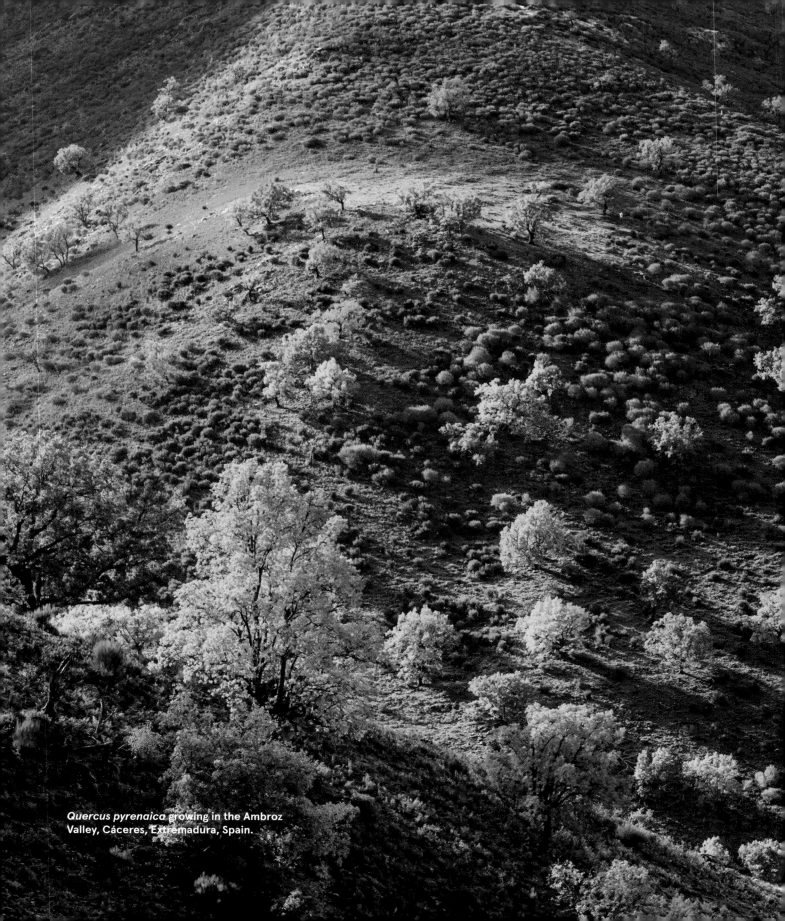

Quercus pyrenaica growing in the Ambroz Valley, Cáceres, Extremadura, Spain.

Quercus suber

Quercus suber (cork oak) is a large tree species of the Mediterranean region. The species is predominantly used for the industrial production of cork and is widely cultivated across its range, which extendsfrom Portugal to Italy and North Africa, for this purpose. Portugal is the main cork-producing country in the world and has the largest area of cork oak forest. Cork may be harvested from the tree bark after 25 years (and every 9–12 years or so thereafter) without killing the tree. Cork is used to produce wine bottle stoppers, flooring, insulation, household products, and a variety of sporting equipment, such as shuttlecocks and fishing rod handles. It is also employed within the space industry. The species has a large distribution, but it is decreasing within Europe. The extent of decline has not been fully assessed, but the species is at risk from changes in forest management, abandonment of rural areas, increased cattle grazing, and habitat conversion due to agricultural expansion. Increases in wildfire and drought are also a threat to the species—and these are exacerbated by climate change. Cork oak forests are protected across Europe, and within Portugal it is illegal to fell *Q. suber* trees. Within Africa this tree is threatened by overexploitation for cork products. The species is also susceptible to defoliators and phytophthora infections, which cause decline in tree health.

Quercus suber is an iconic Mediterranean species, closely linked to cultural practices and ancient farming landscapes. Although not a global priority for tree conservation (it is assessed as least concern), protection of its habitat is extremely important for the Spanish imperial eagle and Iberian lynx, among other species. Fortunately, cork oak forests have been declared protected habitat within the EU Habitats Directive and a High Nature Value (HNV) farming system by the European Environmental Agency. A range of wildlife agencies are working together to protect this habitat and promote sustainable cork production.

(↑) A tile panel depicting the traditional cork harvest, from Azeitão, Portugal.

(→) The thick bark of a *Quercus suber* before harvest.

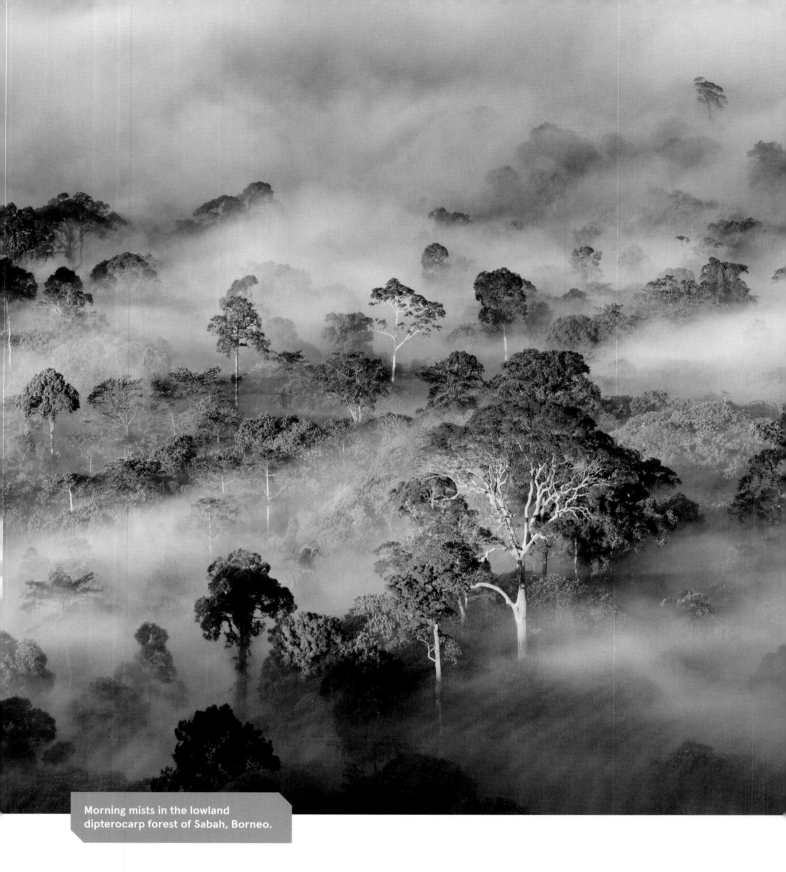

Morning mists in the lowland dipterocarp forest of Sabah, Borneo.

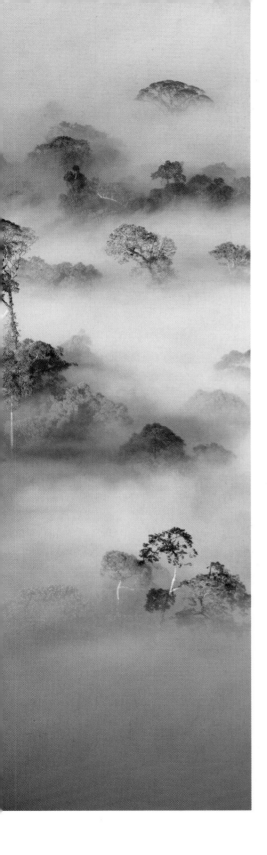

Dipterocarps

The majestic forests of Southeast Asia are rich in a diversity of commercially important timber species that have been used to produce furniture and construct buildings around the world. Predominant among the tropical forest trees are the long-lived dipterocarps, with massive straight trunks and crowns high up in the forest canopy. The logs from a single dipterocarp tree can be worth over US$1000. The majority of species in the Dipterocarpaceae are confined to Southeast Asia. Borneo has the richest diversity of these majestic trees. Dipterocarps are not only of great importance economically, they are of immense importance ecologically, defining forest types, providing habitat for a wide range of other plants and animals, and helping to control climate and water supplies. The loss of these approximately 500 species, and their forest habitats, would have profound implications for the planet. Southeast Asia is estimated to account for 29 percent of the global greenhouse gas emissions that result from deforestation. The rate of tropical forest loss in the region is greater than all other tropical regions of the world; however, impressive conservation efforts are now underway there, and these should be fully recognised and celebrated.

Conserving dipterocarps is intimately dependent on managing and conserving the forests where they grow. An important first step, as with all tree species in need of conservation action, is to understand where the dipterocarp species are and what their conservation status is. Over 70 percent of all dipterocarp species are threatened.

Peninsular Malaysia has 159 species of dipterocarps, with new species of this major tree family still being discovered. As elsewhere in the tropics, continued botanical exploration is taking place alongside use and clearance of the natural forests. The forests of Peninsular Malaysia have been managed for commercial timber production for over a century, with systems designed to allow dipterocarps to be felled rotationally. Harvesting was on a relatively small scale until the 1950s, when international

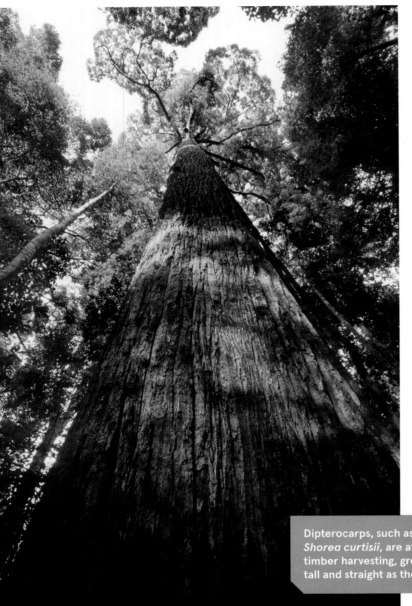

Dipterocarps, such as this widespread *Shorea curtisii*, are attractive for timber harvesting, growing very tall and straight as they do.

demand increased rapidly. Since the 1980s, rubberwood from the rubber plantations initially established by British in the 1880s has become a very important timber export from Peninsular Malaysia, overtaking the export of dipterocarp timbers, but harvesting of the dipterocarps continues.

The decline of dipterocarps in the natural forests of Peninsular Malaysia is a direct result of harvesting over the past century, together with the expansion of plantation agriculture, mining, and general development pressures. As elsewhere in tropical regions, the creation of oil palm plantations to supply an ever-growing global demand is a major cause of deforestation. Fortunately, conservation measures are being designed to ensure that the future is secure for some of the 34 dipterocarps found only in Peninsular Malaysia and the 15 native species that are threatened. Lillian Chua of the Forest Research Institute Malaysia (FRIM) and her colleagues are helping to ensure that the critically endangered and endangered dipterocarp species survive. Lillian is responsible for documenting the conservation status of plants in Peninsular Malaysia, using the resources of the National Herbarium, and contributing to species action plans; she advocates for plant conservation at both federal and state levels.

Vatica yeechongii

IUCN RED LIST CATEGORY

Critically Endangered

NE DD LC NT VU EN **CR** EW EX

NATURAL RANGE

Peninsular Malaysia

PREFERRED HABITAT

Steep slopes along gentle watercourses in inland forests

THREATS

Roads and railroads

Smallholder farming of non-timber crops

Vatica yeechongii, a highly threatened endemic dipterocarp, survives in an area of recreational lowland forest within the Sungai Lalang Forest Reserve, in the state of Selangor. This forest area is close to the capital Kuala Lumpur and is an important site for bird diversity as well as for the imposing trees. Chan Yee Chong noticed the unusual tree, with larger leaves than its close relatives, during a FRIM botanical survey in 2000. When flowers and fruit were found two years later, the species could be described as *V. yeechongii*, new to science and named after its discoverer. The species has also been found in Setul Forest Reserve, Negeri Sembilan; hopefully, further meticulous botanical surveys will turn up more individuals elsewhere in the wild.

The Sungai Lalang population is likely to remain secure, as the forest forms part of the catchment for the Semenyih Dam. This is a major water

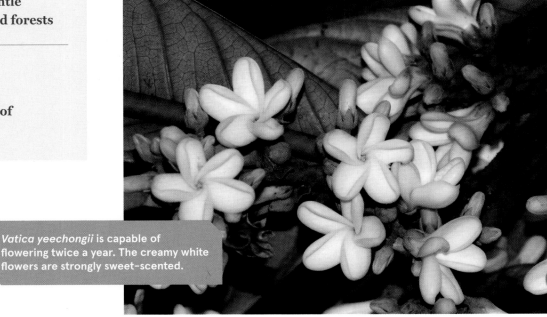

Vatica yeechongii is capable of flowering twice a year. The creamy white flowers are strongly sweet-scented.

FRIM Selangor Forest Park

FSFP is vital to the conservation of a wide range of animals, including 184 species of birds, which is a quarter of the total birds recorded in Malaysia. Fifty-eight species of mammals have been recorded, including the protected species shown here.

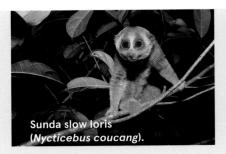
Sunda slow loris (*Nycticebus coucang*).

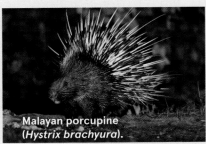
Malayan porcupine (*Hystrix brachyura*).

Sunda flying lemur (*Cynocephalus variegatus*).

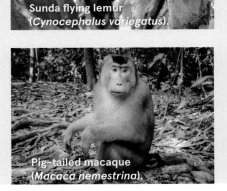
Pig-tailed macaque (*Macaca nemestrina*).

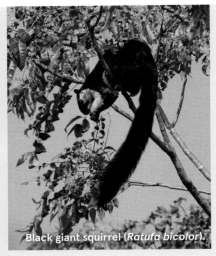
Black giant squirrel (*Ratufa bicolor*).

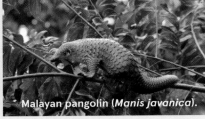
Malayan pangolin (*Manis javanica*).

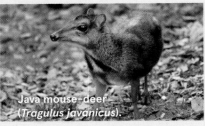
Java mouse-deer (*Tragulus javanicus*).

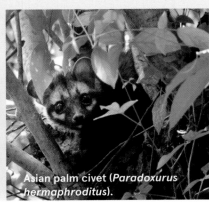
Asian palm civet (*Paradoxurus hermaphroditus*).

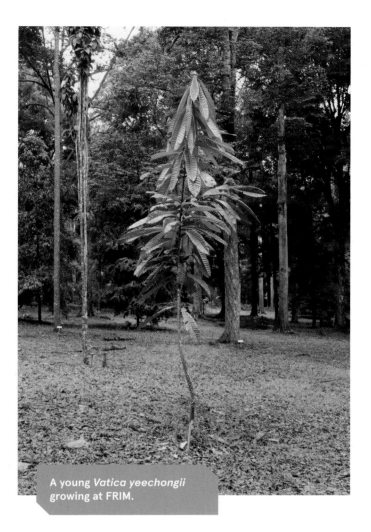

A young *Vatica yeechongii* growing at FRIM.

source for the Klang Valley, an area between the Titiwangsa Mountains and the sea, where Kuala Lumpur and other growing cities are located. Management for recreation in the reserve will need to ensure that the trees are not damaged and that new plants can establish. The site in Negeri Sembilan, where about 70 trees of the species remain, is a small protected forest fragment designated as a High Conservation Value Forest (HCVF) but is close to a busy main road; this population is potentially more threatened by development.

A backup strategy for conservation of *Vatica yeechongii* is provided in the FRIM Selangor Forest Park (FSFP). This stunning 544-hectare park, which is being considered for adoption as a UNESCO World Heritage site, consists of restored tropical rainforest with the meandering River Kroh and its waterfalls running through the forest. The extraordinary restored rainforest dates back to 1917, when the head of the Malayan Forest Department, G. E. S. Cubitt, decided to set up the forest research centre. He enlisted the help of F. W. Foxworthy, an American renowned for research on tropical trees and timbers. The site chosen for the FRIM research centre is 14 km from the capital city of Kuala Lumpur and adjacent to the natural virgin forest of Bukit Lagong. One hundred years later the location remains internationally important for research, biodiversity conservation, environmental education, and public recreation. The creation of this forest shows what is possible with vision and planning.

Within the grounds of FSFP, many different species of dipterocarp have been planted, including endemic and threatened species. *Vatica yeechongii* is one of many species introduced into ex situ conservation, and with luck it will flourish as part of the mature forest. Material is also maintained as part of the National Germplasm Bank for forest species.

The botanists and conservation experts from FRIM share their expertise working to save trees with people throughout Malaysia and elsewhere in the world. East Malaysia (Sarawak and Sabah) forms part of the island of Borneo, the third-largest non-continental island in the

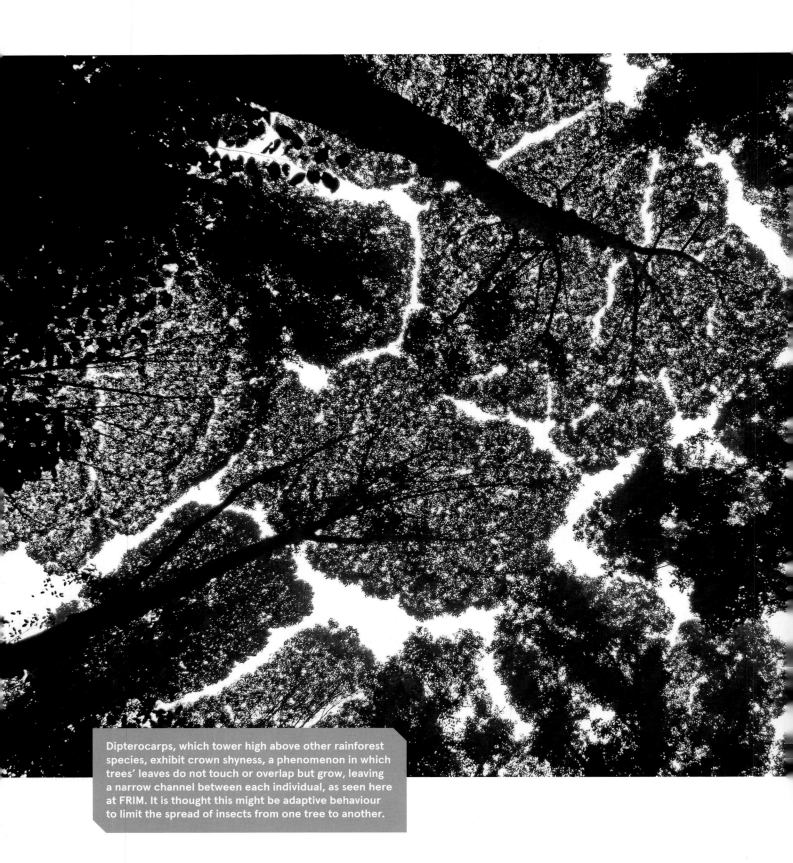

Dipterocarps, which tower high above other rainforest species, exhibit crown shyness, a phenomenon in which trees' leaves do not touch or overlap but grow, leaving a narrow channel between each individual, as seen here at FRIM. It is thought this might be adaptive behaviour to limit the spread of insects from one tree to another.

world. Commercial logging throughout Borneo began on a large scale in the 1970s, initially in the coastal regions. At the time, around 75 percent of Borneo was covered in natural forest. Over 30 percent of this ancient forest has since been lost. Nevertheless, Borneo has the largest remaining stretch of rainforest in Southeast Asia, the third-largest rainforest on earth and perhaps the richest in biodiversity. Half a million indigenous people—such as the once-nomadic or semi-nomadic Dayak, Penan, and Iban—still rely on this rainforest for their livelihoods, sometimes in conflict with current development of the forest land. As in Kalimantan (the Indonesian portion of Borneo), logging of the rich timber resources of Sabah and Sarawak started later than in Peninsular Malaysia, developing rapidly by the 1970s. Logging concessions are still economically important but, in Sabah, are losing ground to oil palm plantations.

Sabah and Sarawak have over 260 dipterocarp species concentrated in the rich evergreen forests. As in Peninsular Malaysia, the conservation status of dipterocarp species is being evaluated as a basis for conservation action. In Malaysia, Sarawak has the most diverse species of dipterocarps, with 247 species in nine genera. The dipterocarps are very important for timber production in Sarawak, and so a major project was undertaken in 2008 to take a closer look at the conservation status of *Dipterocarpus*, *Dryobalanops*, and *Shorea* species. This project was carried out by Sarawak Forestry, the government agency that manages and conserves forests, and was partly funded by the Sarawak Timber Association.

Julia anak Sang, one of the leading researchers of the project, explains that herbarium records and data from ecological plots established in Sarawak's protected areas were used to assess the rarity and abundance of the dipterocarp species. New fieldwork was also undertaken yielding some exciting results. *Shorea cuspidata*, formerly listed as extinct, was reassessed as near threatened in Sarawak, as it was found to be well represented in Bako, Kubah, and Santubong national parks. Another species, *Dipterocarpus coriaceus*, was feared extinct in Peninsular Malaysia when the last known stands in Bikam Forest Reserve, Perak, were cleared for oil palm cultivation. It was subsequently rediscovered in Chikus Forest Reserve, some 30 km away. The population is now protected in designated HCVF. In Sarawak, it was discovered in private land in the inland trading city of Sri Aman and in fragmented forest close to the capital of Kuching. Fortunately, this species also survives in the forests of Indonesia.

With information on the conservation status of dipterocarps, action can be taken to save species from extinction. Conservation within the

forest is always the best option. This is possible in formally protected areas where biodiversity conservation is the main aim, as well as within forest that is sustainably managed for commercial timber production and forest that is managed by local communities. Throughout Malaysia and Indonesia, sustainably managed forests can allow tropical forests to retain significant diversity of species. In both countries, some areas of forest are managed for conservation, with no logging allowed, whereas others are zoned for extraction of dipterocarps and other timbers.

Changes to natural habitats in Sarawak resulting from forest conversion for other land uses and continued exploitation of dipterocarp species will adversely affect the natural populations unless conservation measures are taken. The loss of these giant tree species is not only a loss of tree diversity of Borneo but also creates damaging cascading effects on the forest's ecosystem functions and associated biodiversity. More detailed research on these threatened species is urgently needed to plan and implement effective conservation measures. Julia anak Sang stresses that cooperation between all stakeholders—government and private agencies, timber licensees, local communities—is important if effective in situ conservation is to be implemented in Sarawak.

In neighbouring Sabah, a major plant red list project was started in 2009 as a joint activity of the Forest Research Centre, Sabah Forestry Department, and University of Aberdeen. Initially this project concentrated on dipterocarps, the dominant trees in this part of Malaysia, accounting for 80 percent of the growth at ground level; not only that, dipterocarps are the best-known tree group, both taxonomically and ecologically, and they are of major commercial importance in the region. Conservation assessments have been undertaken for the 195 dipterocarps of Sabah, ahead of assessments for other tree species. As in Sarawak, assessing the status of dipterocarps in Sabah involved studying herbarium specimens, mapping the distribution of species, and surveying trees in their natural habitats.

Dipterocarpus lamellatus (keruing jarang), a dipterocarp found only in Sabah, was listed by IUCN in 1998 as critically endangered, possibly extinct in the wild; until recently, it had not been seen since 1955. In 2011, as part of survey work for the plant red list project, three individuals were discovered in Sianggau Forest Reserve, which is consistent with keruing jarang being known to occur only in the west coast of Sabah. Unfortunately, a large part of this reserve has since been destroyed by fire. In 2012 IUCN and the Zoological Society of London highlighted *D. lamellatus* as one of the 100 most endangered species on the planet. This list (titled

"Priceless or worthless?") was presented as a challenge, drawing attention to highly threatened species that, unlike tigers and pandas, are not generally considered to be iconic and charismatic.

Sustainable forest management should enable dipterocarp timber to be removed without permanent damage to the forest. In the past, lowland forest in managed concessions was allowed to recover for 55 years after timber of all commercial species was removed in a single felling of trees over a certain size. Now in both lowland and hill dipterocarp forests, selective logging is practiced, and harvesting based on 30-year cycles is undertaken in a more flexible approach based on inventory data. Monitoring of forest operations is based on remote sensing, GIS, and field data. Practices have also been introduced to reduce logging damage in forest stands.

In Indonesia, with high tree diversity and lack of markets for the timber from most species, commercial logging is selective. Regulations governing the selective harvest of timber from natural forests in Indonesia are set by its Ministry of Environment and Forestry. Harvests are approved following the preparation of forest management plans (valid for 10 years) and detailed annual plans for permits (with durations of up to 70 years). The minimum cutting cycle for harvesting commercial timber is 30 years.

In parts of Indonesia, traditional forest management is included in wilayah adat activities, which lay down the basic ethics and codes of conduct for local people, forming an intrinsic part of the local culture. Although traditional rights may have been eroded, in some parts of the country responsibility for sustainable forest management is being returned to local communities by the government. In West Kalimantan, large areas of dipterocarp, heath, and peat forest have been converted to oil palm plantations or lost to forest fire. Some of the remaining forest blocks are protected, typically within nature reserves or by village organisations awarded formal management rights under the Indonesian government's community forestry programme, Hutan Desa. However, even where forest habitat is protected, high-value timber species such as meranti (*Shorea*) are selectively logged, causing further population decline. The loss of mature fruiting trees means that many species are unable to reproduce adequately and are thus unable to recover unassisted, especially where forest has been degraded by fire or replaced by grasses. Where species are failing to regenerate, active forest restoration and reinforcement planting may be required. For example, FFI has been working since 2010 with three Village Forest Management Organisations, initially

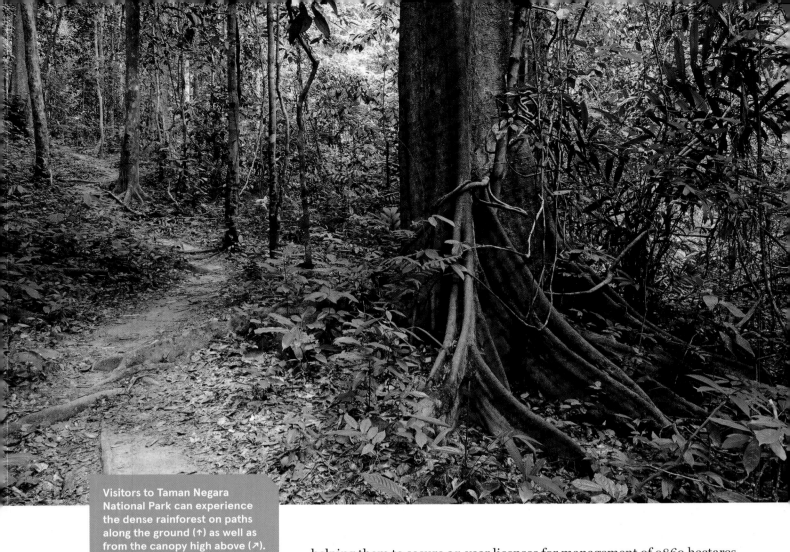

helping them to secure 35-year licenses for management of 9860 hectares of peat swamp and dipterocarp forest habitat. These licenses give communities the right to sustainably manage their forests and protect them from expansion of oil palm, and provide a basis from which to carry out more targeted interventions for threatened trees. At a fourth site, Muara Kendawangan Nature Reserve, FFI is supporting effective monitoring and patrolling to reduce threats to 149,000 hectares of orangutan habitat. In all four of these sites, the aim is to tackle specific management gaps that affect populations of threatened dipterocarps and other trees and to integrate threatened species into the wider restoration of degraded patches of forest.

FFI is also helping to conserve *Dipterocarpus cinereus*, a tree known only from Mursala Island off northern Sumatra. Previously thought to be extinct, this species was rediscovered in 2013, and surveys in August 2018 by FFI Indonesia found 163 individuals, 30 of them mature trees.

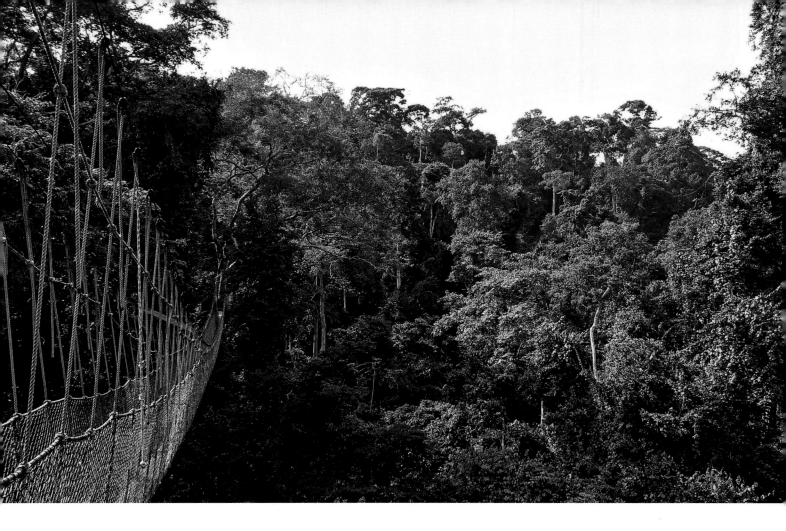

Mursala is a tropical paradise with a total of 26 dipterocarps on the island, 20 of which are threatened, mostly by illegal logging, which continues to threaten the forests and their unique species. In the long term, local people need to find alternative sources of sustainable income; in the short term, ex situ is the best insurance policy.

In Malaysia, terrestrial protected areas are managed either by the Department of Wildlife & National Parks or the Forestry Department. Peninsular Malaysia has 220 protected areas. Taman Negara National Park in central Peninsular Malaysia is the largest of these. Within this impressive national park, home to elephants, tigers, tapirs, and hornbills, most forest habitats remain in a natural condition, with massive dipterocarps and species of balau (*Anisoptera*).

Sarawak also boasts a network of Totally Protected Areas (TPAs); nevertheless, some of the species therein are still categorized as vulnerable or endangered because their populations are so small. In Sabah,

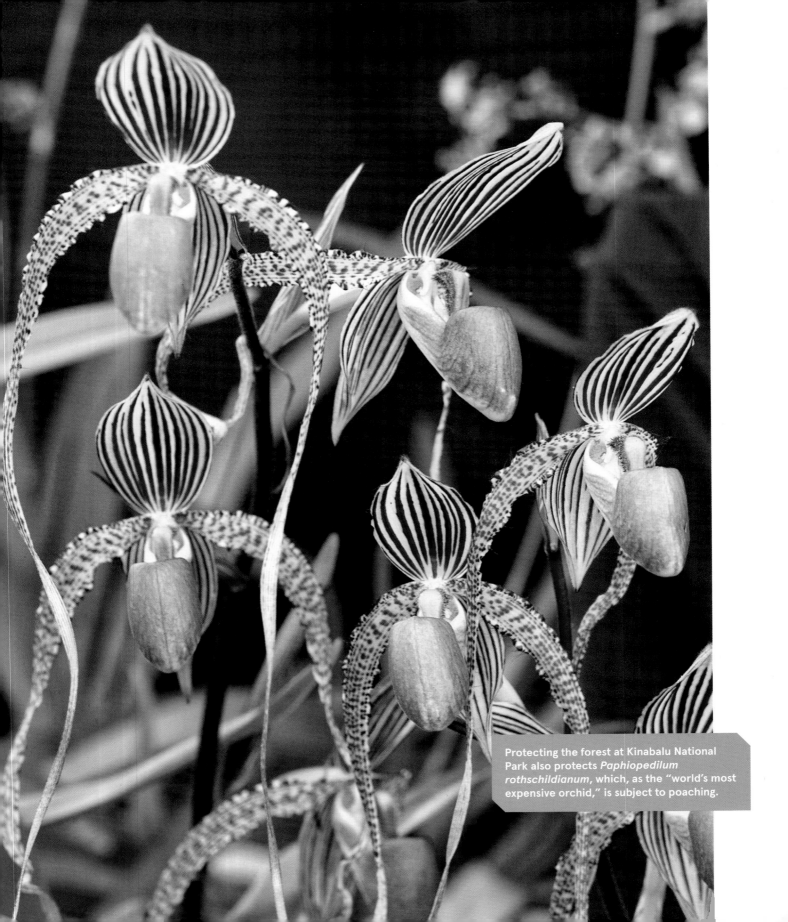

Protecting the forest at Kinabalu National Park also protects *Paphiopedilum rothschildianum*, which, as the "world's most expensive orchid," is subject to poaching.

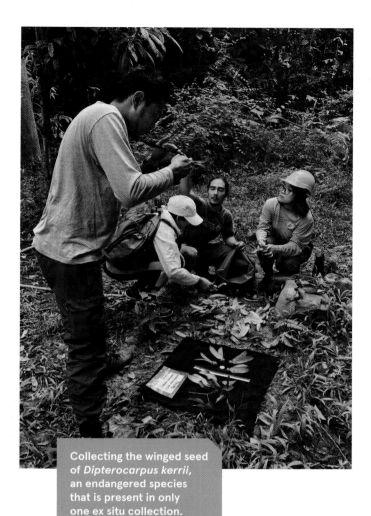

Collecting the winged seed of *Dipterocarpus kerrii*, an endangered species that is present in only one ex situ collection.

dipterocarps dominate the forests in the lower reaches of Kinabalu National Park, another World Heritage site. They provide forest cover for a diversity of other fascinating plants, including the fabled slipper orchid (*Paphiopedilum rothschildianum*), which is endemic to Mount Kinabalu.

We have the technical knowledge to propagate dipterocarps on a relatively large scale, but sourcing mother plants presents a challenge because information on dipterocarp reproductive ecology remains patchy. A striking characteristic of the dipterocarp family is mast flowering once or twice every 10 years or so. Masting is a canopy-wide event, with many families in the lowland and hill forests flowering and fruiting simultaneously. This phenomenon is seen as critical for forest regeneration, with dipterocarp species reported to synchronise their flowering over very large areas. Dipterocarp flowering and seed production is linked to the El Niño Southern Oscillation (ENSO)—a natural climatic event that begins in the Pacific Ocean.

Dipterocarp seeds have two or more wing-like structures, which help dispersal by wind. Seed dispersal is, however, generally poor, and the seeds are recalcitrant, meaning they cannot be stored in conventional seed banks. For forest restoration schemes, seeds need to be collected as quickly as possible, protected from fungal infection and other forms of damage, and then germinated as soon as possible. The sheer size of the trees can make seed collecting very difficult. Restoration of dipterocarp forest can be carried out by planting seedlings of selected species produced in nurseries, within the degraded forest; this is known as enrichment planting. Alternatively, complete forest restoration can be undertaken by establishing a nurse canopy of fast-growing light-demanding species followed by underplanting with dipterocarps. Enrichment planting is likely to be most cost-effective but is considered less beneficial in terms of ecological functioning and local livelihoods. Another approach is to collect wild seedlings from the forest floor, taking care not to overcollect them, as this will impair natural regeneration. Enrichment planting in Indonesia typically uses plants

propagated from stem cuttings from wildlings. Ideally, seed should be used in propagation of dipterocarps for forest restoration, but in logged forest seed production can be low.

Botanic gardens have a major role in helping to restore dipterocarp species and their habitats. Currently 264 of the approximately 500 known dipterocarp species are recorded in botanic garden collections, based on the BGCI PlantSearch Database. Of these species in cultivation, 175 are threatened according to the IUCN Red List. One exciting new initiative is the Global Conservation Consortium for Dipterocarps, which is tackling dipterocarp conservation and restoration through joint action.

THE THREATS CONTINUE

Despite the impressive conservation efforts underway for dipterocarps in Malaysia and parts of Indonesia, the threats continue. Illegal logging remains a problem. At the same time, conversion of forests to agricultural plantations is a far bigger threat than timber extraction, both to the dipterocarp trees and the other forms of biodiversity. Global demand for palm oil continues to grow relentlessly. Indonesia supplies about half the world's palm oil, and Malaysia is the second-biggest producer. Oil palm (*Elaeis guineensis*) is native to the tropical forests of western and central Africa; it is used in plastics, industrial chemicals, and biodiesel production. Now, oil from its fleshy fruits and kernels is a major ingredient in food production, household products, and cosmetics around the world. Palm oil is used to make margarine, cooking oil, ice cream, and coffee creamer. Palm kernel oil is extracted for use in the manufacture of glycerine soaps and as a substitute for cocoa butter in chocolate. Palm oil has risen in global importance in the past several decades, with world production rising to 72 million metric tons in 2020–21.

Oil palm production is replacing rich tropical forest ecosystems; it is a form of industrial-scale monoculture, complete with intensive use of fertilisers and pesticides. Modern oil palm plantations usually have trees of uniform age with a low canopy and sparse undergrowth. The oil palm tree generates fruits from the third year, with yield per tree increasing gradually until it peaks at approximately 20 years. Oil palm plantations are typically destroyed and replanted at 25- to 30-year intervals.

In Kalimantan, the law stipulates that forests in timber concessions are permanent, but rezoning has taken place to allow development of

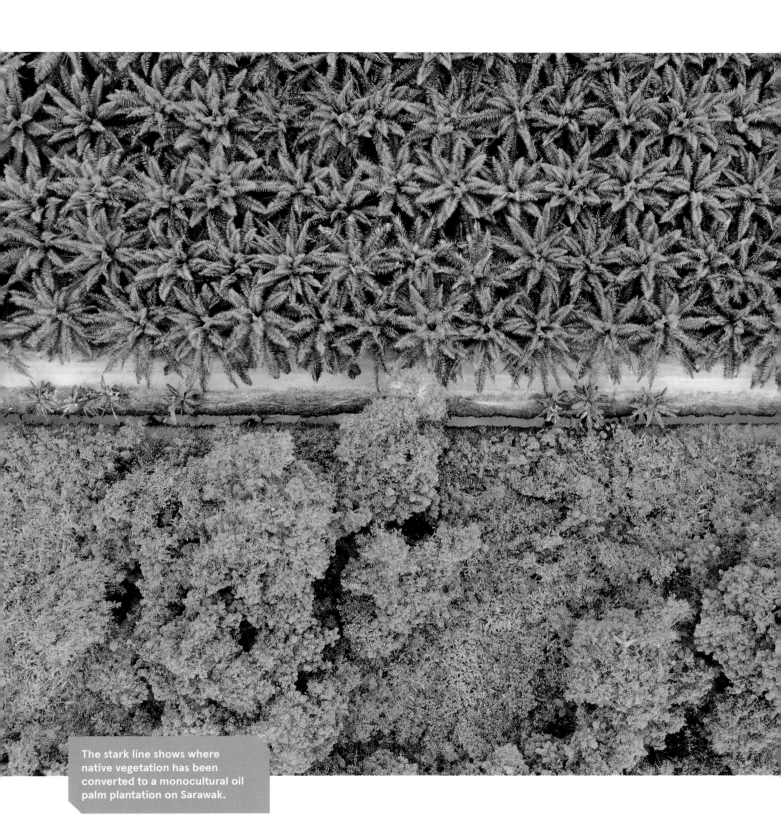

The stark line shows where native vegetation has been converted to a monocultural oil palm plantation on Sarawak.

Traditional Products from Dipterocarps

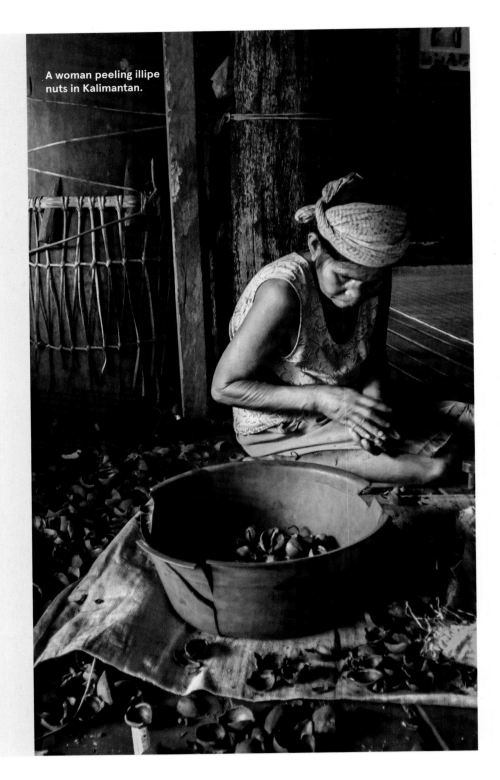

A woman peeling illipe nuts in Kalimantan.

Timber is the most valuable dipterocarp product, but these important trees also provide nuts, resin, and camphor. Traditionally, rural communities have benefitted from the harvest of these goods and from the income derived through their trade. For two millennia, Chinese and Indian traders regularly visited Southeast Asian ports for these products. Camphor from *Dryobalanops aromatica* was used by Arabs since the 6th century. Illipe nuts from *Shorea* species, which yield oil used to make candles, soap, and cosmetics, have been traded within the region and exported to Europe, with processing facilities in Sarawak and West Kalimantan. There are some plans to expand the trade in illipe nuts from Kalimantan as an alternative livelihood for local people, instead of converting their land for oil palm production.

oil palm plantation. In contrast, deforestation has been lower in Sarawak, despite its having the highest density of logging roads. Sarawak developed the most effective techniques to penetrate the rugged forest interior to harvest natural timber but has not systematically converted forests to plantations.

LOOKING AHEAD

The future of dipterocarps and the forests where they occur depends on concentrated action backed up by further research to understand the ecology of these extraordinary trees. Collaboration between different organisations and different countries will help support the level of action needed. The Indonesian Forum for Threatened Trees, which FFI helped to establish as part of the Global Trees Campaign, has brought together government departments and NGOs to boost tree conservation efforts with a National Action Plan for selected species. At a broader scale, the Heart of Borneo Initiative is an exciting example of international collaboration. This historic agreement was signed in 2005 by the nations that share the island of Borneo: Indonesia, Malaysia, and the tiny oil-rich country of Brunei. The initiative focuses on joint responsibility for managing the remaining intact band of forest in the centre of Borneo, straddling the mountains that run from Mount Kinabalu in the northeast, down to the Schwaner Range in the southwest. Almost the entire area covered by this agreement is licensed for logging, agriculture (including palm oil), and even mining. Improving sustainable forestry, promoting more sustainable approaches to oil palm production, and promoting ecotourism are positive measures encouraged to secure the green Heart of Borneo. Peninsular Malaysia has a similar initiative, the Central Forest Spine, which aims to restore the connectivity of the region's main forest complexes, the source of 90 percent of the population's water supply.

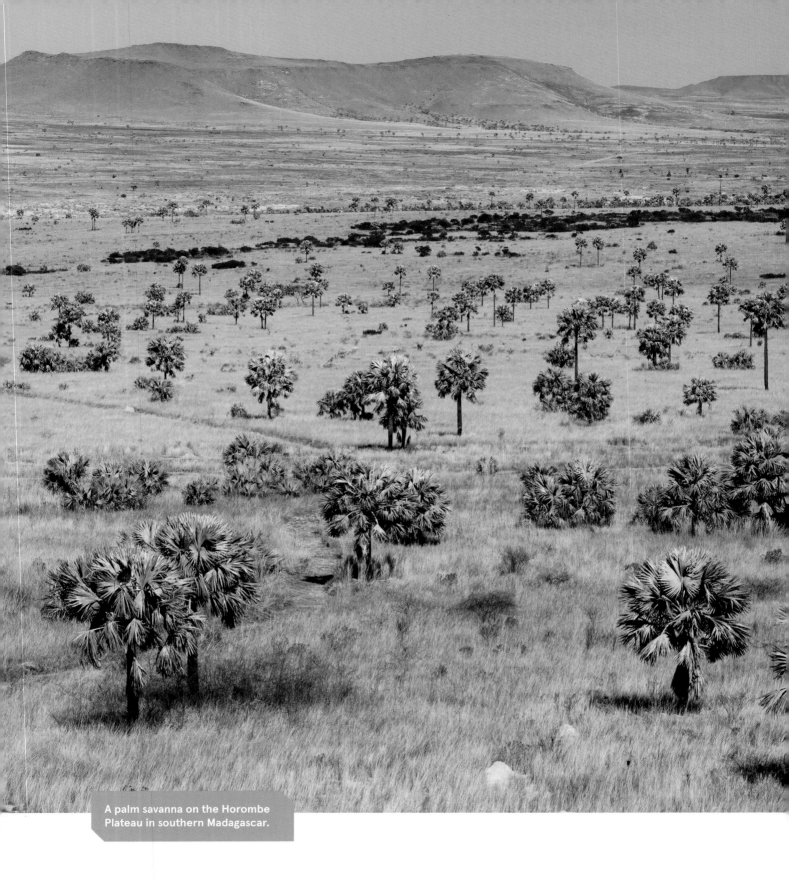

A palm savanna on the Horombe Plateau in southern Madagascar.

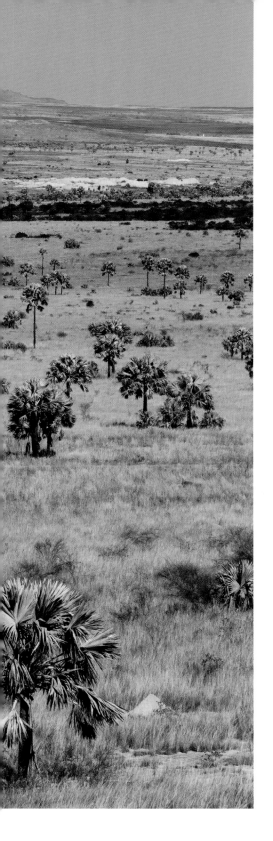

Palms

All palms are in the Arecaceae, a family of trees, shrubs, and climbing palms characterised by large, compound, evergreen leaves arranged at the top of an unbranched stem. Nearly half of the family's 2600 species are trees. Palms, commonly cultivated for their exotic appearance and plethora of useful products, grow in different habitats, mainly in tropical Asia and America. They are fundamental components of tropical ecosystems, supporting many other species, including a range of birds and mammals that depend on their fruits for food. Many palm species face extinction as a result of the familiar threats of deforestation and overexploitation.

The palm family is the most economically important plant family after the grasses and legumes. Palm species are used for food—the date palm and coconut being extensively cultivated around the world. Medicines, timber, thatching, and fibre are also essential products of palms, especially at subsistence levels, and palms are vital to local cultures. One example of a multi-purpose palm is murumuru (*Astrocaryum murumuru*), a tall, sometimes dominant Amazonian palm that is important both for local livelihoods and international trade. Locally, the leaf fibres are used to make hammocks, seeds are used for handicrafts, the fruit is eaten, and an edible oil is extracted from the seeds. Internationally the oil is used in food, cosmetics, soap, and for other industrial purposes. Local collection and production along the Amazon and its tributaries provide an important source of seasonal revenue for rural people, whose livelihoods depend on harvesting natural forest products. After collecting the reddish orange murumuru fruits by hand and separating the seeds, oil is extracted by machinery owned by rural cooperatives. These cooperatives, and in some cases local intermediaries, negotiate the trade with large companies. Oil is traded within Brazil or exported to other countries, primarily for the cosmetics industry. Virtually all harvesting of murumuru products is from wild populations, with a minimum price for

seed established by the Brazilian government. Fortunately, despite high demand, this important species of palm seems to be stable in the wild. Other palms are in serious trouble in their native habitats.

As with other groups of trees, a starting point for conservation action is to understand the conservation status of palms. Currently 410 of the 644 palm species on the IUCN Red List are threatened. Many of these palm assessments are from a comprehensive evaluation of the conservation status of all endemic palm species in Madagascar, which was carried out in 2010 by Mijoro Rakotoarinivo, a member of the Kew Madagascar team. This study set alarm bells ringing for the palm community, as it showed that 83 percent of the endemic palms of Madagascar are threatened. More recent conservation assessments for palms have been undertaken through the Global Tree Assessment, and there have been many assessments of palms at a national level in Brazil, Colombia, and Cuba. Not all such national plant red list assessments follow the IUCN categories, criteria, and guidelines, but they are invaluable for national action and are a major contribution to global knowledge. If a country has assessed endemic palm taxa, the assessments are, by default, global assessments.

Supporting information is usually required when national assessments are added to the IUCN Red List, but Lauren Gardiner, Curator of the University of Cambridge Herbarium, and former Red List Coordinator for the IUCN/SSC Palm Specialist Group, believes that national efforts can be invaluable stepping stones toward the production of full global assessments for palms. She believes that tackling the backlog in global palm conservation assessments is an essential activity and has looked at ways to speed up the process:

> We should follow the lead given by the global community of birdwatchers and experts in embracing citizen science projects. Tools such as iNaturalist can be promoted as a way of rapidly contributing observations and identifications of palms, from anywhere in the world, irrespective of the degree of formal "expertise." Palms are a relatively conspicuous and recognizable plant family, and there is an active and large global community of extremely enthusiastic and knowledgeable experts on palms, including scientists, professional horticulturalists, conservation practitioners, and amateur growers.

Lauren set up a Palms of the World project in iNaturalist to test how the system worked and quickly found that palm experts in Madagascar, Singapore, and New Guinea responded very well to the idea. She believes that harnessing the power of palm enthusiasts around the world could lead to a genuine step-change in the amount of evidence-based distribution data available for palm species, making the production of a global Red List assessment of the palms of the world a much more achievable goal.

No question, citizen scientist initiatives are a great way for palm enthusiasts and gardeners who enjoy the beauty of palms to support effective conservation. Meanwhile as data gathering continues, many palms are already identified as urgent priorities for conservation attention, and a range of different conservation approaches are being used around the world.

PALMS IN THE AMERICAS
Attalea crassispatha
CAROSSIER PALM

NATURAL RANGE

Haiti

PREFERRED HABITAT

**Subtropical to tropical
moist lowland**

THREATS

Droughts

Storms and flooding

**Problematic native
species/diseases**

**Annual and perennial
non-timber crops**

Attalea crassispatha, endemic to southern Haiti, was one of the first species identified for conservation attention through the Global Trees Campaign, and a conservation helping hand is still needed to ensure its long-term recovery. It may already be functionally extinct as a wild species; very few mature individuals are extant, and about half the population is found only in courtyard gardens. The species is long-lived and does not reproduce until plants reach about 40 years of age. Individuals bear male-only flowers before this, at around 20 years, but do not produce female flowers for another 20 years or so. Further research into the reproduction and propagation of *A. crassispatha* is needed—which is one way botanic gardens can support its conservation.

Attalea crassispatha is present in four ex situ collections. In Haiti it is growing in botanic gardens and has also been planted in cemeteries, on the grounds of hospitals and monasteries, and in urban gardens of Port-au-Prince and Pétionville. Florida's Fairchild Tropical Botanic Garden and Montgomery Botanical Center are also helping to conserve this species. Although germination remains difficult in ex situ collections, botanists and conservationists are committed to saving this species from extinction.

The natural habitat of carossier palm is subtropical humid forest, and the few remaining individuals in the wild are found in degraded areas of forest on slopes and ravines. Forests once covered nearly the entire land area of Haiti but have been reduced to about 4 percent of the country. Logging and plantation crop development led to historical forest loss, and the use of charcoal and firewood is now a significant problem. Deforestation has led to severe problems of soil erosion, particularly on the steep hillsides where many Haitian farmers grow their crops. Deforestation has been a major factor in the decline of *Attalea crassispatha*, and now lightning strikes and tropical cyclones are damaging individuals and uprooting the older trees. With climate change, hurricanes have become more severe, causing tragedy for the people of Haiti. Conserving the forests should be a major strategy to help increase environmental resilience.

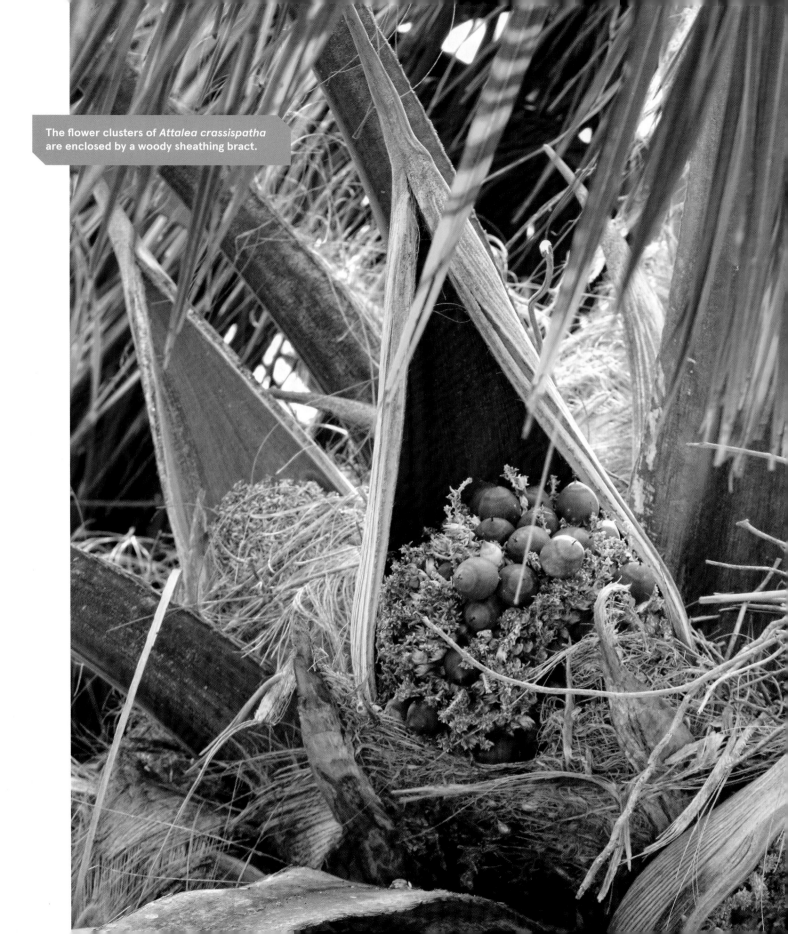

The flower clusters of *Attalea crassispatha* are enclosed by a woody sheathing bract.

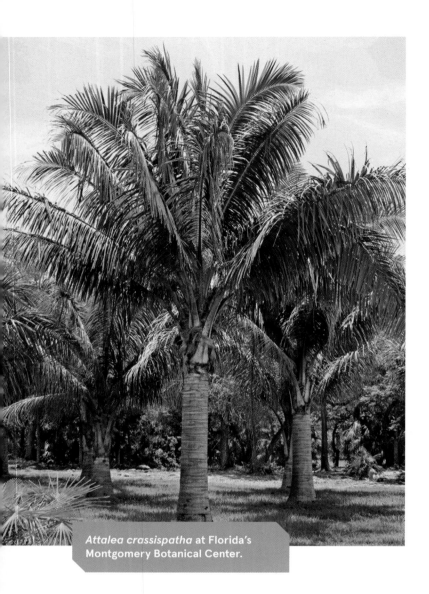

Attalea crassispatha at Florida's
Montgomery Botanical Center.

Sadly, the rate of conversion of natural forest to urban and agricultural land is intensifying.

One interesting threat to *Attalea crassispatha* comes from an unlikely source, an endemic bird of Haiti and the Dominican Republic, the Hispaniolan woodpecker (*Melanerpes striatus*). This common bird, which has become an agricultural pest in some areas, builds its nest inside the woody bract of the palm's inflorescence, and this is thought to affect fruit production. Conservation action for *A. crassispatha* includes raising awareness of tree owners, encouraging them to protect trees from both cutting and damage by the Hispaniolan woodpecker.

Traditionally, *Attalea crassispatha* was an important palm in Haiti, with many uses. Its trunk has been used for hanging corn to dry, and the large woody bract is used for bowls. In the past, the trunk was felled for its durable and insect-resistant timber, used in construction. The seeds of the palm are edible and as well as being eaten raw are cooked in sweet cakes. Oil has been extracted from the seed for cooking, and when the palm was more abundant, the fruit was fed to pigs. During cultural and religious ceremonies, candles are lit at the base of the tree. The longevity and architecture of any solitary palm makes it a favourite landmark and boundary marker for farmers. Despite all the threats faced by this species, perhaps there is still hope that it can survive and become a conservation success story.

Butia eriospatha

BUTIÁ

IUCN RED LIST CATEGORY

Vulnerable

NE DD LC NT **VU** EN CR EW EX

NATURAL RANGE

Eastern Brazil, northern Argentina, Paraguay, Uruguay

PREFERRED HABITAT

Rainforest

THREATS

Cattle grazing

Deforestation

Other perennial crops

Butia eriospatha is endemic to the Mata Atlântica (Atlantic Forest). Like so many palm species, it is valued as an ornamental and is used to make fruit juice, jelly, and wine. The development of pine forests and cattle ranching have been major threats to the habitat of this species, which is now listed as vulnerable on the Brazilian red list. According to Pablo Hoffmann of Sociedade Chauá (which with support from the Global Trees Campaign has assessed conservation issues for the species), "Many farmers see butiá as an obstacle to agricultural expansion since they are

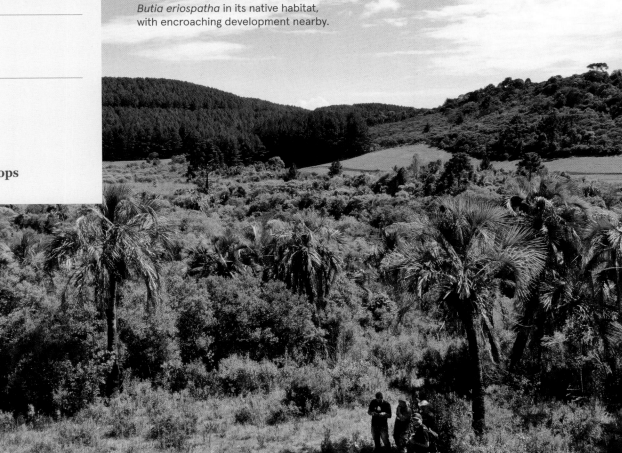

Butia eriospatha in its native habitat, with encroaching development nearby.

exceedingly hard to remove, and the fruits are used simply as livestock feed. The framing of butiá as a problem species with limited use is exacerbated by a high turnover of residents in many settlements within Paraná state and systemic problems regarding land ownership. These two issues contribute to myopic natural resource management and a gradual loss of traditional knowledge regarding the value of this palm."

Looking forward, Sociedade Chauá is exploring numerous avenues for action, which include building capacity for cooperation and entrepreneurship within communities, incentivising the restoration and protection of *Butia eriospatha* through the promotion of its potential for sustainable economic use, and training stakeholders in its propagation and cultivation. Work so far has identified four villages with significant stands of this palm, and in two of these residents showed a strong level of interest in butiá conservation and its potential for economic use.

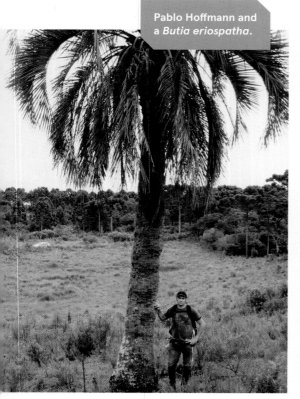

Pablo Hoffmann and a *Butia eriospatha*.

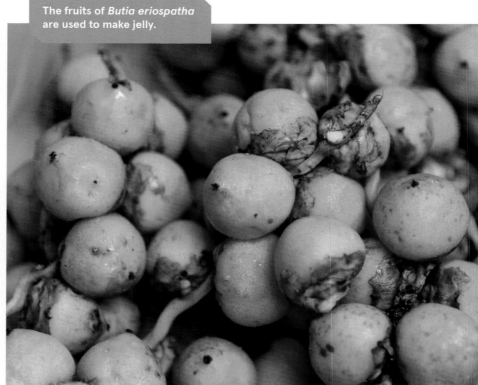

The fruits of *Butia eriospatha* are used to make jelly.

Ceroxylon quindiuense

QUINDÍO WAX PALM

IUCN RED LIST CATEGORY

Vulnerable

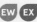
NE DD LC NT **VU** EN CR EW EX

NATURAL RANGE

Colombia, Peru

PREFERRED HABITAT

Humid montane forest

THREATS

Pressure from surrounding agriculture

Leaves removed for ornamental and religious use

Quindío wax palm is the world's tallest palm, growing up to 60 metres in height. It belongs to *Ceroxylon*, a genus of 12 species confined to the Andes. The whole genus is considered a keystone for ecological functioning of the cloud forest, not least because the fleshy fruits of its members support a wide range of birds and mammals. *Ceroxylon quindiuense* grows in Andean montane forests in Colombia and Peru. This long-lived species was considered very abundant until the beginning of the 20th century, with dense populations in the lush forests. But now this towering palm is listed as globally vulnerable by IUCN and endangered at a national level in Colombia.

Ceroxylon quindiuense continues to face a barrage of threats. Currently the main threat to its survival is forest conversion to pasture for cattle grazing. Periodic burning every 5–10 years is also undertaken in the montane forests to clear land for cultivation of subsistence crops, such as corn, potatoes, tomatoes, and beans. Even where mature individuals remain in pastureland, intensive grazing can prevent regeneration, so as the mature trees die there is no replacement with young trees. Where palms surviving in pastures are relatively abundant, the longevity of *C. quindiuense* may be misleading, giving the impression that well-conserved populations survive.

One of its last strongholds in Colombia is the Cocora Valley in the department of Quindío. In this area, the population has been monitored by scientists, who have recorded a 78 percent decline in the palm over the past 20 years. About 2000 trees remain in the valley, which is an important tourist destination. Tochecito, a little-known area in Tolima province is thought to have a much larger population of *Ceroxylon quindiuense*. Parts of this area, which covers around 40 km^2, were previously dangerous for researchers to visit as they were occupied by the FARC guerrilla group. This area is considered safe since the peace settlement of

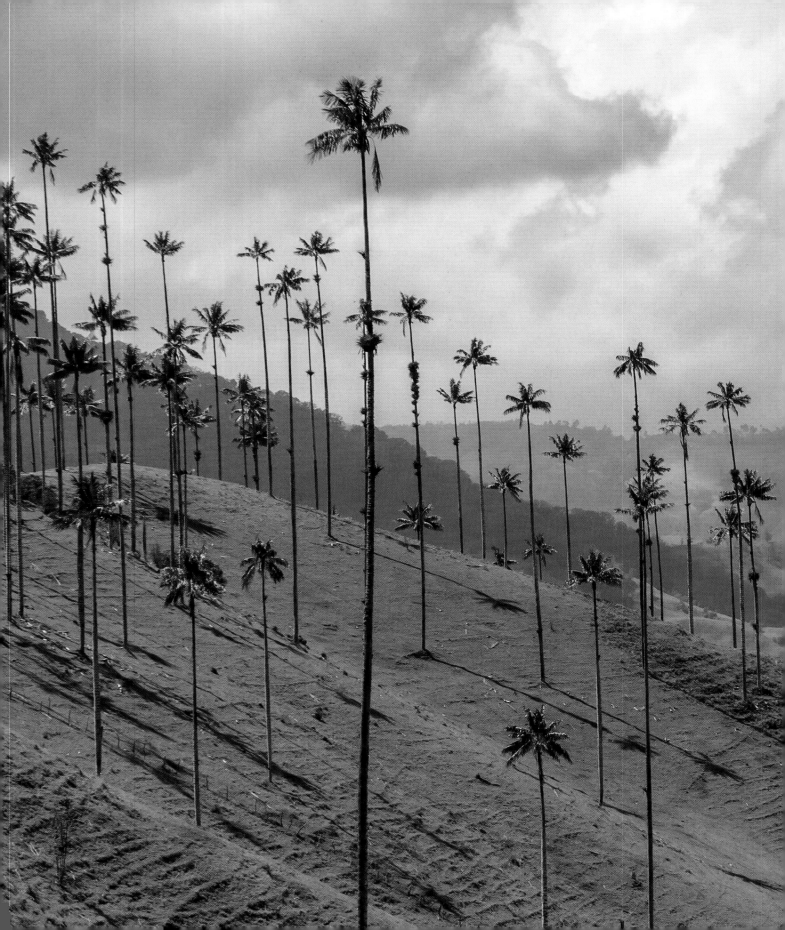

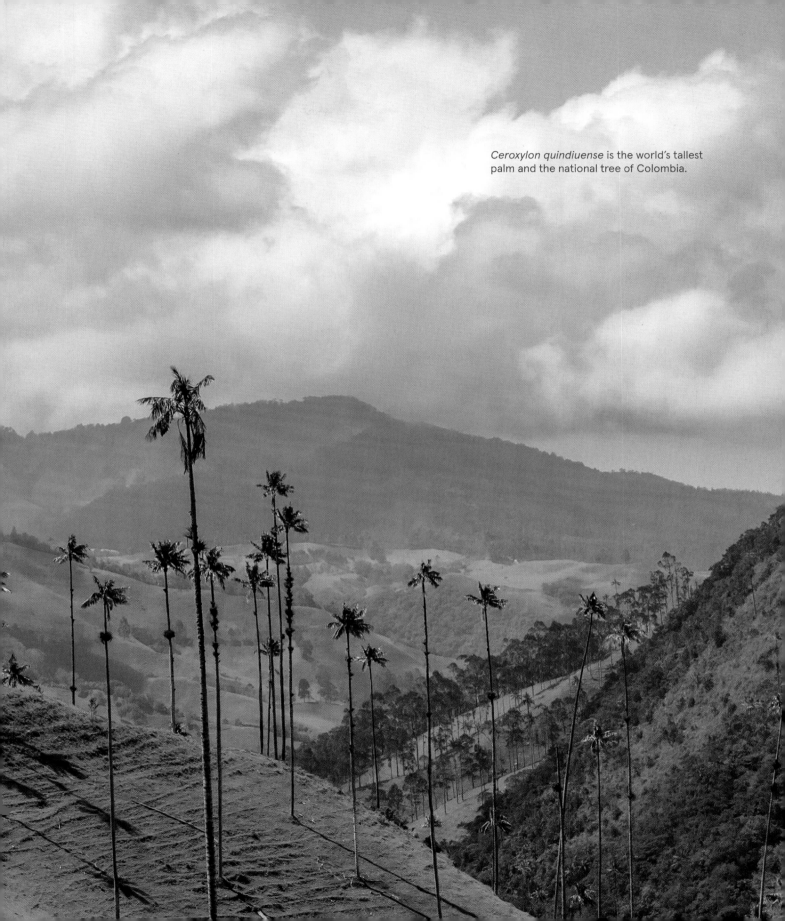

Ceroxylon quindiuense is the world's tallest palm and the national tree of Colombia.

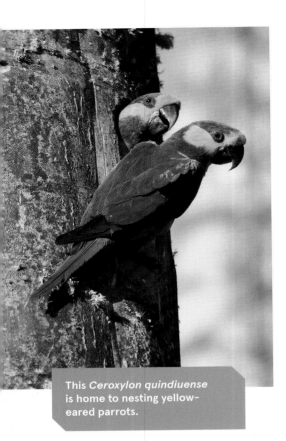

This *Ceroxylon quindiuense* is home to nesting yellow-eared parrots.

2016—but not necessarily for the wax palm, if farmers clear the forest. It is very important to protect the site before it is lost to deforestation.

Ceroxylon quindiuense is an important flagship species for biodiversity conservation in Colombia. It is the national tree and emblem of the country, protected by national law. Previously used to make fencing, beams, and walls of houses, logging of the species is now banned in Colombia. Another traditional use of this palm was extraction of wax for making candles and matches; in Colombia, this was a major activity until the middle of the 19th century. The extraction of the wax often involved felling the trees. In Peru, adult trees are still exploited for wax, which is used to make components for torches and lighting.

Another traditional use of the species was to use the leaves on Palm Sunday and throughout Holy Week—an important cultural festival. Collection of leaves was undertaken on a commercial scale, with thousands of trees felled each year, but there have been campaigns to discourage use. It was the fate of a parrot species, dependent on the iconic palm for roosting, nesting, and feeding, that stimulated action.

The yellow-eared parrot (*Ognorhynchus icterotis*) was once common across the Andes in Colombia and Ecuador. It is thought to be extinct in Ecuador, and experts were not sure it survived in Colombia until 81 birds were discovered in a remote region of the Colombian Andes in 1999. The decline of the yellow-eared parrot has been largely linked to the decline of *Ceroxylon quindiuense*. In response to the plight of these two species, Fundación ProAves (a local NGO) and Conservation International (CI) carried out a community-based conservation and research programme in Colombia. A publicity campaign, including television and radio appeals, music concerts, and a touring "parrot bus," successfully raised awareness of the problems facing the parrot and its habitat throughout Colombia. By building public support, local projects were able to implement active protection measures, such as installing nest boxes, protecting palm seedlings, and planting trees. The successful campaign brought together over 35 national NGOs, government departments, and, perhaps most importantly, the Episcopal Conference of Colombia. With the endorsement of the Catholic Church, the project was able to end the use of wax palm fronds across large parts of the country by promoting sustainable alternatives. A measure of the campaign's huge success has been the increase in the population size of the yellow-eared parrot to over 800 individuals in Colombia and its transferral from critically endangered to endangered on the IUCN Red List.

Although the recovery of *Ceroxylon quindiuense* has been less remarkable, and it now faces the further threat of an unknown disease that is affecting trees in the wild, plant conservationists are working hard to save the species. There have been genetic studies to understand the population structure and help design in situ conservation strategies. Cristina López-Galego, Co-Chair of the IUCN/SSC Colombian Plant Specialist Group, sketches out the next steps: "We need to connect with local communities and all sectors of society if we are to save Colombia's incredibly rich plant diversity. We need to use strategic and charismatic species to promote the conservation of all biodiversity, like palms, parrots, and many others. Scientific research and traditional knowledge are of fundamental importance for conservation, but so too is a love of plants and awareness of how all biodiversity is interconnected and of fundamental importance to human well-being."

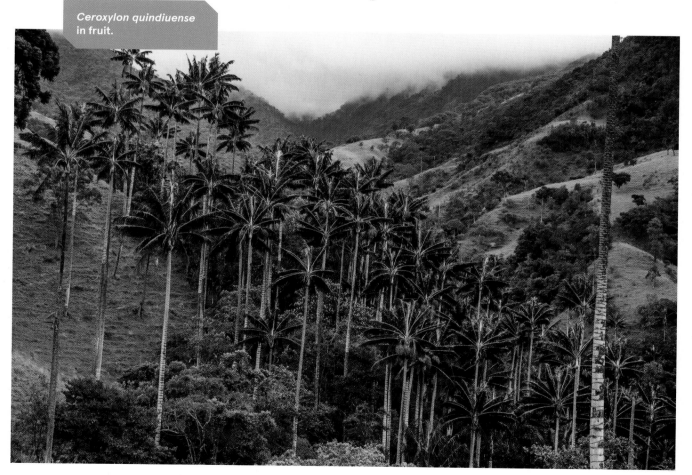

Ceroxylon quindiuense in fruit.

Coccothrinax crinita

OLD MAN PALM

Cuba is a great place to see palms: over 80 native species are known from the island's various ecosystems, and 87 percent of them are endemic. The National Botanic Garden, close to Havana, is a wonderful place to start. An FFI Global Trees Campaign grant supported seven expeditions within Cuba, to both check the conservation status of selected palms and to implement priority conservation activities for globally threatened species. Unfortunately, Cuban palm expert Raul Verdecia and his colleagues were unable to find *Roystonea stellata*, an endemic palm of eastern Cuba now believed to be extinct; they were much more successful in locating other target species, including the very beautiful and scarce *Coccothrinax crinita*.

Coccothrinax is the richest palm genus in Cuba; of 54 known species in the Caribbean region, about 40 are present in Cuba. These silver palms are generally widespread all over the mainland of Cuba and Isle of Youth (formerly Isle of Pines), growing in coastal and mountain limestone thickets, serpentine thickets, pine forests, seasonally flooded forests, savannas, and sometimes in semideciduous forests. Some are restricted to specific rock and soil types, such as limestone or serpentine soils. The type of *C. crinita* is confined to dry thickets on serpentine soil in the Artemisa province. In 2004, only 130 individuals remained in the wild; that population now stands at around 1060 plants. It is still recorded as critically endangered in the Cuban Plant Red Data Book.

Coccothrinax crinita is found at only two localities. Habitat destruction has been a major threat to this palm, with cattle grazing and burning causing the species to decline. Overexploitation has also been a threat, as elsewhere in the world the old man palm, with its distinctive fibres covering the trunk in a big "beard," is quite commonly cultivated as an ornamental.

Palms are generally of great value for rural people in Cuba. The local people of Bahía Honda use the leaves and long hanging fibres of

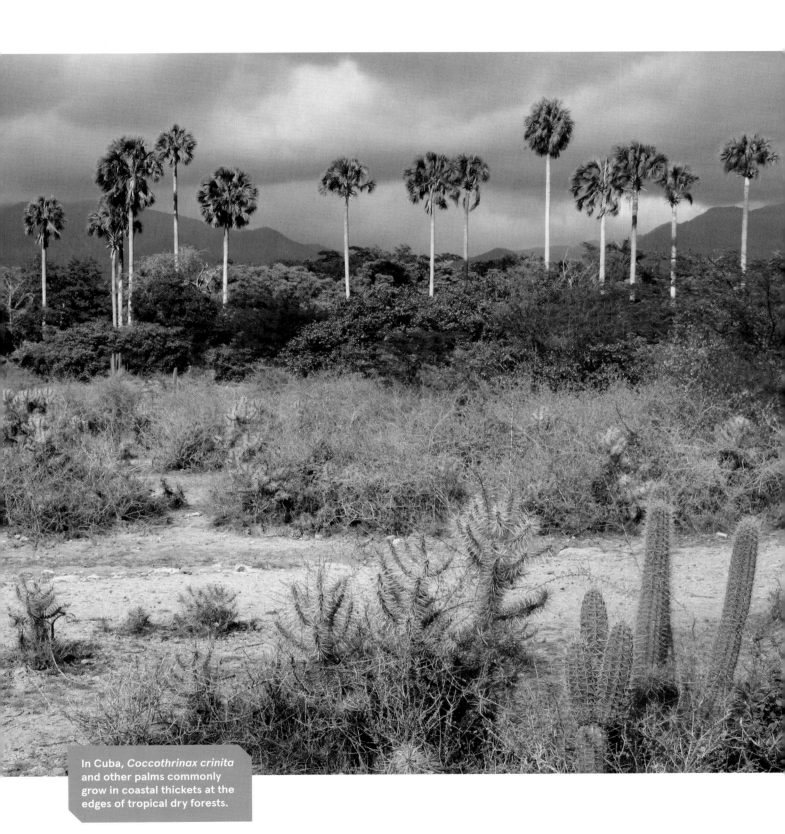

In Cuba, *Coccothrinax crinita* and other palms commonly grow in coastal thickets at the edges of tropical dry forests.

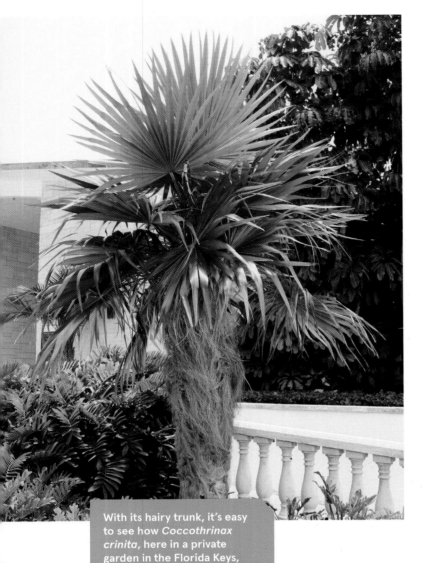

With its hairy trunk, it's easy to see how *Coccothrinax crinita*, here in a private garden in the Florida Keys, got its common name.

old man palm to make brushes, hats, and stuffing for pillows and mattresses. The trunks are used in construction of houses, and the fruits are used as animal feed. Clearly it is important to work with local communities to ensure the survival of this species in its natural habitat.

Cuba's National Botanic Garden took responsibility for the collection of seeds and propagation of *Coccothrinax crinita* for ex situ conservation and reinforcement of the palm in natural areas. Fortunately, this palm is relatively easy to grow; trees have been planted in prominent places, such as in the grounds of health centres and a recreational park in Bahía Honda. This is helping to promote awareness and a sense of pride in this locally important and globally threatened palm. The National Botanic Garden also maintains the species as a backup collection and display to inform its visitors.

Raul is working with other botanists throughout the Caribbean on a regional conservation strategy for *Coccothrinax*, a flagship genus for plant conservation in the Caribbean Island biodiversity hotspot. Thirty species in this palm genus, which has its centre of taxonomic diversity in the Caribbean islands, are threatened, and urgent attention is needed for the critically endangered species that occur in Cuba, Haiti, and the Dominican Republic. Local conservation action is necessary to protect habitats from immediate threats, such as agricultural and tourism development, oil drilling, nickel mining, salinization of soils, and uncontrolled fires. Collaborative research can help botanists understand and overcome problems specific to palms, such as low population recruitment and interspecific hybridization.

Copernicia fallaensis

YAREY MACHO

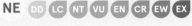

IUCN RED LIST CATEGORY

Not Evaluated

NE DD LC NT VU EN CR EW EX

NATURAL RANGE

Central Cuba

PREFERRED HABITAT

Dry thickets on serpentine soil and semideciduous forests on seasonally flooded, heavy clay soils of subcoastal plains

THREATS

Overexploitation of leaves for hats, brushes, baskets

Copernicia is the second-largest palm genus in Cuba, with 25 species, all endemic to the island. The main centre of diversity is central eastern Cuba, where these palms are particularly abundant and diverse.

Copernicia fallaensis is another critically endangered endemic palm. It is a magnificent species, its massive trunk growing to 20 metres, with a huge, rounded crown of oval leaf blades. The blue-green blades are evenly divided into about 120 stiff segments. Flowering occurs in May and June, coinciding with the first rainy season. No systematic pollination study has been made for this species, but it is thought that insects are pollinators. The fruits mature in late September and early October, coinciding with a second rainy season; they are consumed by bats, which disperse the seeds.

Originally this palm was widespread in the provinces of Camagüey and Ciego de Ávila; the best population is now found near Falla, Ciego de Ávila. Outside this area, only scattered individuals are found. The main factors in the dramatic decline of *Copernicia fallaensis* are the

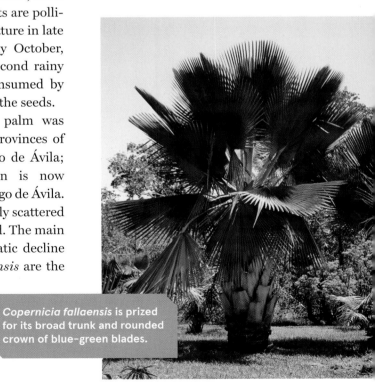

Copernicia fallaensis is prized for its broad trunk and rounded crown of blue-green blades.

unsustainable use of its leaves for thatching and to make hats and bas-kets, and the use of its fruits for raising animals. When the palm was more abundant, these traditional uses were not threats, but with habitat loss and few trees to harvest, overuse is a problem. The Global Trees Campaign expeditions visited the environs of Falla and Morón in Ciego de Ávila prov-ince and farms in nearby Coralia to count the tree in its natural secondary savanna habitat. Only 84 adult trees were found—together, fortunately, with around 187 juveniles and seedlings of the palm. Conversations with the owners of the farms and local authorities were held in order to alert them to the need for conservation actions to avoid the continuous decline of this important economic resource. Las Tunas Botanical Garden took responsibility for working on education in the community and coordinat-ing with the local authorities for conservation of this palm. Local people have helped in the collection of seeds, and an ex situ collection of 50 speci-mens was established to reinforce the natural population.

Euterpe edulis

PALMITEIRO, JUÇARA

IUCN RED LIST CATEGORY

Not Evaluated

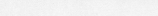

NE DD LC NT VU EN CR EW EX

NATURAL RANGE

Eastern Brazil, northeastern Argentina, Paraguay

PREFERRED HABITAT

Rainforest

THREATS

Agriculture

Rapid harvesting of palm hearts

Euterpe edulis is a widely distributed palm tree, occurring throughout the Mata Atlântica of Brazil and extending into northern Argentina and Paraguay. It is mainly a rainforest species, growing to 20 metres in height from sea level to 1000 metres; it also grows in parts of the drier Cerrado. Trees produce bee-pollinated flowers in spring followed by purple fruits, which are an important food source for parrots, toucans, and other birds and a variety of mammals, including squirrels, agoutis, and wild pigs. *Euterpe edulis* can be abundant in well-preserved areas of natural habitat, but it has been systematically exploited for the extraction of palm hearts, or palmito, throughout its range. It is one of the most important non-timber forest products in the Mata Atlântica, providing an important source of additional income for farmers. Traditionally it was Brazil's most important palm heart before overharvesting led to its decline. Extraction of the palm heart is undertaken by people who sometimes work seasonally on banana plantations; these palmiteiros, as they are known, fell mature specimens of this slow-growing species, preferably the largest ones. Subsequently the apical meristem of each tree is removed, which leads to the death of the plant. The wood of *E. edulis* is used to make fenceposts and other lightweight constructions. In some areas, all the mature palms have been exploited, leading to local extinction. Overall *E. edulis* is considered to be vulnerable in Brazil by CNC Flora, Brazil's red-listing authority for plants.

Illegal extraction of this and all palm heart trees has been a serious problem, with organised gangs invading forest land in protected areas at night to fell thousands of palm trees, extract and process the heart of palm, and move on. Local farming communities, who have traditionally gathered palm hearts, have joined local authorities to help curb the illegal trade. Exploitation of palm hearts in the Mata Atlântica was particularly intense in the 1970s, when large quantities were exported overseas. In 1990, 14 factories were legally processing palmito in Vale do Ribeira, and

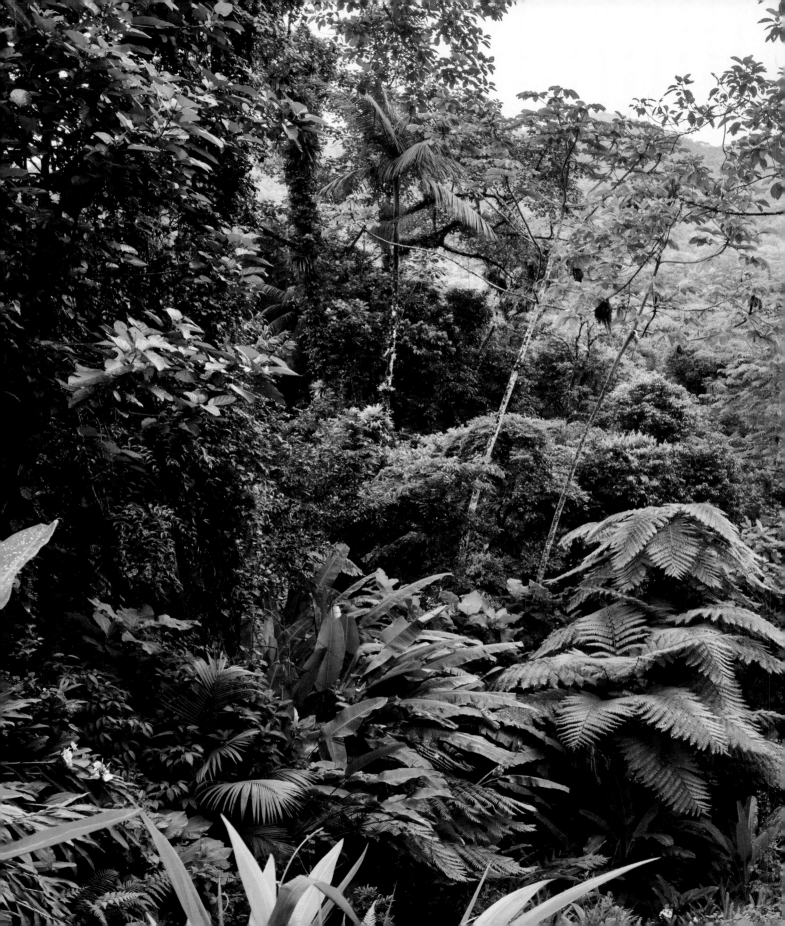

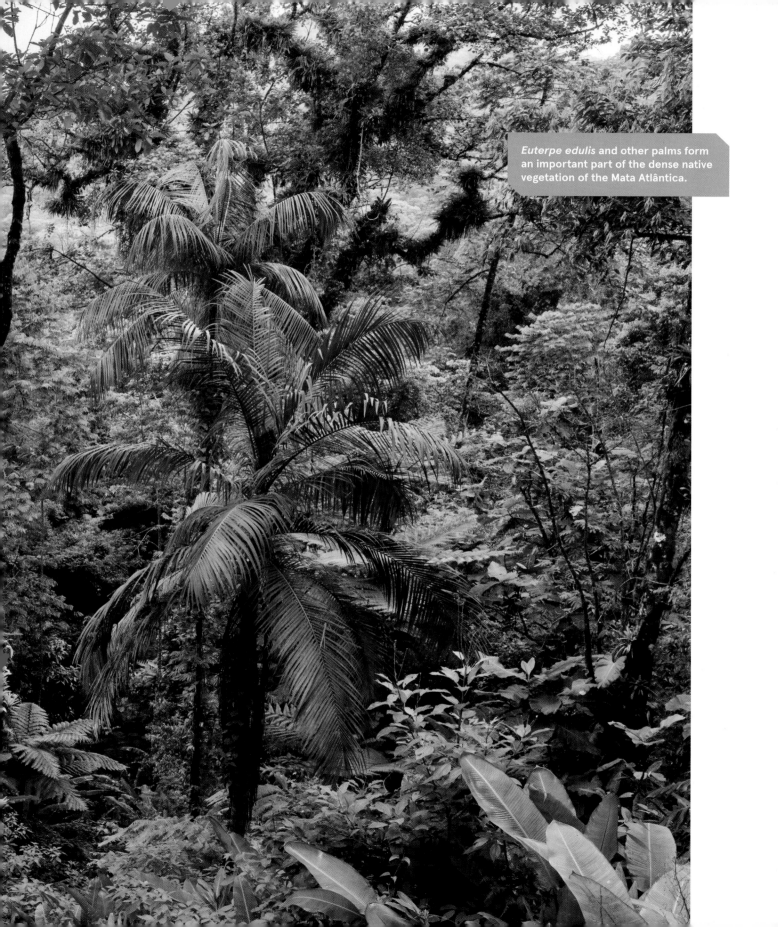

Euterpe edulis and other palms form an important part of the dense native vegetation of the Mata Atlântica.

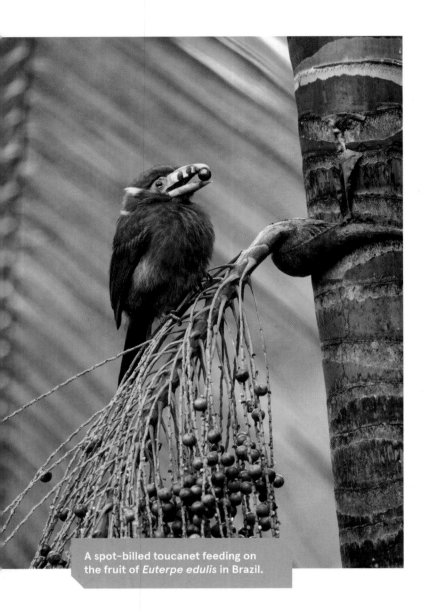

A spot-billed toucanet feeding on the fruit of *Euterpe edulis* in Brazil.

several illegal factories operated along the coast of the states of Paraná and Santa Catarina. Many informal home factories are still scattered within the region, and now the main palm heart exported from Brazil is *Euterpe oleracea* from the Amazon forest.

Fortunately researchers have found that *Euterpe edulis* can be sustainably harvested if sufficient trees are left standing in the forest to allow regeneration. Much of the Mata Atlântica is privately owned, so there is scope for landowners to gain a sustainable income from careful exploitation of *E. edulis*. Each landowner is required to submit a management plan prior to exploitation. Another promising development is the growing demand for the pulp and juice of *E. edulis* fruit; the first fruit manufacturing plant for this palm was developed in the state of Santa Catarina in 2004. Harvesting of fruits does not destroy the palm trees and has great scope for sustainability and supporting local livelihoods. Cultivation may become more popular as the economic potential of the fruit is realised.

Recovery of natural populations is also being promoted. A plan devised for Serra do Mar State Park, the largest protected area of Mata Atlântica, incorporates measures for the recovery of palm heart subpopulations and the development of sustainable management in the area.

Syagrus yungasensis

IUCN RED LIST CATEGORY

Endangered

NE DD LC NT VU **EN** CR EW EX

NATURAL RANGE

Bolivia

PREFERRED HABITAT

Humid valleys in Andean forests

THREATS

Residential and commercial development

Agriculture and aquaculture

Roads and railroads

Syagrus yungasensis is a recently described endemic palm of Bolivia. It is found only in narrow valleys and on steep slopes of the Yungas mountain ranges of La Paz in the eastern Bolivian Andes, growing at 750–1500 metres in direct sunlight, close to coca plantations installed by local communities for the extraction of coca leaf. This palm is under threat from deforestation for coca production, together with attendant road development and construction. Its fruits (known locally as coquito) are popular with children for their sweet juice.

Since 2018 GTC has been working with a local partner, Herbario Nacional de Bolivia, to conserve *Syagrus yungasensis*. In the first year, field survey work revealed new populations of the species, leading to a reevaluation of its conservation status. But, as Mónica Moraes of Herbario Nacional explains, conservation action remains urgent: "We are establishing a nursery using seeds collected from the different populations. Germination trials are being carried out at the experimental research station nursery in Chirca, and we are producing a propagation protocol." The saplings will be planted at selected reinforcement sites in the Yungas. As always, the participation of local communities is vital to both the in situ conservation and ex situ regeneration plan for the species.

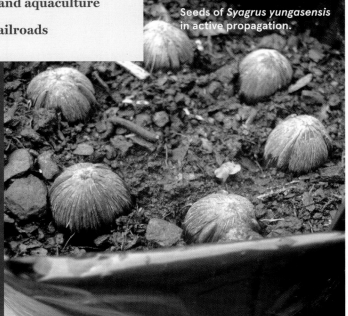

Seeds of *Syagrus yungasensis* in active propagation.

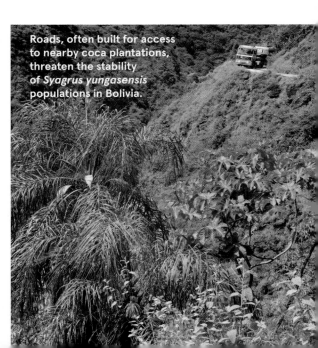

Roads, often built for access to nearby coca plantations, threaten the stability of *Syagrus yungasensis* populations in Bolivia.

PALMS IN AFRICA AND OCEANIA

Madagascar has a rich palm flora, with all but three of its 195 species endemic to the island. Most of the species are restricted to the rapidly declining rainforests found in the east of the island. The Red List of all endemic palm species in Madagascar carried out in 2010 was an excellent basis for planning conservation action. The study revealed that the number of endangered and critically endangered species had substantially increased since a 1995 evaluation, mainly due to the discovery of 28 new species, most of which are highly threatened. Rather better news was that the conservation status of most species included in both assessments remained the same, with more species moving to lower threat categories than to categories indicating a higher extinction risk. This, however, was largely atttibutable to improved knowledge of the species and their distributions, not a decrease in threats faced by Madagascar's palms. Eighty-three percent of all Madagascar's palms are under threat, and conservation action is urgently needed. Madagascar is without doubt a major priority for biodiversity conservation investment—for all trees and indeed for all the biodiversity on which local people depend.

Very little is known about the ecology or genetics of Madagascan palm species. Research to understand the basic biology of the endemic plants remains important, and the Red List helps to target species for fundamental research. What is known are the main threats affecting their chances of survival: as elsewhere in the world, palms in Madagascar are primarily threatened by the clearance of natural vegetation for agriculture, together with direct exploitation for food, timber, and fibre, and collateral damage as a result of logging. What can be done to save the endemic palms? Conservation in situ is the preferred option, and the extension of Madagascar's protected area network between 2003 and 2016, including three of the eight most important protected areas for palms, is highly beneficial; however, 28 threatened (including critically endangered) species and data-deficient species are not protected by the expanded network. And many palm species occurring in protected areas are still threatened, either because they have not had sufficient time to recover or because illegal threats persist. Logging of *Dalbergia*, *Diospyros*, and other valuable hardwoods, which increased around the same time as the expansion of the protected area network, does not respect national park boundaries and may well affect other species, including the palms. Effective management of protected areas and local community engagement

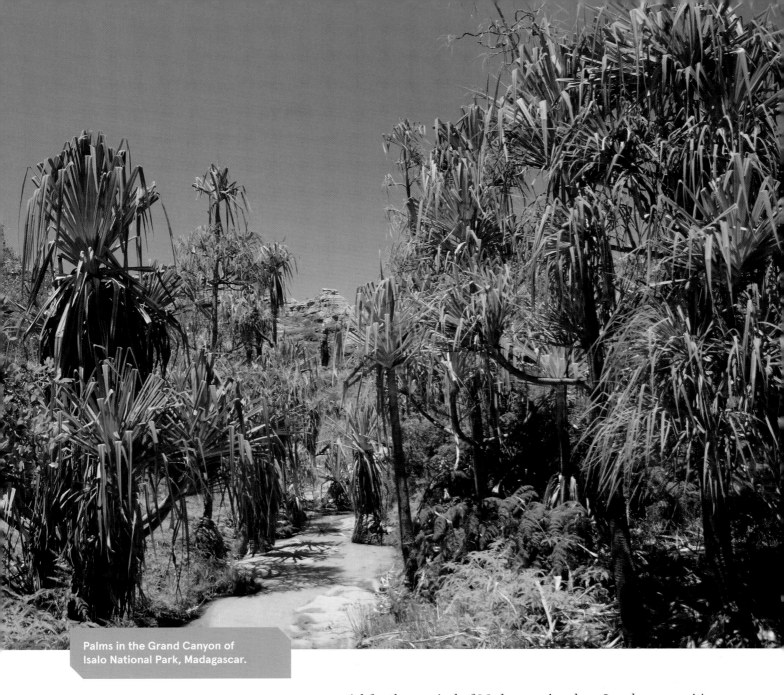

Palms in the Grand Canyon of
Isalo National Park, Madagascar.

are essential for the survival of Madagascar's palms. Local communities depend on wild resources for their general livelihoods, whether for edible palm hearts, wild yams, or orchids for trade. Conservation solutions need to involve and benefit Malagasy people. At a global scale, many international organisations are attempting to conserve Madagascar's unique and precious biodiversity—and we should support them.

Dypsis decaryi

TRIANGLE PALM

IUCN RED LIST CATEGORY

Vulnerable

NE DD LC NT **VU** EN CR EW EX

NATURAL RANGE

Southern Madagascar

PREFERRED HABITAT

Steep slopes on seasonal riverbanks

THREATS

Collection of seed for horticulture trade

Leaves harvested for thatching

Some Madagascan palm species have become very popular in cultivation around the world. *Dypsis decaryi*, with its three-ranked leaves, is one such. The genus has around 140 species, with its main centre of diversity in Madagascar. *Dypsis decaryi* is confined to a small area in southeastern Madagascar. Part of the population occurs in a 500-hectare protected site, one of three parcels of the much larger Andohahela National Park complex, a World Heritage site; the remainder falls just outside the protected area. Andohahela is managed both to conserve biodiversity, protecting 13 lemur species for example, and to support livelihoods of the local communities. It occurs within the unique transition zone between Madagascar's spiny forest with its baobabs and succulents, and the eastern rainforests. Parcel 2, where *D. decaryi* occurs, is rich in succulent *Pachypodium* and *Alluaudia* trees. The entire population of *D. decaryi* is estimated to number about 1000 mature palm trees, growing on slopes in dry forest or bush on stony volcanic soil.

Dypsis decaryi is very widely grown as an ornamental in tropical and subtropical countries, often as a pot plant, including in Madagascar itself. It is propagated by seed, which has in the past been collected from the wild population and exported in large quantities. At one stage all seed being produced by wild trees was stripped for export to supply the international horticultural trade. Fortunately, seed from plants cultivated outside Madagascar is now widely available. But the native population remains in trouble. Within its range, the leaves of the species are used for thatching, and its fruits are eaten by children. Fire and livestock grazing have been significant threats.

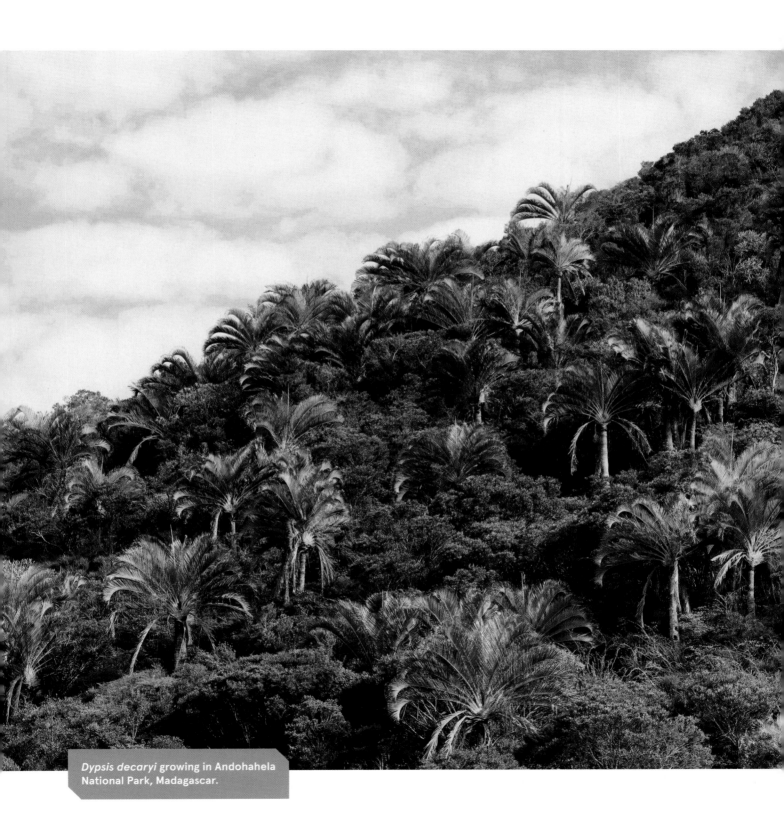

Dypsis decaryi growing in Andohahela National Park, Madagascar.

Lemurophoenix halleuxii

RED LEMUR PALM

IUCN RED LIST CATEGORY

Endangered

NE DD LC NT VU **EN** CR EW EX

NATURAL RANGE

Northern Madagascar

PREFERRED HABITAT

Steep slopes and deep valleys in lowland forest

THREATS

Habitat loss for other agriculture and logging

Collection of seed for horticulture trade

Lemurophoenix halleuxii is endemic to northeastern Madagascar, growing in the Antongil Bay area. Its new growth is reddish in coulour; its fruit is eaten by the endangered aye-aye (*Daubentonia madagascariensis*) and other lemurs. Only three sites for this species are known, with a total of about 300 mature individuals. Very little is known of *L. halleuxii* biology, including its pollination mechanisms. Survival to reproductive maturity is variable among populations, and only a small proportion of the current immature crop may reach maturity. Given the likely long time from seedling to reproductive maturity, any harvesting of this species that leads to tree death is unsustainable for the foreseeable future and could lead to extinction of the species.

Alison Shapcott, from the University of the Sunshine Coast in Australia and a member of the IUCN/SSC Palm Specialist Group, is one of the researchers who is working to conserve this species and *Voanioala gerardii*, another endangered Madagascan palm that grows in the same area. One expedition Alison undertook in 2009 involved travelling four days by truck to reach the port town of Maroantsetra. From there, a day-long trip by speedboat through rice paddies took Alison and her colleagues to their base camp in a remote part of the Masoala National Park, the largest in Madagascar. From the base camp, day-long surveys were undertaken to each of the known populations of the two palms; and, after more long trips by speedboat, further surveys in the forests of the Masoala peninsula were carried out. The researchers were assisted by botanist Jao Aridy from the Madagascan national parks authority; Jao liaised with local villagers, who knew where to find the palms. During their surveys, Alison's team encountered seed collectors claiming to be looking for these very rare palms.

Alison has since been working on the genetics of both *Lemurophoenix halleuxii* and *Voanioala gerardii* and has found that populations from the two main sites where *L. halleuxii* occurs show genetic distinctiveness;

The new leaves of *Lemurophoenix halleuxii* are reddish, and its fruit is a favourite of an endangered lemur (hence the common name).

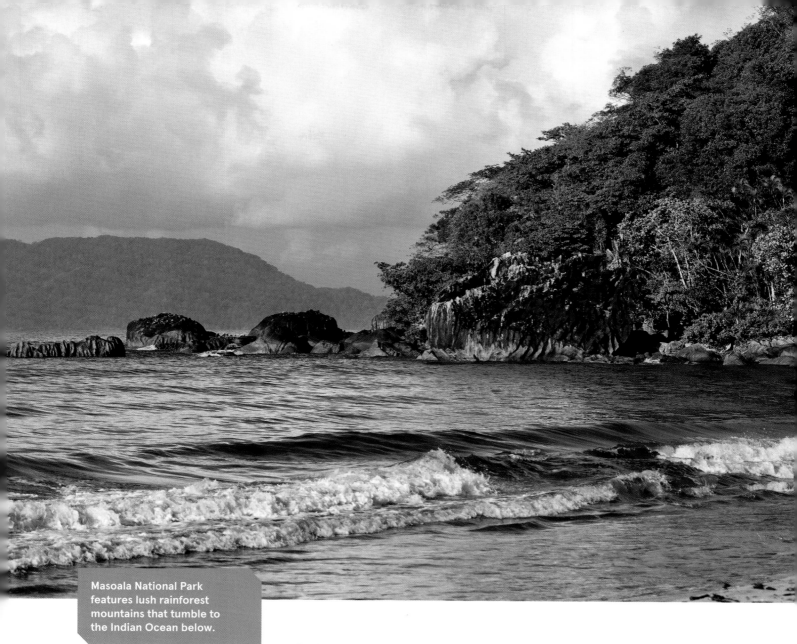

Masoala National Park features lush rainforest mountains that tumble to the Indian Ocean below.

both sites should therefore be conserved: "An active program involving local villagers and land managers in the conservation and restoration of both these species is required to prevent their extinction. Significant populations of both species are currently protected within the Masoala National Park, but park managers need support to maintain their protection. An active program is needed to change methods of seed collection, making them more sustainable and stopping the current destructive seed harvesting practices. And a reduction in demand for the seed of these species by palm enthusiasts internationally could greatly assist in reducing the pressure on wild populations of these species."

Medemia argun

ARGUN PALM

NATURAL RANGE

Southern Egypt, northern Sudan

PREFERRED HABITAT

Dry riverbeds in extreme deserts

THREATS

Commercial gold-mining activities

Trunks used for cooking fires, shelters by miners

Medemia argun is a fan palm with a mysterious past. Confined to the Nubian Desert, this critically endangered species was known only from fruits stored in the tombs of pharaohs, including Tutankhamun, until it was discovered growing in the wild in Sudan in 1837. One female tree and a small number of young plants were found in the Dungul Oasis, southern Egypt, in 1963, and it was refound in Sudan, 30 years later. Fieldwork supported by the Conservation Leadership Programme has confirmed that *M. argun* survives in desert oases at seven widely separated sites in Egypt as well as in northern Sudan. It is ecologically very important as one of the few large trees that can grow in the Nubian Desert, providing shelter and food for wildlife in the harsh desert conditions.

The frequent occurrence in ancient tombs suggests that *Medemia argun* had a much wider distribution in ancient times. Its range may have shrunk as a result of increasing aridity, with climate change likely to be an ongoing factor in its decline. Rainfall in the Nubian Desert is extremely infrequent, as little as one incidence in 10 years.

The species is still used by local Bedouins, who harvest the leaves to make mats. The mats are softer and stronger than those made from the more common doum palm (*Hyphaene thebaica*) or date palm (*Phoenix dactylifera*). The wood from this single-stemmed palm is used to build houses, and the fruits are edible. Exploitation of the few remaining trees needs to be carefully monitored to ensure that the species is not further threatened. Protection of the oases habitats is also needed to prevent damage from human disturbance, vandalism, fire, and agricultural activities.

There is hope for *Medemia argun*. Besides 10 ex situ collections around the world, a nursery to propagate the species has been established in Aswan with support from the Royal Botanic Gardens, Kew. Ideally, local pride in this historically important palm can be fostered by building on initiatives developed by Haitham Ibrahim and his team in the Conservation Leadership Programme.

Each fruit of *Medemia argun* is roughly the size of a plum.

Metroxylon vitiense

FIJI SAGO PALM, SOGA

IUCN RED LIST CATEGORY

Endangered

NE DD LC NT VU **EN** CR EW EX

NATURAL RANGE

Fiji

PREFERRED HABITAT

**Poorly drained alluvial
and coastal plains**

THREATS

**Draining coastal swamps
for agriculture**

**Clearing plains for agriculture
and vacation homes**

Palm heart trade

**Unsustainable leaf
harvest for tourism**

Metroxylon vitiense, endemic to Fiji, is one of the few wild relatives of *M. sagu*, which produces sago, a staple starch for many in Southeast Asia and the Pacific. *Metroxylon vitiense* is not a source of sago, but young trees have been felled for their delicious palm hearts, which feature in millionaire salad. In recent years, *M. vitiense* has been overharvested to provide roofing thatch for traditional-styled buildings in the tourism sector.

Metroxylon vitiense is a single-trunked monocarp, which means each palm dies after flowering at 15–25 years of age. The fruits are dispersed by

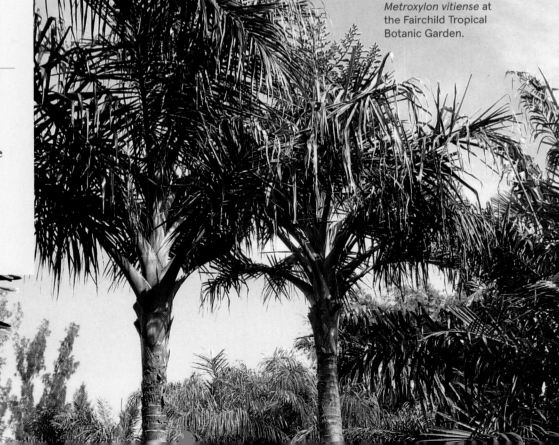

Metroxylon vitiense at the Fairchild Tropical Botanic Garden.

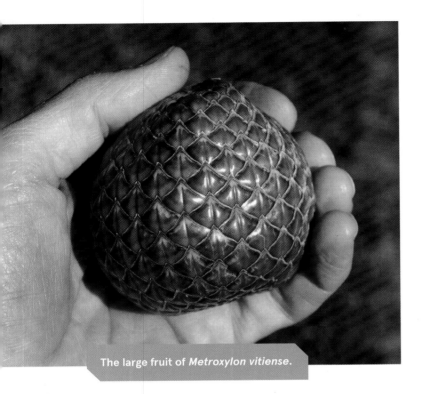

The large fruit of *Metroxylon vitiense*.

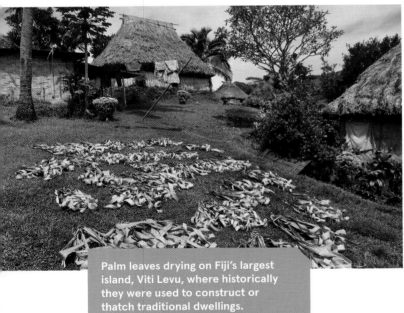

Palm leaves drying on Fiji's largest island, Viti Levu, where historically they were used to construct or thatch traditional dwellings.

the Samoan flying fox, a species of bat that is a local delicacy, and the endemic masked shining parrot. This endangered wetland palm grows in dense clusters on low-lying poorly drained plains inland of coastal swamps and sometimes along major rivers. It is now found only on the islands of Viti Levu and Ovalau. The main threat has been habitat loss, as swampy areas and coastal forests are drained for agriculture, vacation homes, and general development. One major site for the species on Viti Levu has been transformed for a golf course and resort development. The unsustainable harvest for palm hearts and thatch is adding to the pressures.

Fortunately the rapid decline of *Metroxylon vitiense* has not gone unnoticed, and steps are being taken to ensure its survival. NatureFiji, the local biodiversity NGO, is working with Savurua Botanical Gardens and other partners to ensure the species is conserved and local livelihoods are sustained. As part of a recovery plan endorsed by the Department of Environment, a degraded swamp section of the Rewa River in Naitasiri province, where the species had declined to a few isolated individuals, has been replanted with *M. vitiense*.

IUCN RED LIST CATEGORY

Critically Endangered

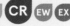

NATURAL RANGE

Northern Madagascar

PREFERRED HABITAT

Seasonally flooded low limestone hills

THREATS

Livestock farming and ranching

Increased risk of fire due to habitat transformation

Tahina spectabilis

TAHINA PALM, DIMAKA

Tahina spectabilis is a fan palm found only in a remote part of the Analalava district in northwestern Madagascar. It has attracted a lot of attention from the scientific community since it was first described in 2008: the nearest relatives of this new palm genus are in distant parts of Asia. The species was discovered by chance two years before its scientific description. Xavier Metz, the manager of a cashew plantation, found an enormous palm with leaves up to 5 metres across, growing in tsingy (an outcrop of karst) near the village of Antanamarina. The tsingy was surrounded by rice fields and grassland grazed by zebu cattle. Returning a year later, Xavier and his family discovered that one of the palms was flowering—displaying a huge pyramidal inflorescence of tiny flowers. This attracted the attention of botanists at Royal Botanic Gardens, Kew, who have been involved in studying Madagascar's palm flora for over 30 years.

Tahina spectabilis grows at the foot of limestone hills, in areas that are very arid during the dry season but flooded during the rainy season. Palm experts suspect it was once abundant in wetlands, but due to reduction of this habitat and an increase in wildfires, the species has retreated into the shadow of the limestone hills for protection. The palm flowers, spectacularly, only once in its lifetime, between the ages of 30 and 50, when it produces a large additional stem that branches into clusters of flowers. Flowering occurs in September, during Madagascar's dry season. After the fruits have matured, they are harvested by lemurs, who distribute the seeds; the "suicide palm" then dies. It is very fortunate that Xavier was able to witness a palm in flower so soon after the initial discovery and that he was able to draw international attention to this remarkable botanical find.

Mijoro Rakotoarinivo, now at the University of Antananarivo, visited the tahina site under Kew's auspices in January 2007. He took measurements and collected herbarium specimens, from which the species could be formally described and named. Kew's Millennium Seed Bank

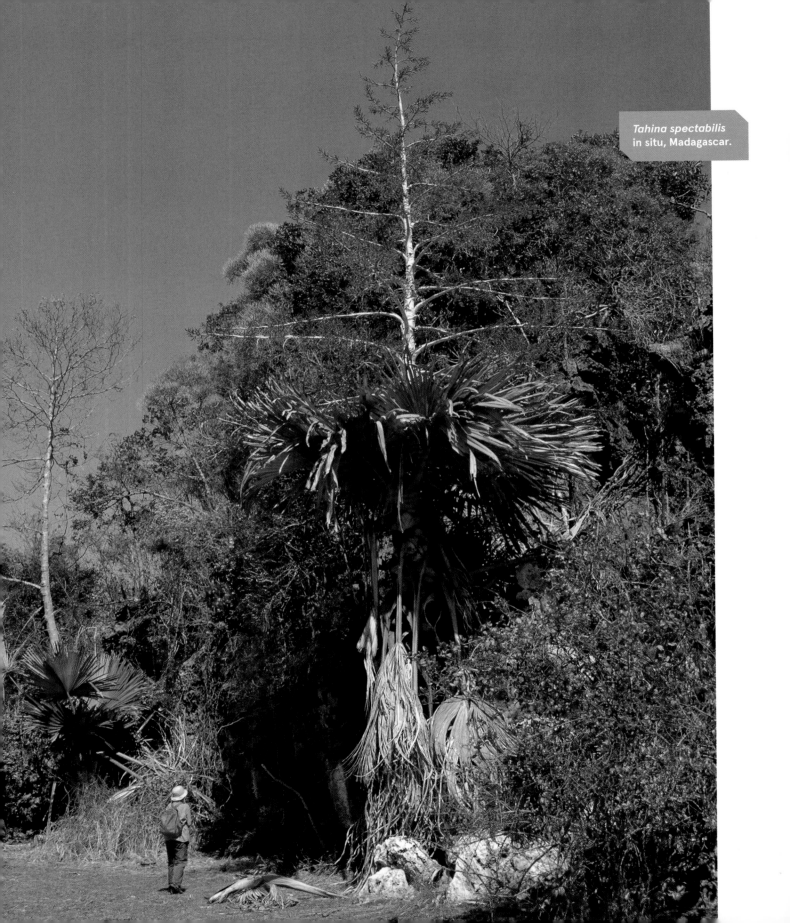

and local partner Silo National des Graines Forestières worked with the cashew plantation and the local community at Antanamarina to sell seeds collected in 2007 in a controlled way. These seeds were eagerly snapped up by the horticultural community worldwide, and as a result *Tahina spectabilis* is flourishing in 24 botanic garden collections, including Kew's magnificent palm house. Funds from the sale of the seeds went back to the local community and were used to build a new school and pump for the village well, as well as to create a firebreak around the vulnerable tsingy habitat.

In September 2008, Alison Shapcott visited the original site and undertook a full population survey, documenting 29 individuals of *Tahina spectabilis*. She collected DNA samples so that the population genetics and diversity of the plants could be studied. Work by Alison and one of her students, Heather James, subsequently showed that the genetic diversity of the individuals at the site was extremely low. Intriguingly results of the genetic analysis predicted that other populations might exist. Kew scientists and Madagascan experts returned in 2016. Another site for *T. spectabilis* was discovered approximately 1.5 km away from the first location, and during the same expedition, another much more significant population was found, toward the village of Amparahibe. Lauren Gardiner describes the excitement of the discovery:

> We were taken by villagers to see a couple of individual stunted palms on the surrounding hillsides, but it was difficult to tell if they were actually tahina. We saw that the hillsides had been burnt relatively recently and that the plants had been damaged by machete, likely in an attempt to remove the edible palm hearts. Our hopes plummeted, but the next day we were taken to see a remarkable 12-metre-tall adult *Tahina spectabilis* in a remnant patch of forest, unmistakeable and with a small grove of young tahina plants and seedlings below. The large tahina towered over everything else—including us—and my heart soared! We counted 27 individuals.

The villagers also told of foreigners visiting the area and specifically asking for, and buying, plants collected from the forest—and how they would collect plants from the wild and take them to the roadside nurseries to sell.

Xantolis tomentosa (woolly ironwood), growing in Thailand.

Sapotaceae

The Sapotaceae (sapota or miracle berry family) contains plants ranging from tall rainforest canopy trees to gnarled and spiny shrubs in semi-arid regions. Peter Wilkie, of RBG Edinburgh, is one of the leading researchers of Sapotaceae. Peter has spent many hours in the field and in tropical herbaria getting to grips with this complex botanical family and supporting a wide range of conservation efforts; he has provided the following account of the Sapotaceae.

Composed of around 60 genera and 1300 species, the Sapotaceae is an impressive component of many rainforests around the world, providing a range of timbers, edible fruits, latex, and oils used in cosmetics. Centres of diversity for this ecologically and economically important family are the lowland and lower montane forests of the Congo basin, the Amazon basin, and the Malesian region (Brunei, Indonesia, Malaysia, New Guinea, the Philippines, Singapore, Timor-Leste). In terms of endemism, Brazil and the islands of New Caledonia and Madagascar have the highest levels and are by far the most important, with 218, 121, and 87 species, respectively.

Of course, in order to prioritise conservation actions, we need to identify which species of Sapotaceae are under most threat. To date, 887 Sapotaceae species have an IUCN Red List assessment. Five species are currently recorded as extinct, 87 as critically endangered, and 166 as endangered, with the main threats being habitat destruction and encroachment.

If one story sums up the need for more research and action on the conservation of Sapotaceae, it is that of *Madhuca klackenbergii*. This species was first collected from secondary forest in northeastern Thailand by botanist Tem Smitinand, of the Royal Forest Department of Thailand, on 16 November 1966; however, it was only described as new to science 32 years later, by botanist Pranom Chantaranothai. A group of researchers from the Forest Herbarium Bangkok and RBG Edinburgh visited the only known locality to collect material of this species for further research in

2014. They were met by a large rubber plantation, and in searching the surrounding area, they found no trace of this species. It must therefore be presumed lost, joining the growing list of extinct Sapotaceae species. Clearly, if we are to stop other species suffering the same fate, we have to redouble collection efforts and increase taxonomic capacity; only with a suitable foundation can we make threat assessments confidently.

The most species-rich genera in the Malesian region are *Madhuca* and *Palaquium*, each with more than 100 species; in the neotropics *Pouteria* is the most species-diverse, with about 190 species. As with many other plant groups, Africa has a large number of genera, but species numbers within them are relatively low. *Mimusops* is the most species-rich (42 species), followed by *Manilkara* (37) and *Synsepalum* (36).

Taxonomically, the family is a difficult group. Genera are often defined by a combination of characters rather than a single defining character, and many species are difficult, if not impossible, to place to a genus when sterile (without fruit or flower). Molecular sequence data have helped better illuminate genus and species relationships and limits; however, much more herbarium-based taxonomic study and molecular sequencing data is needed before this enigmatic group is fully understood and confident threat assessments can be made for all the species. As with most other large families, the Sapotaceae is morphologically diverse; however, many of the trees have spirally arranged leaves that cluster at the ends of branches and have a distinctive golden to brown hairy undersurface, which helps us to locate them when walking through the rainforest. The slightly scented, often white, flowers are usually in simple unstructured clusters, although the genus *Sarcosperma*, which was once considered to be a separate but closely related family, has its flowers sitting on obvious stalks.

Like dipterocarps, Sapotaceae species can flower infrequently, often producing flowers only once or twice a decade. Many have the peculiar habit of remaining in bud for several months, during which time the style continues to grow, eventually protruding through the unopened folds of the petals. A useful feature of several large tree species, which can help locate them in the dense forest, is that the ring of petals often falls off, forming a dense mat on the forest floor, alerting the botanist to the flowering happening 50 metres up in the canopy.

The fruits are usually berries or drupes and can be leathery or fleshy. Together with the presence of distinctive white latex from cut bark, twigs, and sometimes leaves, a persistent calyx and style in the fruit is a good combination of characters to place any specimen in the Sapotaceae. The number of calyx whorls and lobes can help place a

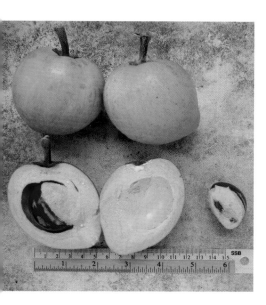

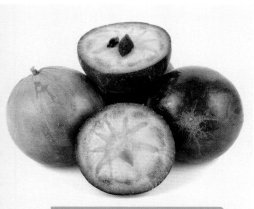

The fruits of *Pouteria campechiana* (top), grown in a temple yard in Thailand, and *Chrysophyllum cainito* (above), beloved in Central and South America, are economically important to local populations but rarely marketed internationally.

specimen to a genus. All Sapotaceae have distinctive seed scars, and if you come across these on the ground it will alert you to the fact that a Sapotaceae tree is nearby.

USES

Although uncommon in European shops, the delicious fruits produced by many species of Sapotaceae are easily found in markets across the tropics. Most species are native to Central and South America, but many are now cultivated across Asia and other tropical regions. Some are economically important, but they tend not to be traded internationally. The edible fruit of *Chrysophyllum cainito* (star apple) is also widely cultivated throughout Central and South America but probably originated in the West Indies. The fleshy fruits have a distinctive shiny purple coat, often greenish toward the base, and produce a sweet, juicy purple-white pulp. Although *Pouteria campechiana* (canistel, sawo belanda) originates in southern Mexico, it is commonly cultivated and sold in the markets of Indonesia and Thailand. The bright orange fruits produce a pulp with the consistency of the yolk of a hardboiled egg, which some say is an acquired taste but is nonetheless very popular.

Sapotaceae produce good-quality timber that is used locally for light construction and furniture production and traded internationally as plywood and timber. As such, legal and illegal logging poses a major threat to many species in the family. A major difficulty in assessing the threat of logging and trade to specific species is that timber is often sold under a trade name that can cover a multitude of different species.

Although no Sapotaceae species are yet listed in CITES, many species are traded internationally for their timber, latex, and fruits. As the forests in which many of these species occur are logged, degraded, or converted into plantations, the threat of international trade to the survival of many of these species will no doubt increase.

In Latin America, *Manilkara* is the most prized timber genus. The large imposing trees of *M. bidentata* growing in the forests of South and Central America produce an attractive and durable red-brown timber (traded as massaranduba and bulletwood; often together with *M. huberi*) that is used in heavy construction, decking, and flooring; however, this species has traditionally been most famous for its valuable latex, balata. The timber of *Chrysophyllum cainito*, which also produces an economically

important fruit, is traded as caimito and caimitillo. Other genera producing less-used commercial timber are *Pouteria* (traded as coquino), *Micropholis* (traded as curupixa), and *Pradosia* (traded as casca doce).

In the Malesian region, Sapotaceae timber was formerly traded as an inferior meranti (Dipterocarpaceae timber), but it is now recognised as a class-one timber in Indonesia and traded separately. Within the region, the attractive medium-grained light- to medium-weight timber produced by some *Palaquium*, *Payena*, and *Madhuca* species is commonly traded as nyatoh (padang in UK) and used in light construction and decorative work. Less valuable heavy-timber-producing species (e.g., *M. betis*, *M. utilis*, *Palaquium ridleyi*, and *P. stellatum*), traded as bitis, are generally used in heavy construction.

An early 20th-century poster advertising the strength of balata from *Manilkara bidentata*.

There is clear international demand for the timbers of Sapotaceae, and the Forest Stewardship Council has issued certificates for 18 genera in the family across many different parts of the world and for a wide range of different uses.

Historically, the most important product from the family was its latex, with different species producing latex with different properties and thus different uses. Gutta-percha, the product of *Palaquium gutta* (a species native to Malaysia and Indonesia), is regarded as one of the original natural plastics, and when it first came to the attention of Europeans around 1844, it excited and inspired a generation of Victorian entrepreneurs in equal measure. It is easily moulded when heated and keeps its shape when cooled. Within a few years, a plethora of new gutta-percha products was for sale, including bottles, boots, surgical instruments, and jewellery, to name a few; however, it is gutta-percha's electrical insulation qualities used to insulate deep sea telegraph cables (and allowing the Victorian communication revolution to take place) for which it will be best remembered. But this came at a cost. The latex from *P. gutta* cannot be tapped and was initially harvested by "slaughter tapping," in which the tree was felled to remove the latex. It has been estimated that to meet demand 88 million trees in Asia were felled. This led John Hutton Balfour, the Regius Keeper of RBG Edinburgh, in 1858 to talk even then about "the probable exhaustion of gutta-percha in the countries from which it is now supplied." Today the latex is in less demand but is still used for root canal work in orthodontics; it is now obtained from the sustainable harvesting of the leaves rather than the bark.

Unlike gutta-percha, balata, the more-elastic latex produced by the South and Central America tree *Manilkara bidentata*, can be tapped, and the combination of its elasticity with its ability to be easily moulded made it ideal to be woven with fabric to produce strong and practically stretchless machine belts. These were superior to the expensive leather belts used in most machines at the turn of the 20th century and became a worldwide success.

Manilkara zapota

SAPODILLA

IUCN RED LIST CATEGORY

Least Concern

 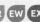 NE DD **LC** NT VU EN CR EW EX

NATURAL RANGE

Belize, Guatemala, Mexico

PREFERRED HABITAT

Subtropical to tropical moist lowland

THREATS

General deforestation and overexploitation

Hurricanes and consequent fires

The latex known as chicle, believed to have been used as a chewing gum by the ancient Maya people, is produced from sapodilla or chicle trees (*Manilkara zapota, M. chicle, M. bidentata, M. staminodella*) of South and Central America. It is easily tapped. Demand for this gum increased significantly during Prohibition in the US, and at its peak in the 1950s, around 10,000 tonnes of chicle was tapped each year. Nowadays chewing gum is largely derived from synthetic materials, but many older trees in the forests still bear the herringbone slash marks of past tapping. A modest demand for organic natural chewing gum continues today, and this provides an important source of income for the chicleros (forest tappers) of the Yucatán in Mexico and Belize.

Manilkara zapota is often grown in home gardens to provide a modest source of seasonal income to local people. It has been cultivated for its fruit throughout Central America and the West Indies for centuries. The rough, pale brown fruits, about 8 centimetres in diameter, have a very sweet fleshy pulp with a malty flavour; they are sold in great quantities, in-country, when in season.

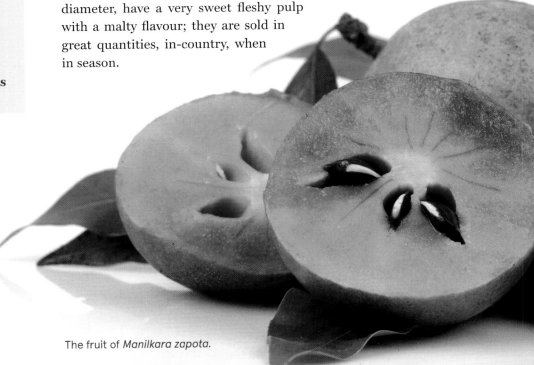

The fruit of *Manilkara zapota*.

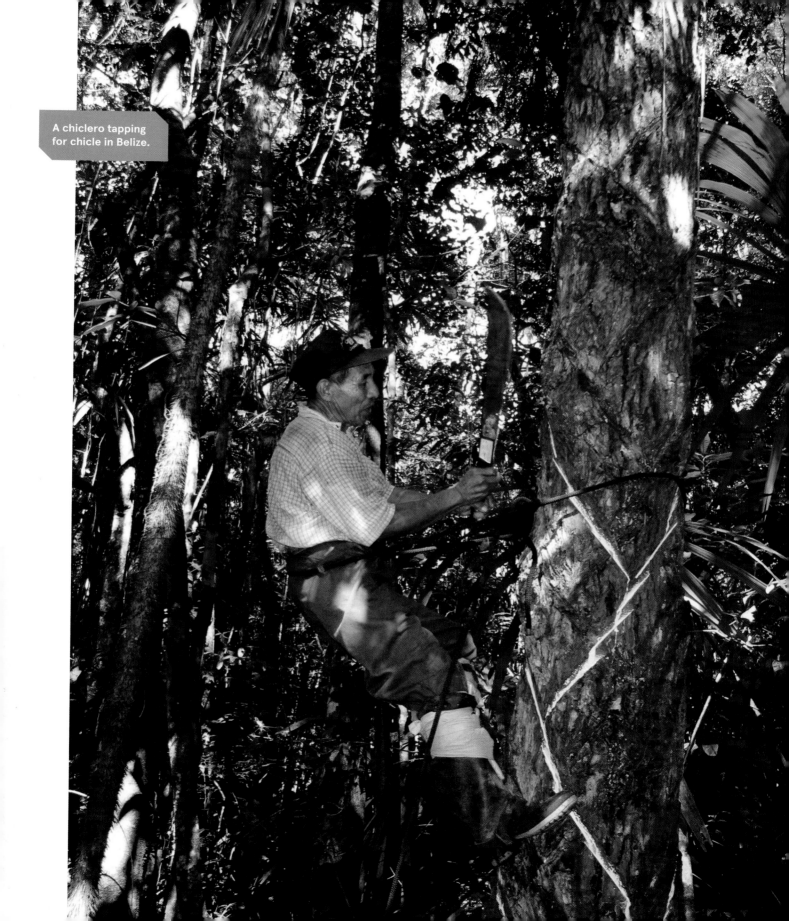

A chiclero tapping for chicle in Belize.

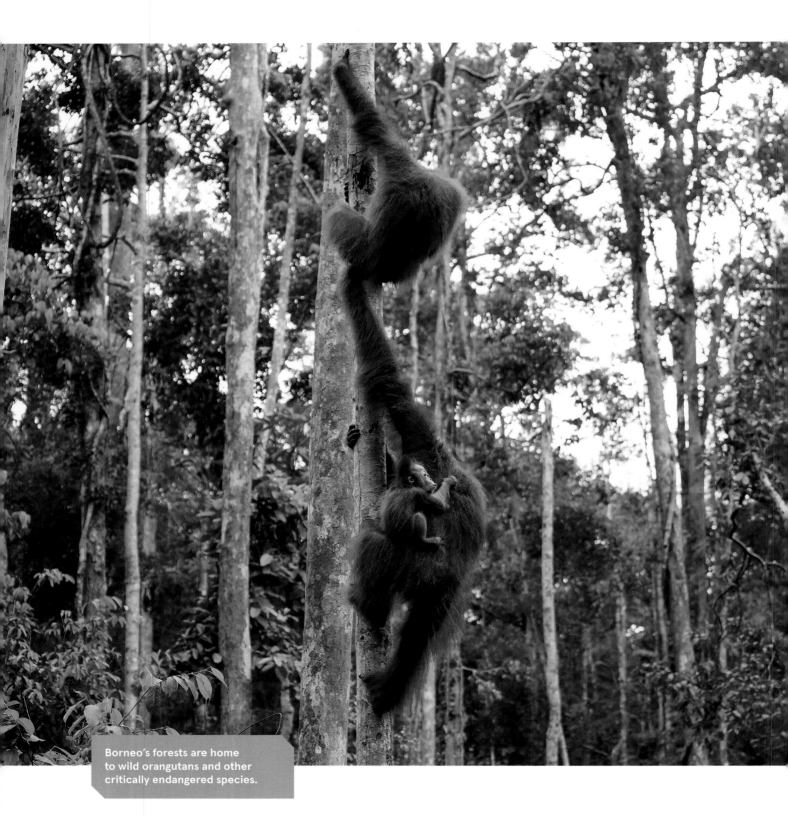

Borneo's forests are home to wild orangutans and other critically endangered species.

SAPOTACEAE IN BRAZIL

Brazil, with the greatest number of Sapotaceae species, is a megadiverse country covering some 8.5 million km² but, with a population of over 200 million, much of its natural vegetation is under threat. It has 11 genera and over 200 species of Sapotaceae, of which 104 are endemic. The majority of species can be found in the moist Mata Atlântica (76 species), but several can also be found in the drier Cerrado (31 species) and desert Caatinga vegetation (14 species).

Two critically endangered South American sapotaces, *Pouteria bapeba* and *P. butyrocarpa*, are found in the Mata Atlântica, which has been intensely degraded, experiencing a staggering 80 percent reduction over the past 30 years largely due to the establishment of eucalyptus plantations. There is still hope for even *Chrysophyllum januariense*, which was recorded as extinct in 1998 but following further investigations was found, not in its original locality but in degraded Restinga vegetation nearby; it has been reassessed as vulnerable. This happy development supports comments made by Rogério Gribel, Director of Scientific Research at the Rio de Janeiro Botanical Garden, who believes we are just beginning "a dynamic and continuous process, monitoring the preservation status of Brazilian flora."

SAPOTACEAE IN INDONESIA

Indonesia is another megabiodiverse country, with about 15 percent of the total flora of the world and 40–50 percent endemism. It is also one of the most species-rich countries in terms of Sapotaceae, with an estimated 15 genera and 158 species spread across its magnificent archipelago. Sadly, it also has one of the highest deforestation rates in Southeast Asia, with forest cover declining by about 1 percent every year since the turn of the millennium. Government conservation policy has formalised in situ conservation areas in Indonesia to legally protect native and rare species and, to date, about 49 percent of the total 131 million hectares of Indonesian forest has been protected as national parks, nature reserves, and protected forests.

In 2011 an exciting initiative saw the introduction and support of regional botanic gardens in each of Indonesia's 47 ecoregions. Although

many new gardens are still in development, this initiative is very important for ex situ conservation of Indonesian flora: it is accelerating the cultivation of threatened species, including Sapotaceae, from across the archipelago. Prima Hutabarat, a researcher from the Center for Plant Conservation, Bogor Botanic Gardens, has been collating data on Sapotaceae species growing in botanic gardens across Indonesia since 2012. In that time, 10 species have been brought into cultivation at Balikpapan Botanic Gardens from the forests of East Kalimantan, and 13 species from the surrounding forests of South Sulawesi have been introduced at Enrekang Botanic Gardens.

Bogor Botanic Gardens, established in 1817, is the oldest and most important botanic garden in Indonesia. It currently holds 12 genera and 41 species of Sapotaceae, 29 of them native to Indonesia; this represents just under 20 percent of Sapotaceae species currently recorded from Indonesia. Of these species, only three have had a global threat assessment made, and one, *Madhuca boerlageana*, is critically endangered. The garden has many fine Sapotaceae tree specimens and has also hosted many historically important trees. One such, thought to be the parent of the *Palaquium gutta* trees planted in the Cipetir (Tjipetir) plantation in Java established to produce gutta-percha, is unfortunately now dead. Many heritage trees in the garden are in good condition; however, the *Mimusops elengi* var. *parvifolia*, planted in 1823, now leans and is in need of support, and the trunk of the *P. ottolanderi*, more than a century and a half old, has signs of decay.

SAPOTACEAE IN NEW CALEDONIA

The Southwest Pacific island archipelago of New Caledonia has a mosaic of soil types, a third of which are ultramafic (high in nickel, magnesium, and iron; low in silica), and this supports a high number of endemic species. The main threats to species are deliberately set fires, deforestation, and mining activities for nickel, chrome, and cobalt extraction.

The Sapotaceae of New Caledonia has been the focus of extensive systematic research by Ulf Swenson of the Swedish Museum of Natural History and Jérôme Munzinger of the Institute of Research for Development, Marseille, France, and their work has brought clarity to generic and species limits. To date, six genera (*Manilkara*, *Mimusops*, *Pichonia*, *Planchonella*, *Pleioluma*, and *Pycnandra*) and 124 species have been recorded from the islands, 121 of which are endemic; however, these

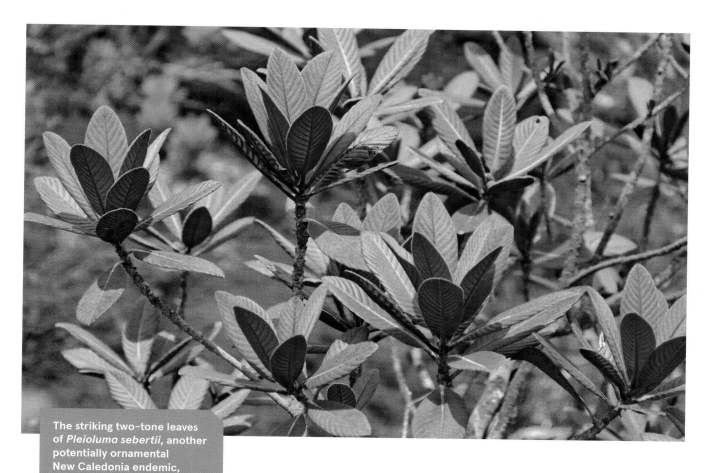

The striking two-tone leaves of *Pleioluma sebertii*, another potentially ornamental New Caledonia endemic, restricted to Grande Terre.

numbers are set to increase, as many species are as yet undescribed due to lack of fertile material.

Pycnandra is the largest endemic genus in New Caledonia. Most of the 59 species of trees and shrubs are restricted to the largest island, Grande Terre; they grow in a variety of vegetation types and have clear substrate preferences (ultramafic, non-ultramafic, calcareous). One species, *P. micrantha*, is provisionally assessed as extinct; so was *P. longiflora*—until, with great excitement, amateur botanist Rosa Scopetra sent images to researchers of the species growing in the wild. Following extensive fieldwork, a population of 167 individuals was found growing on hypermagnesium soils near a mining site, just off the main road of Grande Terre. This species, perhaps the most attractive in the genus, has large red and yellow flowers. It is wonderful news that it has been found once again, as it has a very restricted distribution, and fire, forest clearance, or road enlargement could destroy the entire population; it is now

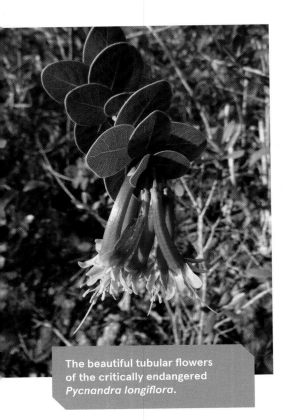

The beautiful tubular flowers of the critically endangered *Pycnandra longiflora*.

assessed as critically endangered along with another 11 New Caledonian species. *Pycnandra versicolor* is in particular need of urgent conservation management as its entire distribution is inside an active mine on the Koniambo massif, and *P. poindimiensis* and *P. comptonioides* are known only from a single unprotected location and in danger from fire and grazing by introduced rusa deer.

Pleioluma, a genus of medium-sized trees and shrubs, has 17 endemic species in New Caledonia. Five species have a preliminary IUCN status of critically endangered; all are located within mining concessions and in need of protection. The attractive *P. belepensis*, a micro-endemic species confined to the northern plateau on Ile Art, has great potential as an ornamental; however, Ulf and Jérôme report that a 2016 fire destroyed 20 percent of the vegetation in which it was found. It is a reminder of how vulnerable many species are to extinction in New Caledonia and the urgent need for conservation management by mining companies.

SAPOTACEAE IN AFRICA

In East Africa, the creamy white timbers of *Chrysophyllum* and *Pouteria* species (traded as aniégré or aningeria) are commonly used as sawn wood and veneer; the yellow-brown timber of *C. africanum* is traded as longhi. The majestic *Tieghemella africana*, a towering presence in the rainforests of tropical West Africa, produces an attractive red-brown timber suitable for veneers and plywood; it is traded as douka, but production is relatively small due to limited supply from natural stands. This species is endangered by ecosystem conversion and logging; an updated Red List assessment is needed. According to the Plant Resources of Tropical Africa, *T. africana* is often traded as cherry mahogany with *T. heckelii* (makore; also endangered), with no distinction being made between the two species.

The thirst-quenching fruit of the South African *Englerophytum magalismontanum* (stemfruit, stamvrug) is also popular; it is not only good to eat but is ideal for making syrup, jam, and mampoer (an alcoholic drink). *Synsepalum dulcificum* (miracle berry) is cultivated for its edible fruit's "miraculous" properties. These bright red fruits contain high levels of the glycoprotein miraculin, which changes how we perceive tastes and makes sour foods taste sweet. Miracle berry has been used in western Africa, where it originates, for centuries and is now marketed internationally as a food sweetener.

Did you know?

Tieghemella heckelii, itself threatened by logging, is an important food source for forest elephants in central Africa.

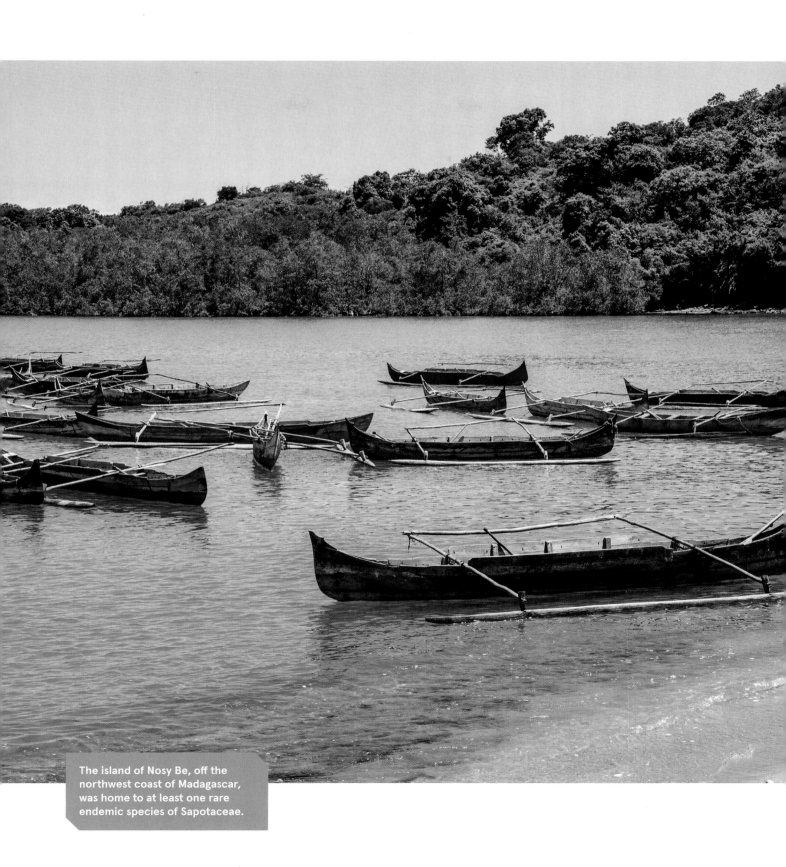

The island of Nosy Be, off the northwest coast of Madagascar, was home to at least one rare endemic species of Sapotaceae.

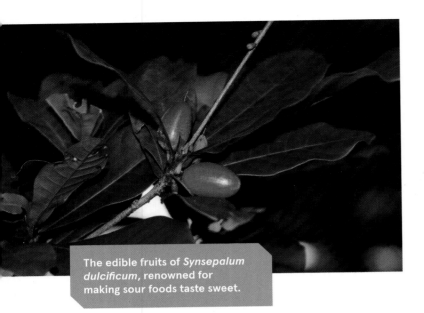

The edible fruits of *Synsepalum dulcificum*, renowned for making sour foods taste sweet.

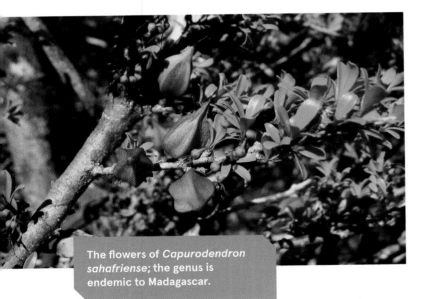

The flowers of *Capurodendron sahafriense*; the genus is endemic to Madagascar.

Madagascar is a biodiversity hotspot—and 87 of the 92 Sapotaceae species so far described there are endemic to the island. Laurent Gautier and Yamama Naciri, curators at the Conservatoire et Jardin Botaniques de la Ville de Genève, are trying to clarify the taxonomy of this difficult family using molecular next-generation sequencing. At present, 11 of its genera (*Bemangidia, Capurodendron, Donella, Faucherea, Gambeya, Labourdonnaisia, Labramia, Manilkara, Mimusops, Sideroxylon,* and *Tsebona*) occur in Madagascar. Of these, four (*Bemangidia, Capurodendron, Faucherea, Tsebona*) are strict Malagasy endemics, and *Labourdonnaisia* and *Labramia* are endemic to islands in the western Indian Ocean. *Capurodendron* is one of the three most-species-rich endemic genera in Madagascar, with 26 described species and at least 10 more to be described.

On Madagascar, Sapotaceae species are generally composed of tall hardwood trees (referred to locally as nato or nanto). These play an important part in the composition and structure of the Malagasy primary forests from evergreen to deciduous rainforests, the family being one of the most important groups in forest inventories. Its trees provide high-quality timber for construction, and their bark, fruit, and latex are used by local people.

The IUCN Red List has assessed 73 percent of Madagascar's described species of Sapotaceae as threatened. Among those assessed as critically endangered are *Bemangidia lowryi* and *Mimusops nossibeensis*. The former is restricted to the *Bemangidia* forest and is under threat from slash-and-burn farming and timber harvesting—despite being recorded from a protected area. The only known collection of the latter, from the island of Nosy Be, was made over 165 years ago in an unprotected area that is now totally deforested. In a 2018 paper, Laurent and Yamama described three new species of the endemic genus *Capurodendron*; all three have since been assessed as critically endangered—a reminder that species are more than likely going extinct before they have been studied and described.

Sideroxylon spinosum

ARGAN TREE

IUCN RED LIST CATEGORY

Vulnerable

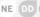

NE DD LC NT **VU** EN CR EW EX

NATURAL RANGE

Southwestern Morocco

PREFERRED HABITAT

Mountainous areas to plains in warm climates

THREATS

Overgrazing

Wood removal

Urban and agricultural expansion

Increased aridity

Sideroxylon spinosum, endemic to the semi-desert areas of southwestern Morocco, is one of the most economically important plants in Africa: valuable argan oil derives from its seed, though it takes an argan tree over 50 years to develop fruit that are ready to be harvested for that purpose. The oil, produced largely by Berber women's cooperatives, is used in cosmetics and as a culinary oil around the world. It supports the livelihoods of over 2 million people; however, many locals are not fully benefiting from the argan oil market due to market barriers and tenure insecurity. This spiny species is also ecologically valuable: its deep roots help stabilize the soil and provide a defence against the encroaching deserts. The Arganeraie Biosphere Reserve, in which it is found, was designated a UNESCO World Heritage site in 1998; however, the area has been reduced by half over the past century from grazing, cultivation, and charcoal making. Increased wealth from the argan oil industry has led to the purchase of more goats and increased grazing of the delicate surrounding habitat, and overharvesting is threatening natural forest regeneration.

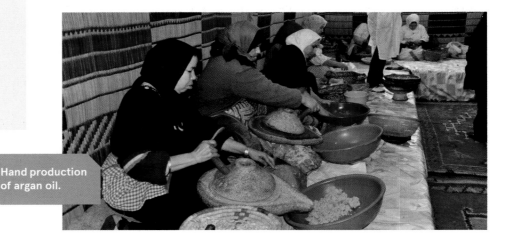

Hand production of argan oil.

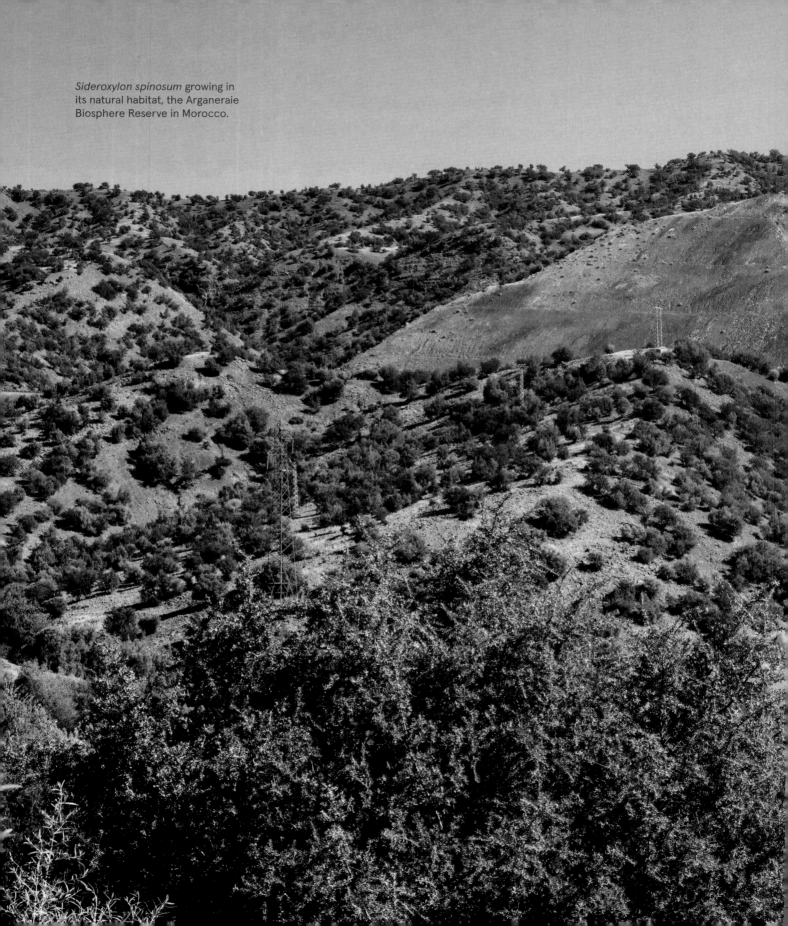

Sideroxylon spinosum growing in its natural habitat, the Arganeraie Biosphere Reserve in Morocco.

Vitellaria paradoxa

SHEA TREE, KARITE TREE

IUCN RED LIST CATEGORY

Vulnerable

NATURAL RANGE

Cameroon, RC Congo, Burkina Faso, Côte d'Ivoire, Ghana, Guinea, Nigeria, Senegal, South Sudan, Sudan, Uganda

PREFERRED HABITAT

Dry savannas and woodlands

THREATS

Exploitation for timber, firewood, charcoal

Increasing population pressure

Another valuable product from the Sapotaceae widely used in skin cosmetics and hair products is shea butter, produced from the seeds of *Vitellaria paradoxa*. Traditionally, shea butter was used throughout western Africa as a cooking fat and rubbed on skin to reduce swelling. The tree is distributed from tropical western Africa to Uganda; it was first brought to the attention of Europeans in 1795, by Scottish explorer Mungo Park, who was exploring Senegal. In the dry savannas of Sudan, the tree has been protected by farmers for centuries, and when fields have been cleared, this has given rise to so-called *Vitellaria* parkland, in which about 40 percent of the trees are the shea tree. Natural regeneration and sustainability of seed production are threatened by increased agricultural activity in the region.

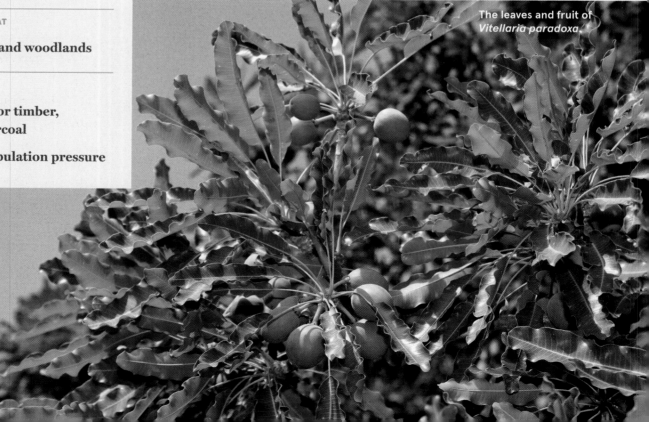

The leaves and fruit of *Vitellaria paradoxa*.

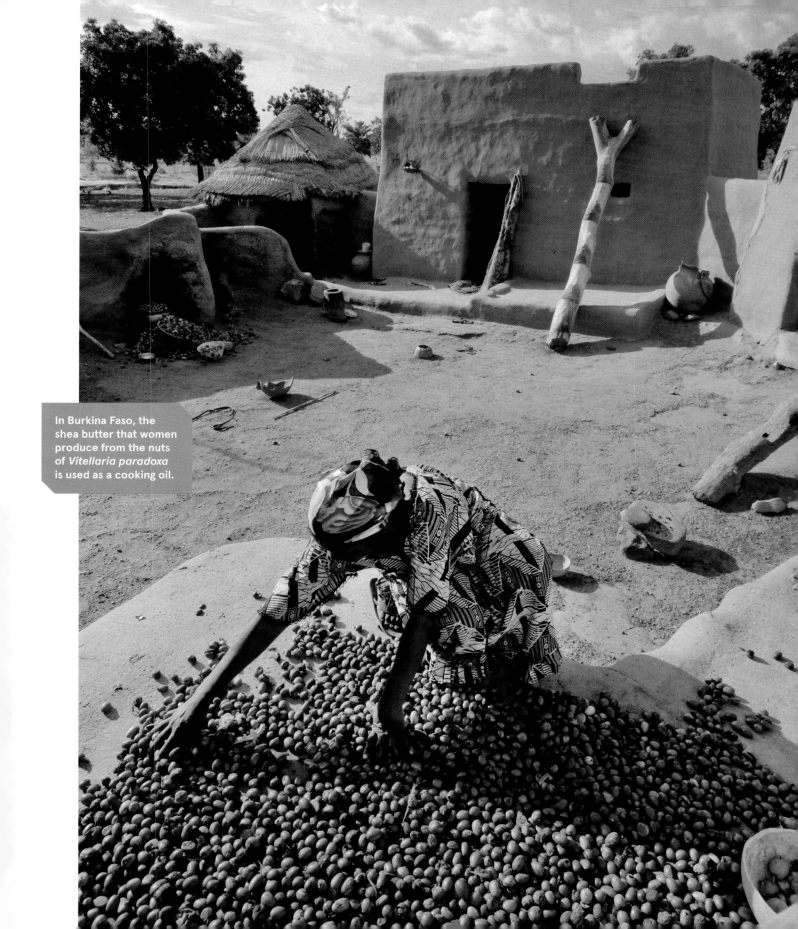

In Burkina Faso, the shea butter that women produce from the nuts of *Vitellaria paradoxa* is used as a cooking oil.

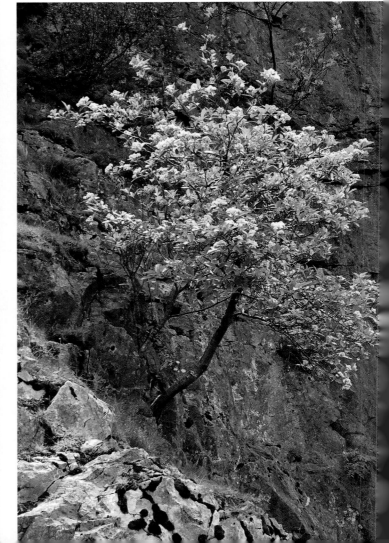

Epilogue: How You Can Contribute to a Future for All Trees

Trees are of immense importance, and a diverse natural mix of tree species is essential for the future of the planet. Yet trees are in trouble around the world. Thirty percent of all tree species are threatened with extinction, with many examples highlighted in this book. Action is already being taken to prevent the extinction of globally threatened trees, but we need to do more. The most important natural habitats for tree diversity must be recognised and protected. Degraded forests need to be restored using appropriate native species, and threatened trees should be included in the mix. Sustainable forest management must become a reality to ensure the supply of ecological goods and services that trees provide. And botanic gardens and arboreta need to fully engage in tree conservation and restoration action.

The signs of progress are mixed. In some areas of the world, forest loss has been stabilized, and in others, notably Europe and China, the total area of forest area is increasing. With over half the world's population now living in urban areas, there is scope to let more rural areas revert to forest. In 2020, the world assessed progress toward achieving global biodiversity conservation targets. There have been major gains—for example, in developing protected areas for biodiversity. The Aichi Target—which called for at least 17 percent of terrestrial and inland

water areas and 10 percent of coastal and marine areas to be conserved by 2020—has been met. The target for areas under agriculture and forestry to be managed sustainably, ensuring conservation of biodiversity, is harder to measure and to attain. Billions of dollars currently paid in subsidies to the agricultural and forestry sectors still need to be redirected to support nature. Better news is that forest restoration continues to scale up, and ambitious schemes are now in place. Looking specifically at tree species, we now have World Flora Online, a platform that provides the taxonomic framework for understanding the diversity of all plant species worldwide. BGCI's GlobalTreeSearch identifies all the world's tree species, noting country-level distribution for each species; so now all countries have access to a taxonomically up-to-date tree checklist. And the Global Tree Assessment has made magnificent strides in assessing the conservation status of each and every tree species; this provides the basis for monitoring future progress in ex situ and in situ conservation of trees.

Botanic gardens and arboreta are, as we have seen in this book, uniquely placed to lead in tree conservation. Ex situ collections of rare and threatened trees offer a huge opportunity for building public awareness, undertaking research, and providing materials for reintroduction and forest restoration. The Morton Arboretum in the US and other leading arboreta have major collections of threatened trees in stable sites set aside for conservation in perpetuity. In tropical countries, botanic gardens such as FRIM Selangor Forest Park and Indonesia's Bogor Botanic Garden have fine collections of trees built up over the last century. Smaller local gardens that concentrate on local trees are also of immense importance, particularly in the most biodiverse parts of the world.

Even the very smallest botanic gardens can have a significant impact. In Wales, Fossil Plants is the private garden of Robbie Blackhall-Miles and Ben Ram. The dual aims of their garden, established in 2011, are to tell the story of how early plants evolved by establishing a living collection of their modern-day representatives, in a temperate garden environment ("and actively engage others in their story"); and to propagate these plants and make them available for the purposes of conservation, education, and research. Robbie is a self-taught botanist and expert plant grower who has been fascinated by plants since his early teens. As the garden expanded, Robbie decided to link with BGCI, and in 2019 Fossil Plants received BGCI Accreditation, which recognises achievements in plant conservation. As Robbie explains:

We don't have space in our 115 m² plot and research nursery to grow many tree species, but I am proud that Ben and I maintain specimens of globally threatened trees such as *Araucaria angustifolia*. We take part in international botanical expeditions documenting the status of species in the wild, and recently I have been working with the National Botanic Garden of Wales to propagate the critically endangered Menai Strait whitebeam (*Sorbus arvonensis*). This small tree is found nowhere else in the world except on the edge of Snowdonia. Above all, I truly believe that everyone can do something to prevent extinction. Avoiding products containing palm oil is one step we can all consider—it's not that difficult!

Robbie's work on *S. arvonensis* is in association with the North Wales Wildlife Trust, a grassroots conservation agency; this kind of local tree conservation partnership is crucial for the future of trees.

Botanic gardens have a tradition of working collaboratively on conservation initiatives that is fostered by national networks and globally through BGCI. Connecting botanic gardens with in situ conservation agencies is one of the key approaches of the Global Trees Campaign, as we have seen in this book. A relatively new mechanism to promote and acknowledge practical tree conservation action for endangered trees is ArbNet. The ArbNet Accreditation Program enables any arboretum or public garden with a substantial focus on woody plants to apply for recognition. It is reaching out to a wider audience, beyond the traditional botanic garden community, embracing cemeteries, school grounds, and corporate properties with tree collections, encouraging high standards in tree care and links to conservation. To achieve the highest standard of accreditation, ArbNet members must demonstrate participation in collaborative scientific or conservation activities related to trees, such as the Global Trees Campaign. So far, 28 arboreta and similar organisations have achieved the highest level of accreditation.

Botanic gardens and arboreta have an important role to play in tree conservation, particularly as they look beyond their garden walls. Managing trees in their natural habitats is the key challenge and a responsibility for a wide range of different organisations. Local, national, and international conservation organisations form an extensive and loosely interconnected network often reliant on the commitment of their members and donors. Each works in its own particular manner to protect and restore species and habitats.

The Global Trees Campaign set out to prevent the extinction of tree species and has achieved considerable success. Mark Rose, Chief Executive Officer of FFI, saw the potential from the outset. "When information became available on the scale of potential tree extinctions globally, how could we ignore it? FFI has never shied away from a challenge and strives to conserve all forms of biodiversity, not only the iconic species. I am very proud of what we have achieved through the Campaign, but of course we need to continue scaling up our outreach and actions working in partnership with local organisations."

Growing international awareness of the devastating impacts of climate change is an opportunity to bring tree conservation to a wider audience. Deforestation and forest degradation, as well as being the major threat to tree species globally, may account for up to 25 percent of global carbon emissions. This represents a significant contribution to global warming and, as such, looking after the world's forests is one of the most effective ways to minimise the impacts of climate change. Innovative funding mechanisms such as REDD+ are helping countries to conserve some of the world's most species-rich forests. With calls for increased and concerted action from governmental to local level, tree planting on a massive scale is also being presented as a solution. Trees play a vital role in sequestering carbon and can offset the emissions from manufacturing, transport, and agriculture. The challenge will be to plant the right tree in the right place if we want to maximise the benefits of tree planting. Planting extensive areas with fast-growing *Acacia* and *Eucalyptus* is not the answer and has been a threat to native trees in many parts of the world. Restoring wild populations of threatened trees is a much more positive way forward, simultaneously sequestering carbon, conserving tree diversity, and supporting insects and other forms of wildlife that depend on each tree species.

Looking ahead, efforts to document, celebrate, and conserve all tree species must continue to grow as trees collectively support life on earth. At the international level, a Global Deal for Nature signed by over 3 million people calls for protecting 30 percent of the biodiversity of the planet by 2030 and half by 2050. Furthermore, at the UNFCCC Climate Change Conference in 2021 (known as COP26), the leaders of over 130 countries committed to work together to halt and reverse forest loss and land degradation by 2030. In the meantime, individuals can help to save trees from extinction in many ways. Here are just a few:

Find out more about threatened trees in your area or places you are visiting

Choose sustainably produced wood and paper products that are certified

Grow native trees and, where possible, trees that are under threat in the wild but available from reputable nurseries

Reduce, reuse, recycle

Remove invasive species and avoid planting them in your garden

Avoid products containing palm oil or buy products certified to have come from sustainable oil palm production

Support citizen science initiatives, such as iNaturalist

Eat less meat and dairy and, where possible, buy locally sourced

Support pollinator initiatives

Take action to reduce your carbon footprint

Support local, national, and international conservation organisations as a volunteer or donor

Campaign for the environment and lobby decision-makers to ensure that imperilled trees are conserved and restored

Visit your local botanic garden or arboretum to find out how they are helping tree conservation—and support them

Resources

Bonn Challenge / bonnchallenge.org

Botanic Gardens Conservation International / bgci.org

Climate, Community and Biodiversity Standards / climate-standards.org/ccb-standards

Conservation Leadership Programme / conservationleadershipprogramme.org

Convention on Biological Diversity / cbd.int

Convention on International Trade in Endangered Species of Wild Fauna and Flora / cites.org

FairWild Standard / fairwild.org/the-fairwild-standard

Fauna & Flora International / fauna-flora.org

ForestGEO / forestgeo.si.edu

Forest Stewardship Council / fsc.org

Global Strategy for Plant Conservation / bgci.org/our-work/policy-and-advocacy/the-global-strategy-for-plant-conservation

Global Tree Assessment / globaltreeassessment.org

Global Trees Campaign / globaltrees.org

International Conifer Conservation Programme / rbge.org.uk/science-and-conservation/genetics-and-conservation/conifer-conservation/

International Tropical Timber Organization / itto.int

International Union for Conservation of Nature / iucn.org

IUCN Red List of Threatened Species / iucnredlist.org

Programme for the Endorsement of Forest Certification / pefc.org

Reducing Emissions from Deforestation and Forest Degradation / fao.org/redd/en

Sustainable Agriculture Network / sustainableagriculture.eco

United Nations Convention to Combat Desertification / unccd.int

United Nations Framework Convention on Climate Change / unfccc.int

Verified Carbon Standard / verra.org/project/vcs-program

World Flora Online / worldfloraonline.org

Yale School of Forestry's Global Forest Atlas / globalforestatlas.yale.edu

Acknowledgements

This book is dedicated to all members of the IUCN/SSC Global Tree Specialist Group and all involved in the Global Trees Campaign over the past 20 years. We would like to thank them all for their inspirational action for tree conservation and for their friendship. We are most grateful to Philippe de Spoelberch for his support for the Global Trees Campaign from the outset. For contributions to the book, we would particularly like to thank Adrian Newton for help with ideas for the contents and providing the section on tropical cloud forests, Georgina Magin for her critical review of the manuscript, and Peter Wilkie for providing the section on Sapotaceae. We are also most grateful to Steve Ball, Emily Beech, Robbie Blackhall-Miles, Lillian Chua, Vincent Deblauwe, Cristian Echeverria, Aljos Farjon, Lauren Gardiner, Martin Gardner, Luis Roberto González-Torres, Joachim Gratzfeld, Lam Van Hoang, Sarah Horton, Pablo Hoffmann, Makala Jasper, Jean Lagarde Betti, Xiaoya Li, Jean Linsky, Cristina López-Galego, Dan Luscombe, William McNamara, Esteban Martínez Salas, Mónica Moraes, Lan Qie, Mark Rose, Godfrey Ruyonga, Marie-Stéphanie Samain, Jarkyn Samanchina, Julia anak Sang, George Schatz, Rudy Schlaepfer, Alison Shapcott, Kirsty Shaw, Deepu Sivadas, Paul Smith, Murphy Westwood, and Oliver Wilson.

Sincere thanks are also due to everyone who contributed photographs, which are not generally easy to source for the world's rarest trees. Thank you to Fred Pilkington and Sarah Pocock, who helped with sourcing and collating the photographs provided by FFI.

BGCI and FFI are two hugely important organisations that champion tree conservation. We appreciate the hard work of all our colleagues and realise that many more have contributed indirectly to the book than those listed above. We are grateful for all the tree conversations, shared workshops, red listing, visits to project sites, and sharing of conservation results that have provided material for this book. Thanks also to the team at Timber Press, who have been a pleasure to work with.

Photo Credits

David Gill / GTC, page 8.

Steven Brewer, page 10.

Joachim Gratzfeld / BGCI, pages 16, 76.

Botanic Gardens Conservation International, pages 19, 20, 91, 98, 158, 163 (top), 168, 170, 250, 252 (right), 255.

Erlantz Perez / Dreamstime, page 26.

FFI / BGCI, pages 27, 63 (right), 145, 182 (bottom), 216, 224 (top), 259, 337.

Sara Oldfield, pages 28, 29, 117, 168, 188, 309.

SI Photography / Dreamstime, page 34.

Arturoosorno / Dreamstime, page 35.

thibaudaronson / Wikimedia, page 39.

Anna Artamonova / Dreamstime, page 42.

Martin Schneiter / Dreamstime, page 46.

Madagasikara Voakajy, pages 50, 63 (left).

Elena Shchipkova / Alamy Stock Photo, page 52.

Cristian Echeverria, page 55.

Pellinni / Adobe Stock, page 57.

Danita Delimont / Alamy Stock Photo, page 59.

Thomas Heller / RBG Kew, page 60.

Malin Rivers / BGCI, pages 61, 62, 64.

Ondrej Vavra / Dreamstime, page 65.

David Eickhoff / Flickr, page 66.

Matheus Eduardo Veloso / Flickr, page 72.

Paralaxis / Shutterstock, page 73.

Jurate Buiviene / Dreamstime, page 75.

Daphanyc / Dreamstime, page 77.

Vladimir Melnik / Dreamstime, page 79.

Mats Thulin / BGCI, page 80.

Natalia Zakhartseva / Dreamstime, page 82.

ePhotocorp / Dreamstime, page 84.

Debashis Kumar / Dreamstime, page 86.

Jeevan Jose, page 87.

Alena Brozova / Dreamstime, page 89.

Anthony Baggett / Dreamstime, page 90.

Ufuk Aladaglioglu / Dreamstime, page 93.

Eugenz / Dreamstime, page 94.

Images & Stories / Alamy Stock Photo, page 95.

Maria 1986nyc / Dreamstime, page 96.

Willem Frost / picfair.com, page 97.

JMK / Wikimedia, page 101.

Ya'axché Conservation Trust, page 103.

Kevin Wells / Dreamstime, page 104.

Sabena Jane Blackbird / Alamy Stock Photo, page 106.

Viktor Tkachuk / Dreamstime, page 107.

Historical Views / Alamy Stock Photo, page 108.

Vasilis Ververidis / Dreamstime, page 112.

Dmytro Synelnychenko / Dreamstime, page 113.

Bennymarty / Dreamstime, page 115.

Fidy Ratovoso / BGCI, page 116.

Lan Qie, pages 118, 120, 121.

monica renata / Flickr, page 119.

Vinícius Silva Couto / Dreamstime, page 122 (top).

Octavio Campos Salles / Alamy Stock Photo, pages 122 (bottom), 342, 344.

Public Domain / Wikimedia, page 123.

Xauxa Håkan Svensson / Wikimedia, page 127.

Jesse Kraft / Dreamstime, page 128.

Katherine Wagner-Reiss / WikiCommons, page 130.

Donajulia / Dreamstime, page 135.

Paralaxis / Alamy Stock Photo, page 137.

Jason B. Smith, pages 139, 148.

Christophe Courteau / Alamy Stock Photo, page 142.

Georgy Lazkov, pages 144, 146 (bottom).

Alexey Yakovlev / Wikimedia, page 146 (top).

Zaneta Cichawa / Dreamstime, page 147.

Nicousnake / Dreamstime, page 150.

Koffermejia / Wikimedia, page 152.

Javarman / Dreamstime, page 153.

Marcin Mierzejewski / Dreamstime, page 155.

Yousheng Chen / BGCI, page 156.

David Williams / Dreamstime, page 157.

Wei Xiao / BGCI, page 159.

Andrei Gabriel Stanescu / Dreamstime, page 160.

Lianem / Dreamstime, page 161 (top).

Florapix / Alamy Stock Photo, pages 161 (bottom), 281.

Plant Image Library / Wikimedia, page 162.

Helmut Steiner / Flickr, page 163 (bottom).

Parin Parmar / Dreamstime, page 165.

Sushil Chettri / Dreamstime, page 167.

Jeff Colman / Flickr, page 168.

Alessandrozocc / Dreamstime, page 169.

Top-Pics TBK / Alamy Stock Photo, page 172.

Stewart Mckeown / Alamy Stock Photo, page 174.

Dee Browning / Alamy Stock Photo, page 176.

Geoff Oliver / Alamy Stock Photo, page 177.

Luis Figueroa / Wikimedia, page 178.

Lisandro Trarbach / Alamy Stock Photo, page 181.

RM Floral / Alamy Stock Photo, page 182 (top).

Kristin Piljay / Alamy Stock Photo, page 184.

Elena Podolnaya / Dreamstime, page 185 (left).

Edward Parker, page 185 (right).

Aljos Farjon, pages 186, 194, 207, 211 (left), 228, 234.

Kate Field, page 187.

Chile DesConocido / Alamy Stock Photo, page 190.

Diego Grandi / Alamy Stock Photo, page 191.

Mark Taylor / Nature Picture Library, page 192.

Kevin Schafer / Alamy Stock Photo, page 193.

BlueOrangeStudio / Alamy Stock Photo, page 195.

Jeremy Holden, page 196.

Mark Taylor / Alamy Stock Photo, page 199.

Larum Stock / Alamy Stock Photo, page 200.

Brad Mitchell / Alamy Stock Photo, page 202.

Dante S. Figueroa, page 204.

Floris van Breugel / Nature Picture Library, page 206.

Caner CIFTCI / Alamy Stock Photo, page 209.

Alan Cressler, page 210 (left).

John Grimshaw, pages 210 (right), 224 (bottom).

IUCN/SSC/MPSG-2017, page 211 (right).

Nicola Pulham / Alamy Stock Photo, page 212.

Tom Christian, pages 213, 214, 215.

Ding Tao / Guangxi Institute of Botany, page 217.

travelbild-Italy / Alamy Stock Photo, page 219.

Leopold von Ungern / Alamy Stock Photo, page 220.

Graham Jepson / Alamy Stock Photo, page 222.

Cao Hai / Dreamstime, page 226.

Henk Van Den Brink / Dreamstime, page 229.

Tim Gainey / Alamy Stock Photo, pages 230, 277.

blickwinkel / Alamy Stock Photo, page 232.

Didier Descouens / Wikimedia, page 235.

Robin Lardon / Alamy Stock Photo, page 236.

Gunnar Keppel, pages 240, 241 (top).

Maika Daveta, page 241 (bottom).

Morgan Trimble / Alamy Stock Photo, pages 243, 245.

Jake Lyell / Alamy Stock Photo, page 244.

John Glover / GAP Gardens, page 246.

Planta!, page 248.

Zeng Qingwen / BGCI, pages 250, 251.

Weibang Sun / BGCI, page 252 (right).

Andrew Bunting, page 253.

Roy Johnson / Alamy Stock Photo, page 258.

Fauna & Flora International, page 259.

Shouzhou Zhang / BGCI, page 261.

Neveshkin Nikolay / Shutterstock, page 265 (top).

Eladio Fernandez / Nature Picture Library, pages 265 (bottom), 327.

Lionel Montico / Alamy Stock Photo, page 266.

Fausto Riolo / Shutterstock, page 268.

Municipality of Jardín, Colombia, page 270 (bottom).

Chris Howes / Wild Places Photography / Alamy Stock Photo, page 272.

Neal Kramer / Flickr, page 278.

Michael Moore, page 279.

Murphy Westwood / The Morton Arboretum, pages 284, 289.

Deborah J. G. Brown / Flickr, page 286 (top).

Rebekah D. Wallace, University of Georgia / Bugwood.com, page 286 (bottom).

Bruce Kirchoff / Flickr, pages 287 (left), 290.

Los Angeles County Arboretum, page 287 (right).

Kara A. Rawlins, University of Georgia / Bugwood.com, page 288.

Silvia Alvarez-Clare, pages 294, 296 (right).

Javier Martin / WikiCommons, page 298.

Pablo Galán Cela / Alamy Stock Photo, page 299.

Juan Carlos Muñoz / Alamy Stock Photo, page 300.

downunder / Alamy Stock Photo, page 302.

Ahfotobox / Dreamstime, page 303.

Nick Garbutt / Steve Bloom Images / Alamy Stock Photo, page 304.

Nigel Hicks / Alamy Stock Photo, page 306.

Cerlin Ng / Flickr, page 307.

Charoenchai Tothaisong / Dreamstime, page 308 (top left).

JJ Harrison / WikiCommons, page 308 (top right).

Christian Zappel / Alamy Stock Photo, page 308 (left, second from top).

Cede Prudente / Alamy Stock Photo, page 308 (left, second from bottom).

Frendi Apen Irawan / WikiCommons, page 308 (right, second from top).

Levg / WikiCommons, page 308 (right, second from bottom).

Ahmad Affandi Lubis / Dreamstime, page 308 (bottom left).

Praveenp / WikiCommons, page 308 (bottom right).

Scenics & Science / Alamy Stock Photo, page 310.

Gergely Nagy / Alamy Stock Photo, page 314.

Atosan / Dreamstime, page 315.

Mim Friday / Alamy Stock Photo, page 316.

Jean Linsky / BGCI, page 317.

Aerial Drone Master / Adobe Stock, page 319.

REY Pictures / Alamy Stock Photo, page 320.

Konrad Wothe / Alamy Stock Photo, page 322.

Paul Craft, pages 328, 338, 339.

Sociedade Chauá, pages 329, 330 (left).

Alex Brondani / Dreamstime, page 330 (right).

Konstantin Kalishko / Alamy Stock Photo, page 332.

Roland Seitre / Nature Picture Library, page 334.

Federico Rios Escobar, page 335.

Gail Johnson / Dreamstime, page 347

Ariadne Van Zandbergen / Alamy Stock Photo, page 349.

William J. Baker / RBG Kew, page 350.

Artushfoto / Dreamstime, page 351.

Haitham Ibrahim / GTC, page 352.

Kyle Wicomb / Flickr, page 353.

Scott Zona / Flickr, page 354 (top).

Donyanedomam / Dreamstime, page 354 (bottom).

John Dransfield, page 356.

Peter Wilkie / GTC, pages 358, 361 (top), 362, 372 (top).

Nipaporn Panyacharoen / Dreamstime, page 361 (bottom).

Creative Commons, page 363.

Wasana Jaigunta / Dreamstime, page 364.

Sam Bridgewater / GTC, page 365.

Katephotographer / Dreamstime, page 366.

Benoit Henry / Flickr, page 369.

Rosa Scopetra, page 370.

Valeriy Tretyakov / Dreamstime, page 371.

Laurent Gautier and Yamama Naciri, page 372 (bottom).

Fabien Growas / Dreamstime, page 373.

Bob Gibbons / Alamy Stock Photo, page 374.

Guenter Fischer / Alamy Stock Photo, page 376.

Joerg Boethling / Alamy Stock Photo, page 377.

All other photos are courtesy of the Global Tree Campaign.

Index

About the Authors

BRUCE PEARSON

SARA OLDFIELD is Co-Chair of the IUCN/SSC Global Tree Specialist Group, responsible for promoting and implementing projects to identify and protect globally red-listed tree species. She was Secretary General of Botanic Gardens Conservation International (BGCI) from 2005 to 2015; previously she was Global Programmes Director for Fauna & Flora International. Throughout her career, she has worked on the conservation of trees and plants for a wide range of other organisations, including UNEP World Conservation Monitoring Centre and Royal Botanic Gardens, Kew, and as a freelance consultant and policy advisor for international biodiversity conservation.

MALIN RIVERS

MALIN RIVERS is the Head of Conservation Prioritisation at Botanic Gardens Conservation International (BGCI). She manages the red list programme at BGCI, with its current focus on the Global Tree Assessment. Recent tree red list projects include Magnoliaceae, Theaceae, European trees, Madagascar trees. In addition, Malin is the Red List Authority Coordinator and Secretary of the IUCN/SSC Global Tree Specialist Group.